NOTICE

THERE ARE NO EMERGENCY MEDICAL SERVICES ON THE YUKON SECTION OF THE DEMPSTER HIGHWAY

"Drive with Care"

THE SPELL
OF THE
YUKON

I WANTED THE GOLD, AND I SOUGHT IT;
I SCRABBLED AND MUCKED LIKE A SLAVE,
WAS IT FAMINE OR SCURVY ~ I FOUGHT IT;
I HURLED MY YOUTH INTO A GRAVE.
I WANTED THE GOLD AND I GOT IT ~
CAME OUT WITH A FORTUNE LAST FALL;
YET SOMEHOW LIFE'S NOT WHAT I THOUGHT
AND SOMEHOW THE GOLD ISNT ALL.

Robert Service

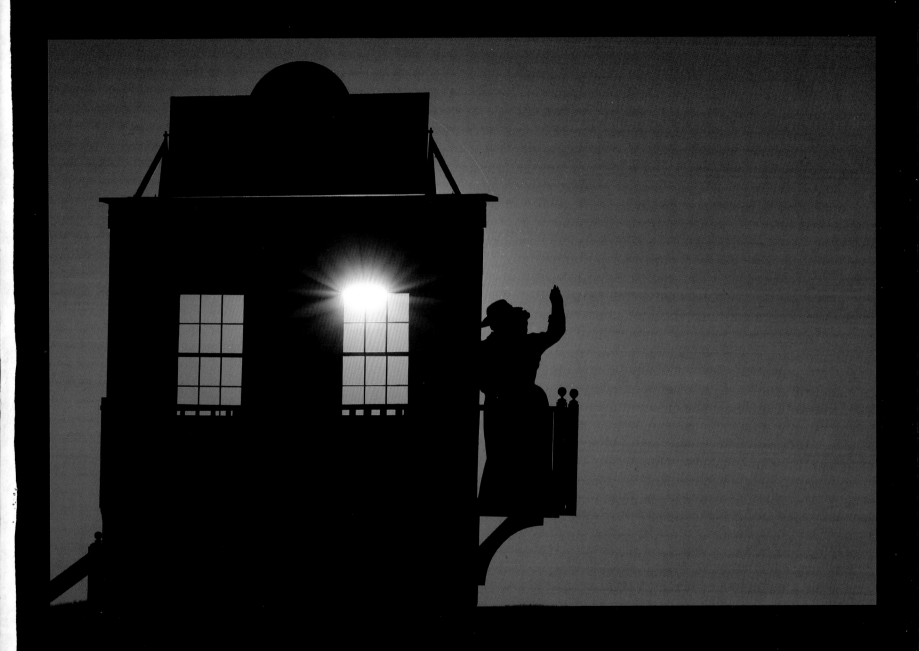

To all those who, like me,
need the wisdom of nature
to balance life.

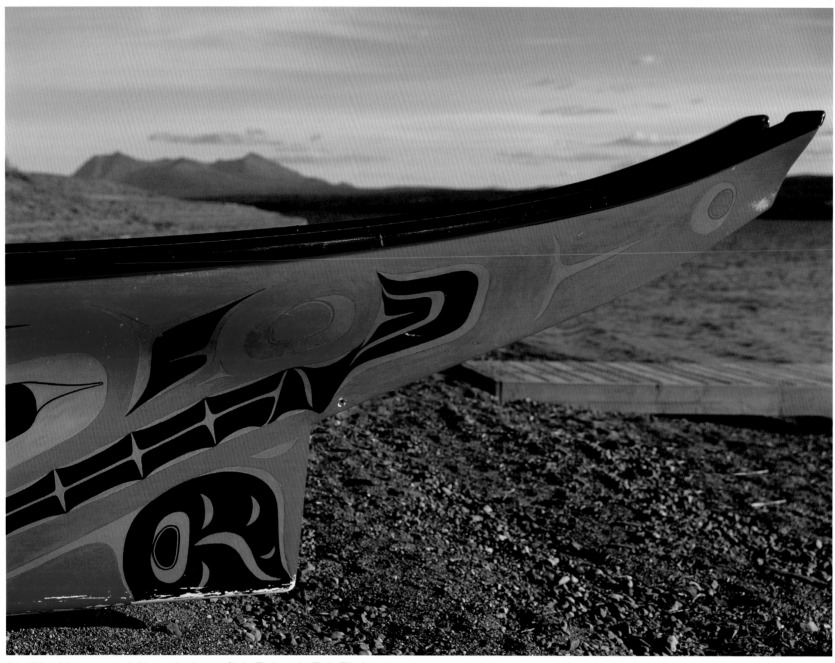

A traditional dugout canoe brightens the shores of Lake Teslin at the Teslin Tlingit Heritage Centre. The site is a dynamic art and cultural hub as well as a meeting place for the Teslin Tlingit Council government.
NEAR TESLIN

PREVIOUS ◦ A second-storey welcome greets visitors at the outskirts of town.
DAWSON CITY

FACING & COVER ◦ Frosted peaks of the Tombstone range cast rough shadows over its reflection.
TOMBSTONE TERRITORIAL PARK, CENTRAL YUKON

Design and captions: Catharine Barker, National Graphics, Toronto, ON Canada

Copy Editor: E. Lisa Moses

Nimbus Publishing Limited
3660 Strawberry Hill, Halifax, NS
Canada B3K 5A9

Tel.: 902 455-4286

Printed in China

NIMBUS
PUBLISHING
— NIMBUS.CA —

Library and Archives Canada Cataloguing in Publication

Fischer, George, 1954-, photographer, author
 Yukon : rugged beauty / photography, George Fischer.

ISBN 978-1-77108-712-4 (hardcover)

 I. Yukon—Pictorial works. I. Title.

FC4012.F57 2019 971.91'040222 C2018-906299-1

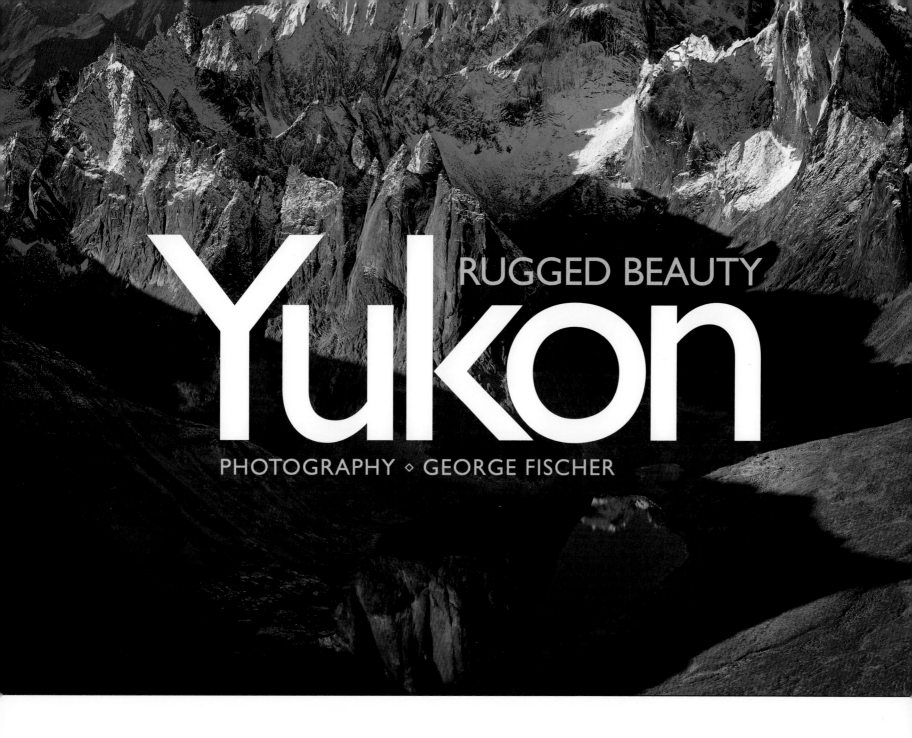

Yukon
RUGGED BEAUTY

PHOTOGRAPHY ◆ GEORGE FISCHER

Yukon

LARGER THAN LIFE

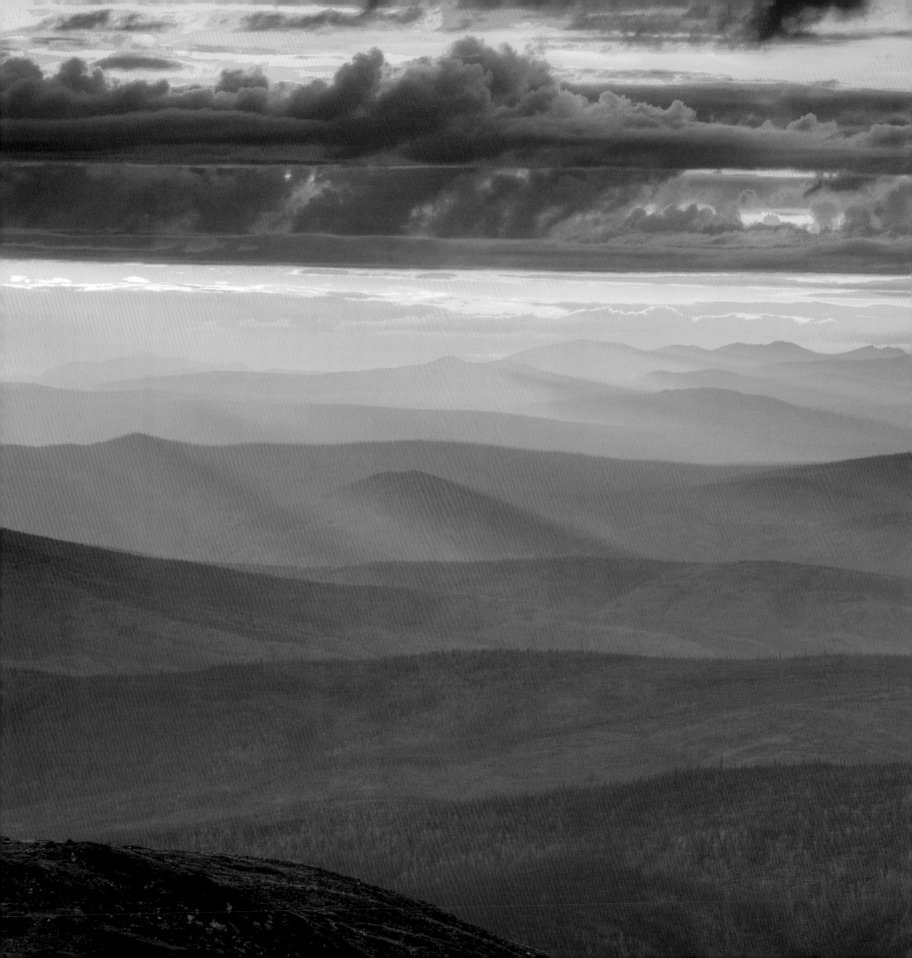

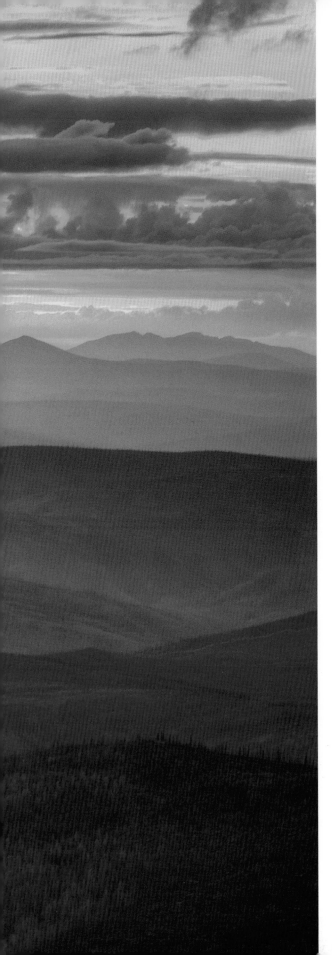

Foreword

On my first comprehensive exploration of this vast frontier, I was dazzled by the colossal mountain ranges, surreal colours and endless skies. It's a land where jagged tombstone-shaped mountains roar silently. Where nomadic wildlife, which greatly outnumbers humans, sees visitors as curiosities. And where the climate, atmosphere and seasons collide to create razor-sharp outlines and deeply saturated hues.

I arrived in the Yukon fresh from the city with distracting lights and competing noises filling my brain. I left imbued with the sounds of silence. Visions of the aurora borealis, mighty glaciers and blue night skies danced in my head. And etched forever on my memory is the magnificence of azure lakes and harvest moons in this land of the midnight sun.

Boots on the ground

Taking a road trip in our GMC Yukon SUV along the renowned Dempster Highway, which connects Yukon's Klondike Highway to Inuvik, Northwest Territories, we only had to look skyward to glimpse the spires of the Mackenzie Mountain Range, where hardy hikers can encounter Dall's sheep and mountain caribou. Also in view was Kluane National park, home to Canada's largest ice field. At ground level, long ribbons of pink fireweed framed the road, while in the distance elk, moose, wolverine and black bears roamed.

Along the way to capturing an iconic sunset shot at Wright Pass between the Yukon and Northwest Territories, we encountered a bit of traffic – a male and female moose blocking our route. Weighing anywhere from 200 to 700 kg, they just stared at us and were not shy about posing for photos. My companion and I eventually had to shoo them away so we could race to the pass before the sun went down.

In sharp contrast to the great outdoors are the city hot spots where lonely miners once gathered to find community. Vestiges of the Klondike Gold Rush have survived for 120 years in Whitehorse and Dawson City, where I felt I had stepped onto a film set. After long days of inhaling the bracing Yukon air, we'd cozy up to local bars to down Yukon Gold brews and sourtoe cocktails. In Dawson City, we rolled the dice at Diamond Tooth Gertie's (Canada's oldest casino) and danced with the chorus line girls, who had pulled us out of the audience and made us don garters and can-can dresses.

Rainbow-coloured hills roll along the Top of the World Highway (Yukon Highway 9) that for more than 127 scenic kilometres connects Alaska's Taylor Highway to West Dawson, Yukon.
BETWEEN DAWSON CITY AND LITTLE GOLD

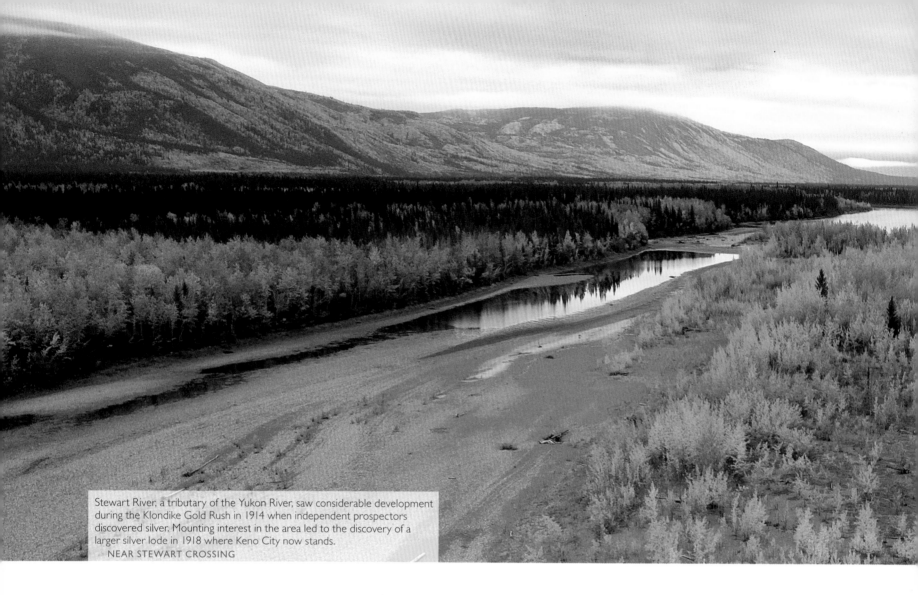

Stewart River, a tributary of the Yukon River, saw considerable development during the Klondike Gold Rush in 1914 when independent prospectors discovered silver. Mounting interest in the area led to the discovery of a larger silver lode in 1918 where Keno City now stands.
NEAR STEWART CROSSING

The end of that evening marked a perfect time to catch the aurora borealis. After changing back into my man clothes and stumbling over to the waterfront with my gear flapping around me, I got the money shot of the northern lights framing the historic *SS Keno* sternwheel paddle steamer.

On a detour into Keno City – a ghostly 50-soul whistlestop at the end of the once-booming Silver Trail – we had a sleepover at the Keno City Hotel. Reputedly haunted, the hostel sported Halloween décor of skeletons, monsters and ghouls. A scary old logging road took us some 11 km to the top of Keno Hill, home to abandoned silver mines and a set of rail tracks leading nowhere. More than 1800 m up, the pinnacle overlooks a dangerous leap into Faro Gulch, and a famous marker points to a number of international destinations.

Head in the clouds

Nowhere did I get a more profound sense of being part of something larger than life than in my Cessna flightseeing tours with Grand River Aviation. These brought me eye to eye with some of the world's most spectacular natural formations with names like Mount Monolith, Tombstone Mountain and Cathedral Mountains.

From 150 metres up, my eye followed the ribbon of the Top of the World

The Yukon is a place where wanderlust takes hold

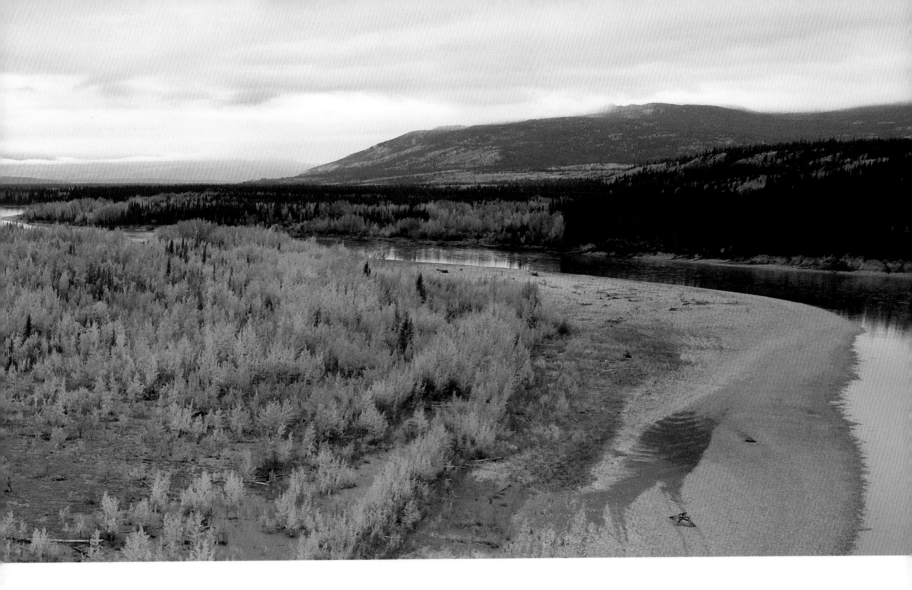

Highway stretching from Dawson City to the Alaska border, lingering over the lustrous multicoloured terrain of the Tombstone Mountain Range. The lichen-covered ground could have been painted by ancient impressionists, whose sweeping brush strokes softened the hard rocky edges piercing a cloudless sky. Soaring over the seemingly trackless tundra, we did spot some well-worn paths criss-crossing the jagged cliffs. Carved by hooves and paws, these trails serve as walkways for big-horned sheep, caribou and other wildlife – safely observed from our lofty perch. Intertwined with the animal tracks is a meandering network of hiking trails.

For me, it's always about immortalizing the sights with my camera – and the abundant layers of the Tombstone range gave me ample material. We arrived just as the sun was rising above the peaks, backlighting them to create shadows and silhouettes, and casting reflections of

Tombstone Mountain into Upper Twin Lake. Since positioning is the key to crafting a perfect photo, the plane had to take three or four passes to put me at the ideal angle and level of reflection. A tough shot to get but a rewarding result that sent my heart into overdrive.

The Yukon is a place where wanderlust takes hold, whether it's on terra firma or in the atmosphere. All it takes to satisfy that craving is simply reaching out to the earth, the sky and the stars. I invite you to share my amazing experience through the images in this book; I'm sure they'll make your heart beat faster.

– *George Fischer*

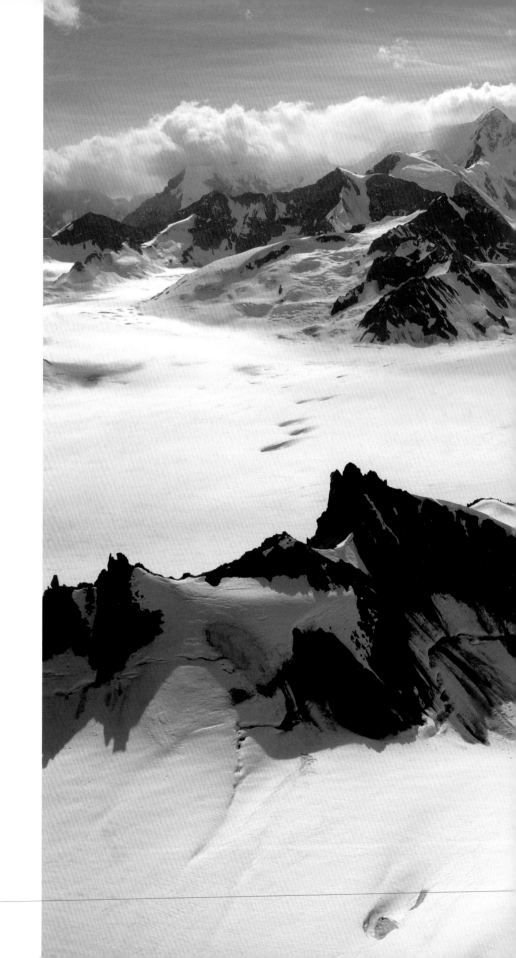

Snow-doused peaks and glaciers of the St. Elias Mountains command the majority of the 22,013 km² of the Kluane National Park and Reserve near the Canadian border. It is the largest protected area in the world and a UNESCO World Heritage Site.

KLUANE NATIONAL PARK AND RESERVE, SOUTHWEST YUKON

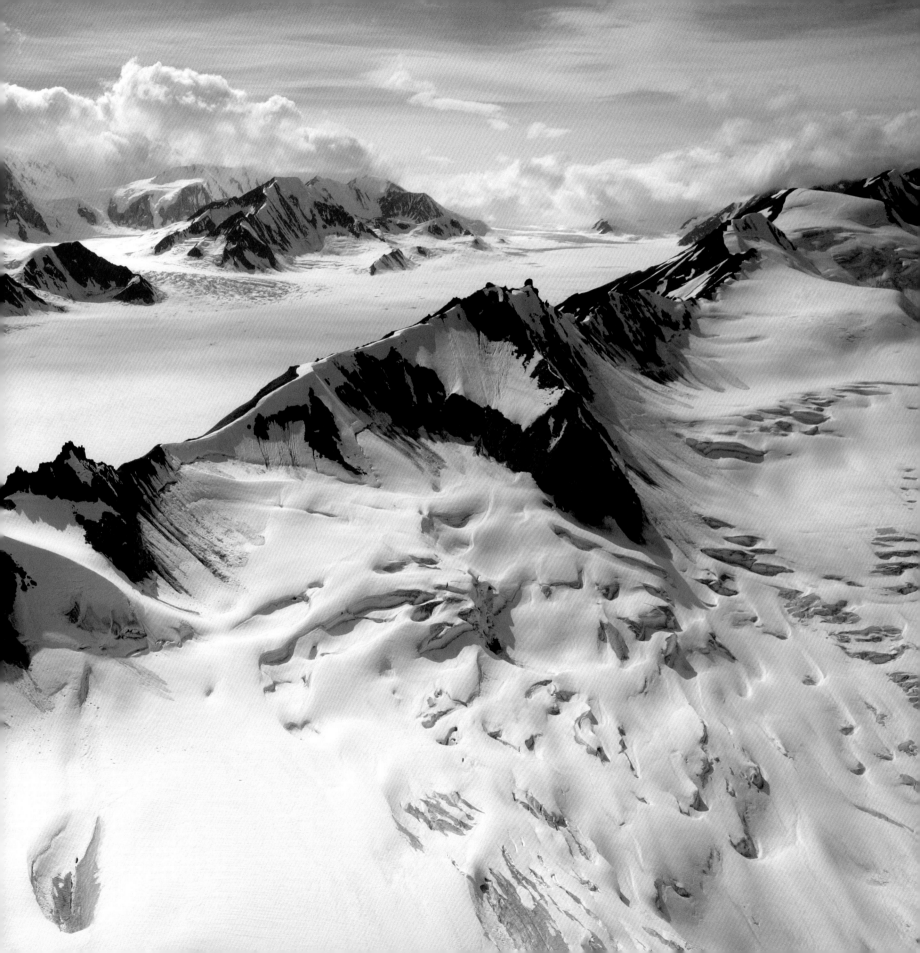

Surreal clouds hang above the Cassiar Mountains against a warm backdrop. A part of the Canadian Cordilleras, they span Yukon and British Columbia.

SOUTHERN YUKON

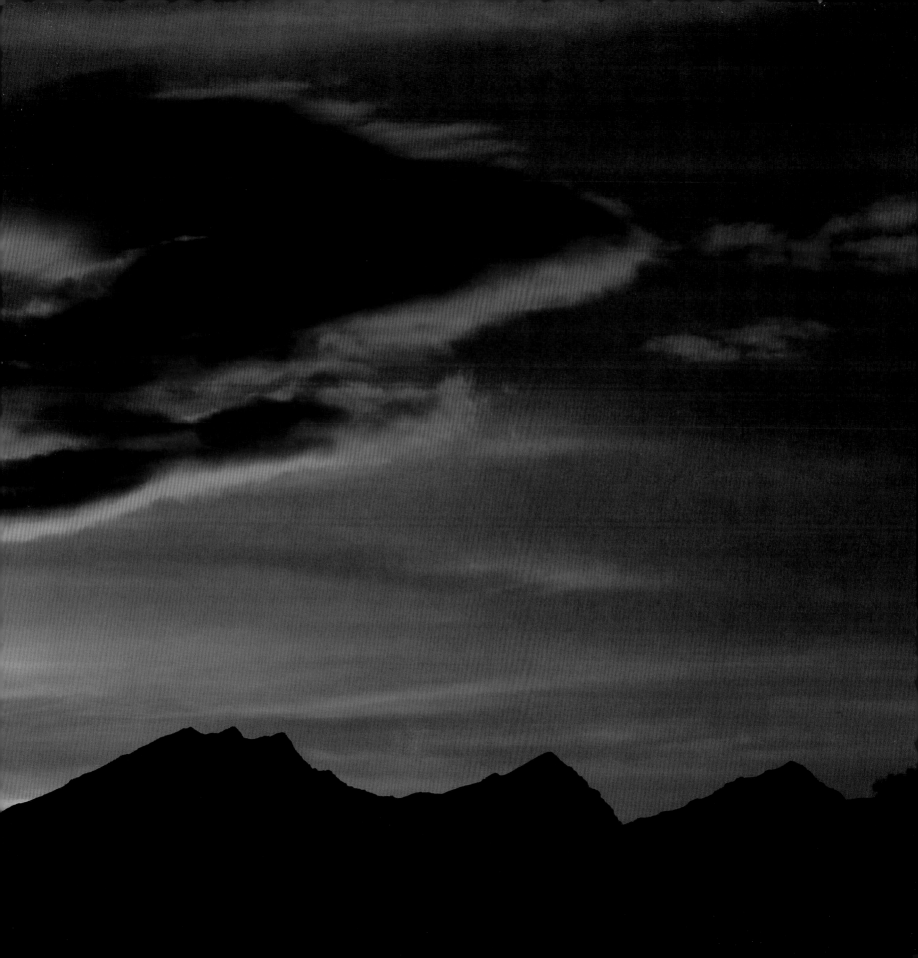

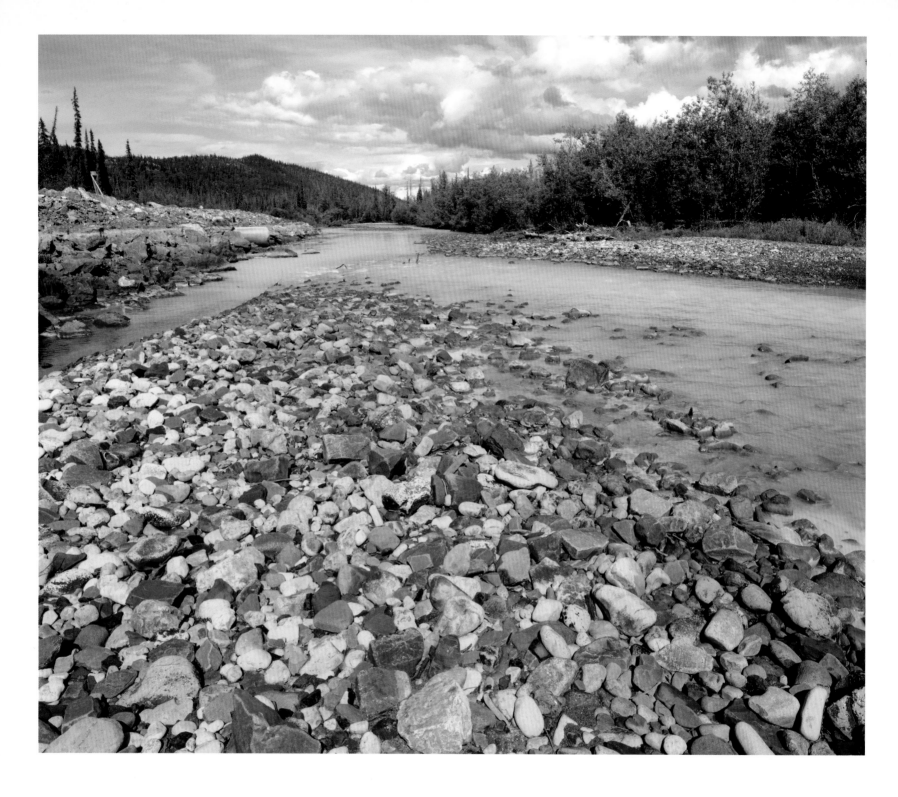

Evening light turns the St. Elias Mountains into solid gold. They are the highest coastal mountain range on Earth.
NEAR HAINES JUNCTION

FOLLOWING 2 PHOTOS The Dempster Highway bares part of its serpentine trail at Wright Pass, named for Allen A. Wright who engineered most of the 742-km route. The highway travels from Dawson City to Inuvik, 325 km above the Arctic Circle.

An opportunity to bond with unspoiled beauty arises on the golden banks of the Ogilvie River where it crosses the Dempster Highway.
DEMPSTER HIGHWAY KM 195, YUKON HIGHWAY 5

DEMPSTER HIGHWAY KM 465, YUKON HIGHWAY 5

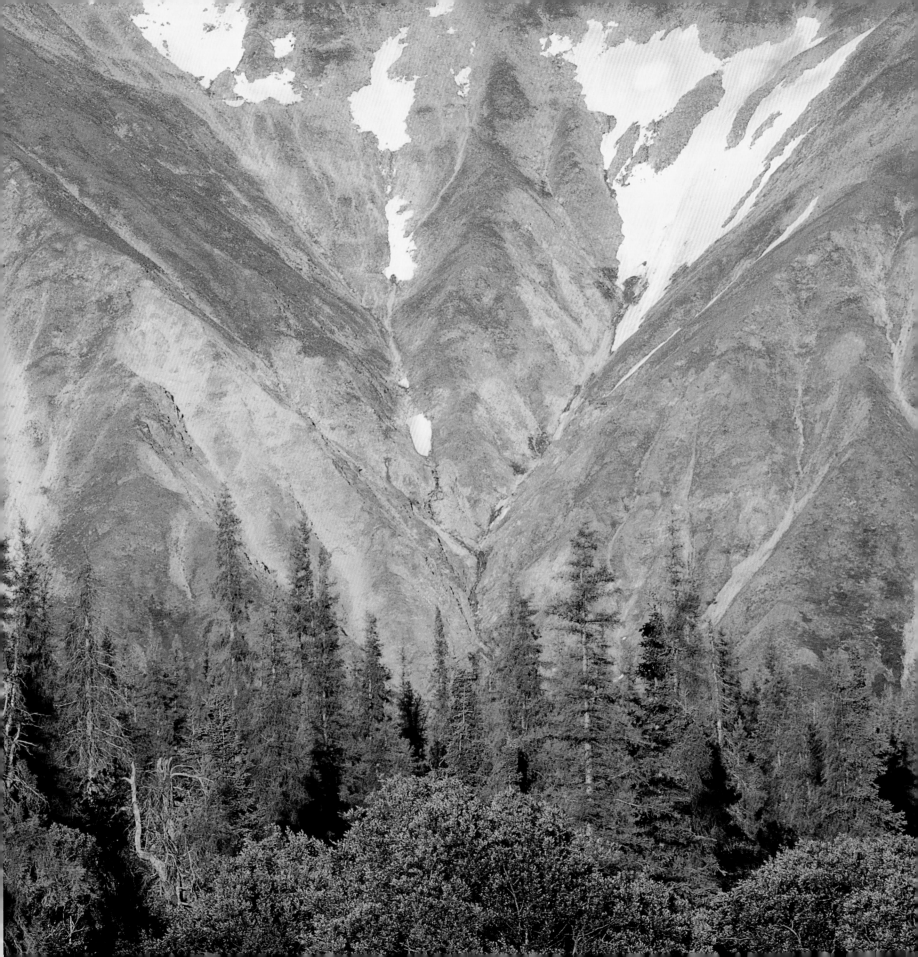

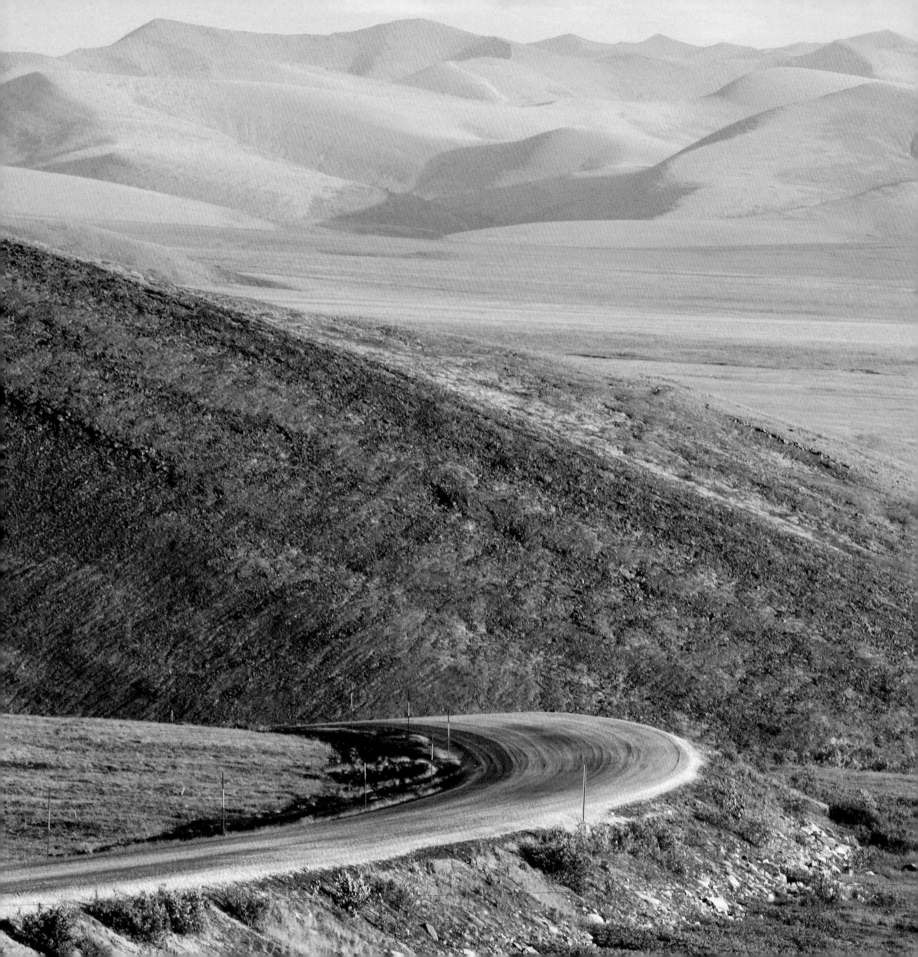

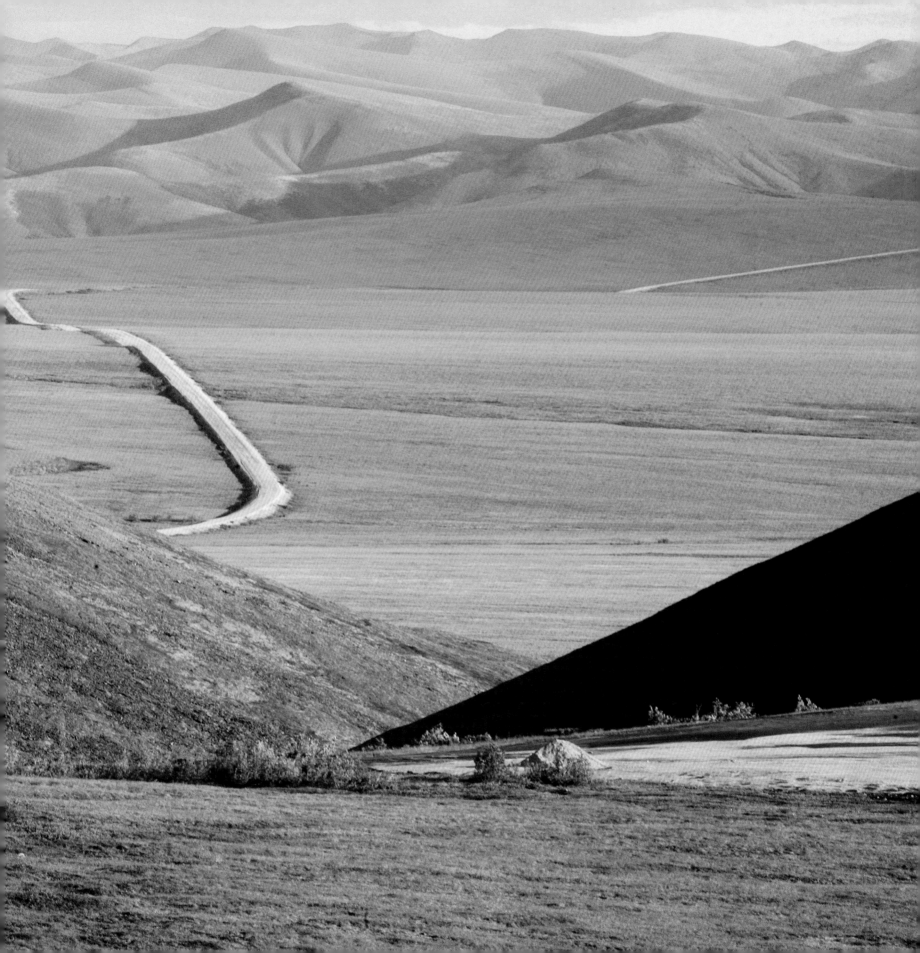

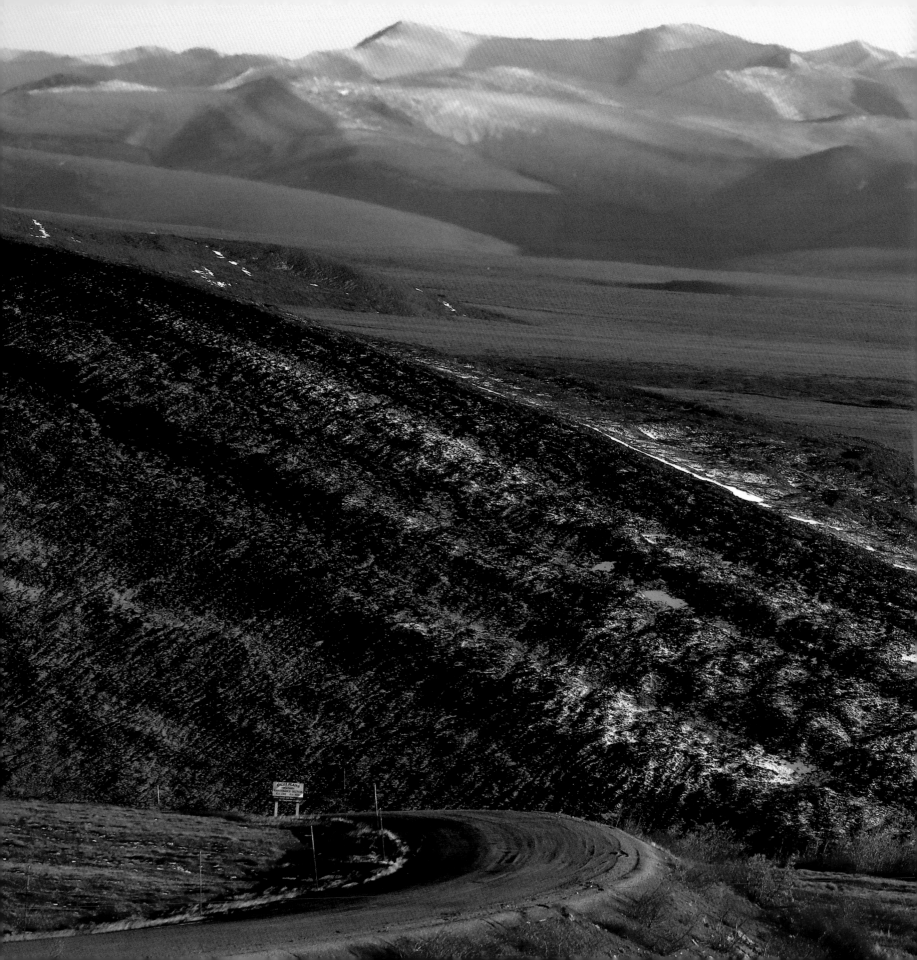

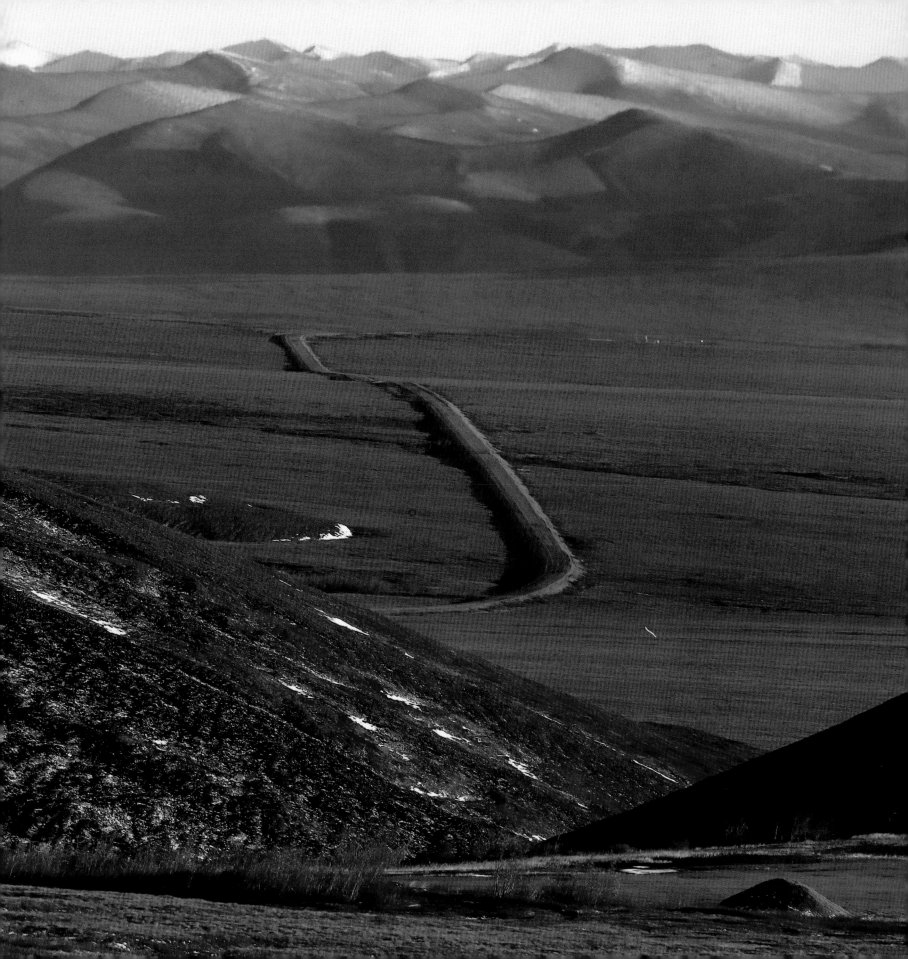

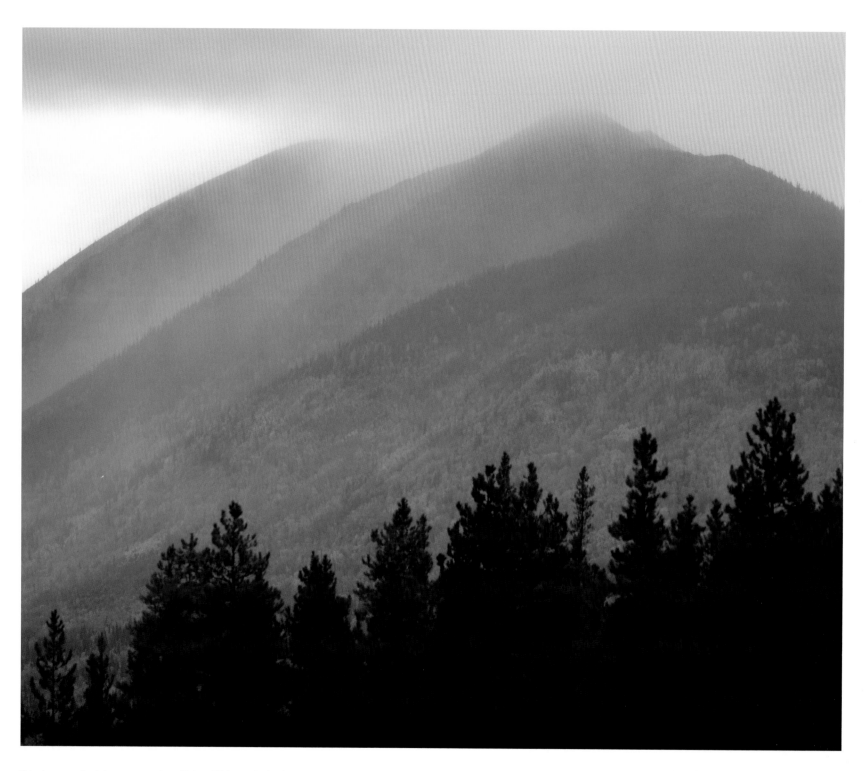

Fabulous scenic vistas emerge along Yukon Highway 4, also known as the Robert
Campbell Highway. It was named after Robert Campbell, a 19th-century explorer and
the first Hudson's Bay trader in the region.

ALONG ROBERT CAMPBELL HIGHWAY, YUKON HIGHWAY 4

FOLLOWING · A view of the monoliths shaped like grave markers that define the
Tombstone Mountains and inspired the territorial park's name. Over 2200 km² of
pristine nature is protected within the area.

DEMPSTER HIGHWAY KM 100, YUKON HIGHWAY 5

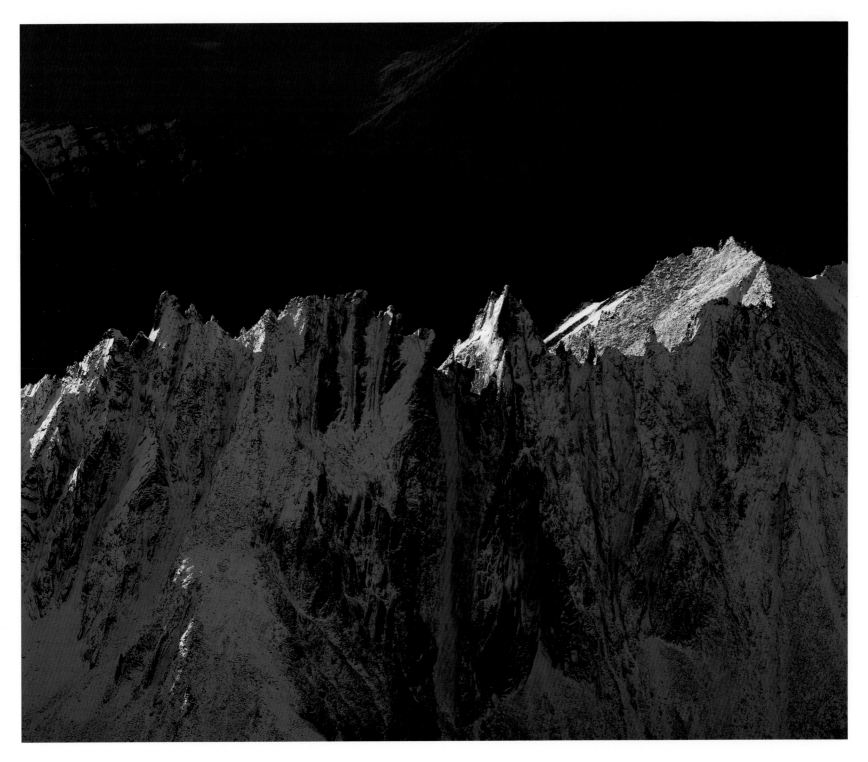

The sharp peaks of the Tombstone range create a foreboding wall. Protecting wilderness and abundant flora and fauna, Tombstone Territorial Park is within the traditional territory of the Tr'ondëk Hwëch'in First Nation.
TOMBSTONE TERRITORIAL PARK, CENTRAL YUKON

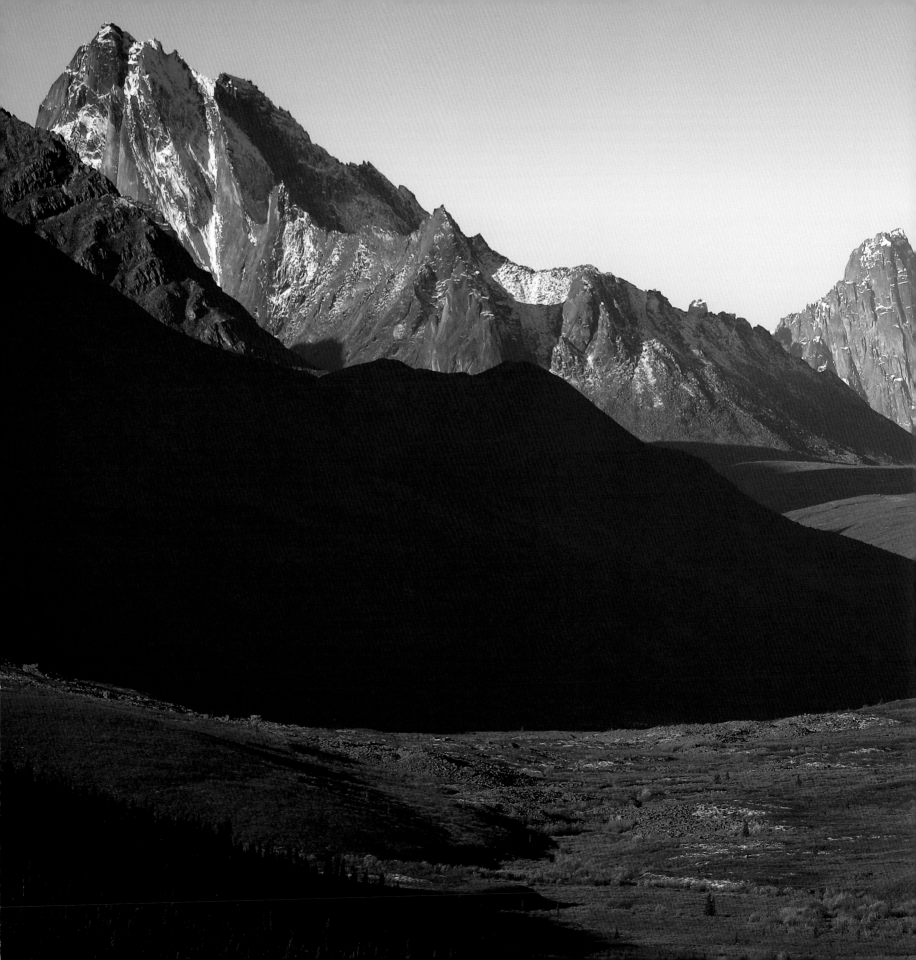

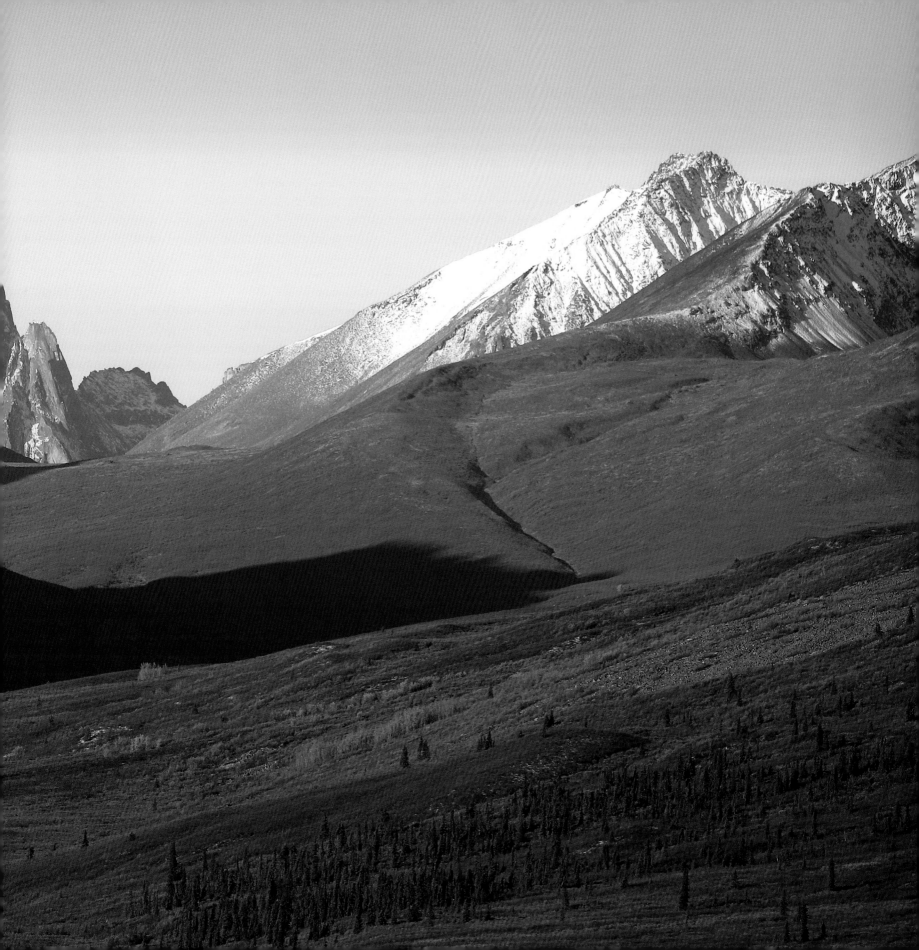

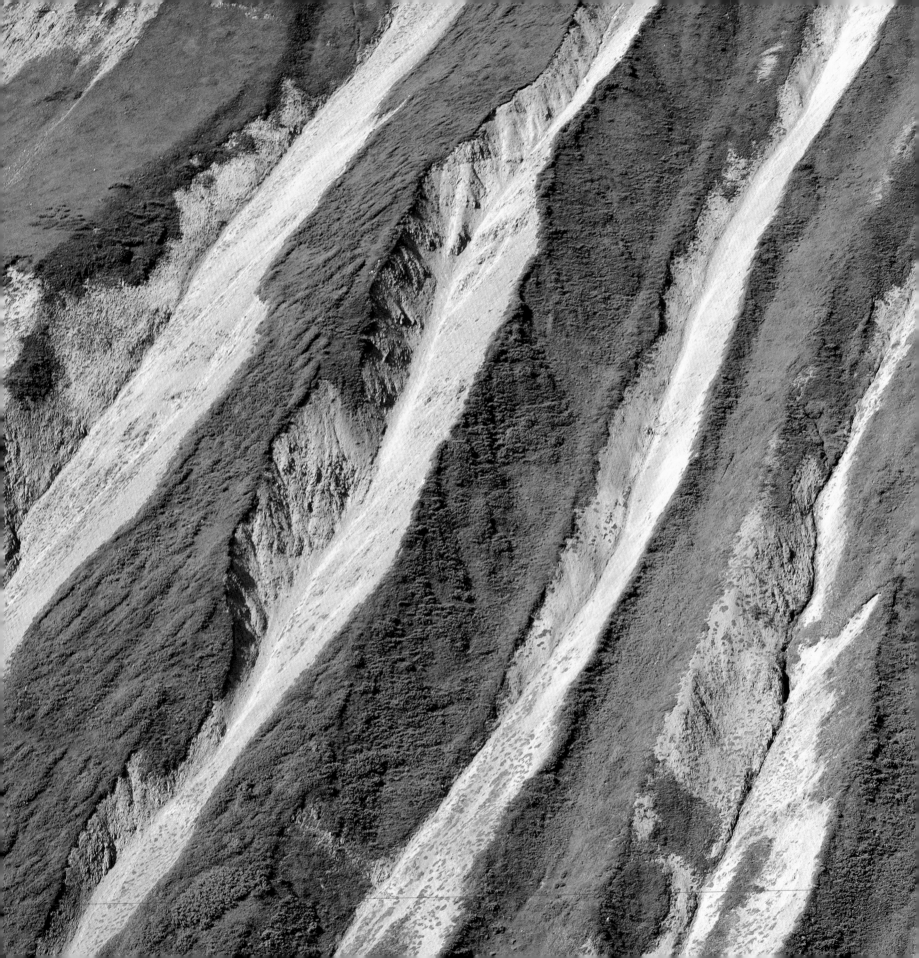

There's a land – oh,
it beckons
and beckons,
And I want to go
back – and I will.

[Robert W. Service, *The Spell of the Yukon and Other Verses*]

The massive St. Elias mountain range shows stunning striations carved
dramatically into the rock face.
KLUANE NATIONAL PARK AND RESERVE, SOUTHWEST YUKON

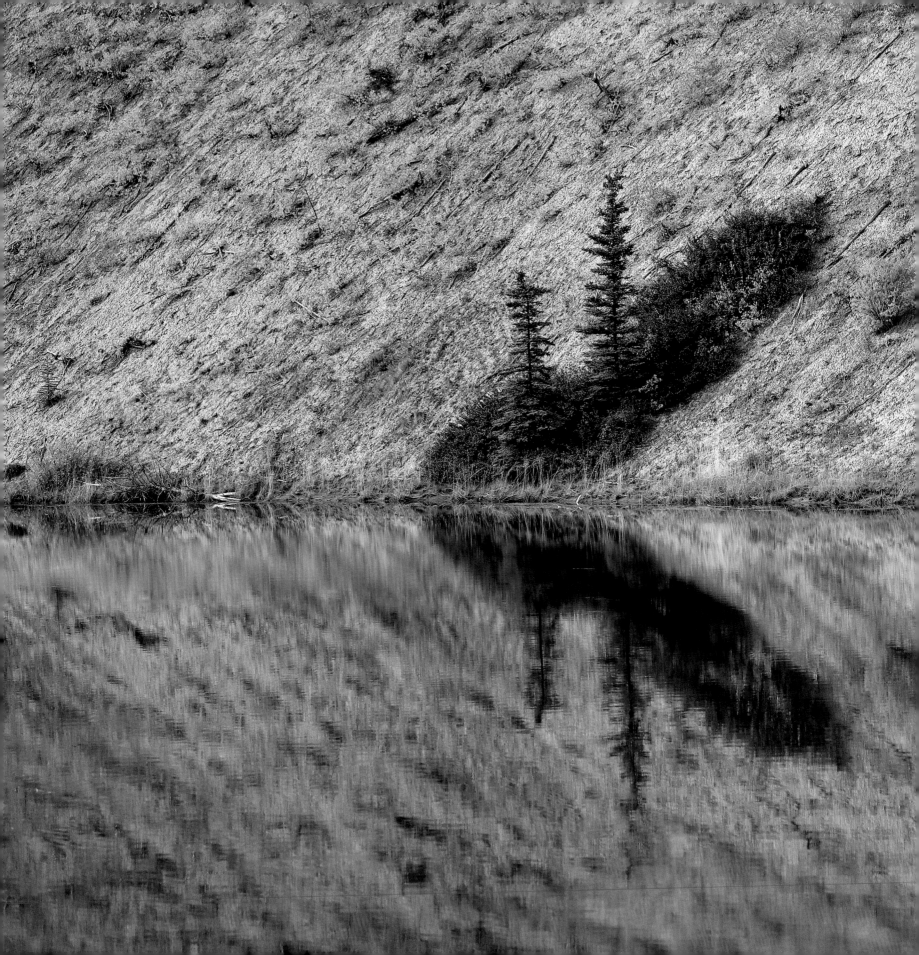

Patchwork tufts of brush reflect in Kusawa Lake at Mendenhall (Steamboat) Landing, gateway to the Kluane goldfields. The distance to the fields from the Takhini River was 225 km. In 1903, the water route service by sternwheelers shaved off 80 km.
KUSAWA LAKE ROAD KM 5

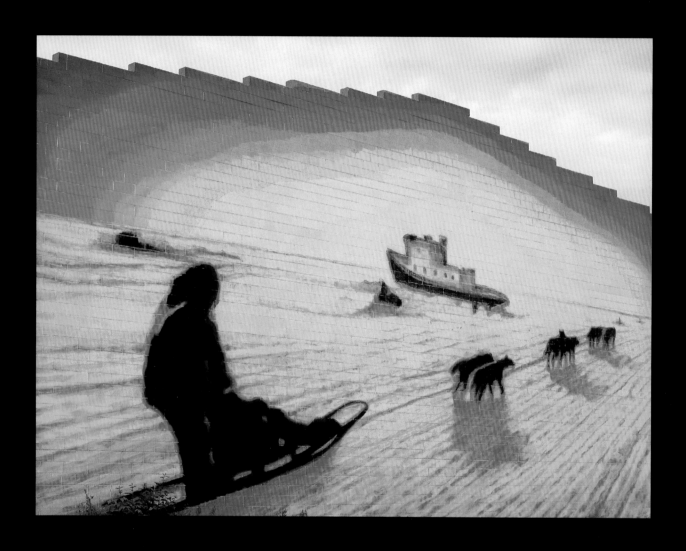

Colourful murals celebrating the city's culture adorn a number of buildings.
Colin Alexander, creator of the dogsledding at sunset image, has been
beautifying the city's public places since 2004 when he and his wife settled
in Yukon.

WALL OF THE CLAIM, WHITEHORSE

Fields of bright pink foxtail barley are a common sight, their feathery heads
swaying in clearings and along roadsides.

ALONG THE DEMPSTER HIGHWAY, YUKON HIGHWAY 5

Formidable clan poles line the entrance to the Teslin Tlingit Heritage Centre.
They represent land, water and air carved by local artists interpreting
Kùkhhittàn (Raven Children), Ishkìtàn (Frog), Yanyèdi (Wolf), Dèshitàn (Beaver)
and Dakhł'awèdi (Eagle).

NEAR TESLIN

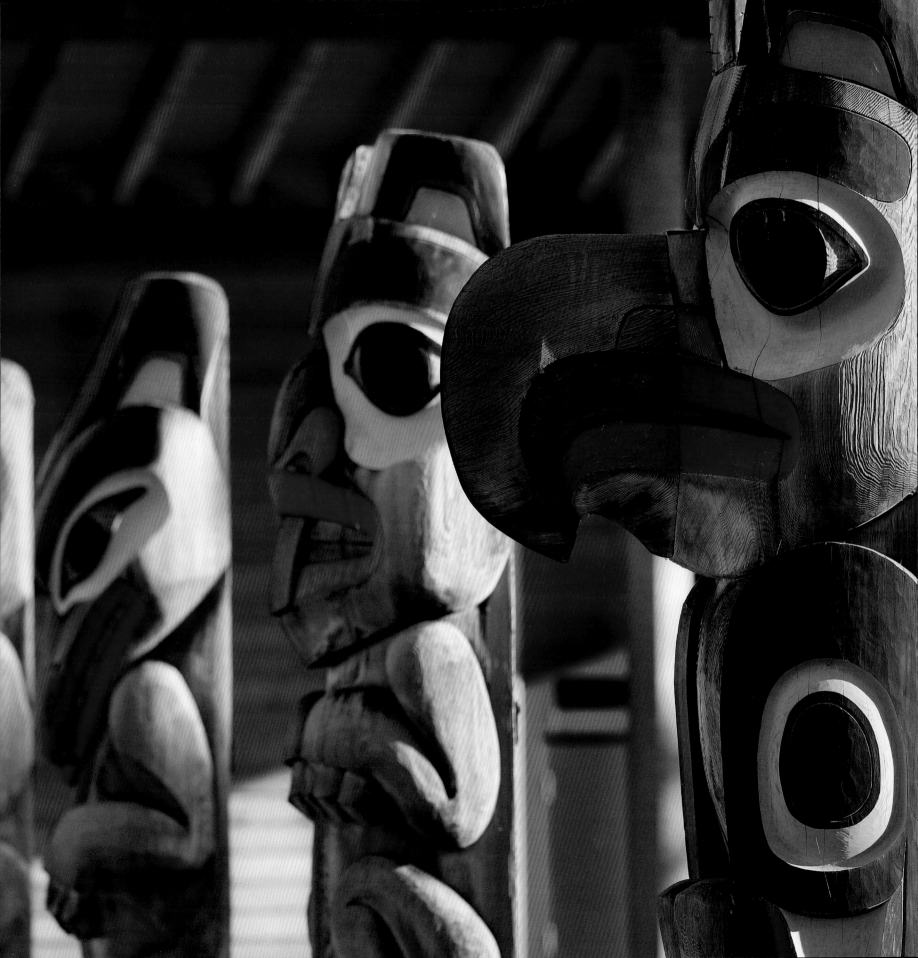

May your footsteps leave only friends behind.

[Frederic M. Perrin, *Rella Two Trees – The Money Chiefs*]

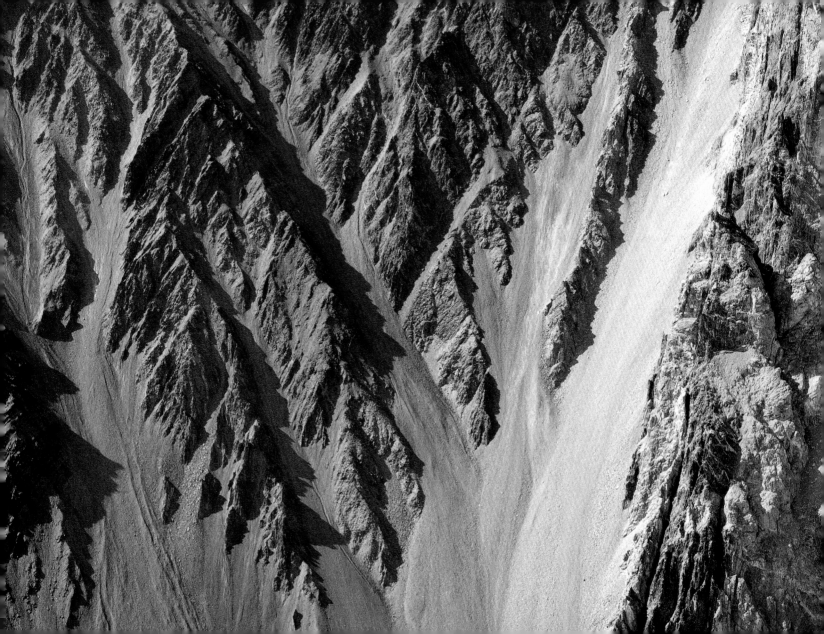

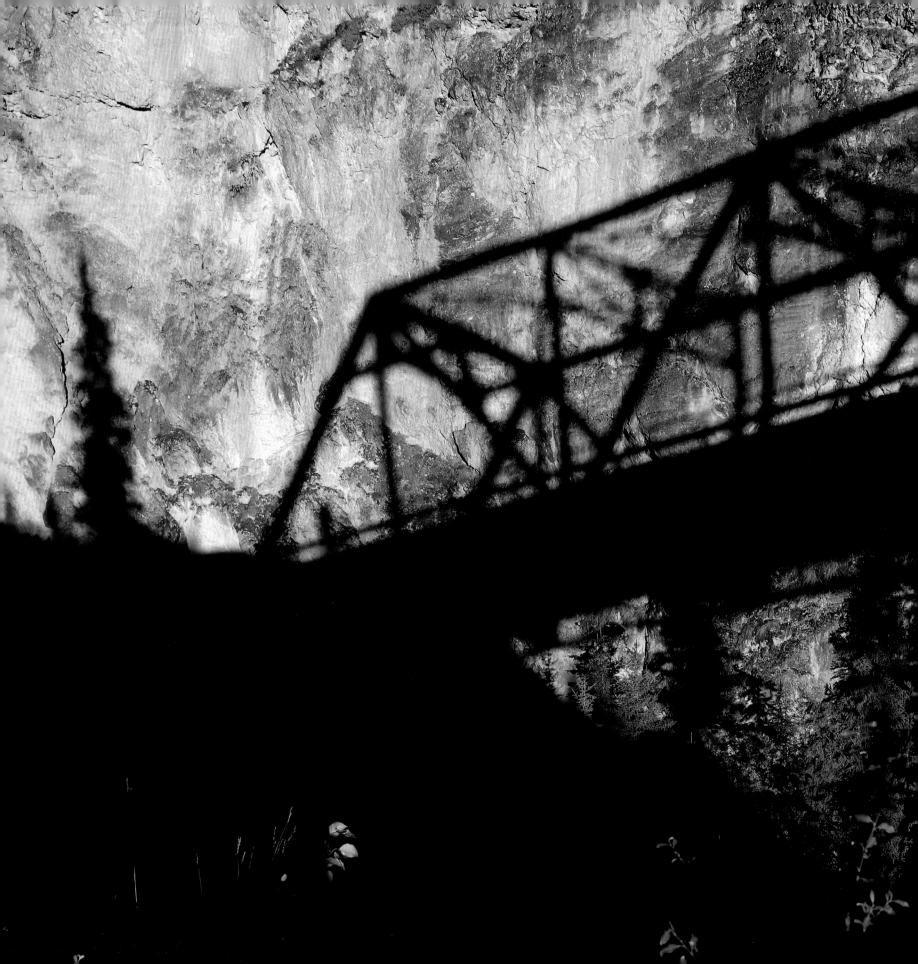

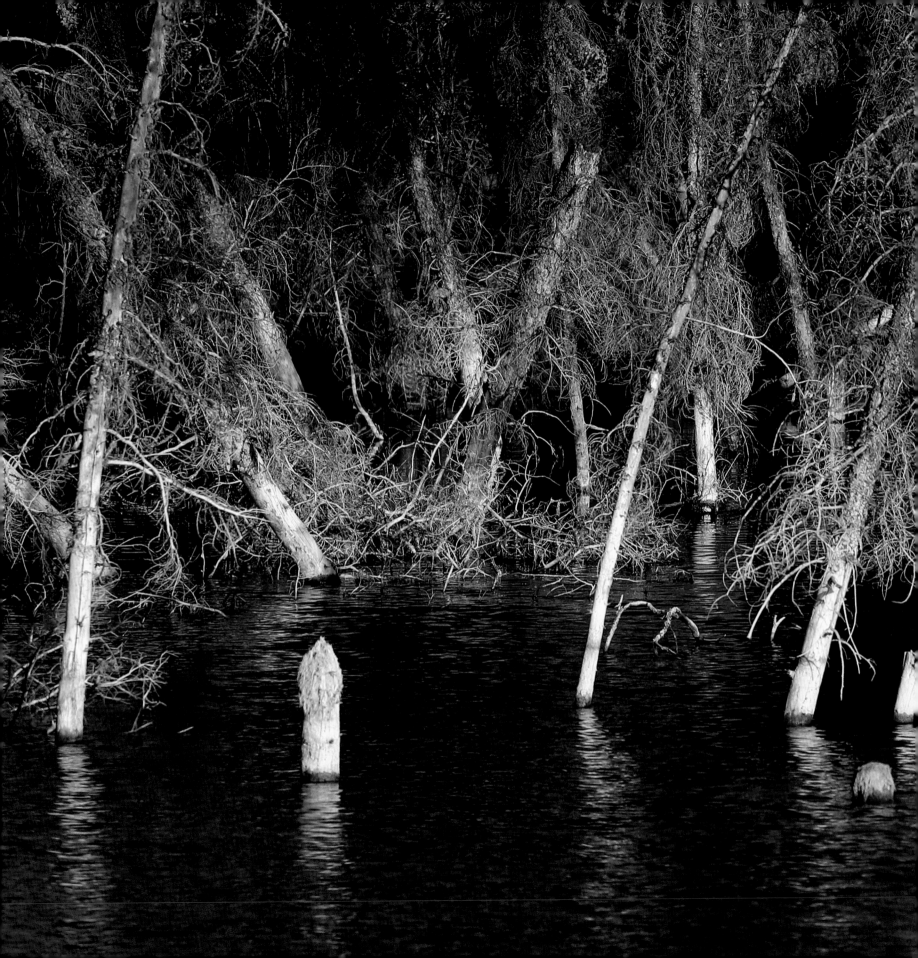

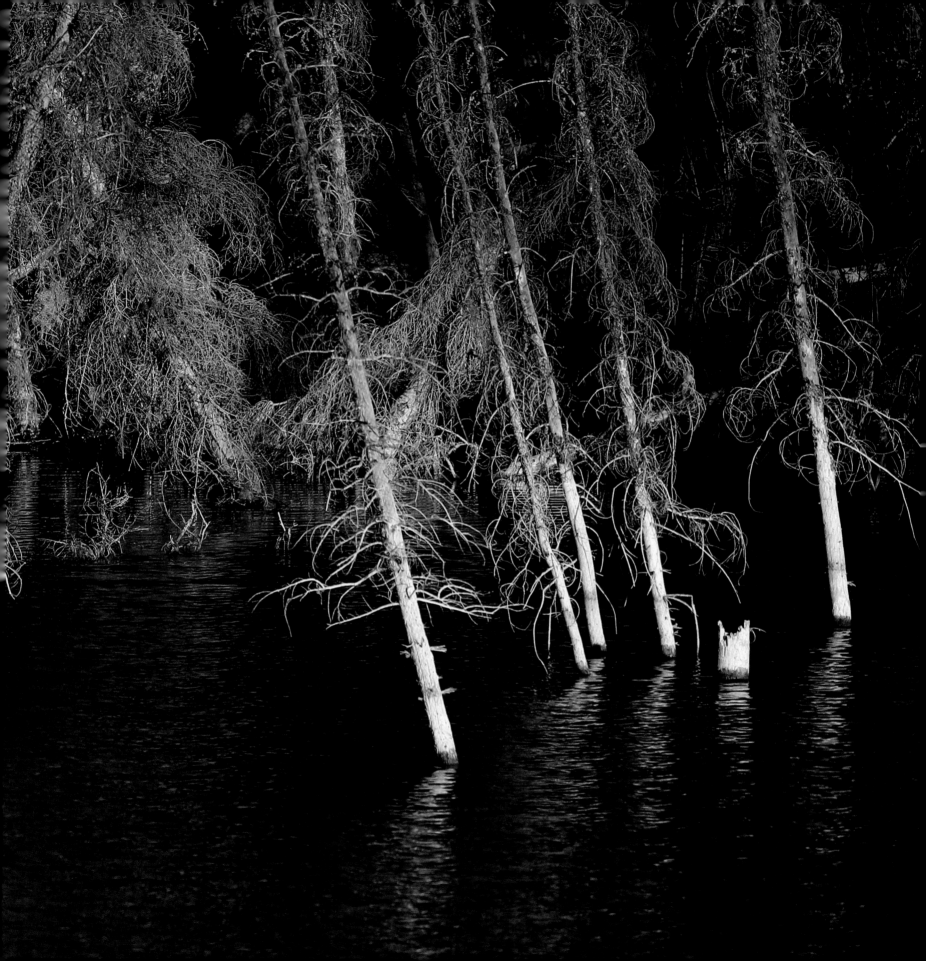

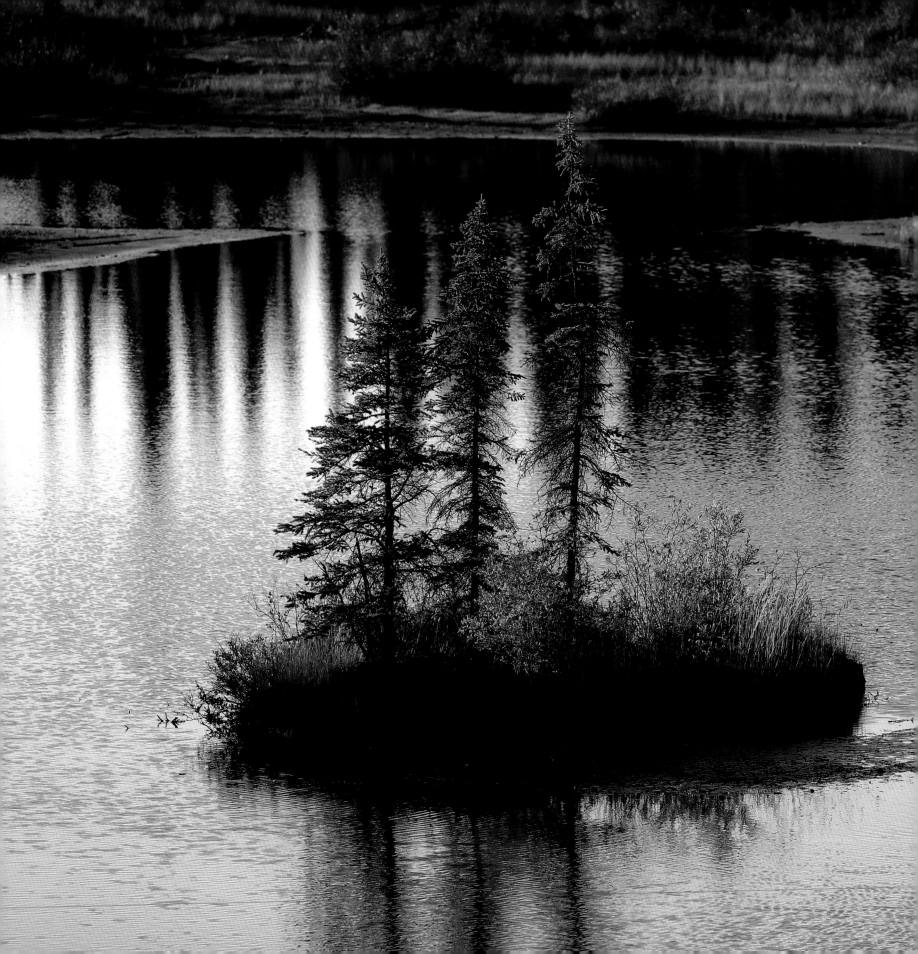

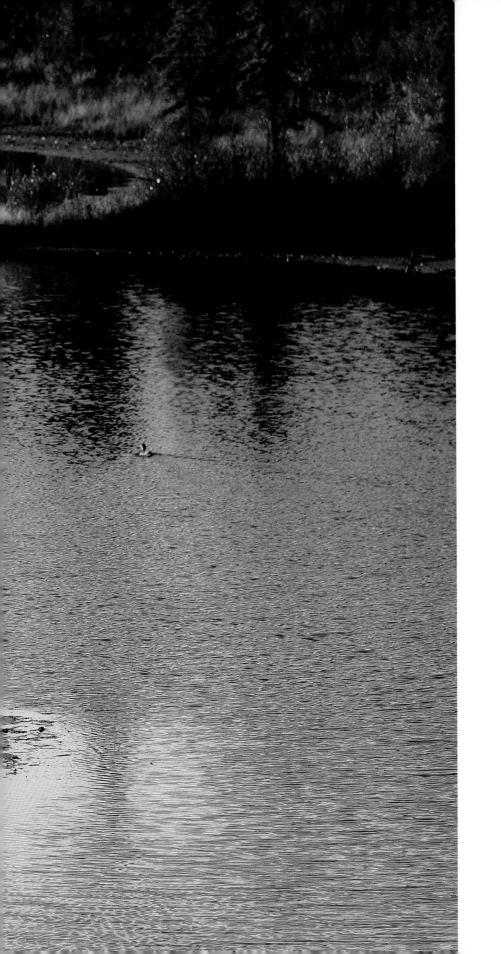

Warm colours surround a small island in a creek near Faro as summer
ends. The nearby settlement was named after the card game.
NEAR FARO

"All human beings are also dream beings. Dreaming ties all mankind together.

[Jack Kerouac]

The Southern Lakes area has been an important part of transportation routes since the Tlingit, Kaska and Tutchone peoples worked in the fur trade. Gold-seekers also found it a necessary route for goods and travel. Today's visitors come for adventure and pristine wilderness.

NORTH SHORE OF SIMPSON LAKE

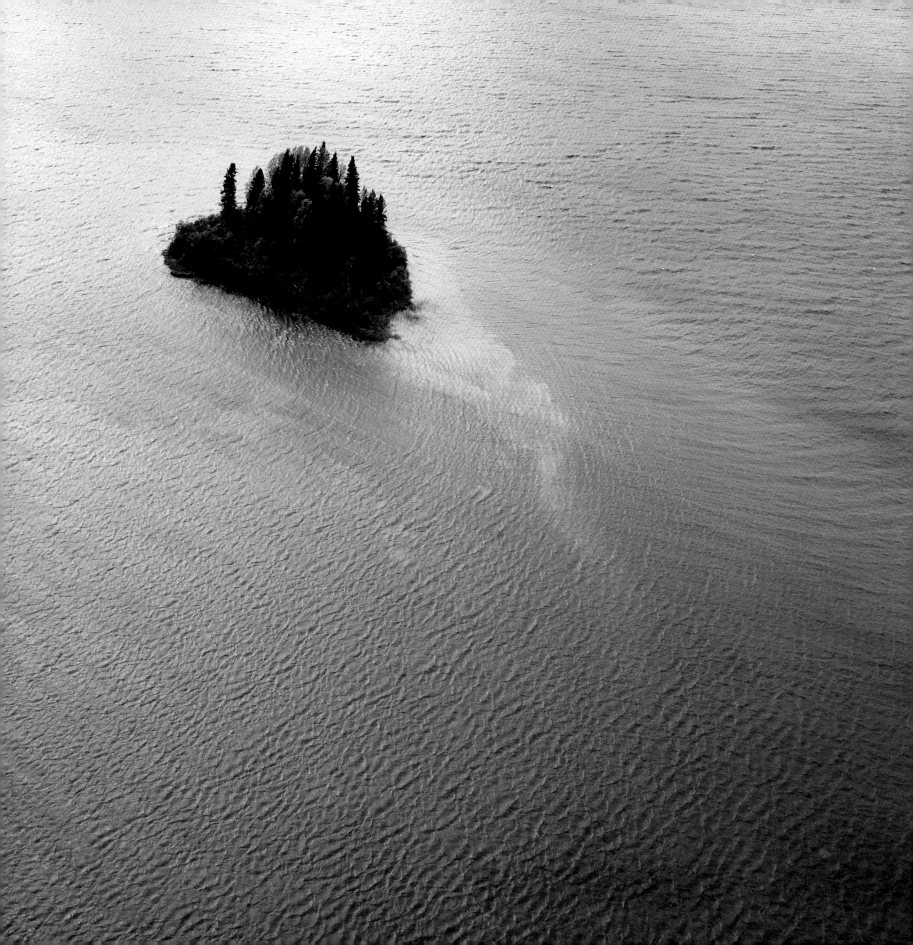

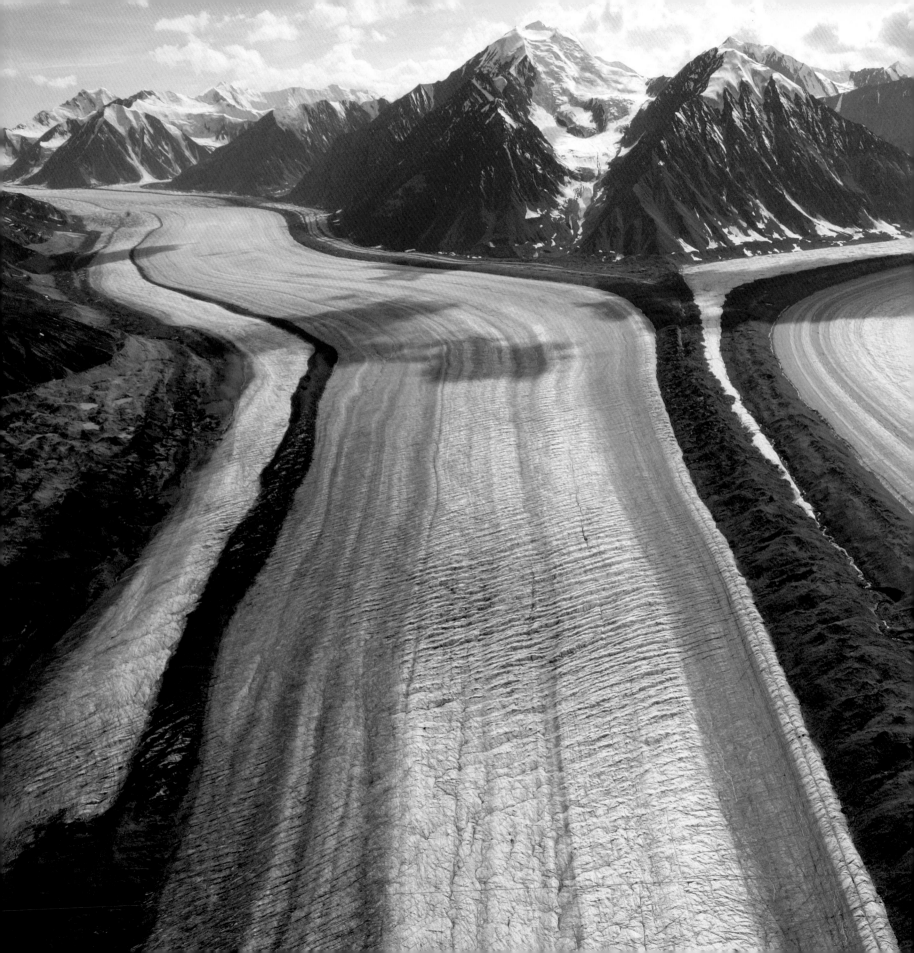

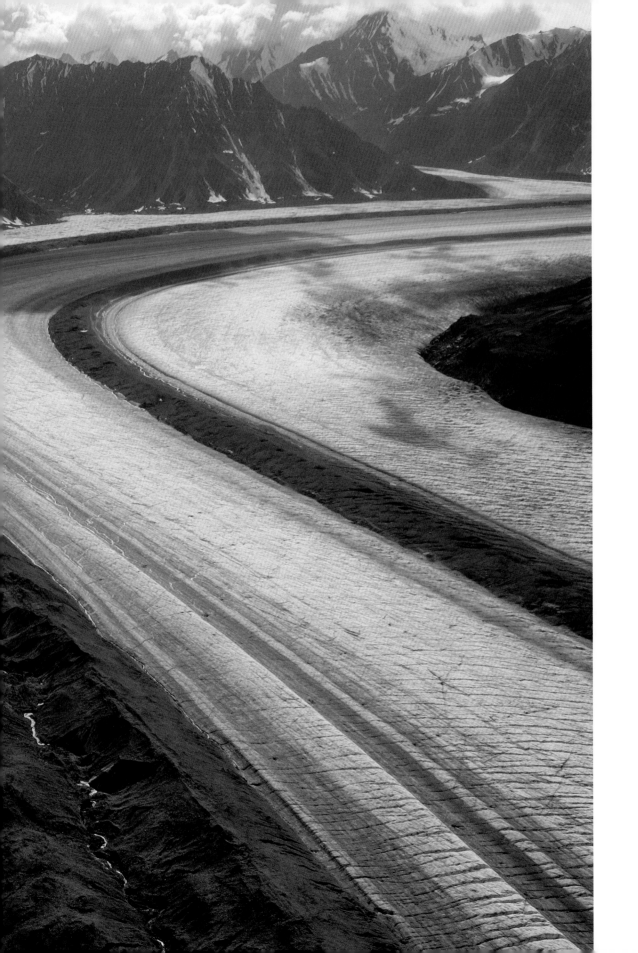

Covering more than 39,000 km² the Kaskawulsh
Glacier feeds the Yukon and Alsek river systems.
The glacier's 800-m depth is shrinking due to
rapidly thinning ice and retreating glaciers.
KLUANE NATIONAL PARK AND RESERVE,
SOUTHWEST YUKON

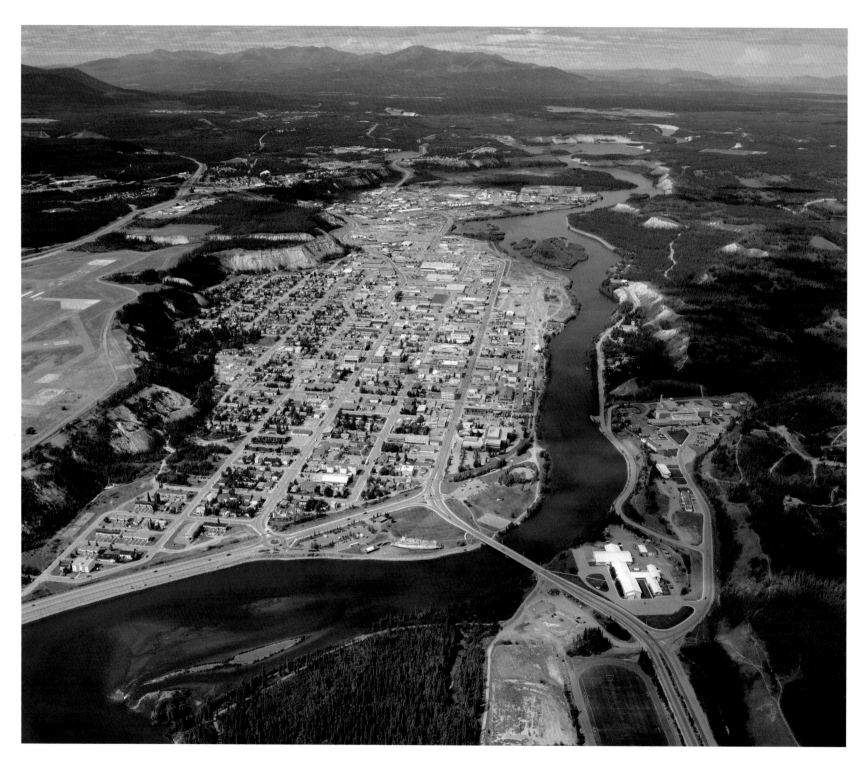

Stretched along the shores of the Yukon River, Whitehorse is the territory's only city and its capital. The name Yukon is derived from the aboriginal word for great river, "Yu-kun-ah."
WHITEHORSE

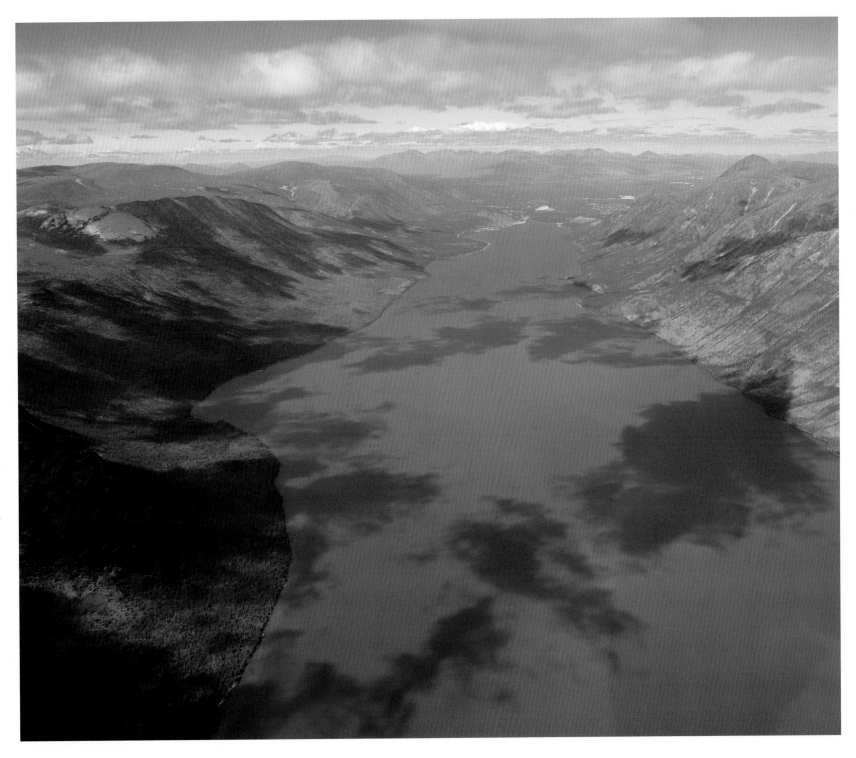

Klondike Gold Rush prospectors steered their boats through the rough waters of Mud Lake into the narrower Yukon River. Frederick Schwatka, U.S. Army lieutenant and noted explorer, changed the name to Marsh Lake in 1883 to honour surveyor Frederick Marsh.

MARSH LAKE

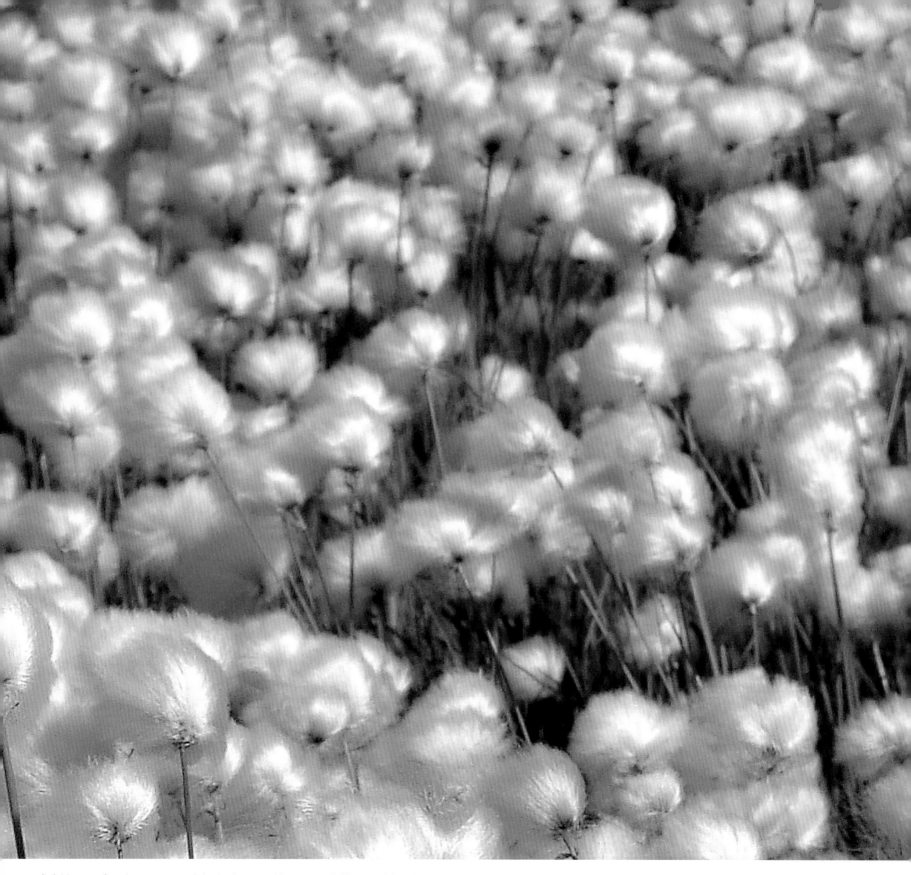

Soft blooms of arctic cottongrass thrive in the wet midsummer soil. The woolly head, which is
food for snow geese and caribou, doubles as a traditional candle wick for Inuit seal oil lamps.

ALONG THE DEMPSTER HIGHWAY, YUKON HIGHWAY 5

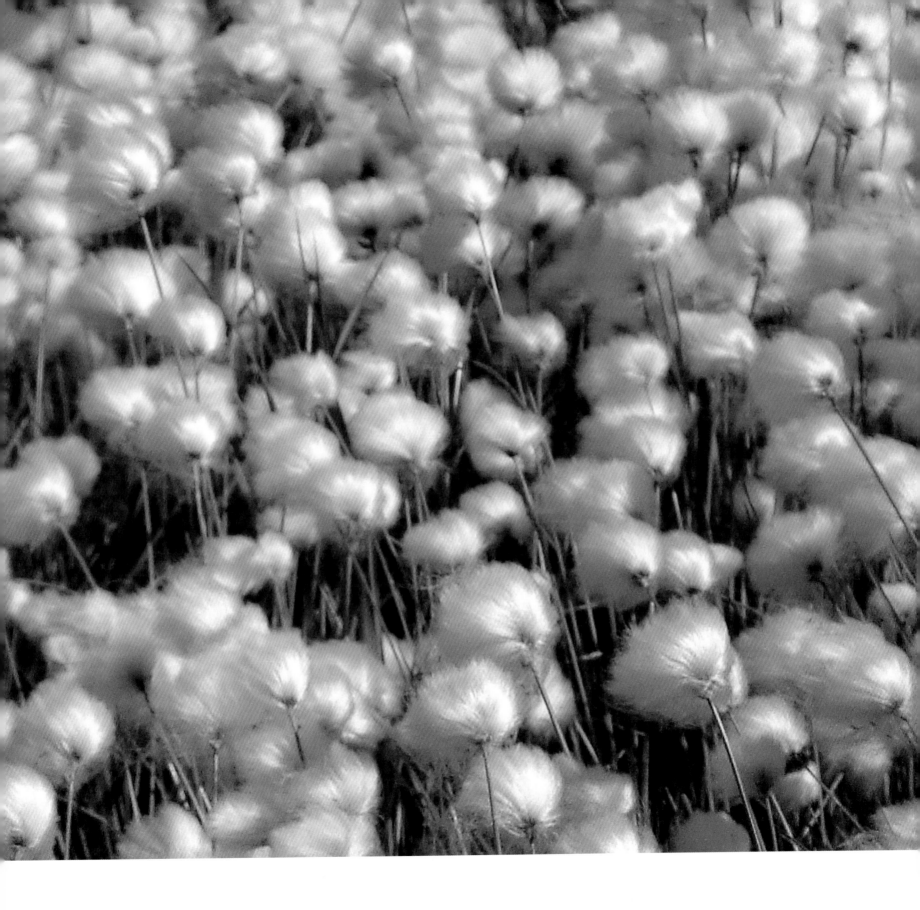

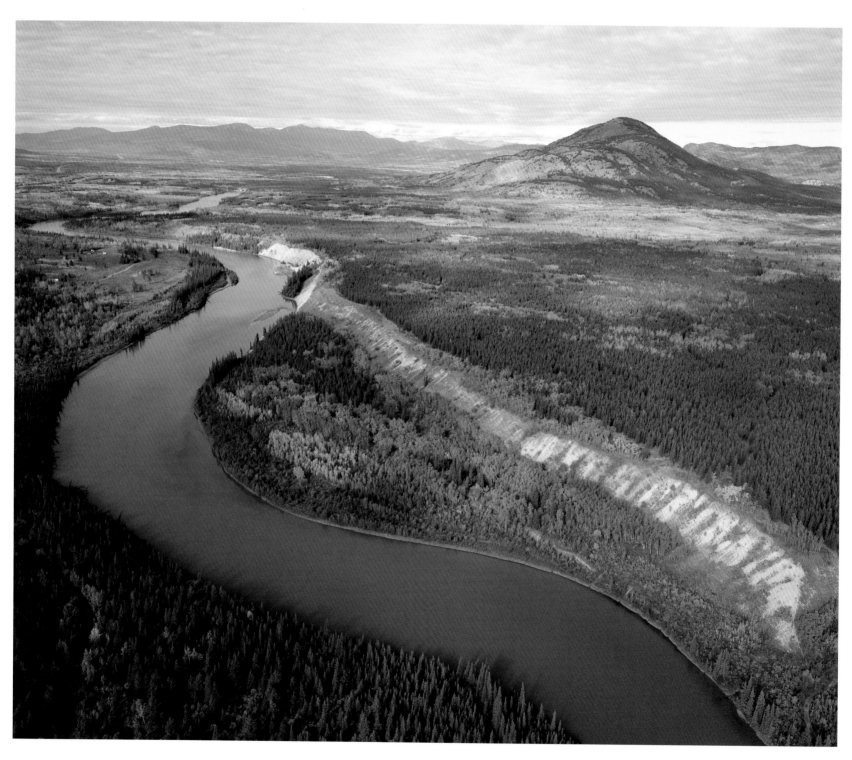

The Takhini River stretches into the distance as far as the eye can see. Close enough to
Whitehorse for public recreation, it is popular for kayaking, canoe trips and sportfishing.
When it freezes in winter, it becomes a leg of the Yukon Quest dog sled race.
IBEX VALLEY

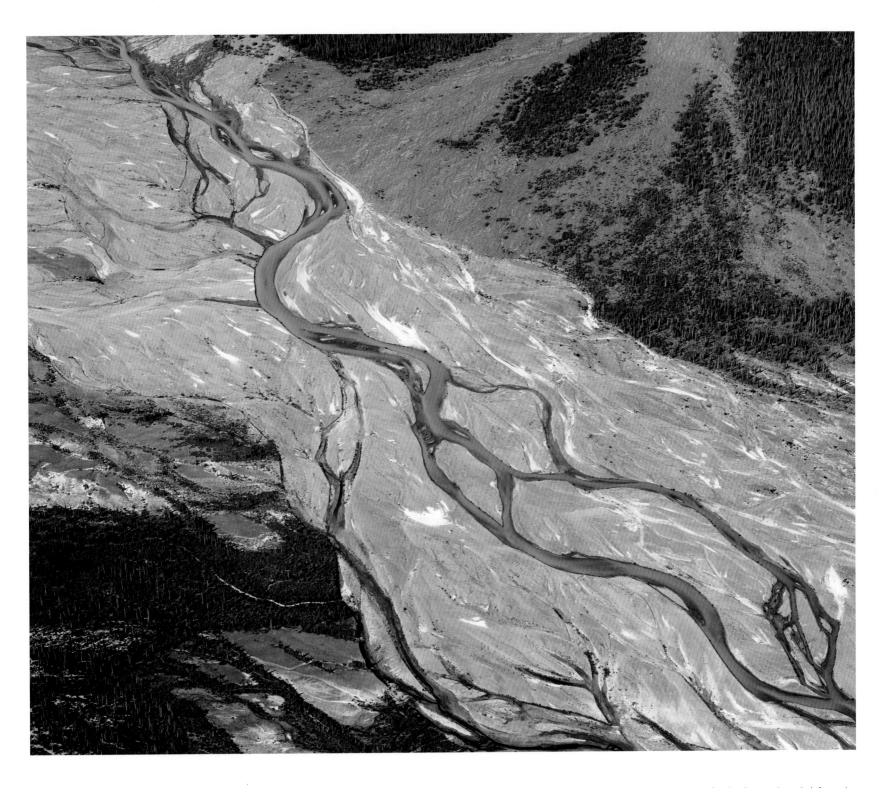

Slims River adds blue veins to the alluvial fan (sediment deposits) from the
Kaskawulsh Glacier drainage.
NEAR KLUANE NATIONAL PARK AND RESERVE, SOUTHWEST YUKON

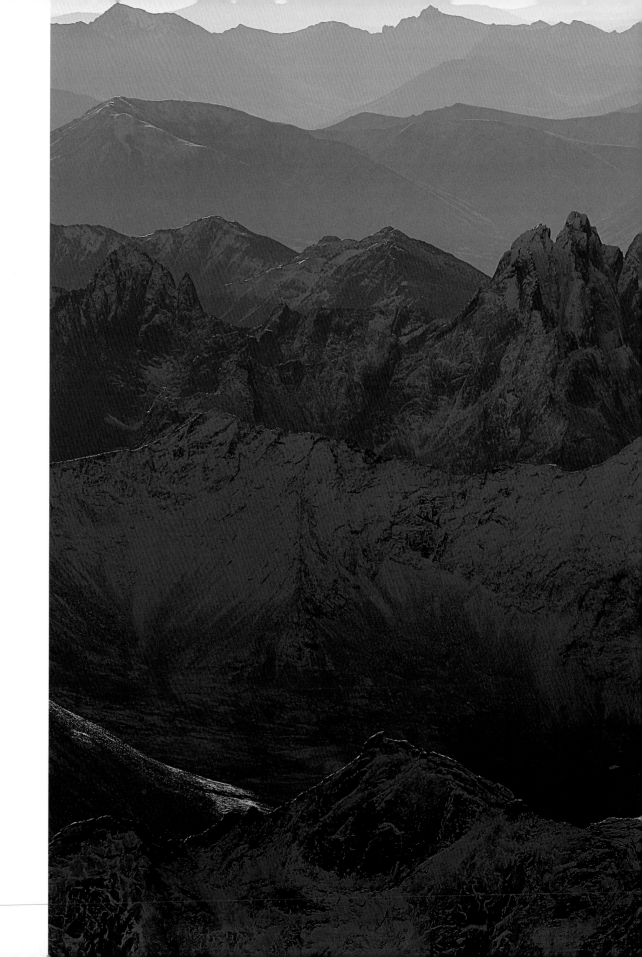

Sharp shadowy ridges travel along the Tombstone range. The unique geology creates an arctic tundra environment normally found in more northern reaches. The unusual setting supports unique flora and fauna, including caribou, Dall sheep, moose, grizzly bears and more than 137 species of birds.

TOMBSTONE TERRITORIAL PARK, CENTRAL YUKON

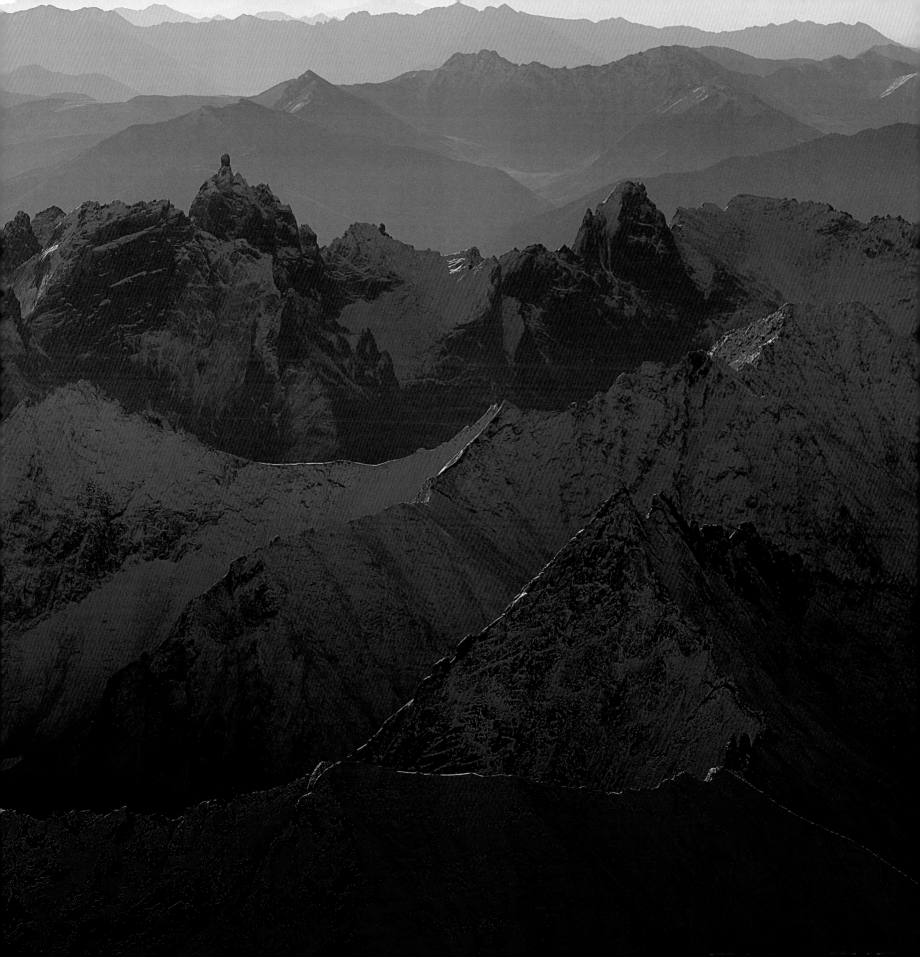

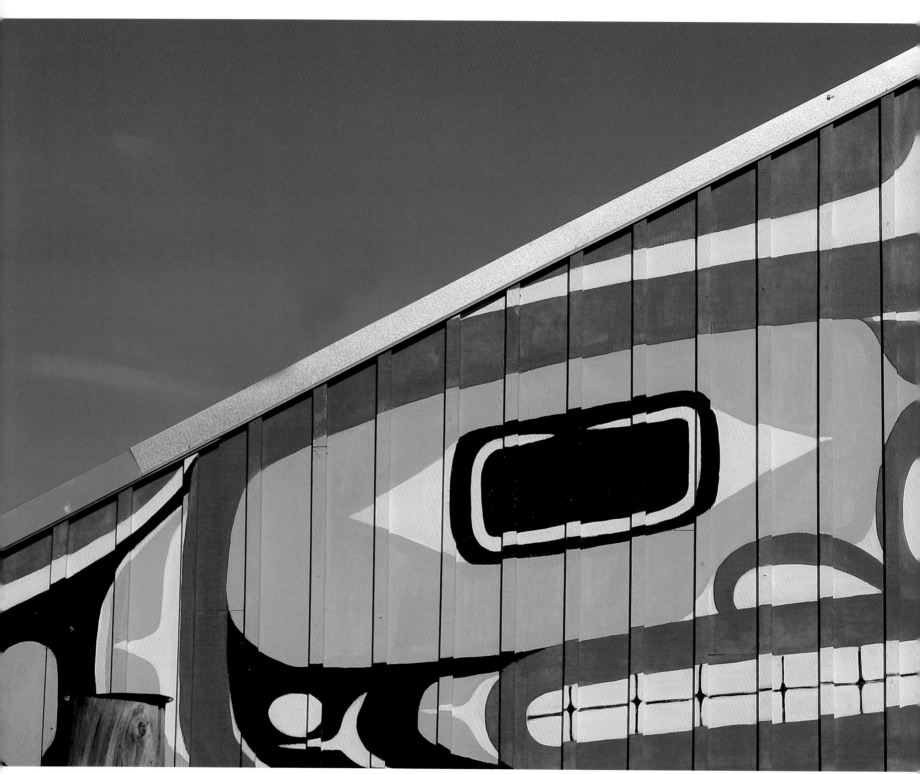

The visitor information centre in the small town of Carcross is the source for meeting, learning and activity planning. The Carcross/Tagish First Nation represents six clans: the Daklaweidi and Yan Yedi clans are the Wolf Moiety, while the Deisheetaan, Ganaxtedi, Ishkahittaan and Kookhittaan clans are the Raven Moiety.
CARCROSS

Keep close to Nature's heart...and break clear away, once in awhile, and climb a mountain or spend a week in the woods. Wash your spirit clean.

[John Muir]

Travellers can rest awhile halfway along the Dempster Highway at Eagle Plains. A welcome respite, this is a good place to stop between Dawson City and Inuvik. It is one of the only places to get food, gas and a motel – and a rare chance to swap stories or travel advice.

NEAR EAGLE PLAINS

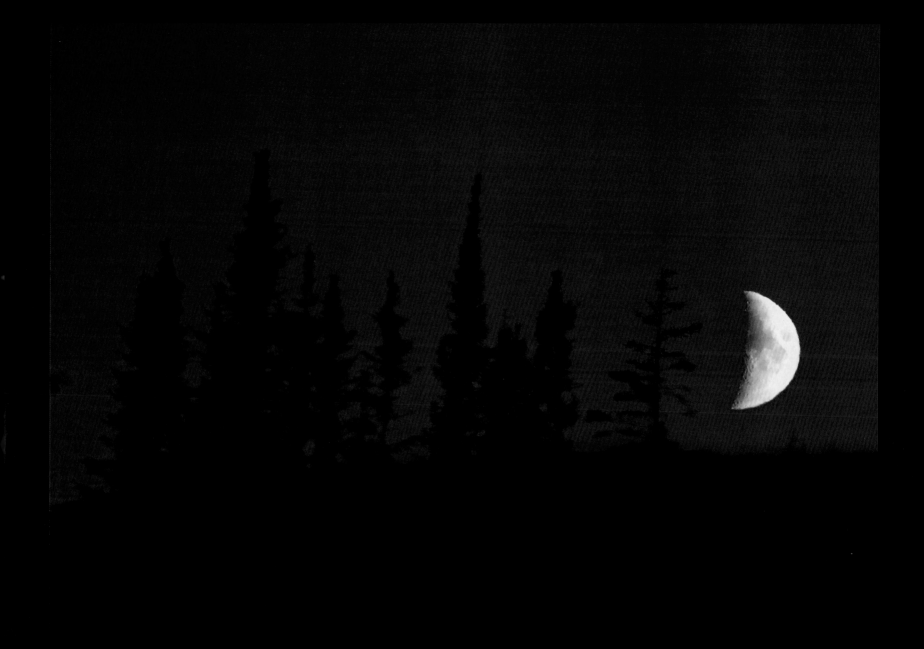

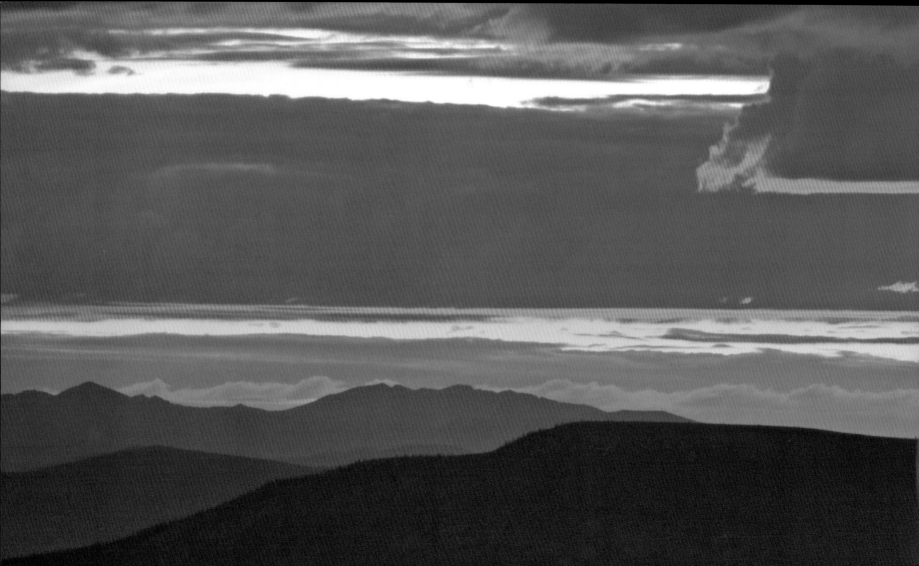

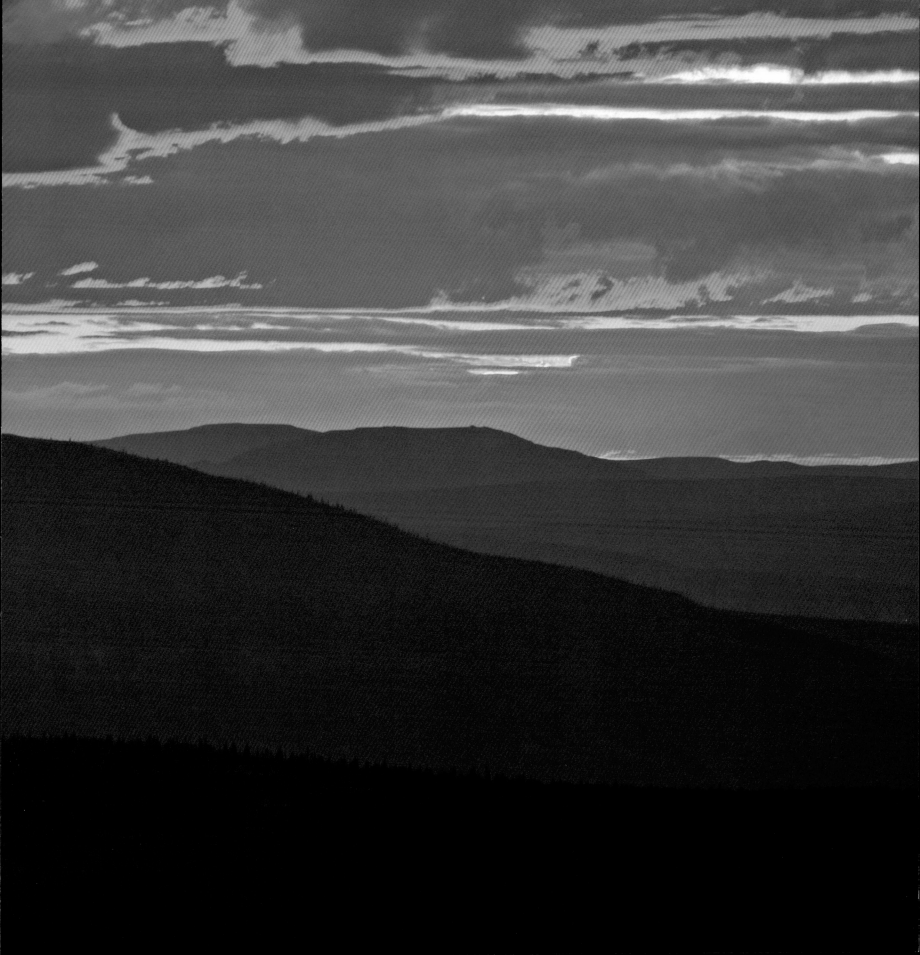

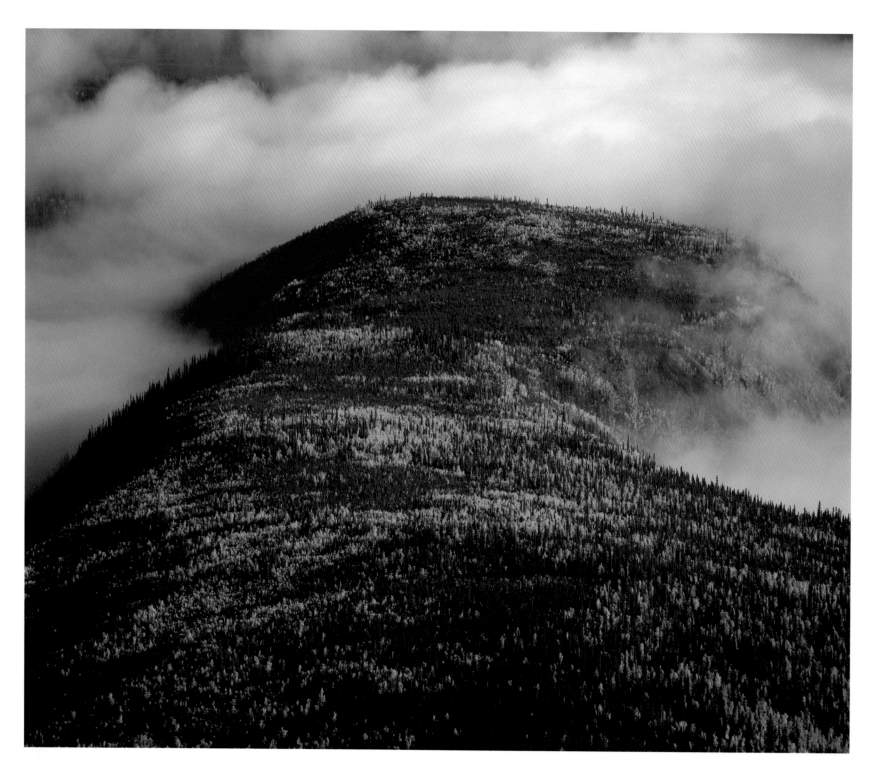

Clouds envelop low rugged crests north of the Top of the World Highway. Extreme temperatures in the subarctic climate are a rich habitat for unique vegetation.
NORTHWEST OF DAWSON CITY

PREVIOUS ◦ Bands of a warm sunset infuse the clouds over the Ogilvie Mountains in the North American Cordillera.
ALONG THE TOP OF THE WORLD HIGHWAY, YUKON HIGHWAY 9

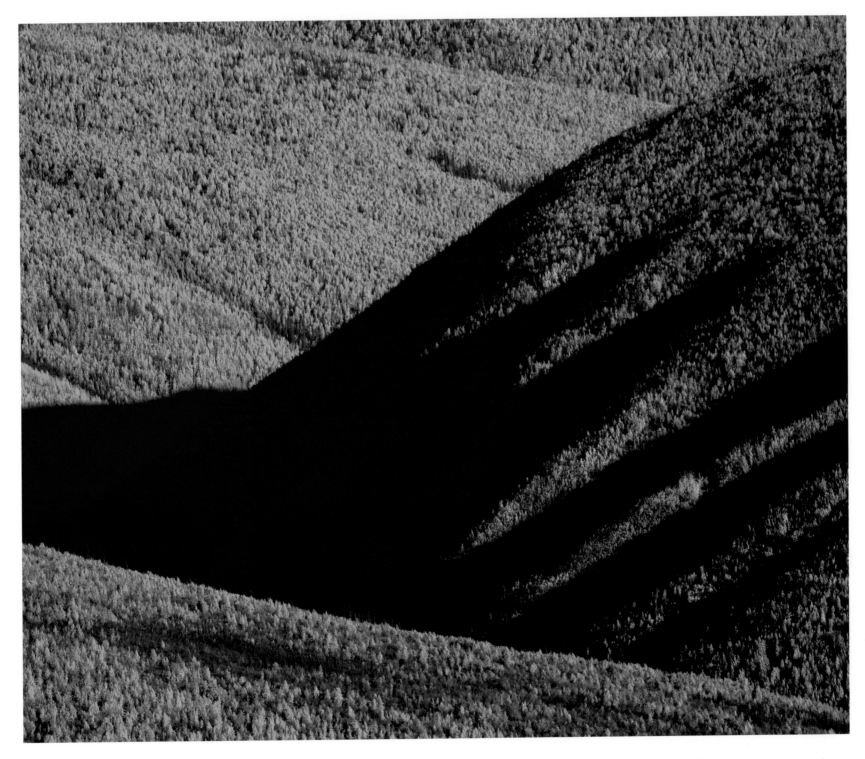

Dark shadowy fingers claw their way up the lowlands. This is only one of many stunning sights from the Top of the World Highway, which offers views down to hills and valleys framing the route.
NORTHWEST OF DAWSON CITY

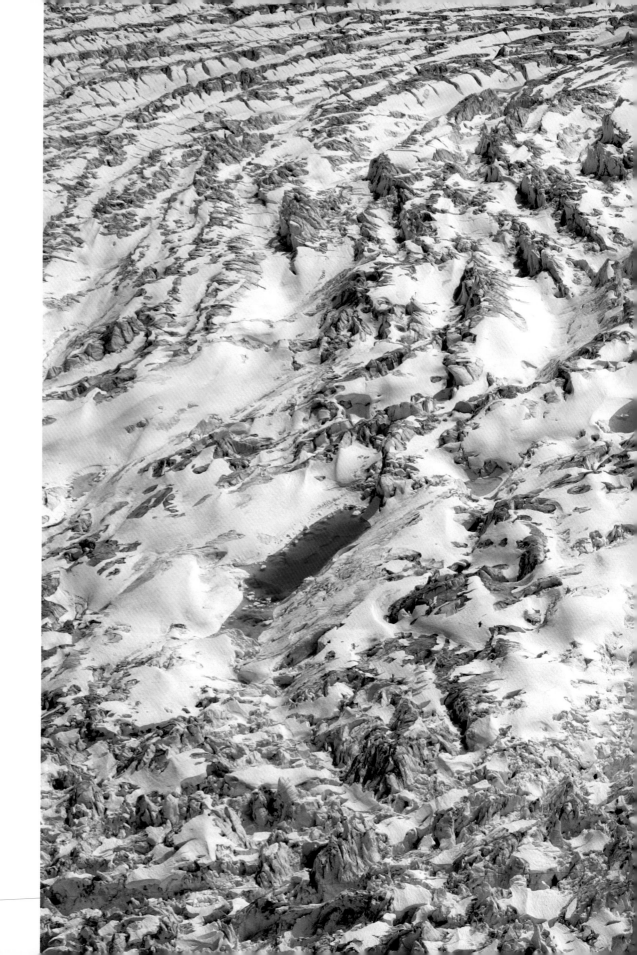

Breathtaking summits and steely blue rifts in
the Donjek Glacier heighten the feeling of the
Yukon's ruggedness. At a length of 56 km, it
pushes 1100 m into the Donjek River Valley east
of the St. Elias Mountains.

**KLUANE NATIONAL PARK AND RESERVE,
SOUTHWEST YUKON**

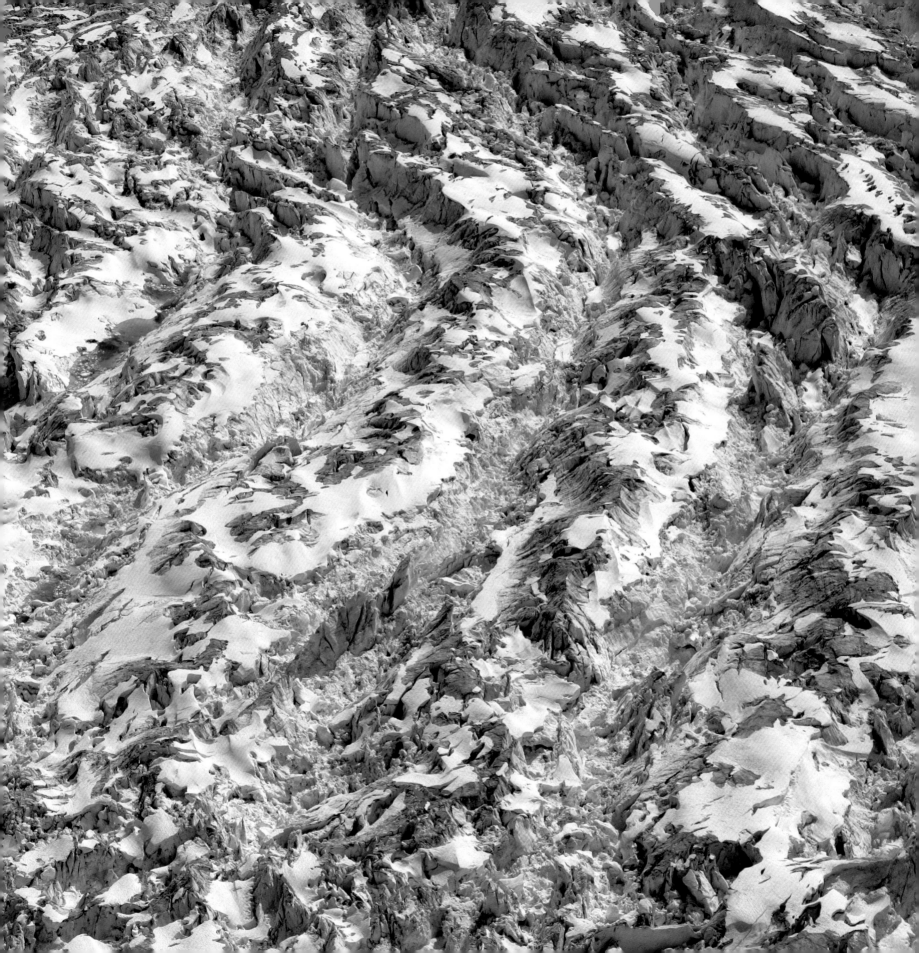

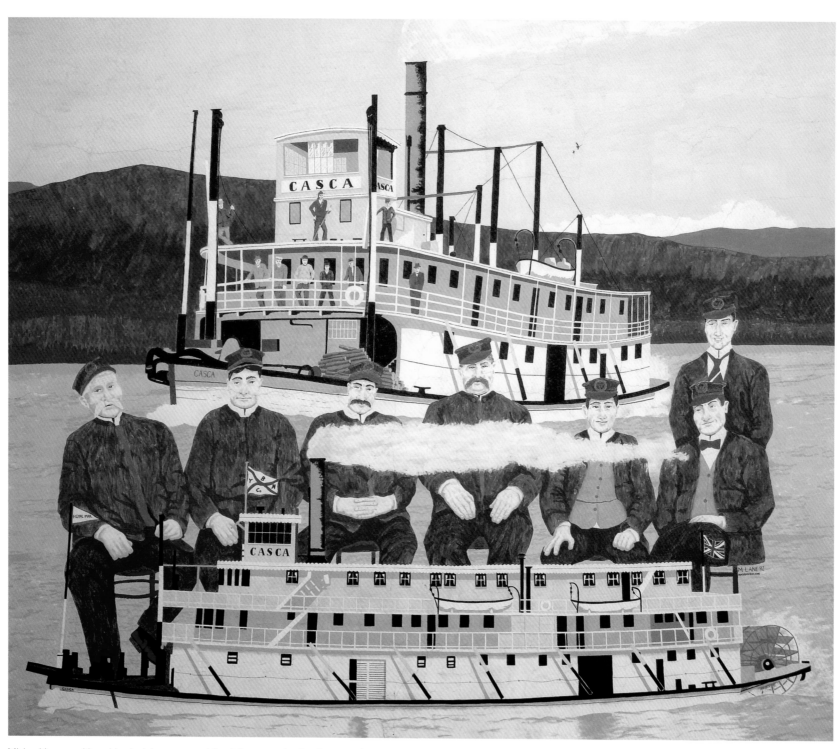

Michael Lane and Jane Haydock have memorialized the sternwheeler *Casca* on the wall of the Yukon News building. The 53-passenger vessel worked from 1898 until 1910 when she hit a large rock and sank. Raised and outfitted as a barge in 1911, *Casca* later became a dock on Lake Laberge.

WHITEHORSE

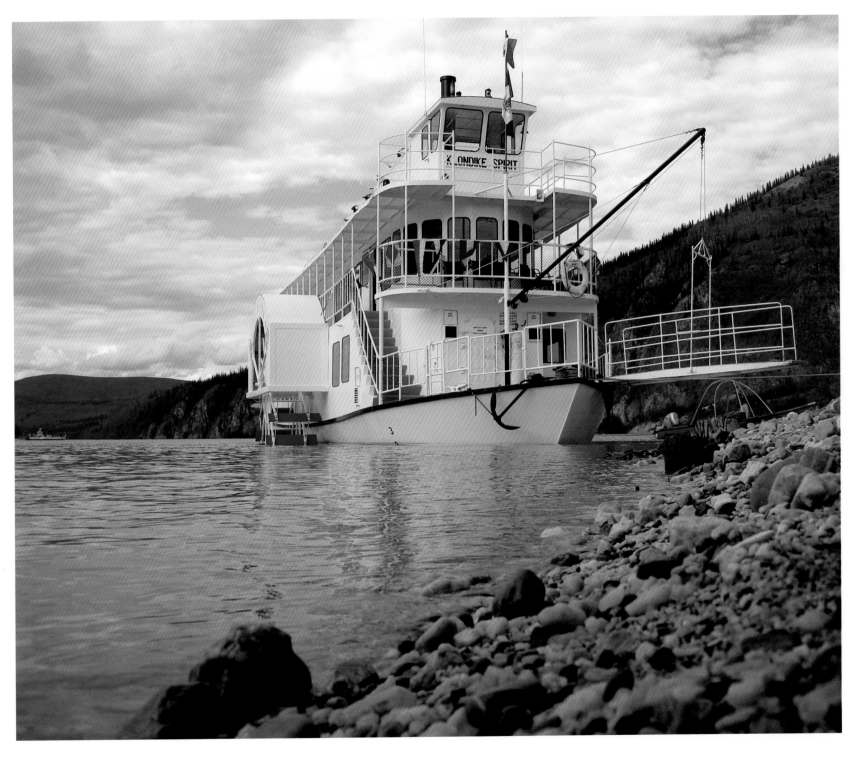

The only operating paddlewheeler in the Yukon, *Klondike Spirit* is a colourful ambassador for the area. A cruise down the beautiful Yukon River affords wildlife viewing and local lore.
DAWSON CITY

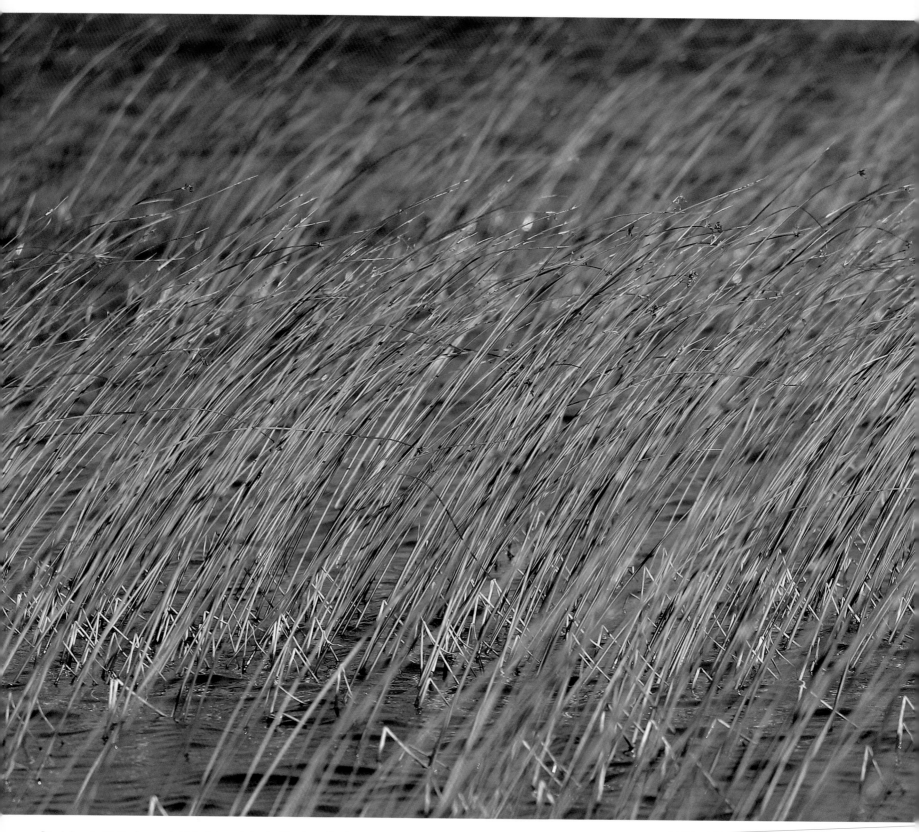

Reeds bend with the breeze in Little Salmon Lake. Its Northern Tutchone name Chu Cho means "big water."
ROBERT CAMPBELL HIGHWAY KM 501, YUKON HIGHWAY 4

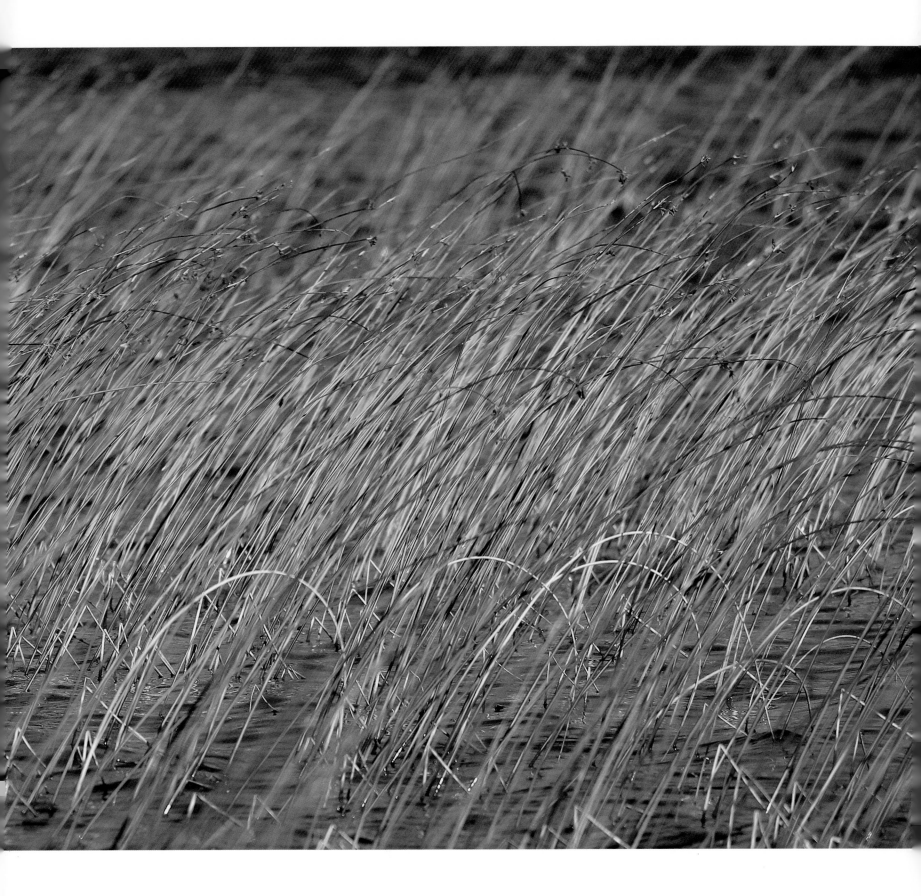

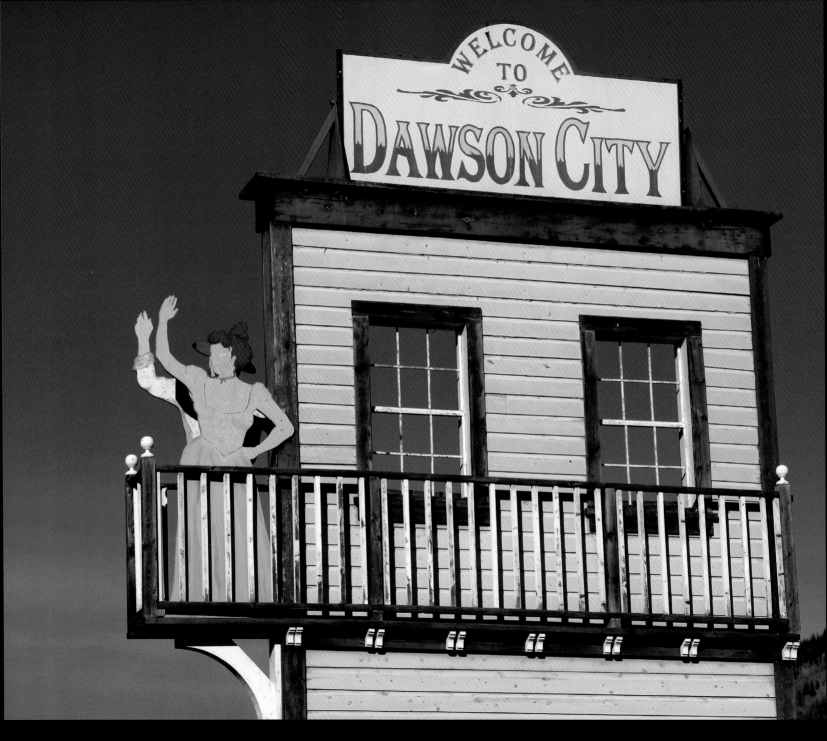

Central to the Klondike Gold Rush, Dawson City saw its population swell to 40,000 at the height of the insanity in 1896. Today, in calmer times, the town's residents number just under 1500.

DAWSON CITY

Visitors to Diamond Tooth Gertie's find a hearty Klondike welcome with fiery shows featuring Gertie and her Gertie Girls. Gertie Lovejoy was a real Gold Rush gal of 1898 who wedged a diamond between her two front teeth to entice patrons.

DAWSON CITY

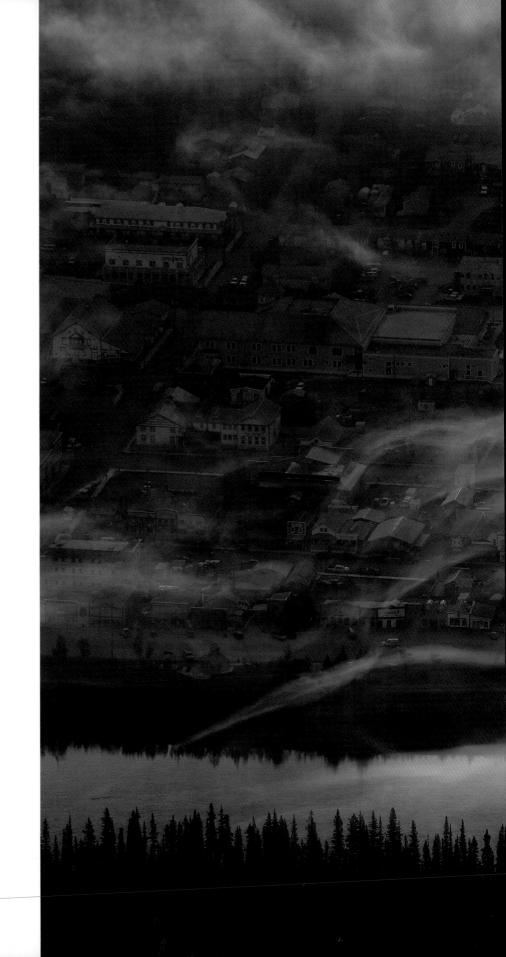

Wispy clouds glide by Dawson City in central Yukon close to the Alaskan
border. Featured in many stories, the town has been home to notables
such as Jack London, Robert Service and Pierre Berton.

DAWSON CITY

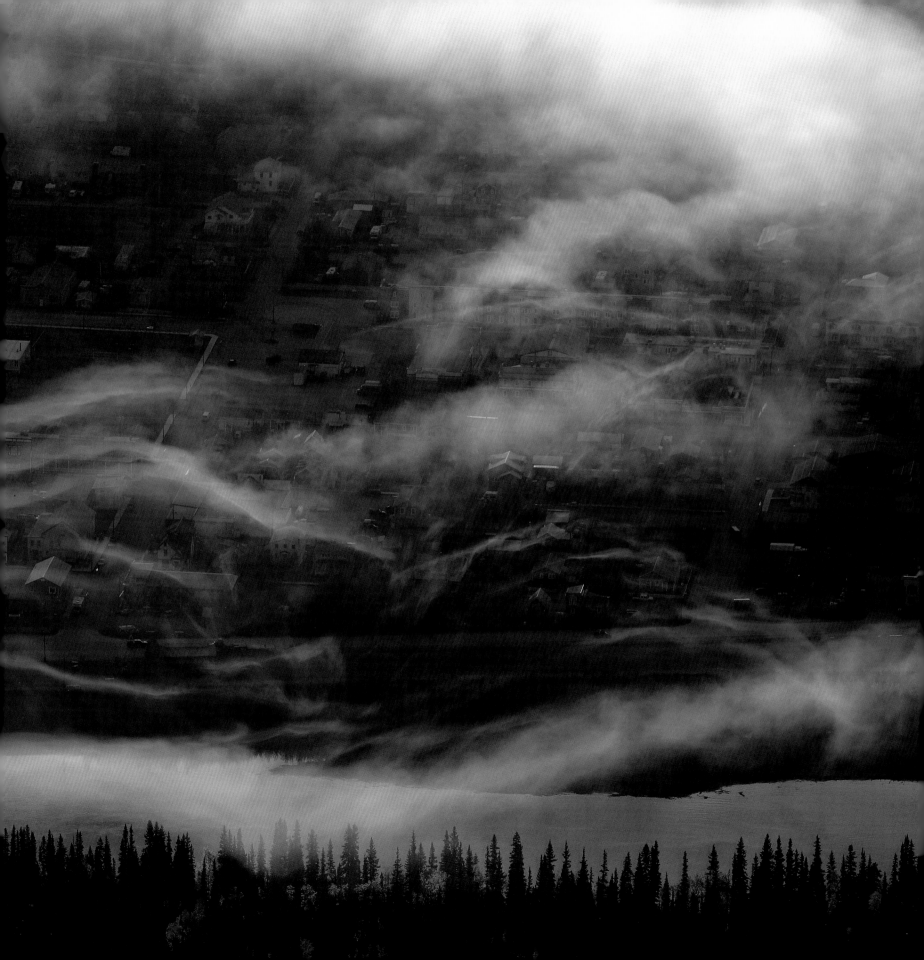

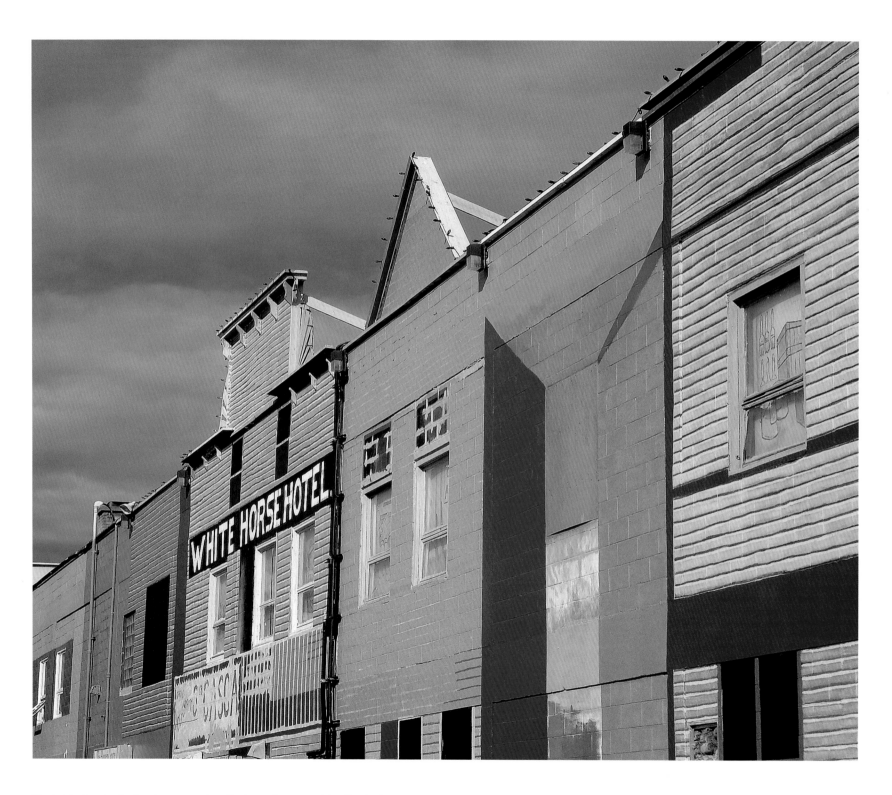

The bright façade of a frontier town painted by Lance Burton and the Youth of
Today Society stands beside a parking lot. It was used as a movie set in 1993.
WHITEHORSE

The historical Third Avenue Hotel Complex offered rooms and a photographic studio
from the Klondike Gold Rush era. The shifting frame is a result of melting permafrost.
DAWSON CITY

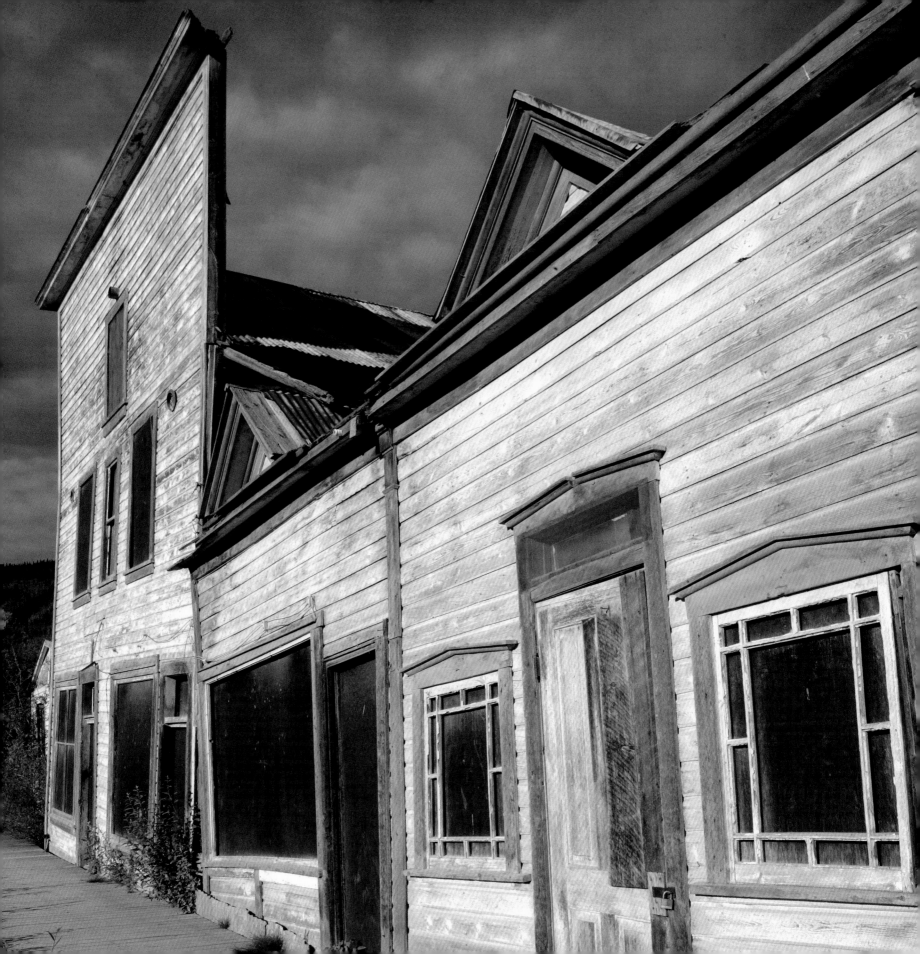

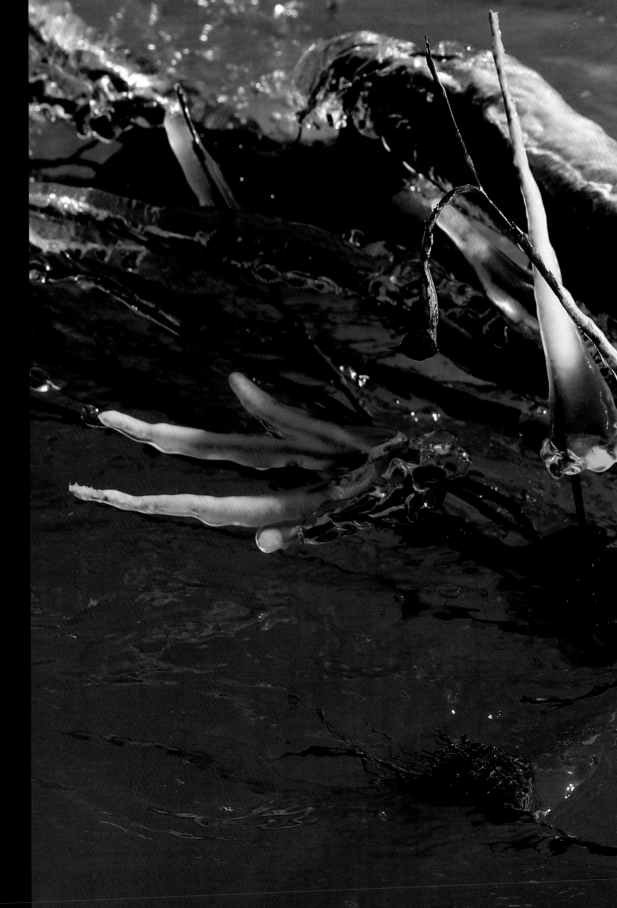

Winter washes in along the Ogilvie River, creating
curious ice sculptures.
DEMPSTER HIGHWAY KM 221, YUKON HIGHWAY 5

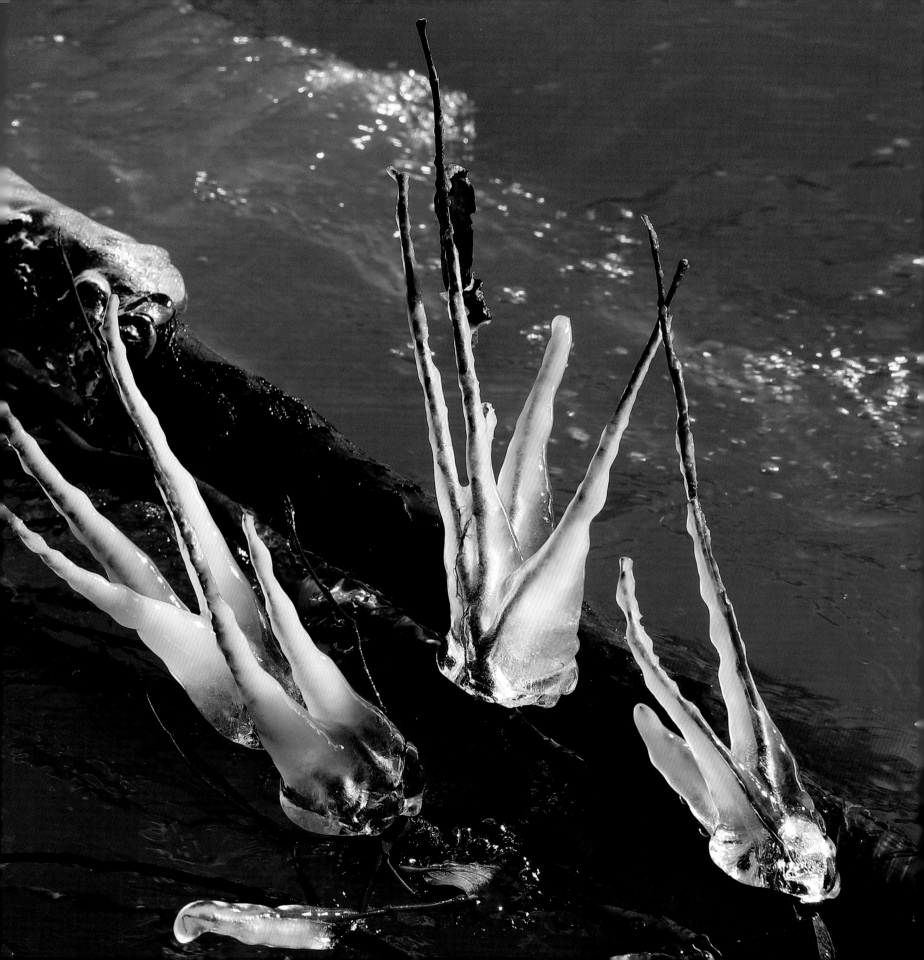

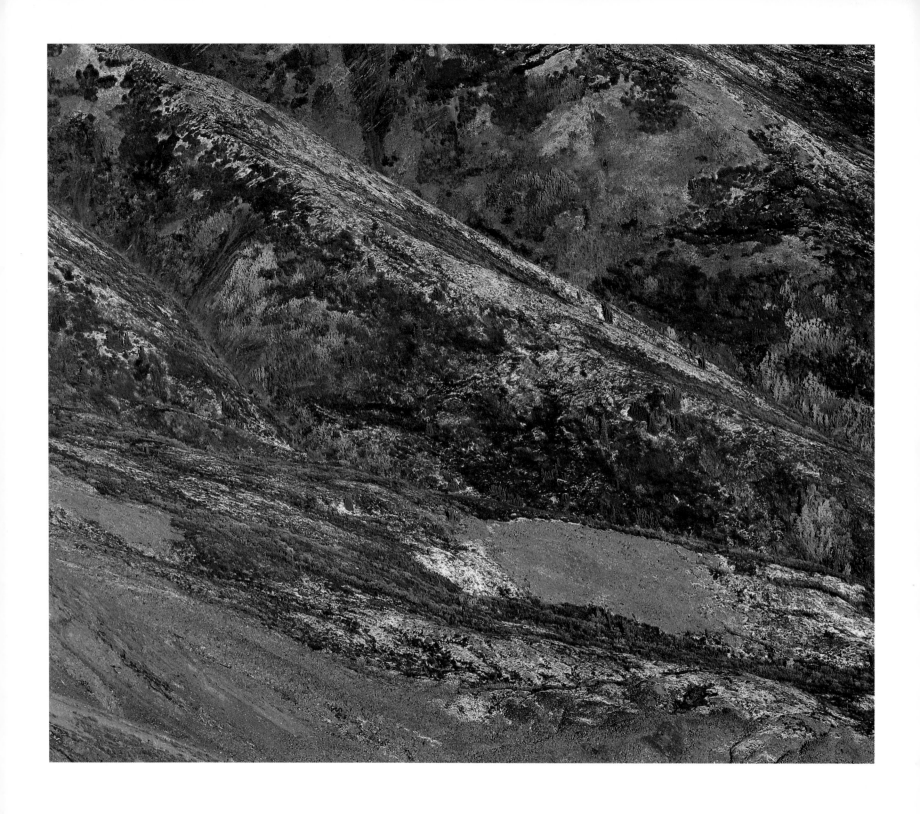

The tough Yukon climate attracts slow-growing, sturdy trees. First Nations traditionally use trees for food, medicine and tools.
DOWNRIVER FROM THE DAWSON CITY FERRY TERMINAL

Splotches of hardy lichen splatter the rock face like a painter's palette. In the ecosystem, the plant provides soil integrity and food for wildlife.
TOMBSTONE TERRITORIAL PARK, CENTRAL YUKON

FOLLOWING • An imposing ice wall at the Donjek River frames the Donjek Glacier, one of the area's largest valley glaciers and part of the St. Elias Mountains icefield.
KLUANE NATIONAL PARK AND RESERVE, SOUTHWEST YUKON

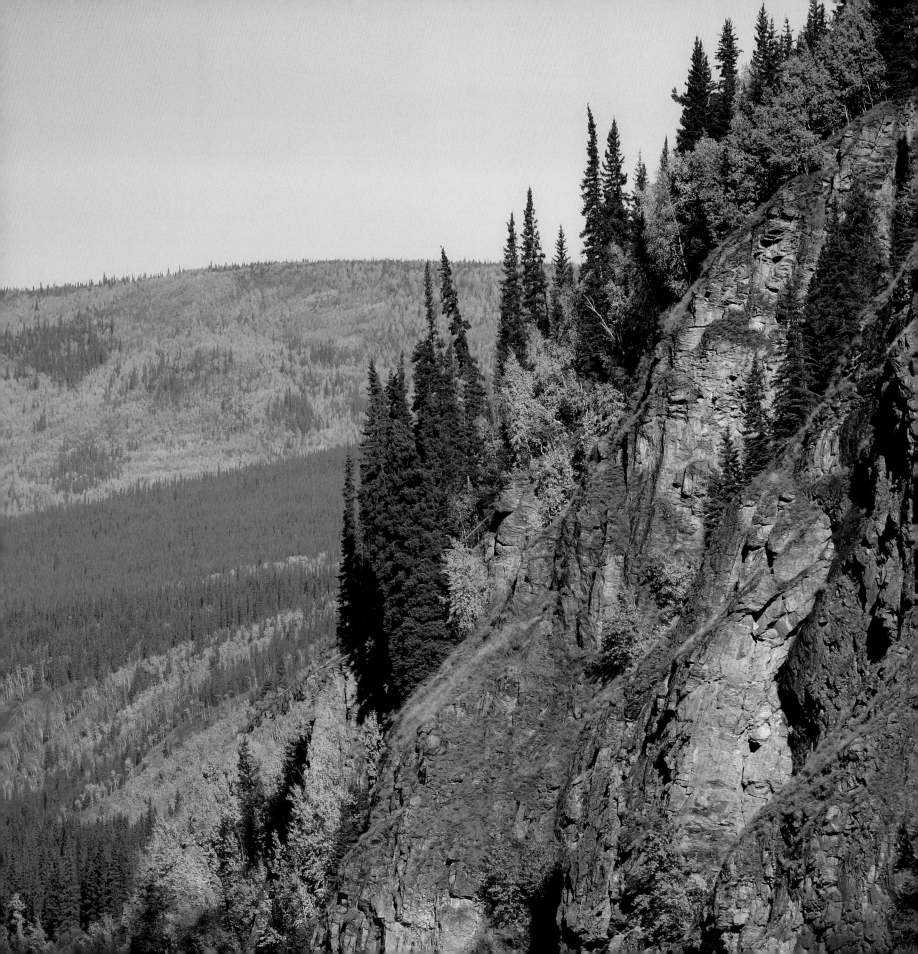

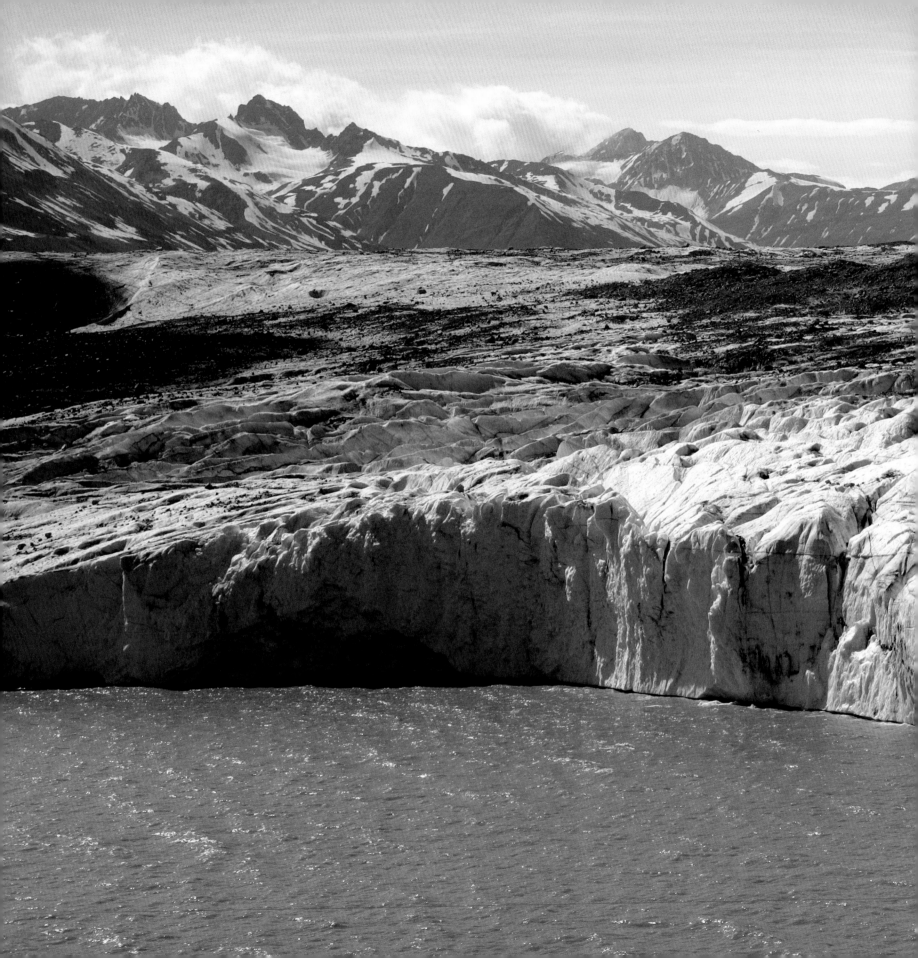

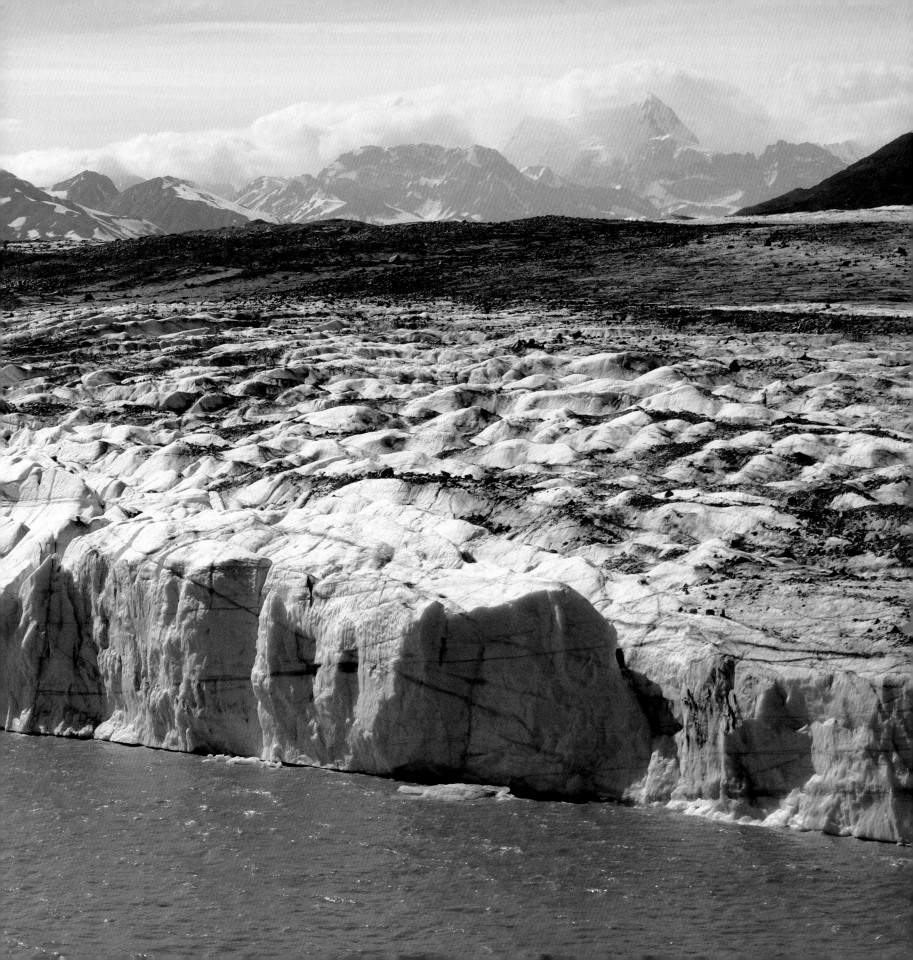

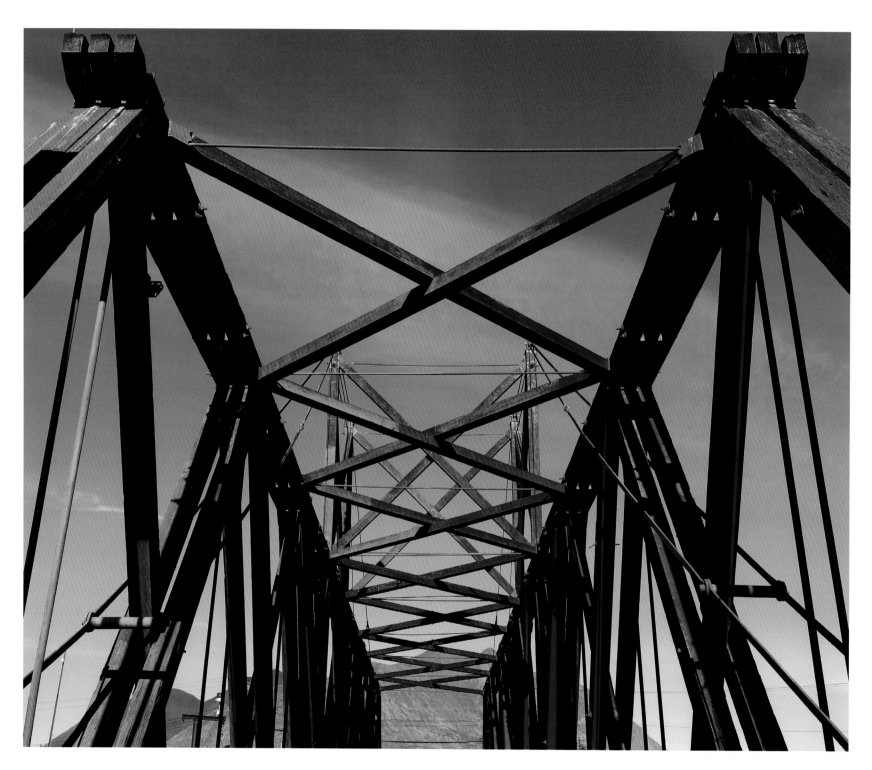

The Carcross Railway Bridge was built in 1900 but rarely used for its intended purpose as a swing bridge. It was refitted in 1998 to remove the swing capability and increase load-bearing capacity.

CARCROSS

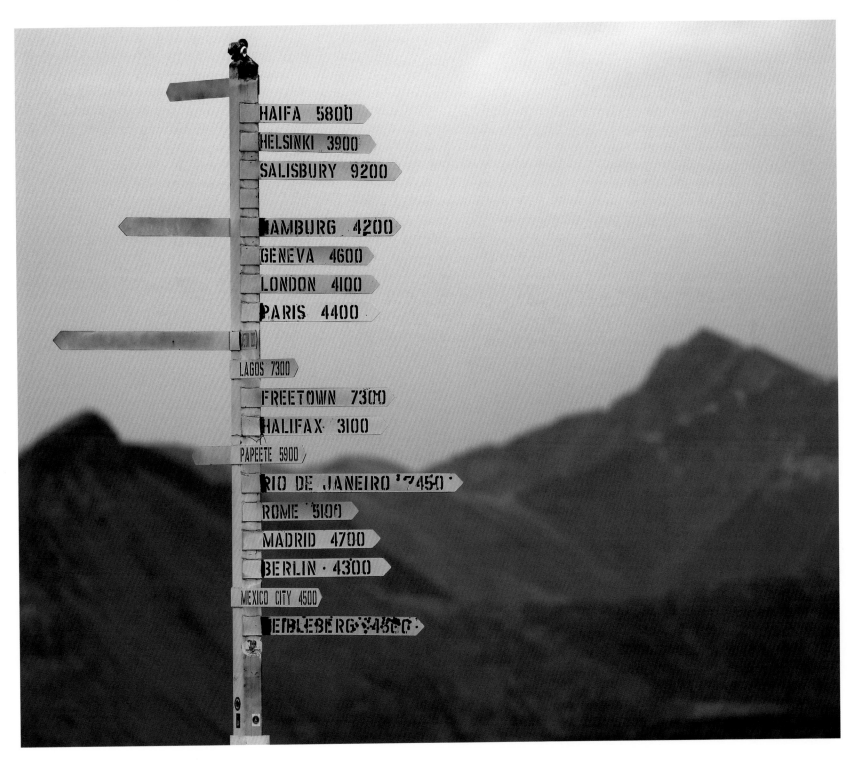

HAIFA 5800
HELSINKI 3900
SALISBURY 9200
HAMBURG 4200
GENEVA 4600
LONDON 4100
PARIS 4400
LAGOS 7300
FREETOWN 7300
HALIFAX 3100
PAPEETE 5900
RIO DE JANEIRO 7450
ROME 5100
MADRID 4700
BERLIN · 4300
MEXICO CITY 4500
EIBLEBERG 4500

One of Keno City's big attractions is the signpost on Keno Hill where the first
prospector staked his claim in 1919. Set up in 1956, the post recalls the home
cities of scientists who visited during International Geophysical Year.
NEAR KENO CITY

77

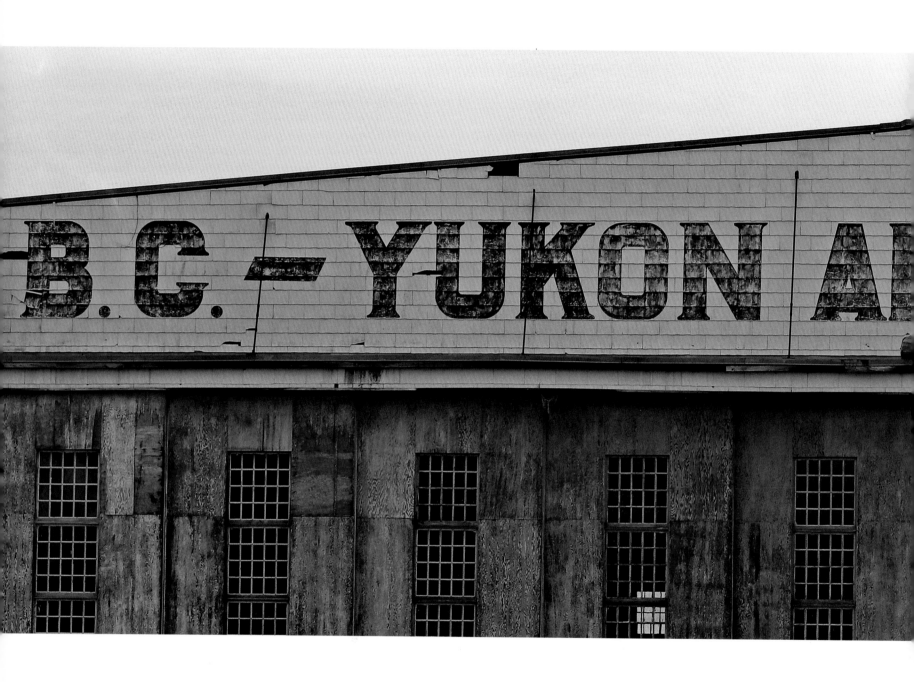

Watson Lake Airport holds on to a bit of history with the 1941 B.C.-Yukon Air Service hangar, which played a key role in WWII for the American army.
NEAR WATSON LAKE

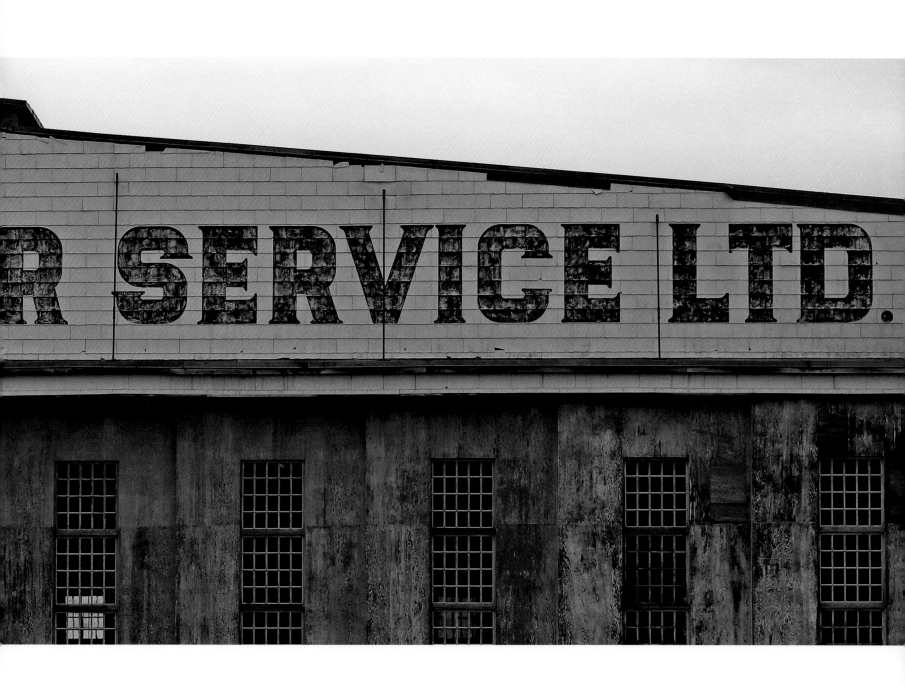

What are men to rocks and mountains?

[Jane Austen, *Pride and Prejudice*]

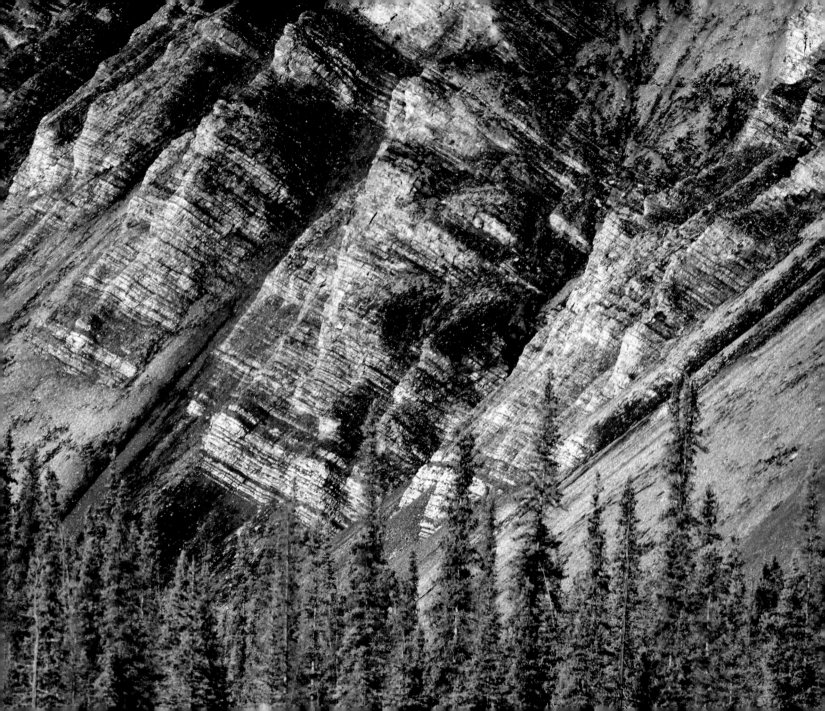

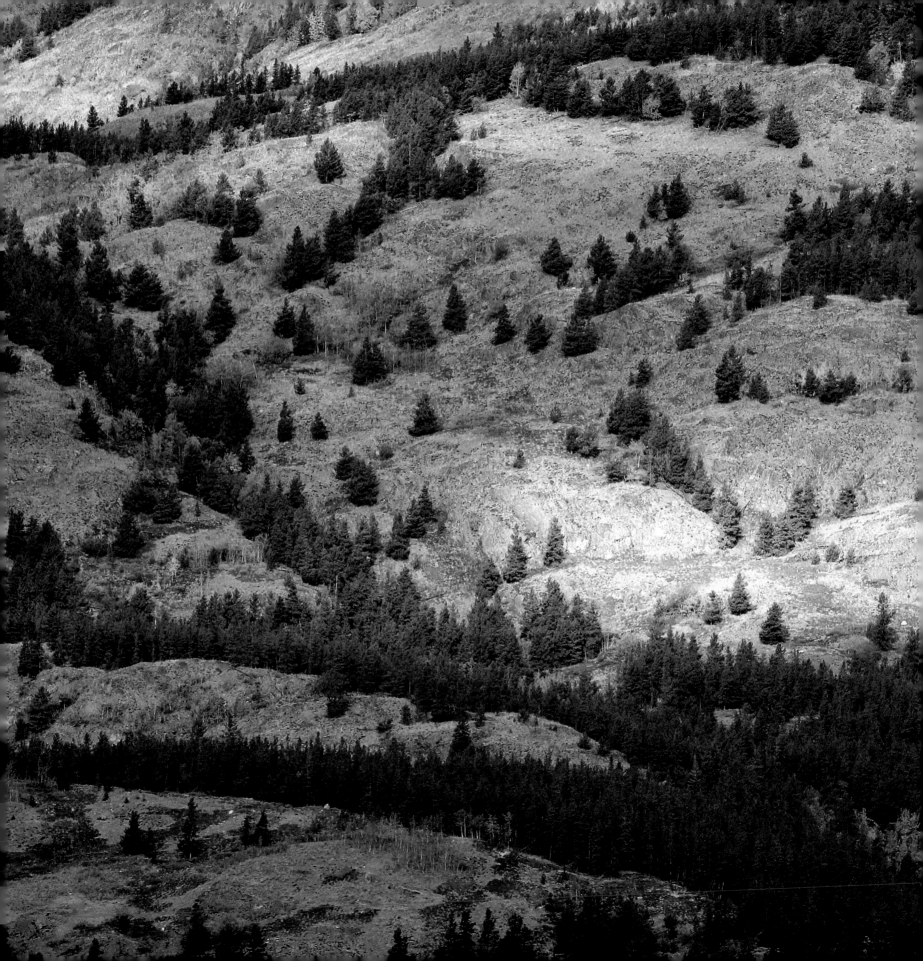

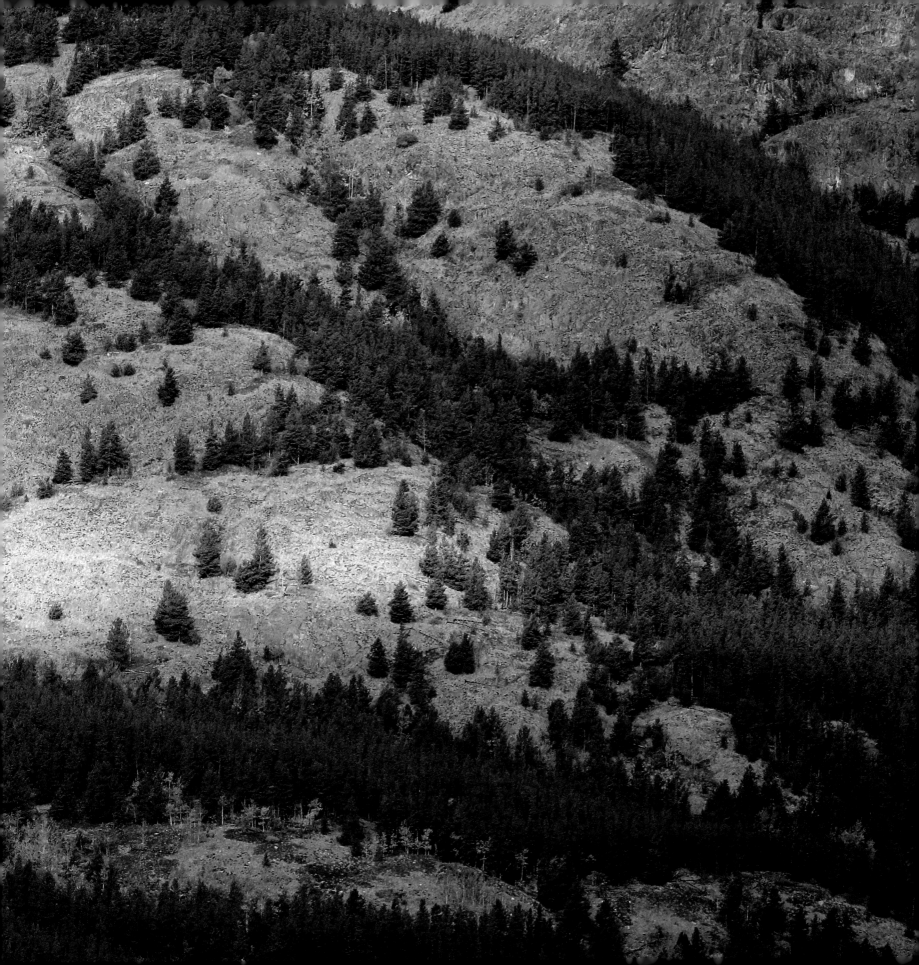

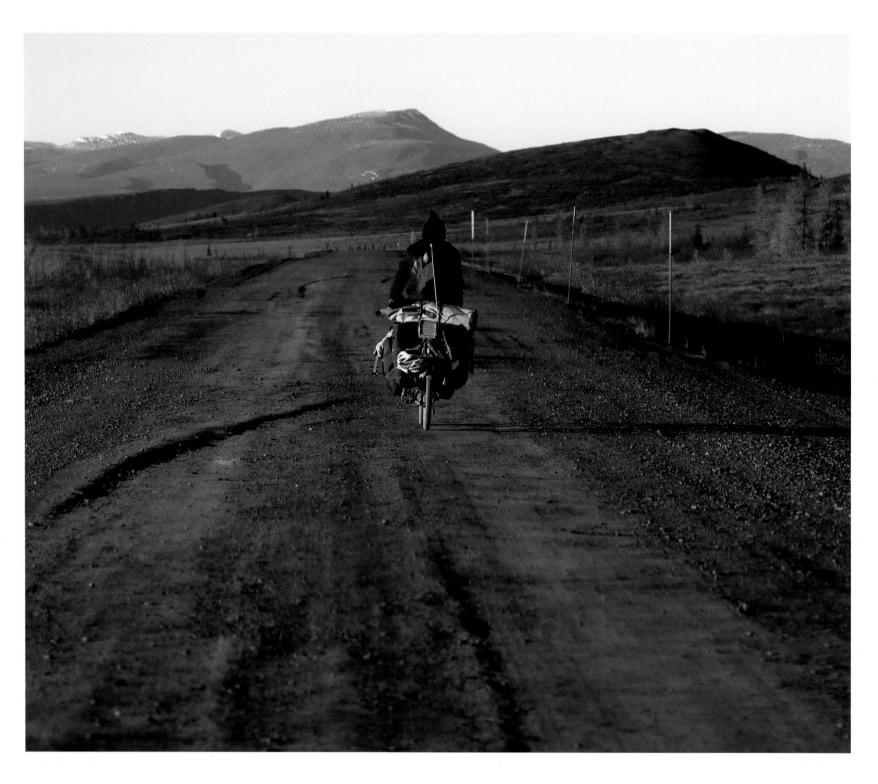

Not for the faint of heart, cycling in the Arctic is challenging, especially on the unpaved stretches of the Dempster Highway. But the thrill is its own reward.
ALONG THE DEMPSTER HIGHWAY, YUKON HIGHWAY 5

Dempster Highway zigzags out from snowy mountain passes. The route was opened in 1979 as the first all-seasons road across the Arctic Circle.
NEAR TOMBSTONE TERRITORIAL PARK, CENTRAL YUKON

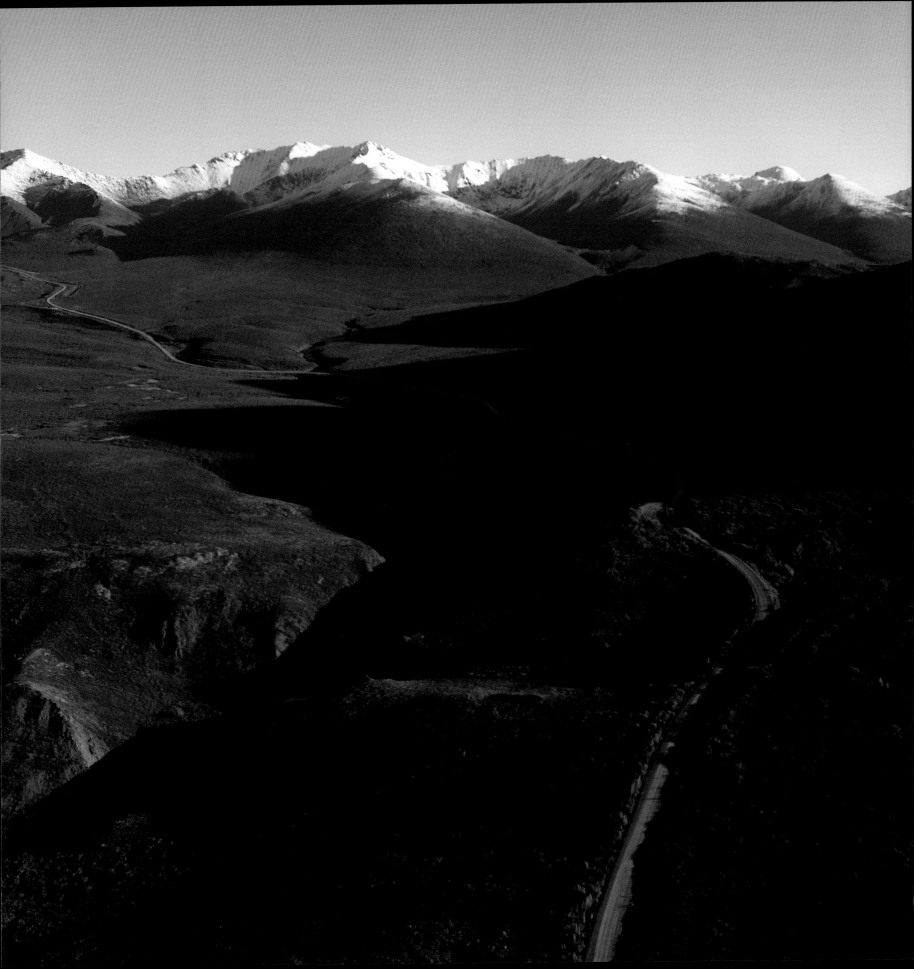

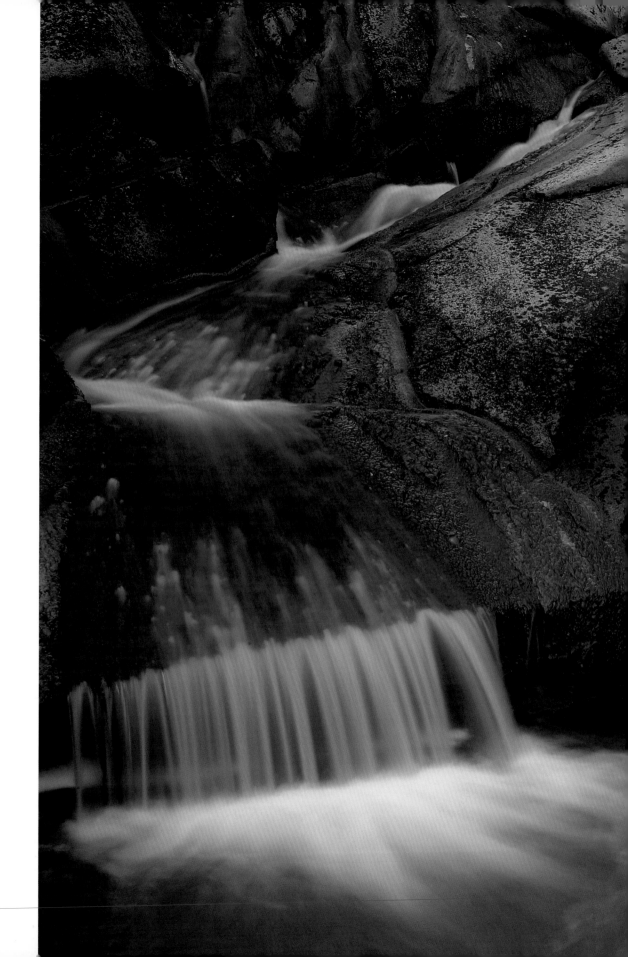

Beautiful Otter Falls cascades softly along the
Aishihik River. A portion of the falls was engraved
on the Canadian 1954 series five-dollar bill.
SOUTHWEST YUKON

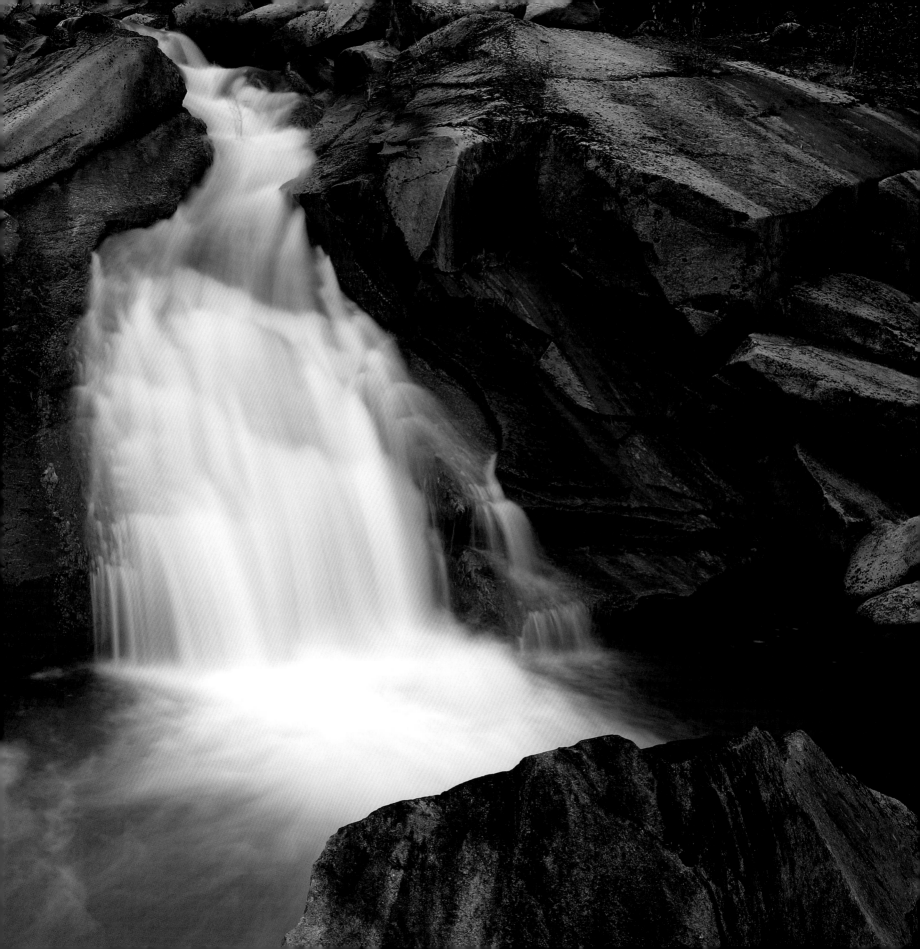

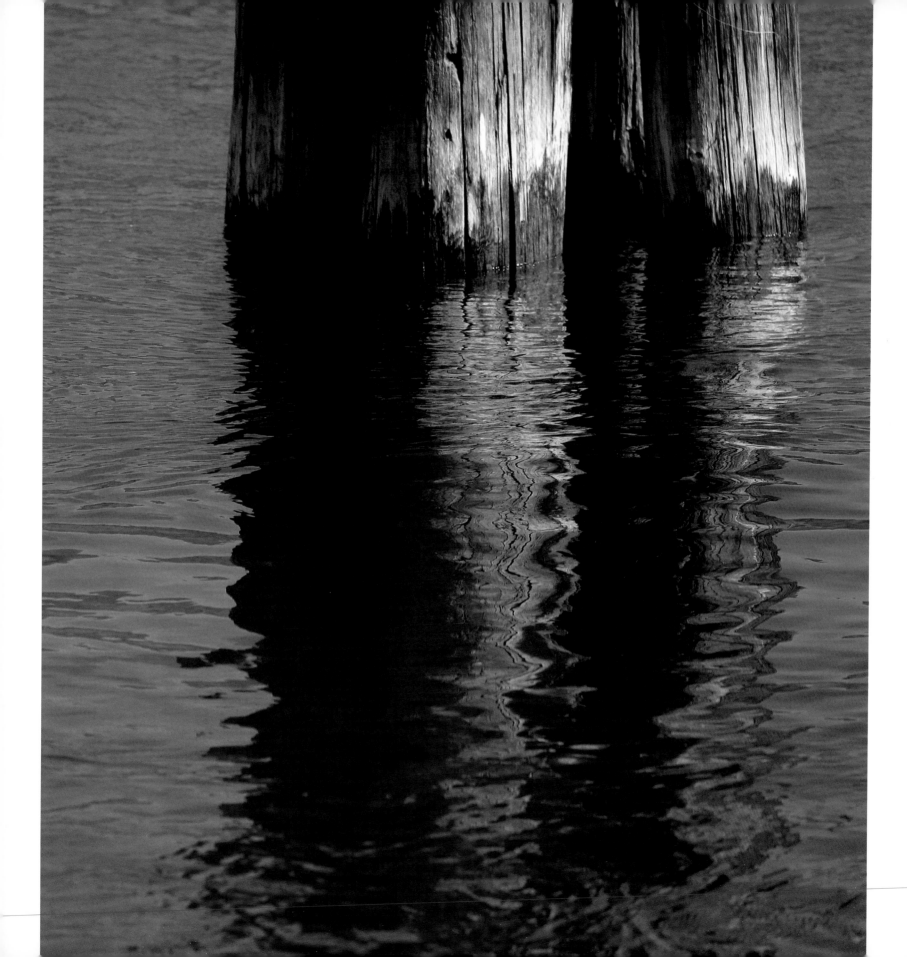

The reflections of old wharf pilings create abstract art on Grayling Bay, the outflow from Lake Bennett.
CARCROSS

A lookout from Keno Hill shows the majesty of surrounding terrain, all within the traditional territory of the Nacho Nyak Dun First Nation.
NEAR KENO CITY

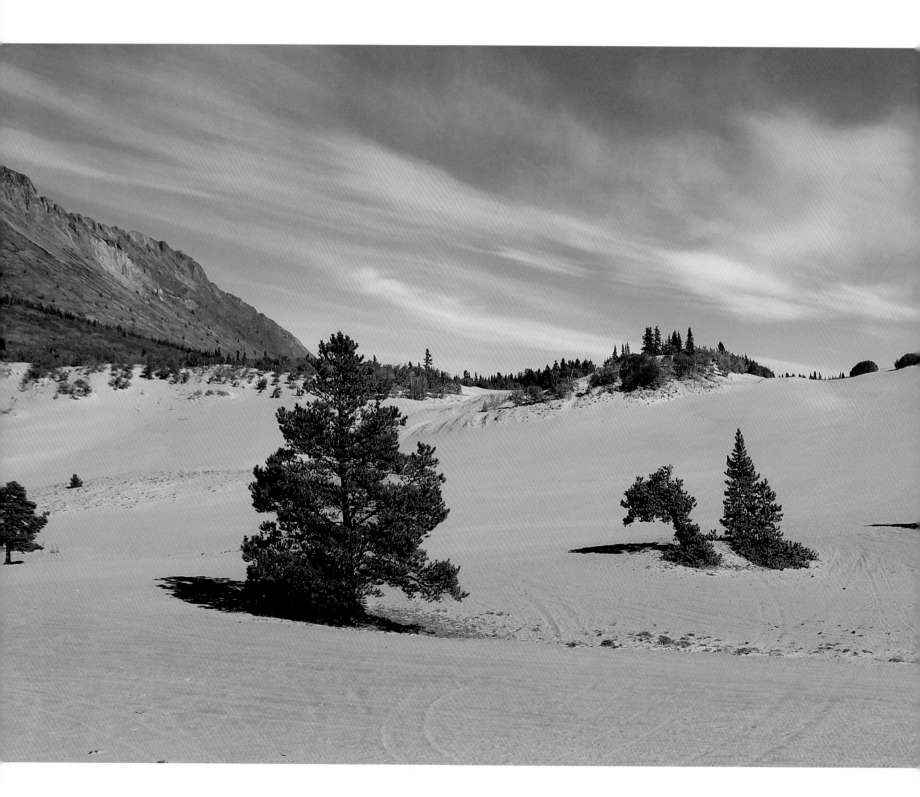

The Carcross Desert is technically a series of sand dunes formed during the last glacial period. With an area of 2.6 km^2 it is sometimes known as the world's smallest desert.
NEAR CARCROSS

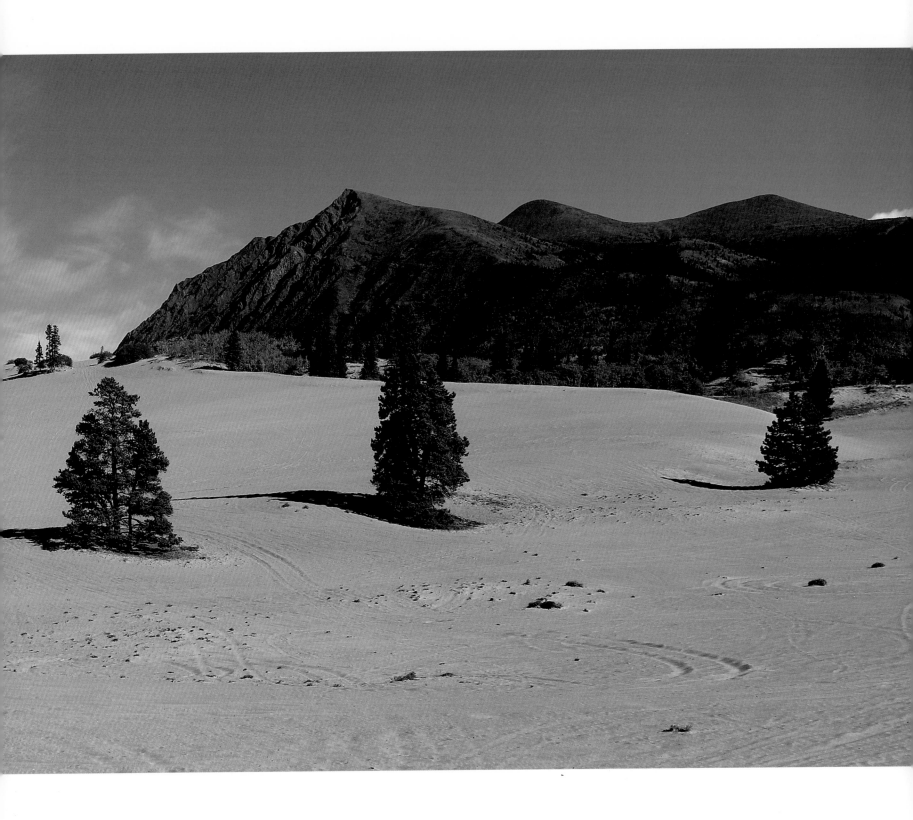

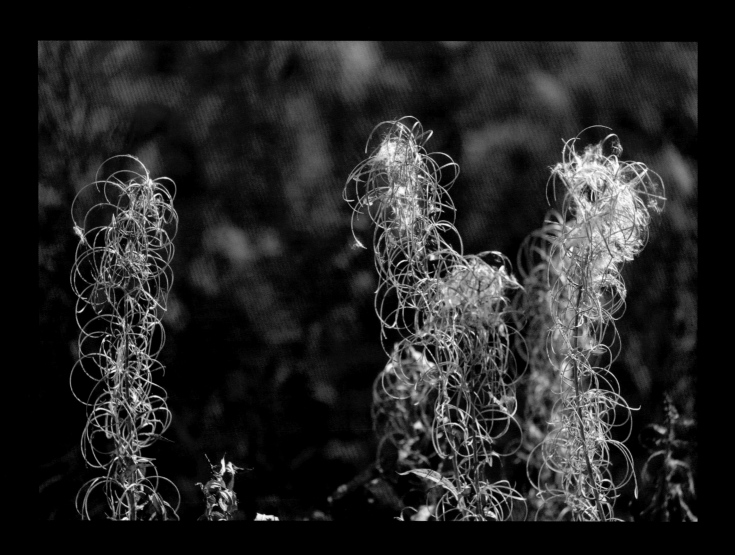

Rust-coloured tendrils tinge roadside landscapes with autumn hues.
ALONG THE ALASKA HIGHWAY, YUKON HIGHWAY 1

A bright tree drips a spot of colour onto a smoky rock face.
ALONG ROBERT CAMPBELL HIGHWAY, YUKON HIGHWAY 4

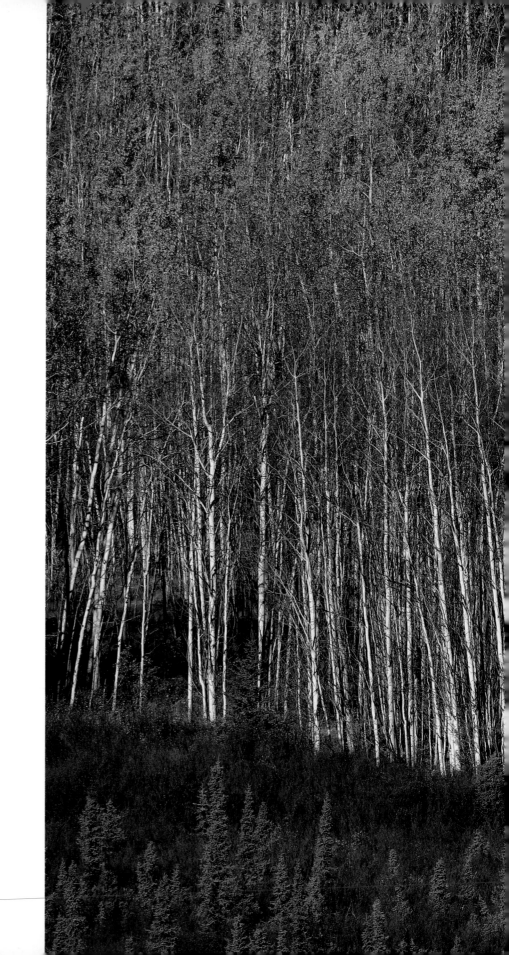

A large stand of birch trees reaches for the sky near Dawson City. Somewhat fragile, birch trees do not do well in shade but can endure various soil conditions.

ALONG THE NORTH KLONDIKE HIGHWAY, YUKON HIGHWAY 2

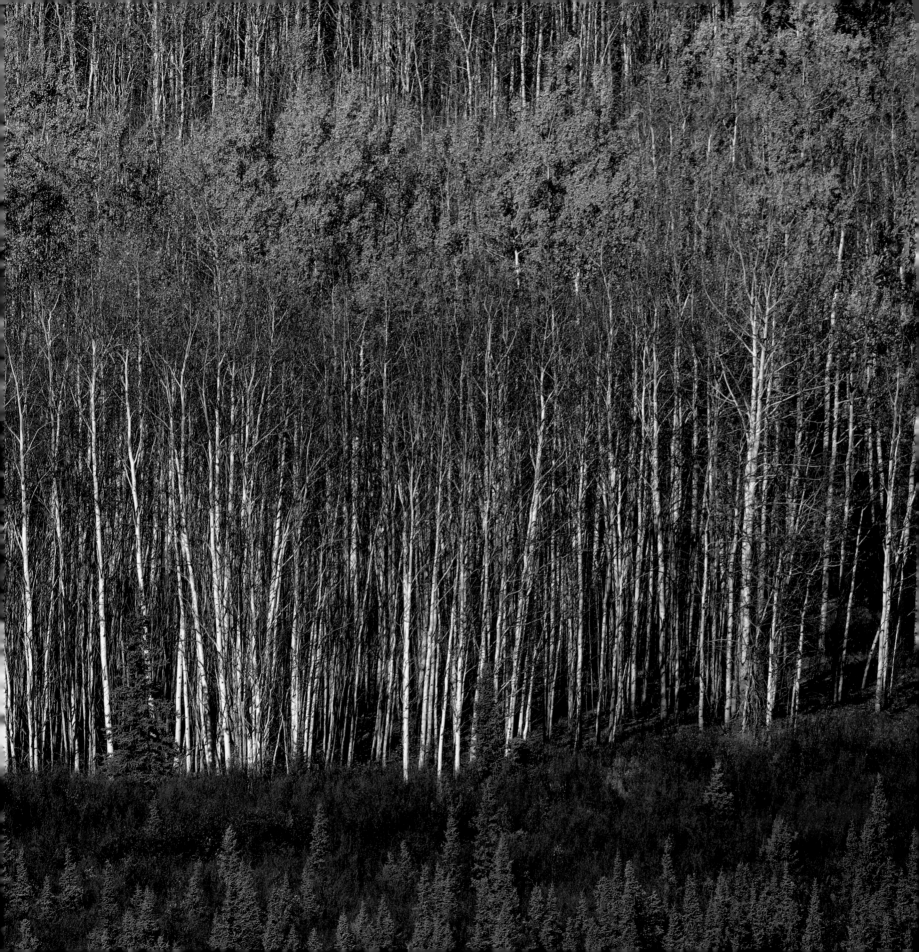

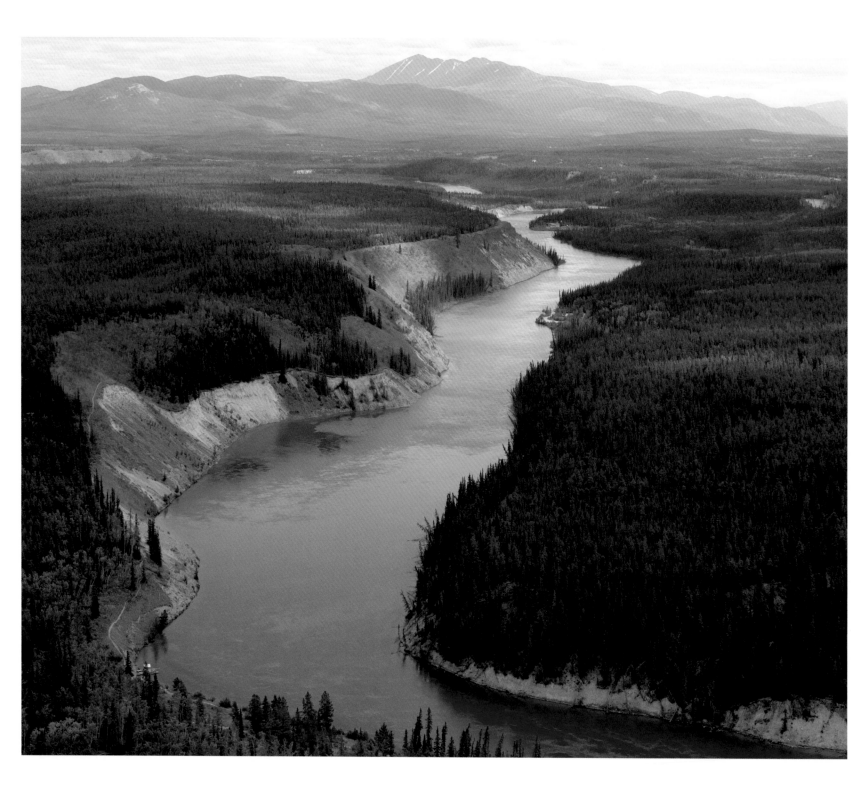

A tranquil vista of the Yukon River reveals a section of its path to the Bering Sea. Its 3185 km straddle Alaska and Canada, with 1149 of those flowing through Canada.
NEAR WHITEHORSE

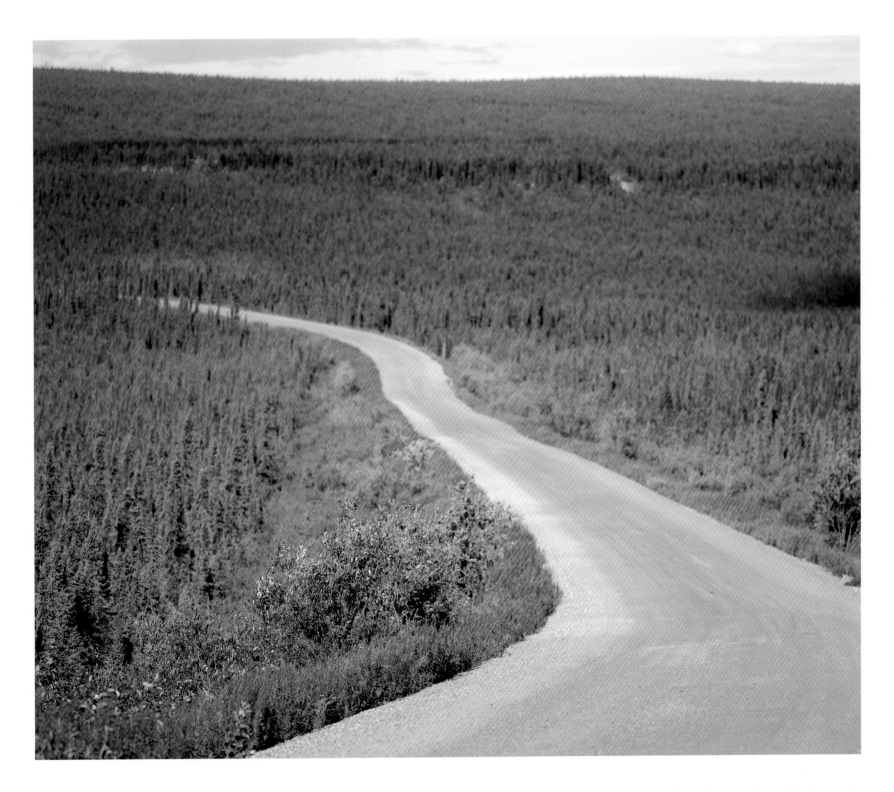

Flaming pink fireweed, Yukon's territorial flower, lines the highway. The fast-growing
plant can be used for tea, honey and salads.
ALONG THE DEMPSTER HIGHWAY, YUKON HIGHWAY 5

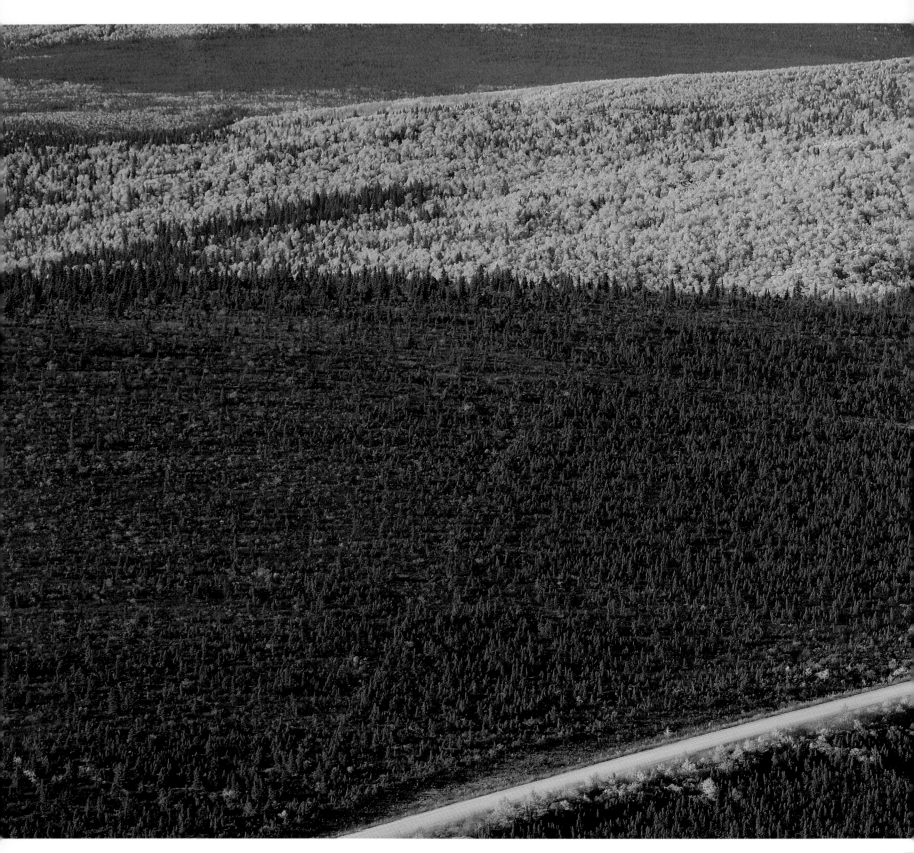

Few amenities are found along the Top of the World Highway but the scenery will take your breath away.
The route is aptly named for the views over valley landscapes as it winds along the crests of hills.
ALONG THE TOP OF THE WORLD HIGHWAY, YUKON HIGHWAY 9

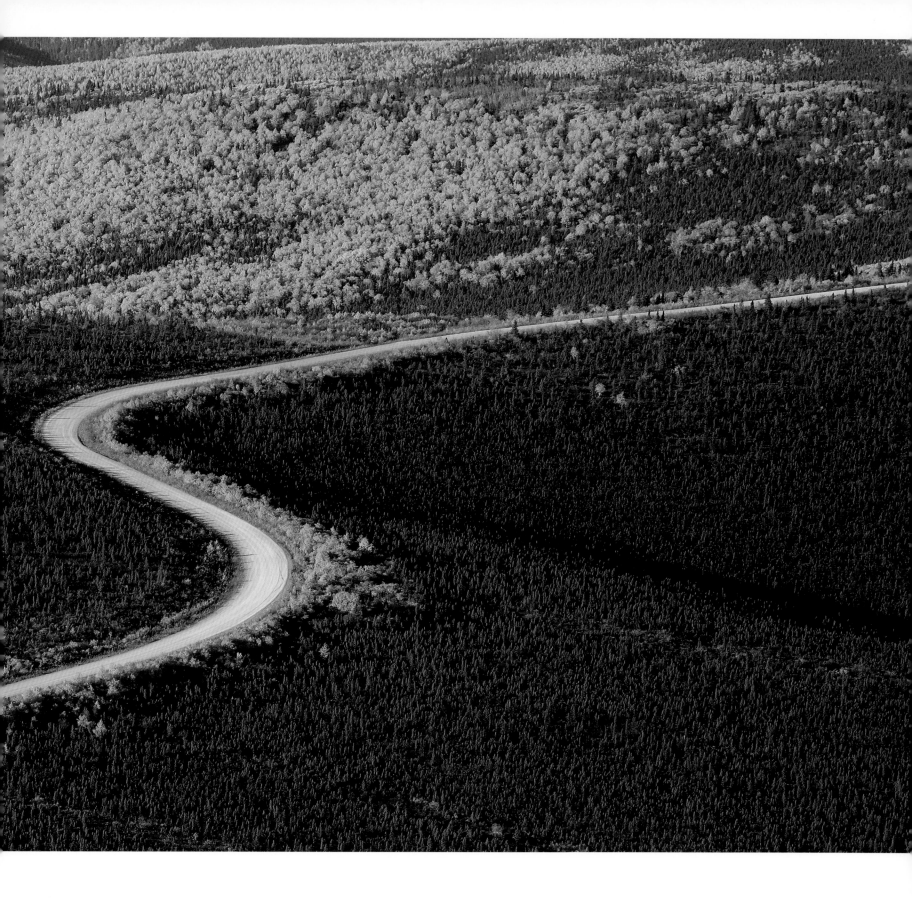

"The North is a special sort of symphony. Its landscape is a dance, the wind is an orchestra, and the cry of the birds are high notes in the background.

[Ted Harrison]

FOLLOWING ○ Surreal colours punctuate a picturesque view of the St. Elias range near the Yukon-Alaska border. The mountains are the geographical divide between the Yukon River and the Pacific Ocean.
KLUANE NATIONAL PARK AND RESERVE, SOUTHWEST YUKON

The Peel River is shared by Yukon and the Northwest Territories, but the Peel Watershed is mainly in the Yukon. First Nations are the only residents and it is a very important site for the Tetlit Gwich'in ("people who live at the head of the waters").
NORTH EAST YUKON

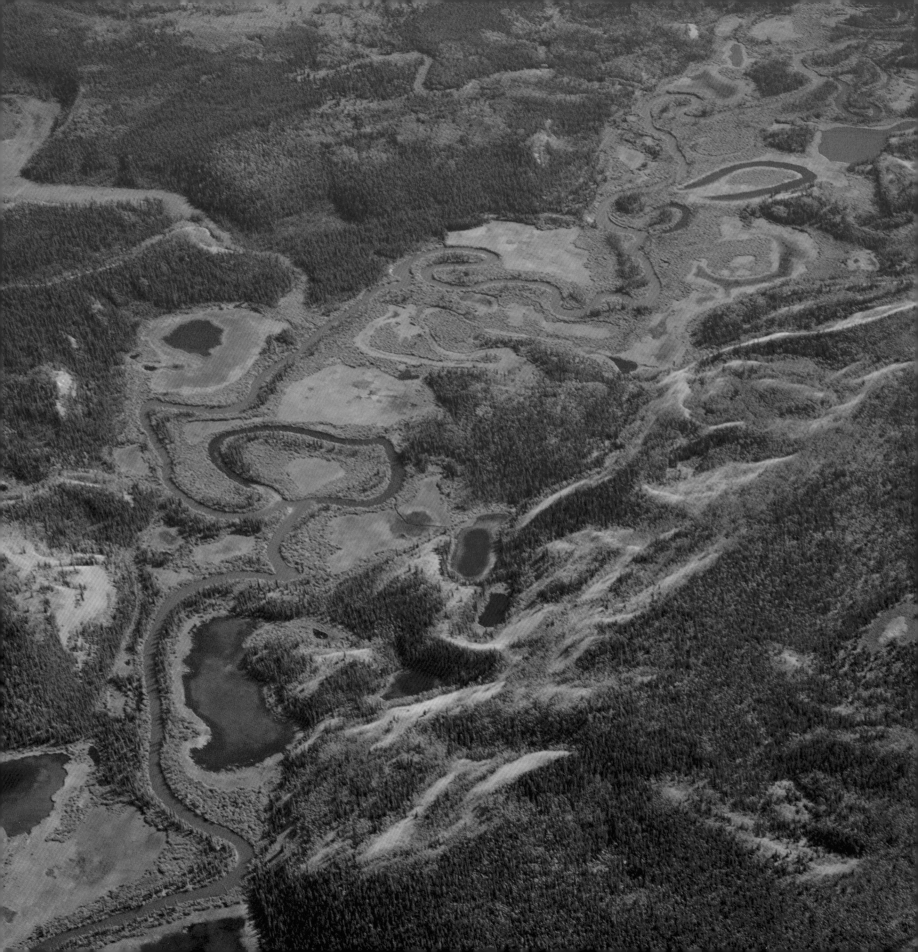

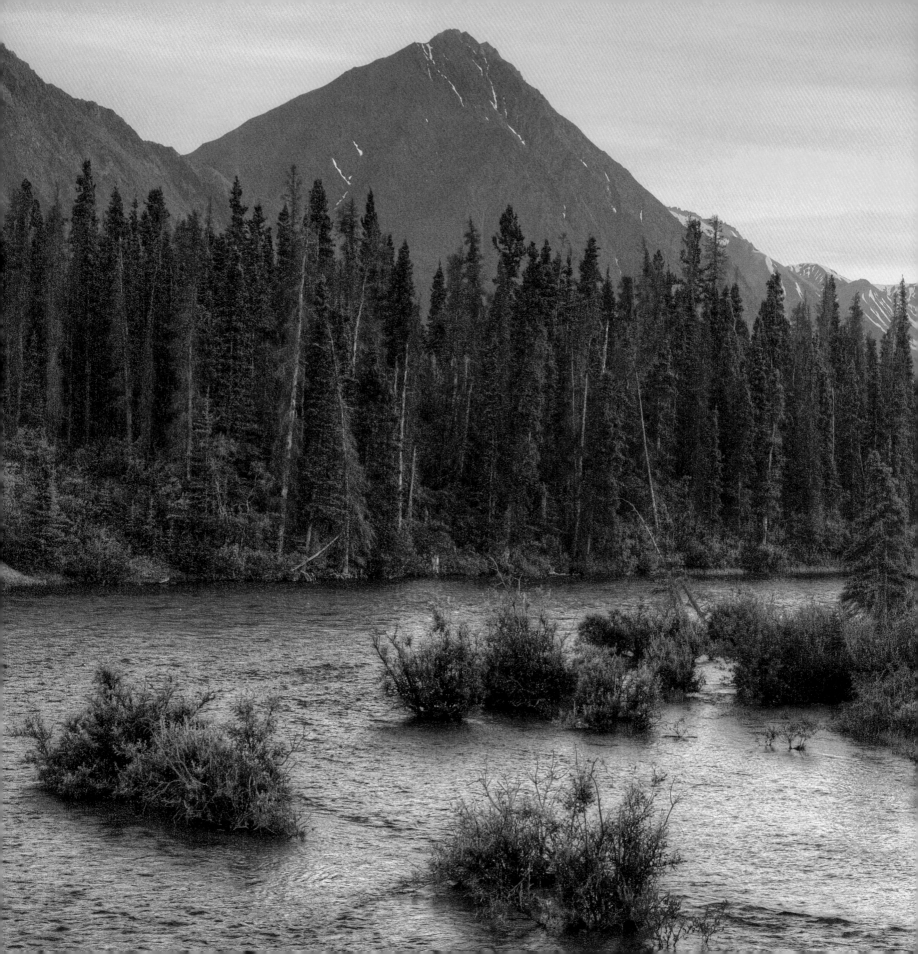

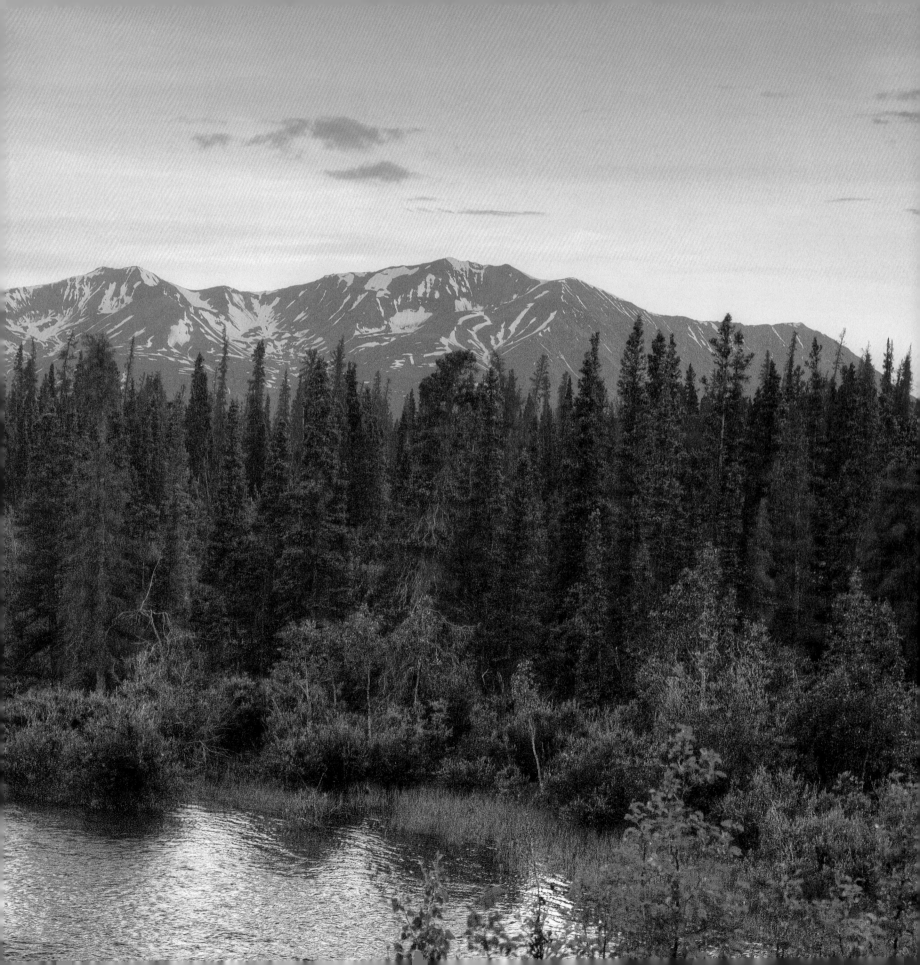

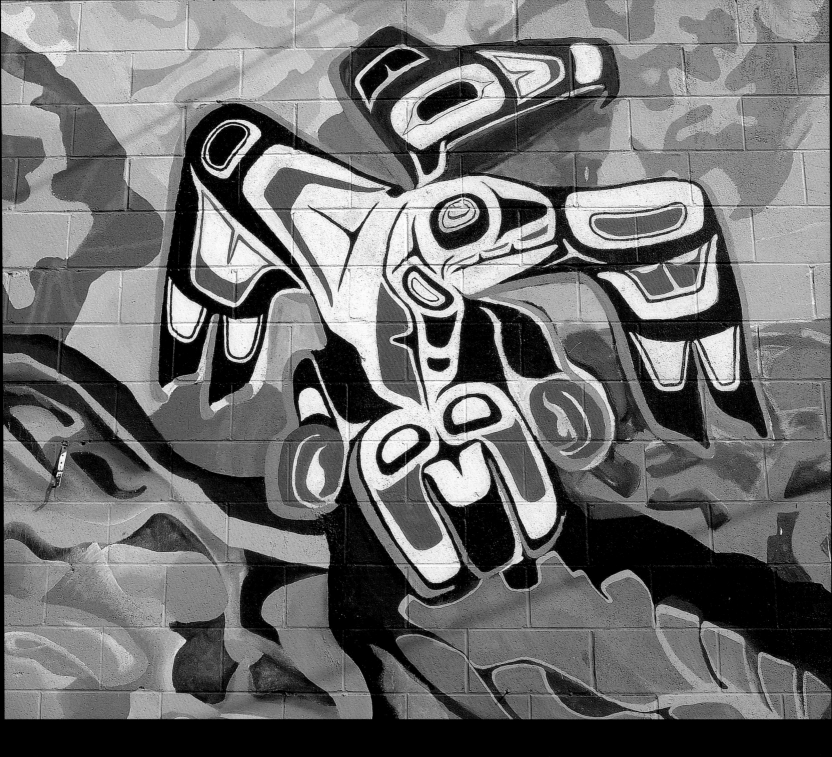

A small part of a wraparound mural on Main Street illustrates how Lance Burton and the Youth of Today Society are reimagining traditional art.

A project of the Carcross Tagish First Nation business plan, the Carcross Commons showcases vendors, artisans, food and live performances.

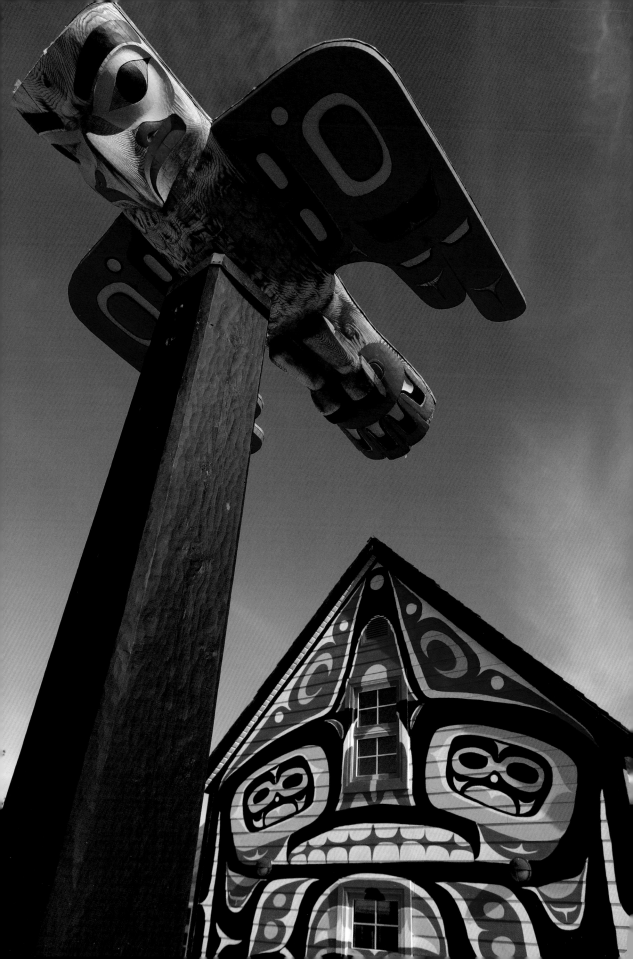

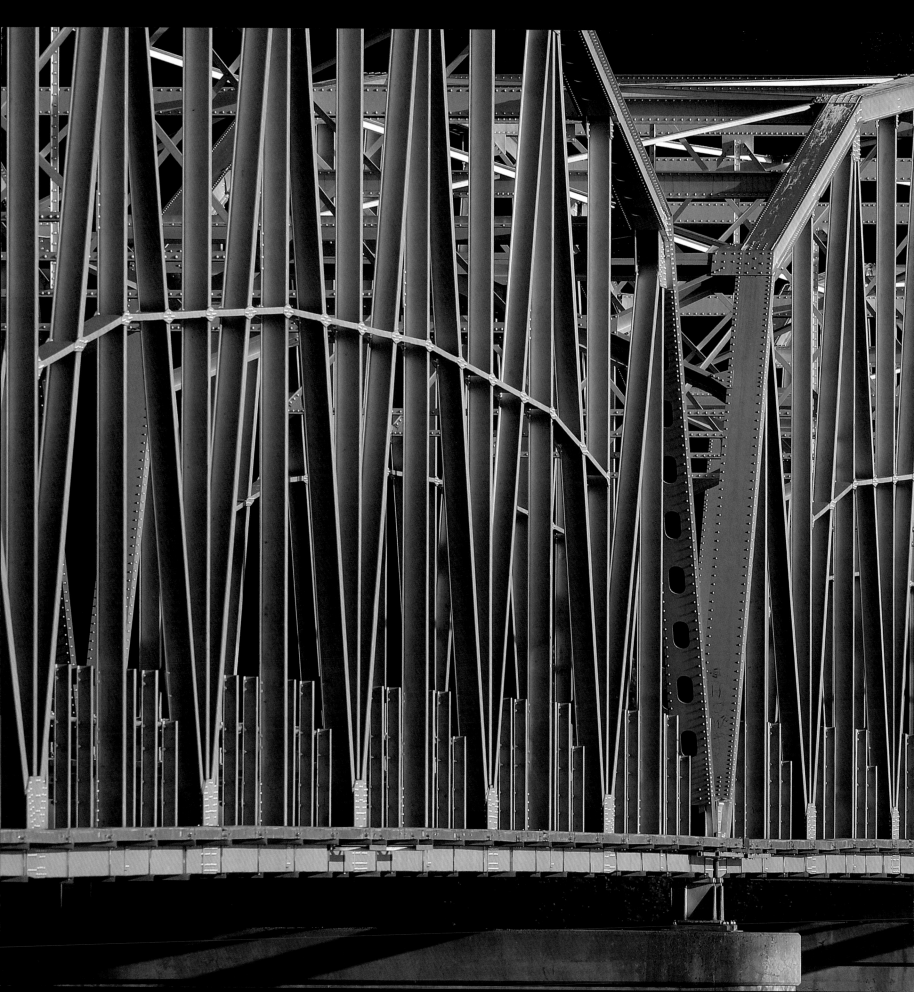

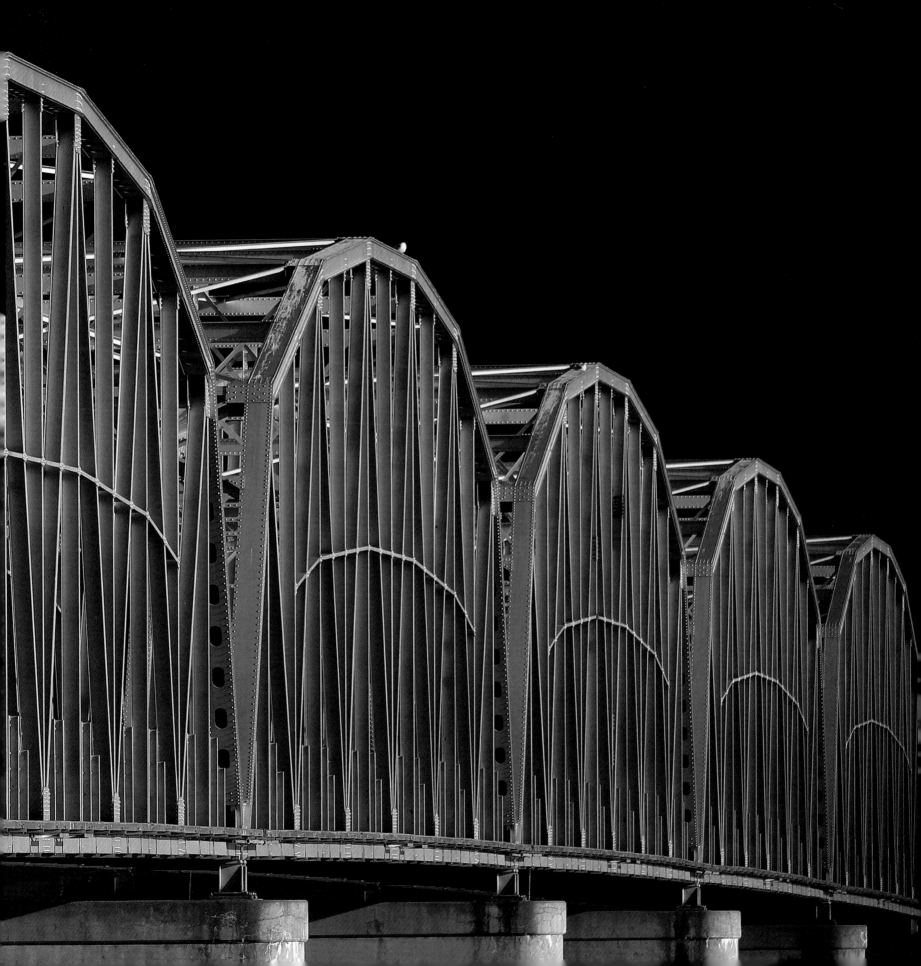

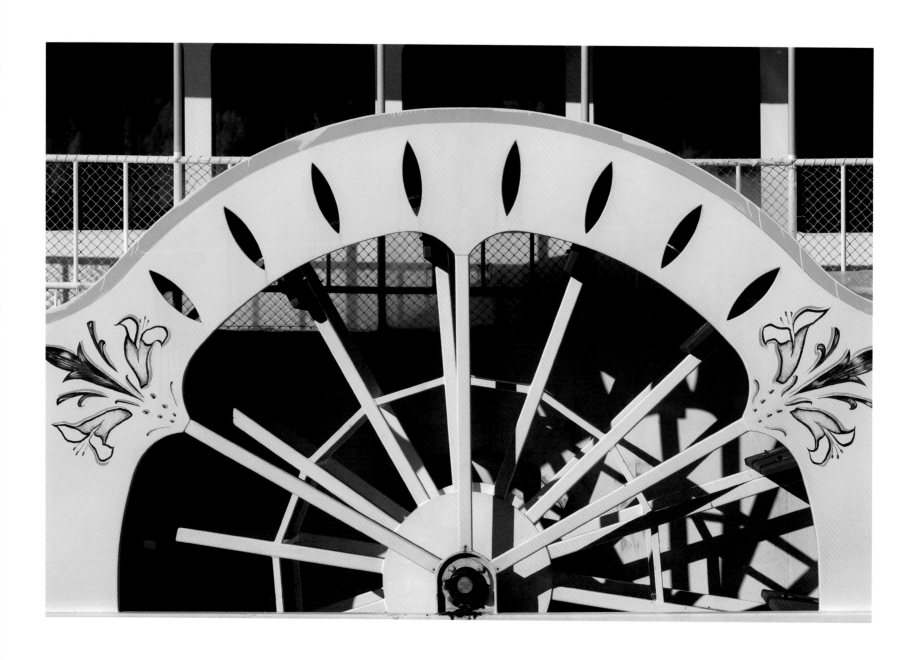

A pretty paddlewheel on the *Klondike Spirit* captures the romance of riverboats, and recalls the vessels that once ruled the waters. When trucks replaced ships for moving supplies, most paddlewheelers were lost to progress.
DAWSON CITY

PREVIOUS ◦ Waves of Warren through-truss steel sustain the Nisutlin Bay Bridge. At 584 m, it is the longest bridge along the Alaska-Canada Highway.
TESLIN

A detail of the vast Kaskawulsh Glacier is part of the St. Elias mountains that are almost entirely covered by icefields. It is 1800–2700 m above sea level.
KLUANE NATIONAL PARK AND RESERVE, SOUTHWEST YUKON

Playful waters bubble over the iron-coated rocks in Red Creek.
Deposits of iron, nickel and zinc are very high in the area, which is
a part of Beringia where the topography was not affected by the
last ice age.

DEMPSTER HIGHWAY KM 193, YUKON HIGHWAY 5

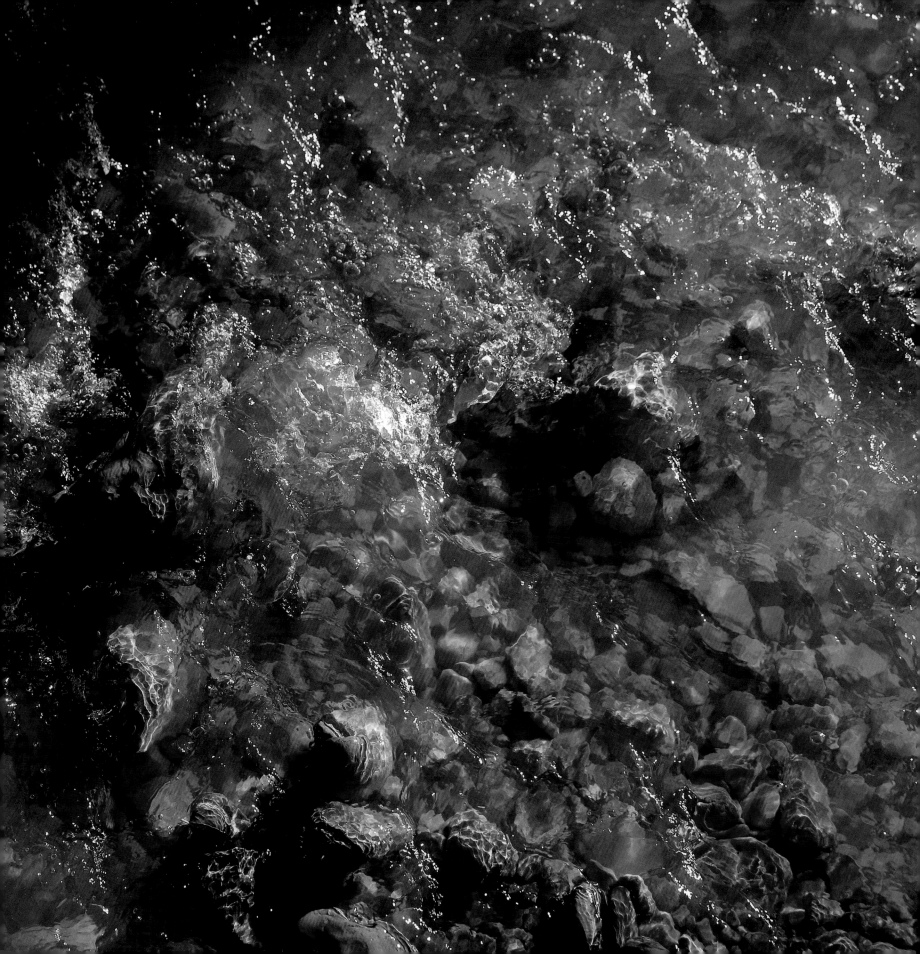

Outside Baked Café on Main Street, local talent entertains passersby. It is a welcome place for artists of many genres.
WHITEHORSE

FOLLOWING ○ Colourful inside and out, the Westminster Hotel features the Snake Pit tavern and the Arm Pit lounge. Known simply as The Pit, the building is an authentic 1898 structure featuring live music and tall tales.
DAWSON CITY

Created by Lance Burton, artist and executive director, Youth of Today Society, a lively mural outside the 98 Hotel alludes to its old-time dance-hall origins as the 98 Ballroom.
WHITEHORSE

COCKTAIL LOUNGE

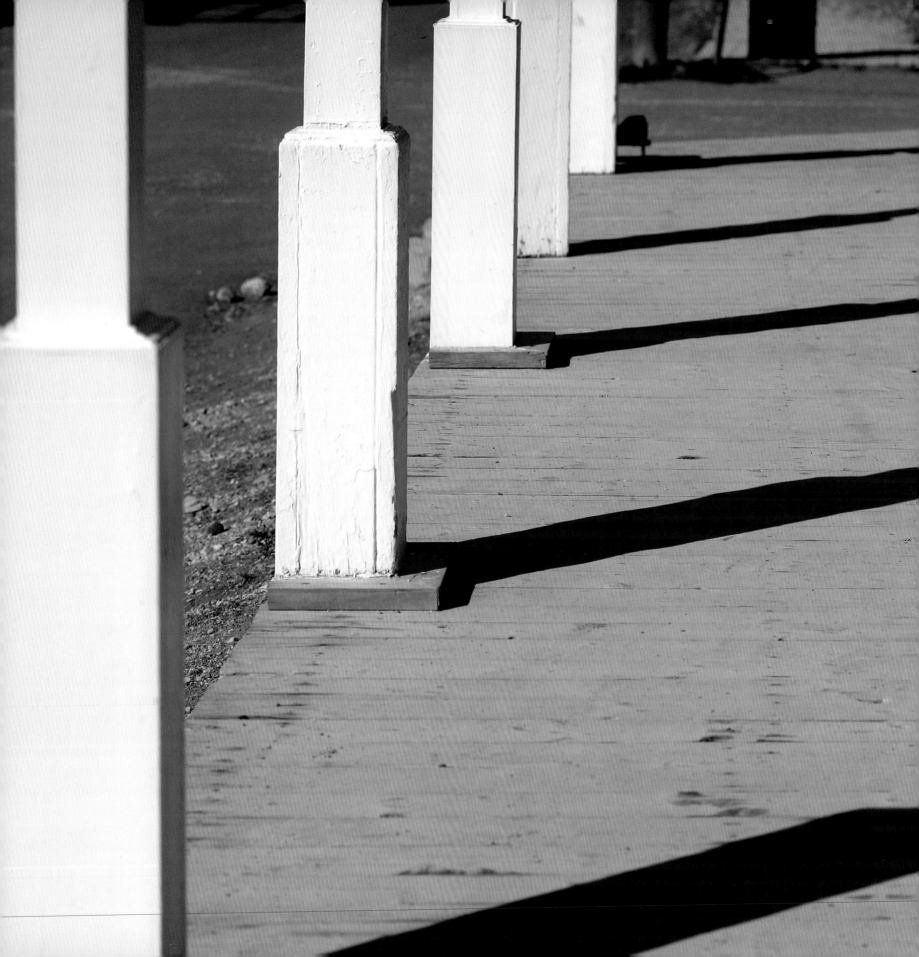

Dawson City is a vibrant town where wooden sidewalks invite strollers to step back in time. History is also preserved in the town's architecture and gold mining narratives as well as First Nations background. From 1898 to 1953, it was the territory capital.
DAWSON CITY

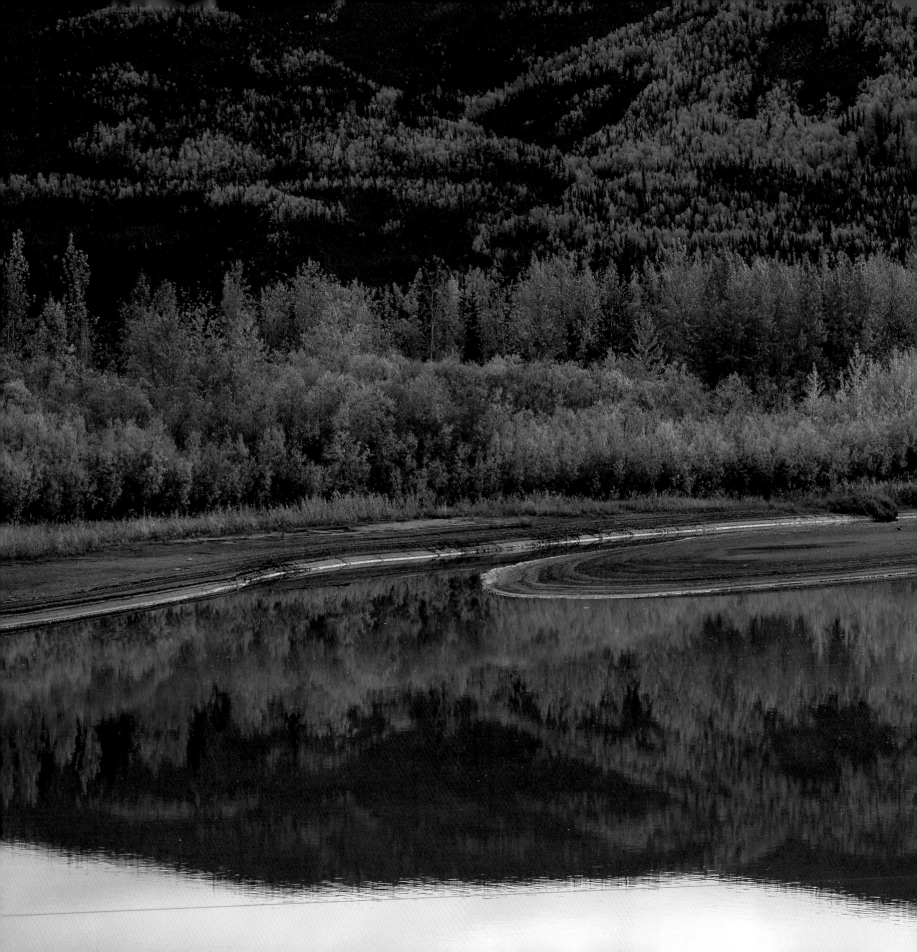

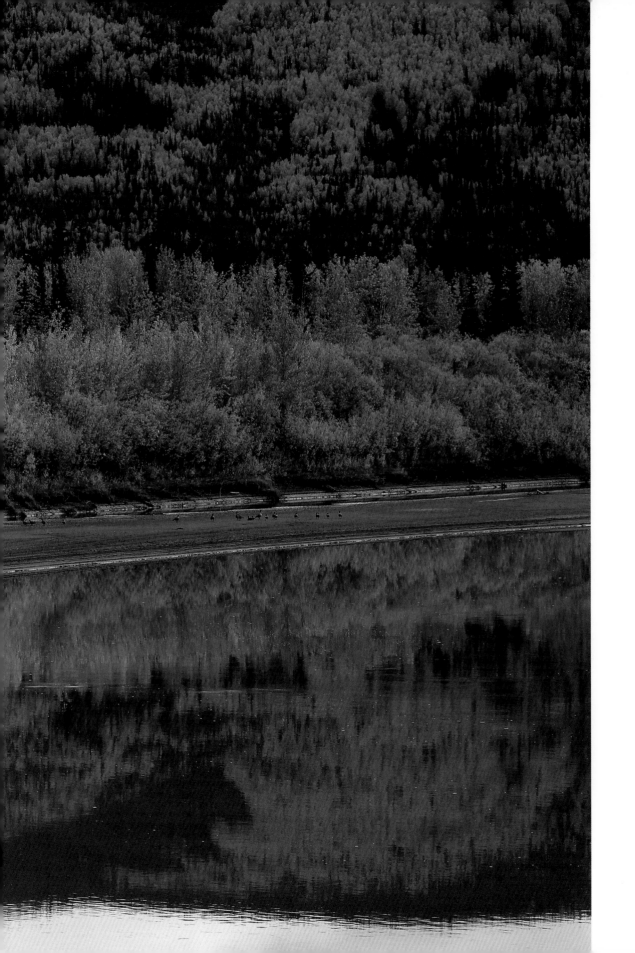

The Stewart River (Na-Cho Nyäk or Big River) is home to the First Nation of Na-Cho Nyäk Dun. When Europeans arrived, the village of Mayo was founded and named after settler and explorer Alfred Mayo, a former circus acrobat. Today, it is a starting point for wilderness adventurers heading into the magnificent Peel River Watershed for canoeing, hiking, hunting and fishing.
MAYO

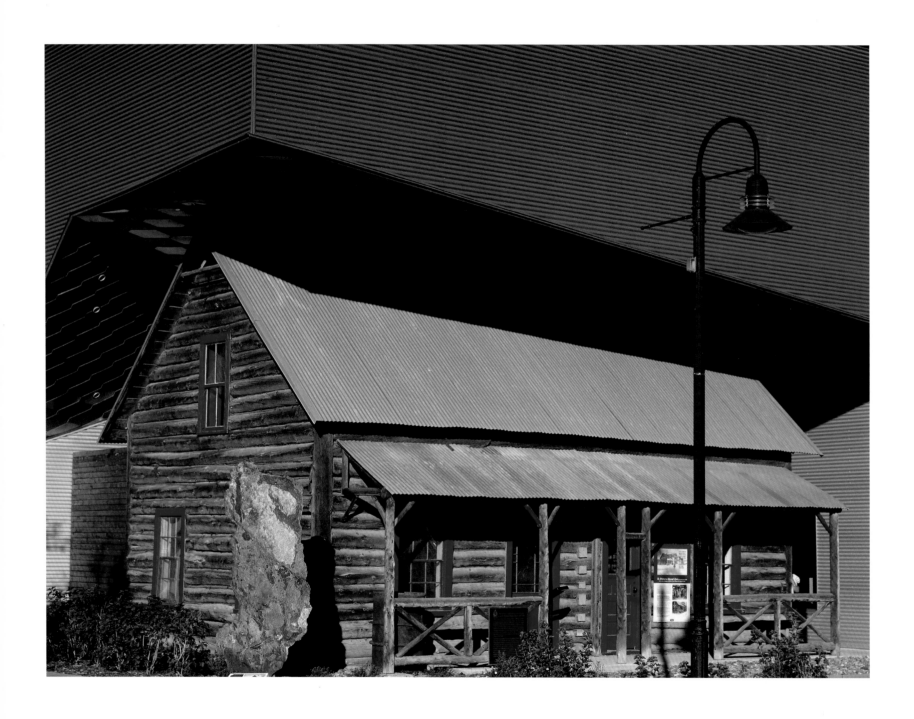

In 1952, with enthusiasm and foresight, William MacBride and Fred Arnot founded
the Yukon Historical Society and a museum in the unoccupied Government Telegraph
Office. Today's MacBride Museum opened its doors in 1967 and is home to more than
37,000 artifacts, including the two-storey log Telegraph Office.

WHITEHORSE

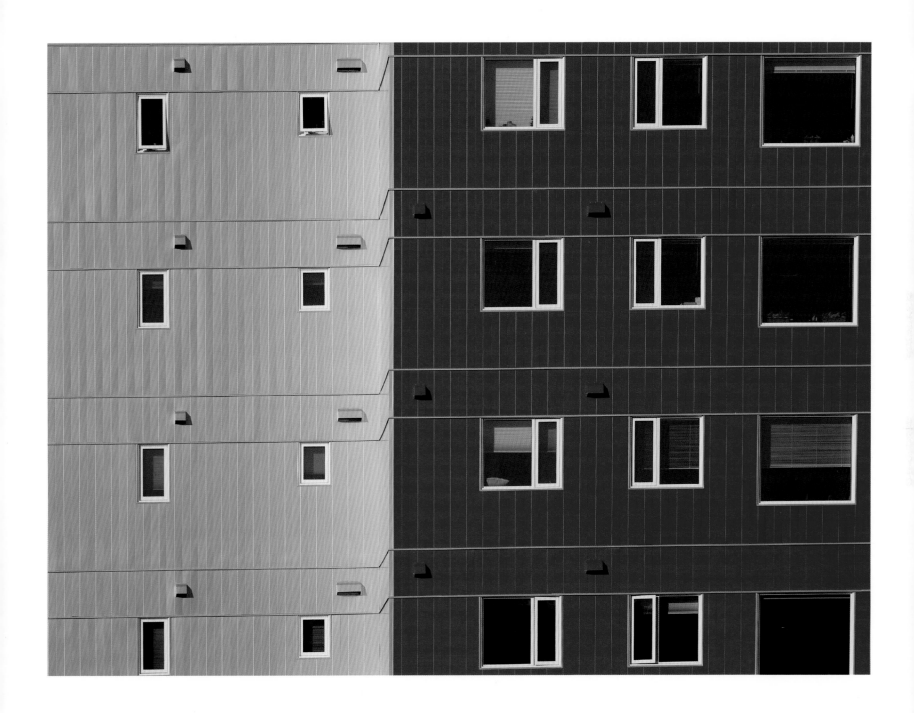

Mah's Point planned two-condo building – a 44-unit waterfront complex – is well-situated in Whitehorse, home to about 75% of the territory's population.
WHITEHORSE

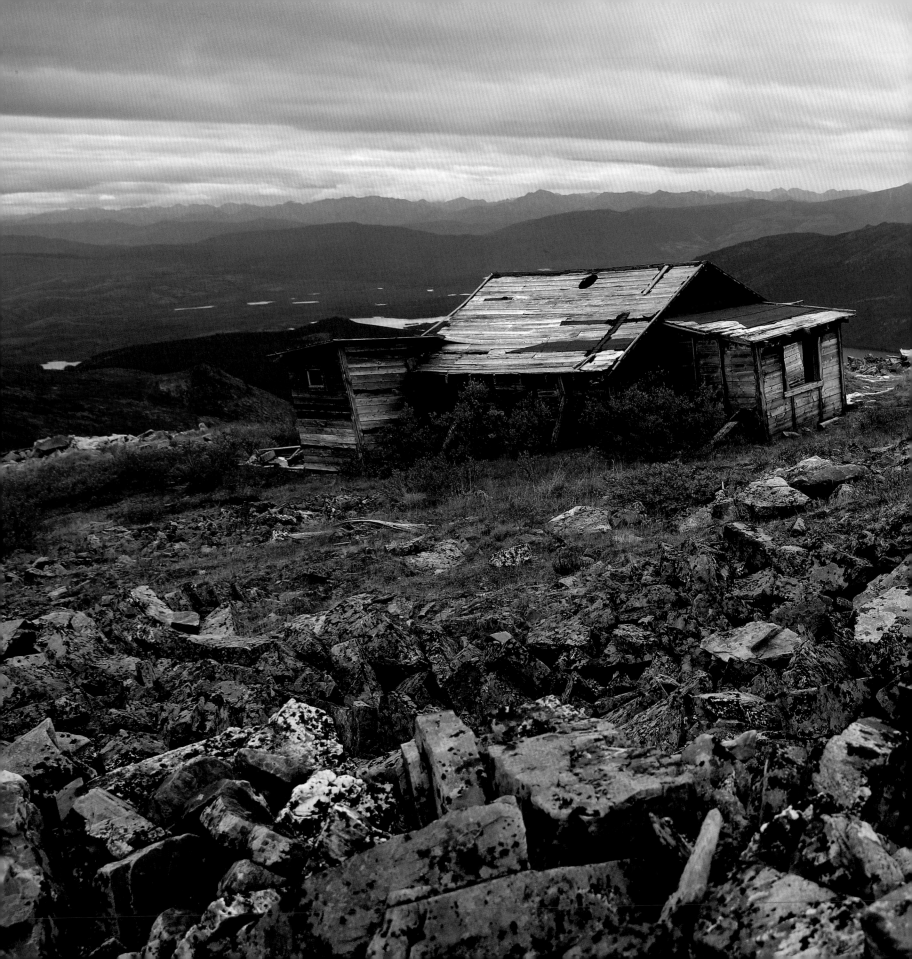

Following directions like "veer off to the right just before the old Sheep Camp mine cabin," Monument Trail leads to an abandoned miners' dwelling and awesome views of both the McQuesten Valley and the Ogilvie and Wernecke Mountains.
NORTHEAST OF KENO CITY

"Today is
your day!
Your mountain
is waiting,
So... get on
your way!

[Dr. Seuss]

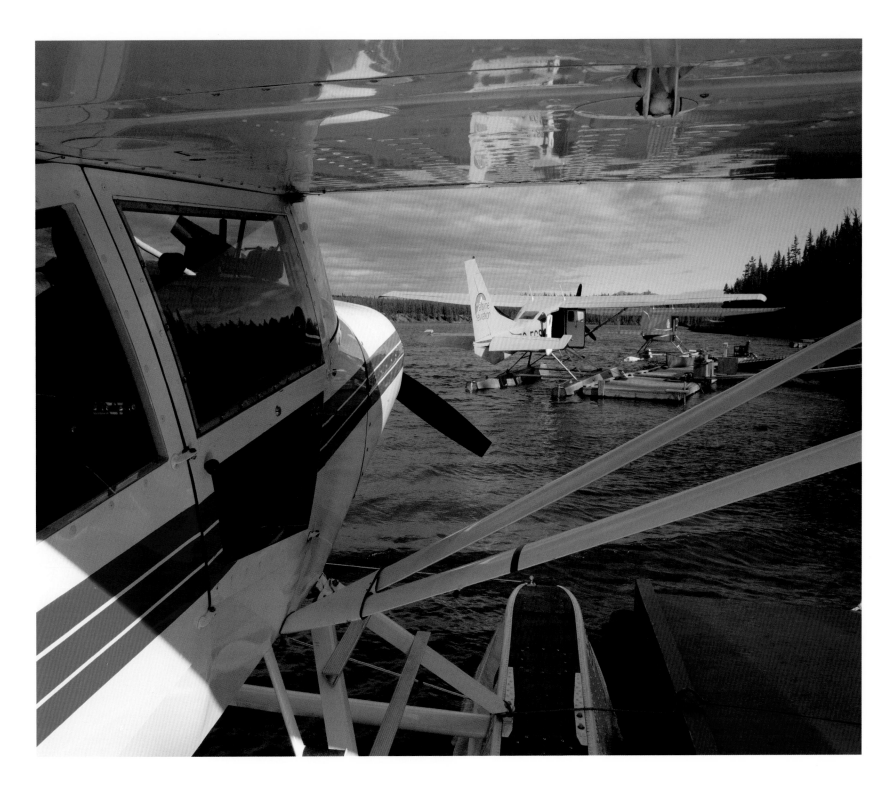

Alpine Aviation Yukon Ltd. readies part of the fleet for its next charter. Year-round flightseeing and wilderness access are tempting opportunities.
WHITEHORSE

Marking the Arctic border, the latitude of Earth's northernmost region also signals a change in the pattern of sunlight and darkness closer to the North Pole.

DEMPSTER HIGHWAY KM 405.6, YUKON HIGHWAY 5

FOLLOWING ∘ Sunset adds fire to the Cassiar Mountains, the northernmost peaks of the Northern Interior Mountains. They are part of the Continental Divide separating water drainage to the Arctic and Pacific Oceans.

SOUTHERN YUKON

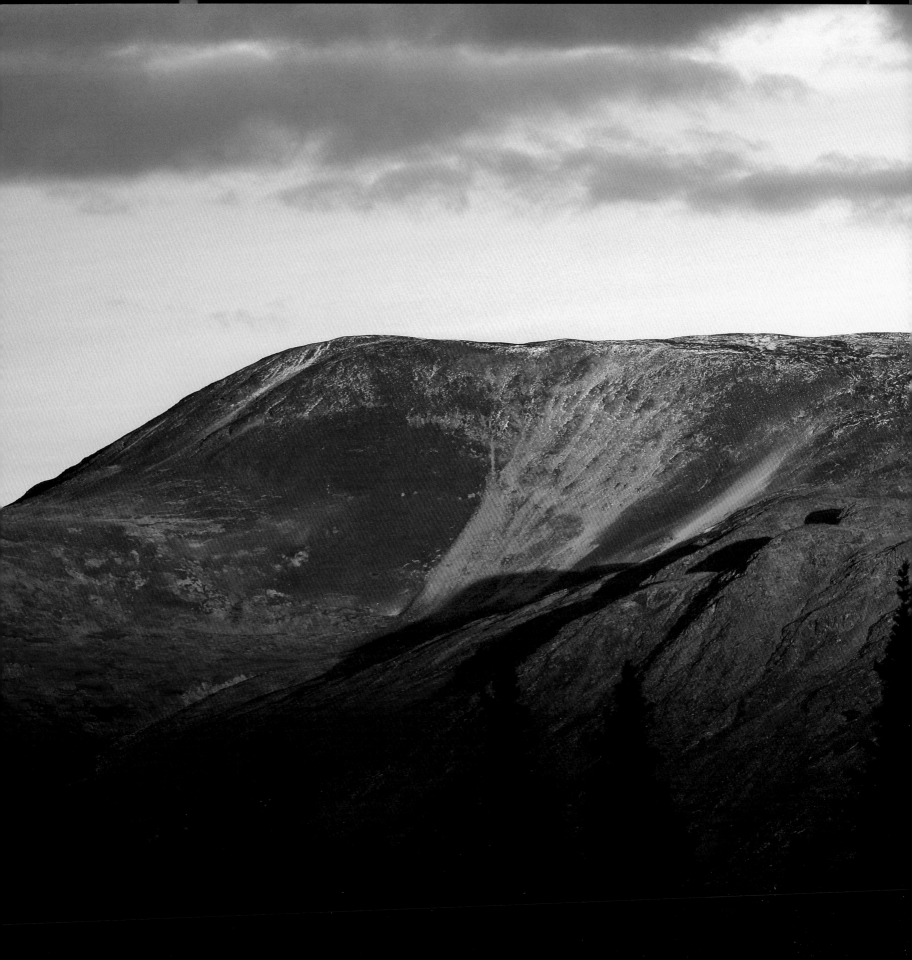

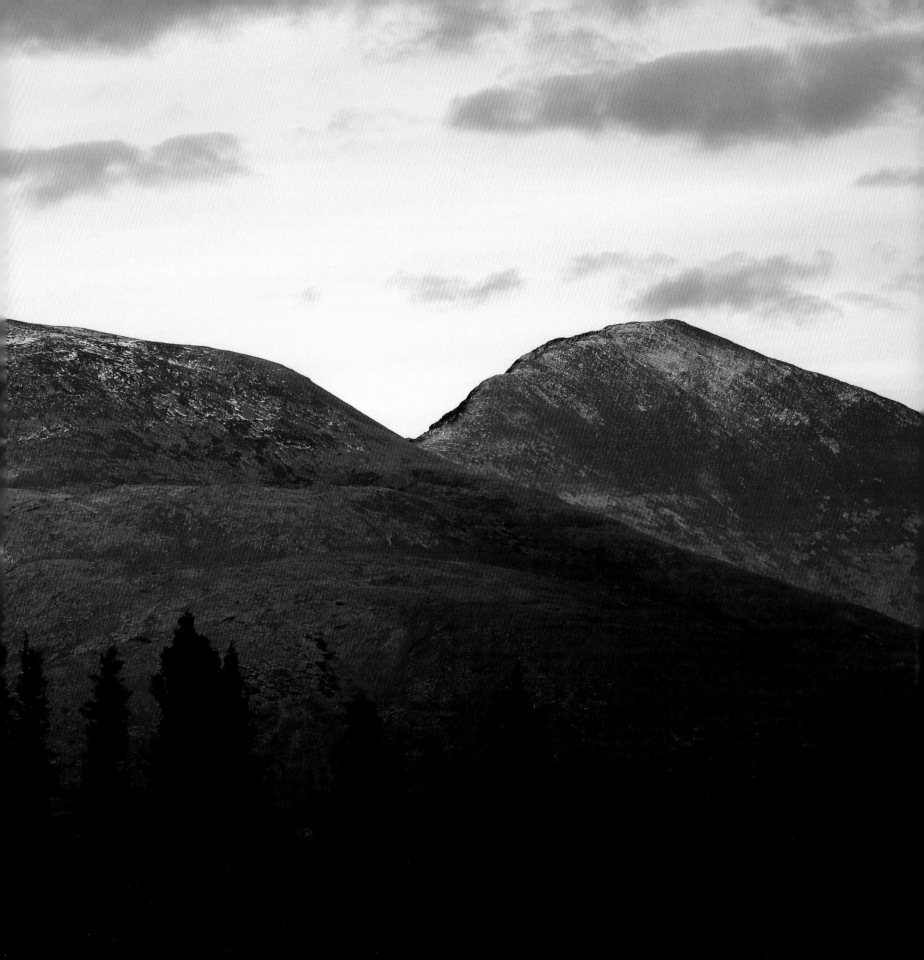

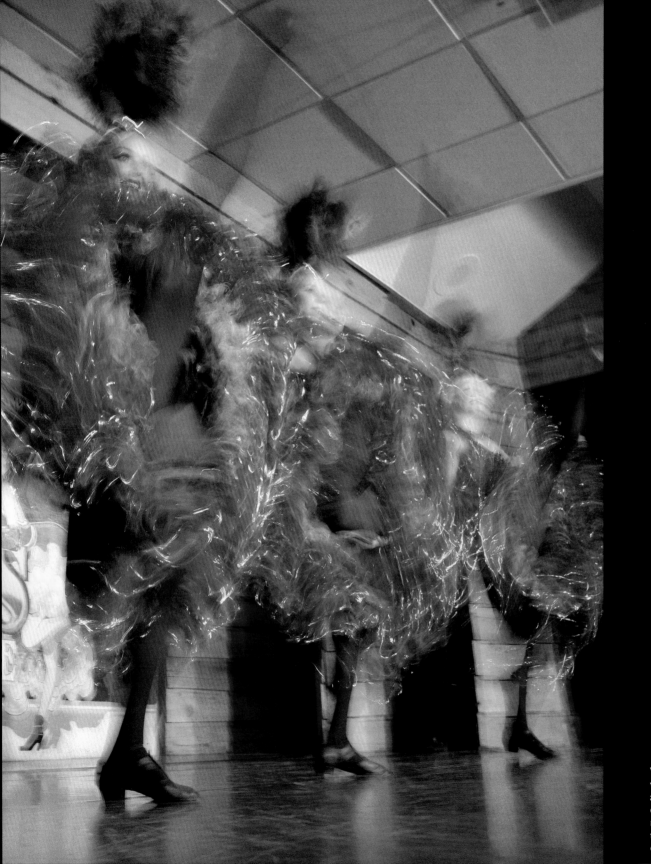

Women of the Gold Rush filled various roles, with dance-hall girls aiming for their fortune in the entertainment business. After a rousing dance, they would encourage the men to spend their money drinking and gambling.

DAWSON CITY

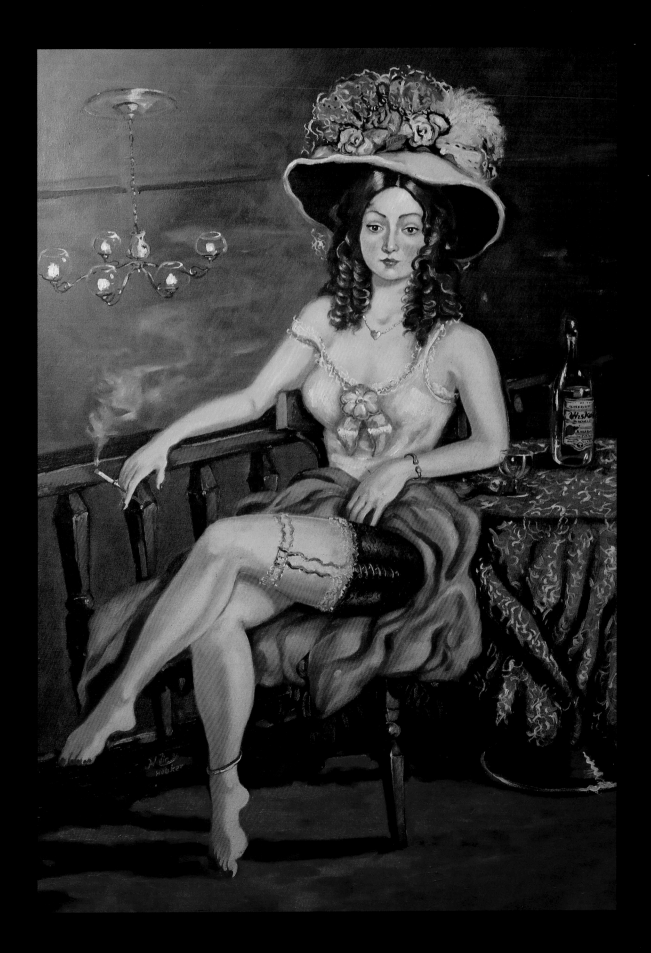

A painting at the Downtown Hotel
celebrates its role in yesterday's frontier
town and today's vitality and excitement.
DAWSON CITY

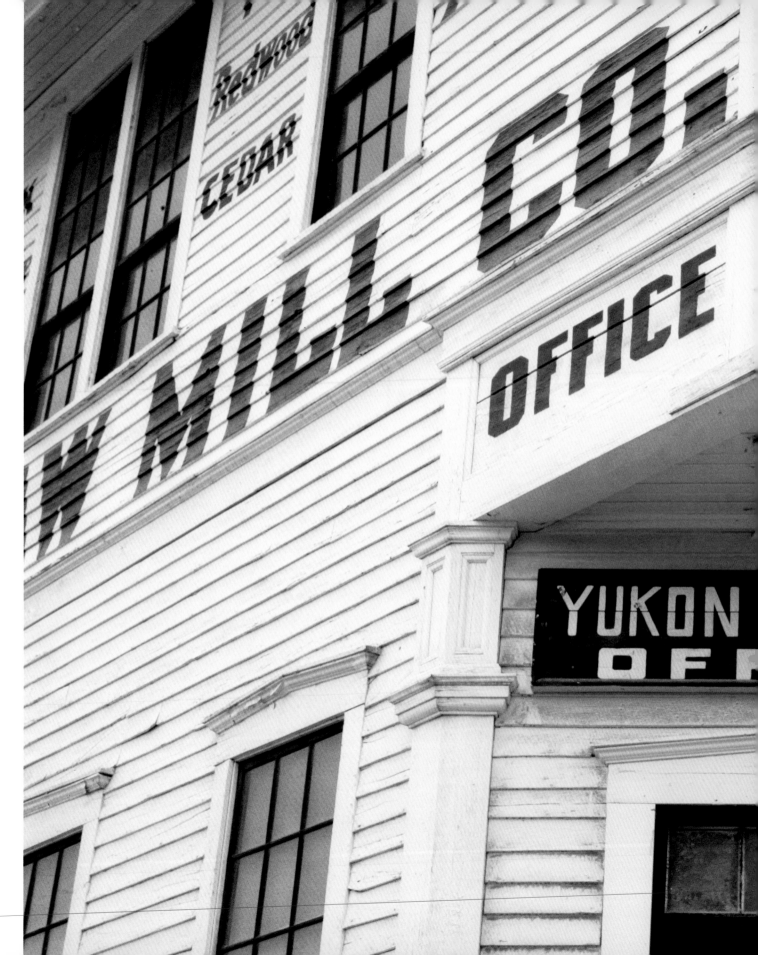

Typical of the wood-frame design of its day, the corner office of the Yukon Sawmill Company is a well-preserved commercial building. It had been part of a seven-sawmill complex in the booming economy of the Klondike Gold Rush.

DAWSON CITY

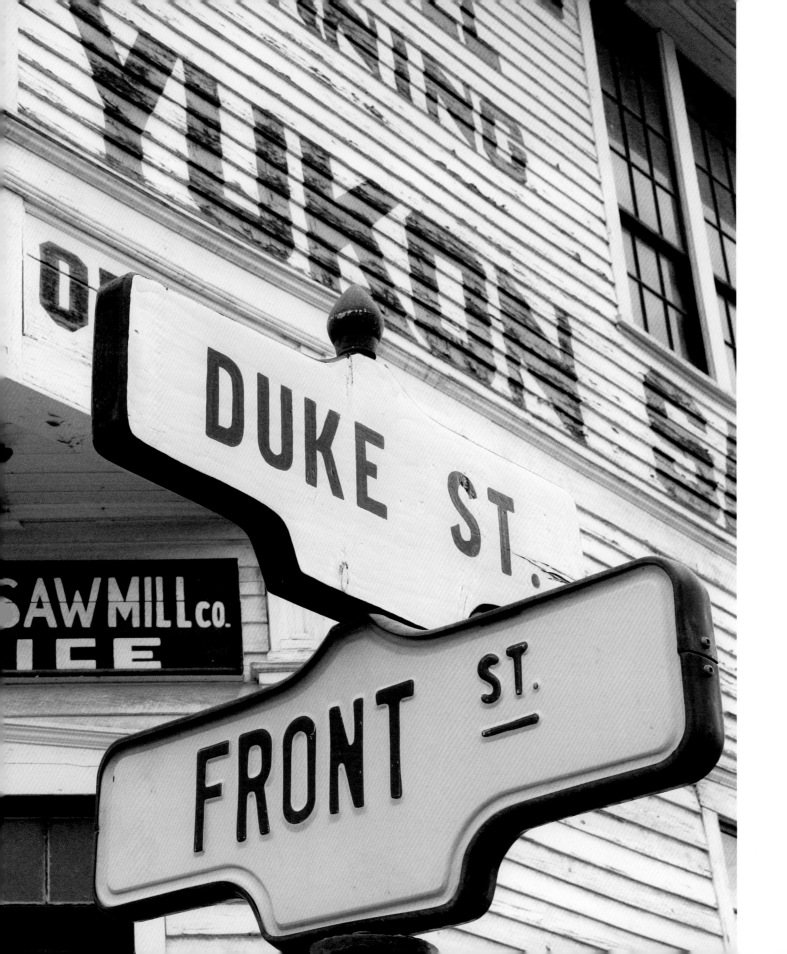

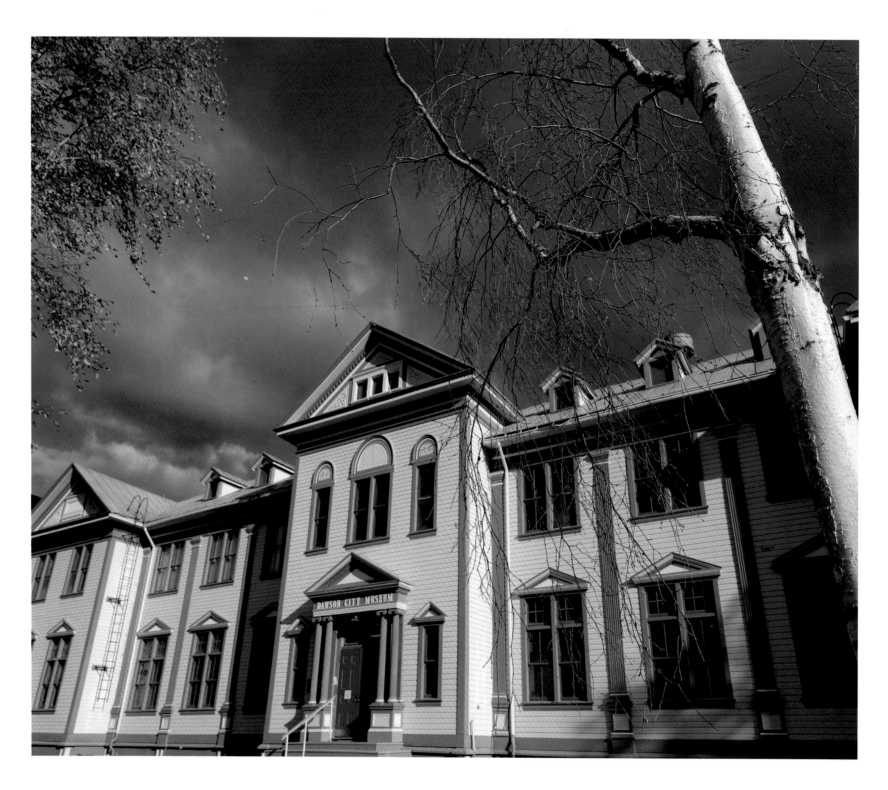

From First Nations culture to the Klondike boom, and geology to exploration, the
Dawson City Museum houses an impressive historical and archival collection.
DAWSON CITY

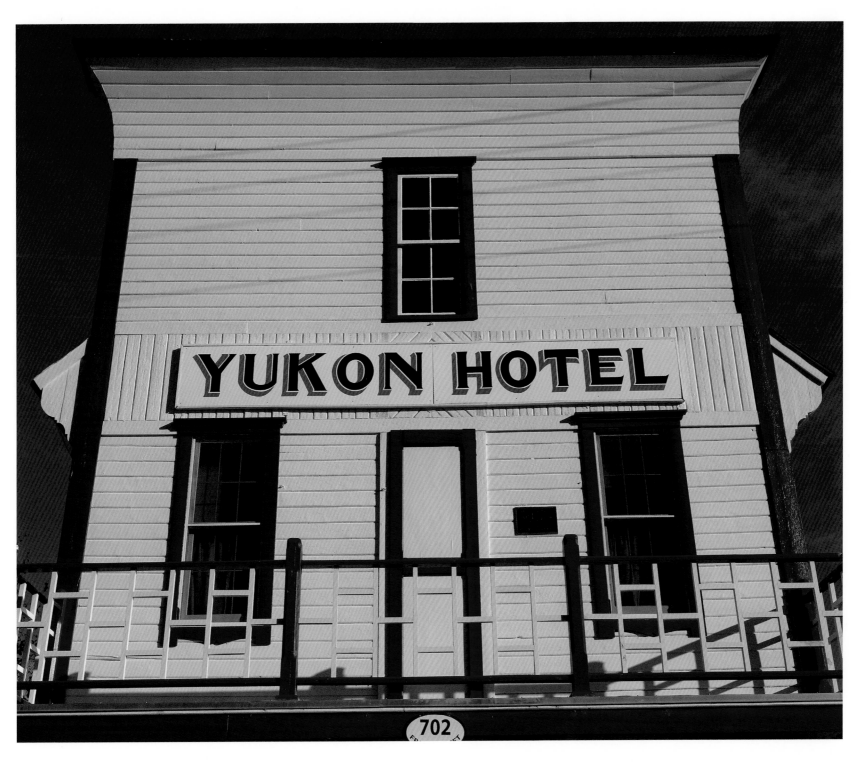

Refurbished to its original glory, the Yukon Hotel is part of the Dawson Historical Complex. Built in 1898, it went through many owners and industry changes. The main structure comprises logs and mud while the front façade is lumber, which at the time was in short supply.
DAWSON CITY

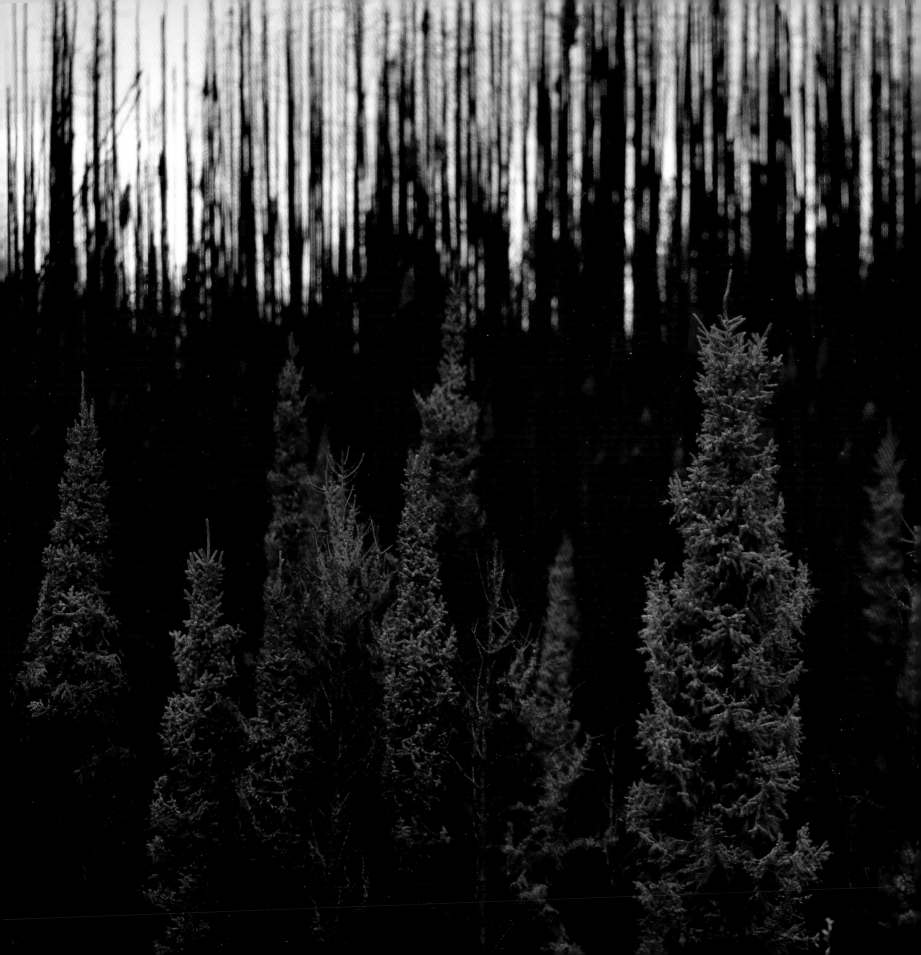

Hot, dry weather and lightning strikes are a fire hazard in densely forested areas along the Robert Campbell Highway. Surprisingly, fires do have some benefits: soil nourishment, underbrush cleanup and pest destruction. Canada has about 8000 wildfires a year.
ALONG ROBERT CAMPBELL HIGHWAY, YUKON HIGHWAY 4

It's always further than it looks.
It's always taller than it looks.
And it's always harder than it looks.

[*The Three Rules Of Mountaineering*]

A chilling view of Mount Logan, the highest peak
in Canada and second-highest in North America
behind Denali. The elevation is 5959 m but, due to
tectonic uplifting, it is still rising.
KLUANE NATIONAL PARK AND RESERVE,
SOUTHWEST YUKON

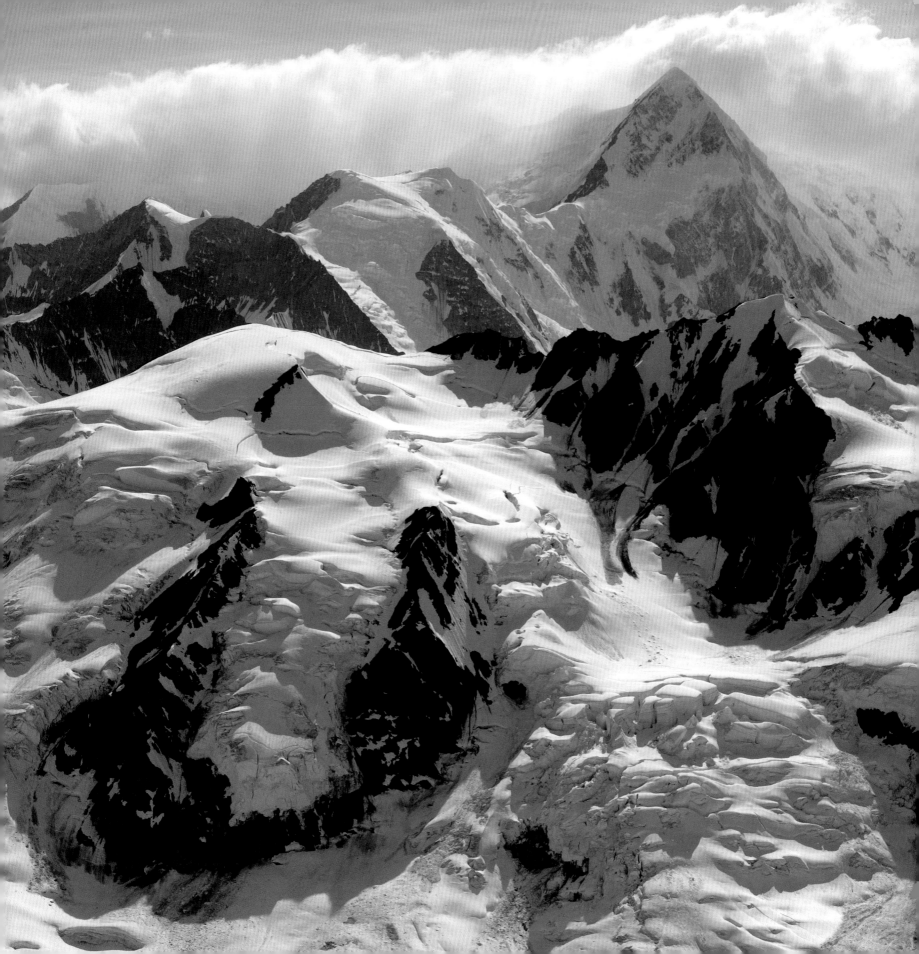

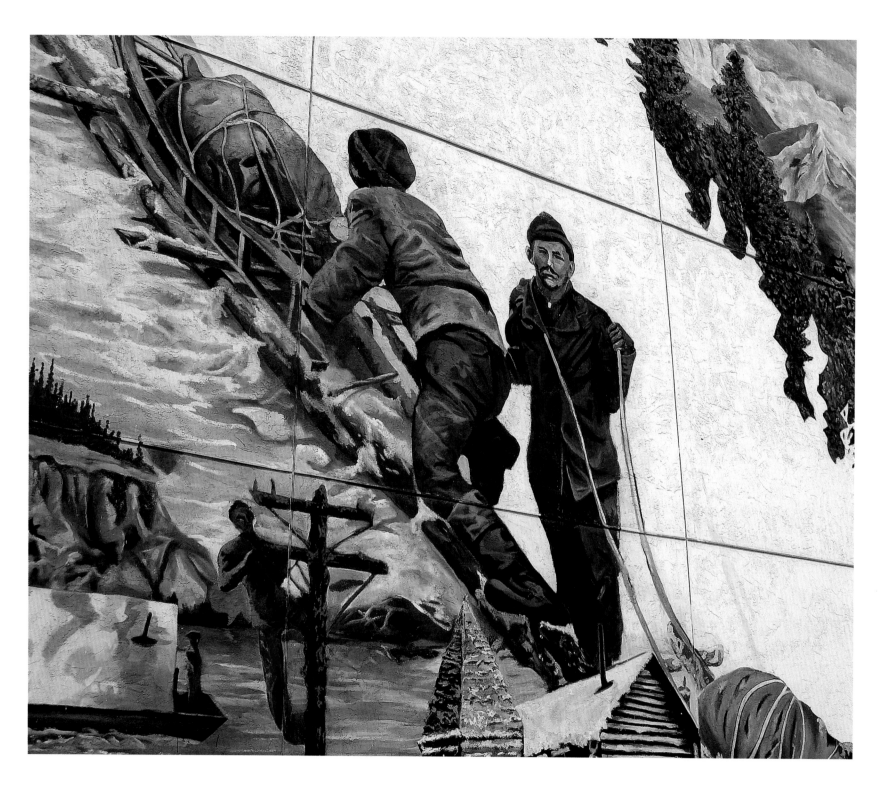

On the parking lot wall of NorthwesTel's office, Lance Burton and artists from the
Youth of Today Society recount a story about pioneers settling the Yukon.
WHITEHORSE

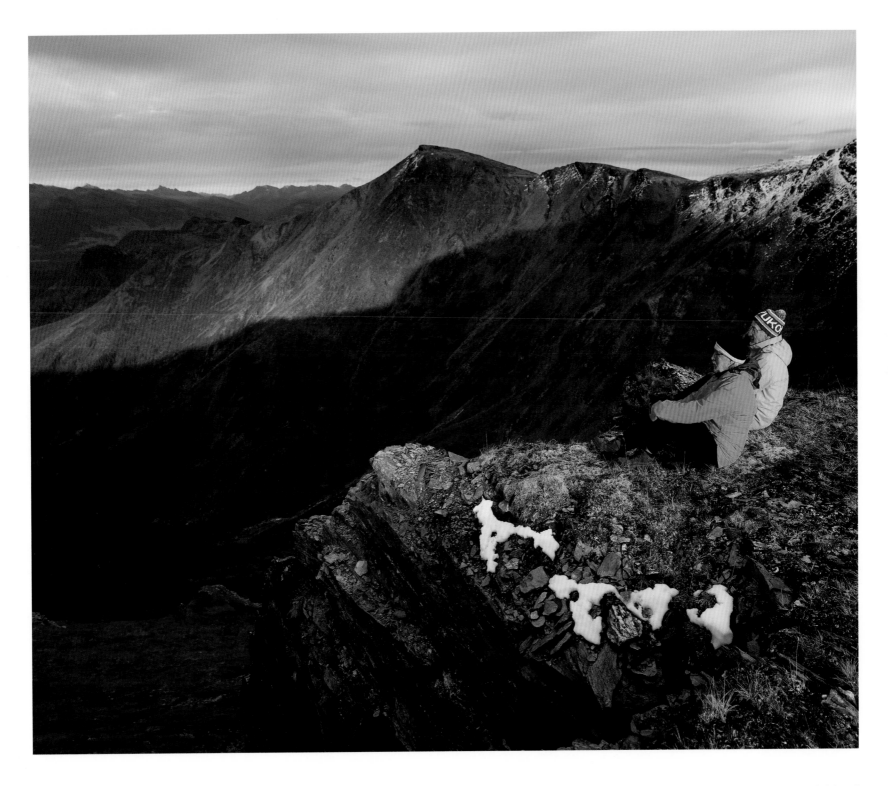

A few trails take explorers to the top of Keno Hill. The Gambler Gulch trail
yields magnificent views over Faro and Gambler Gulch.
NEAR KENO CITY

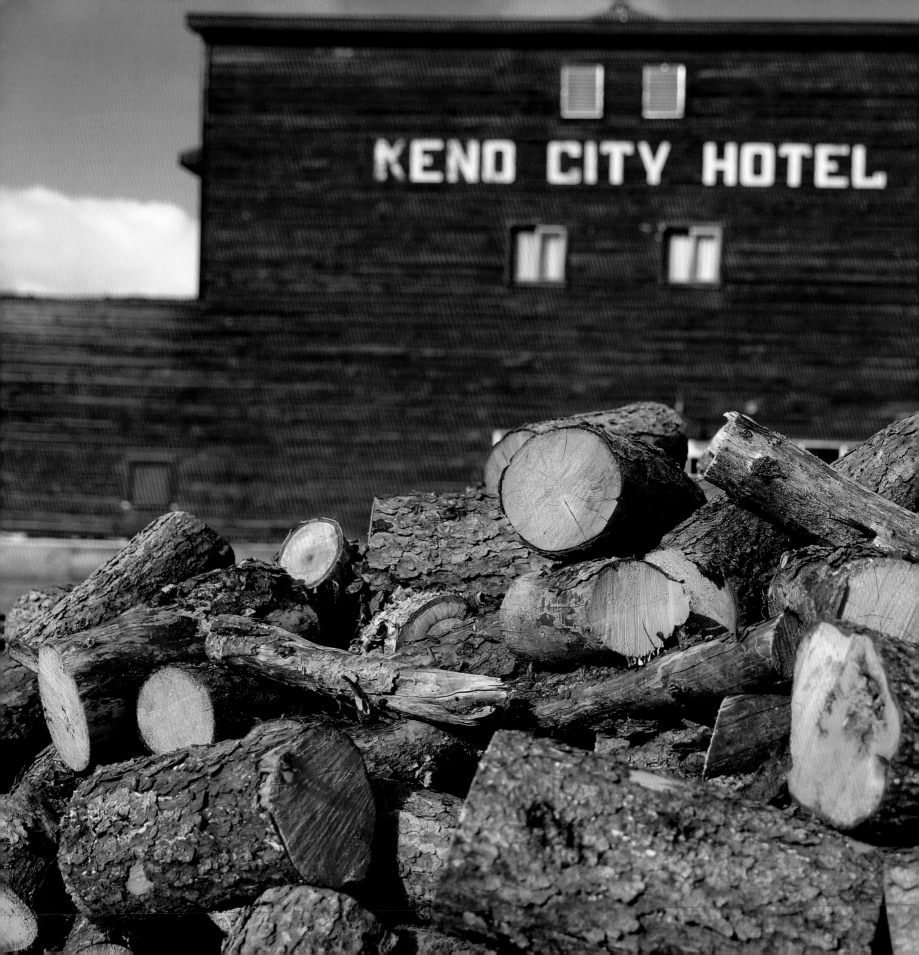

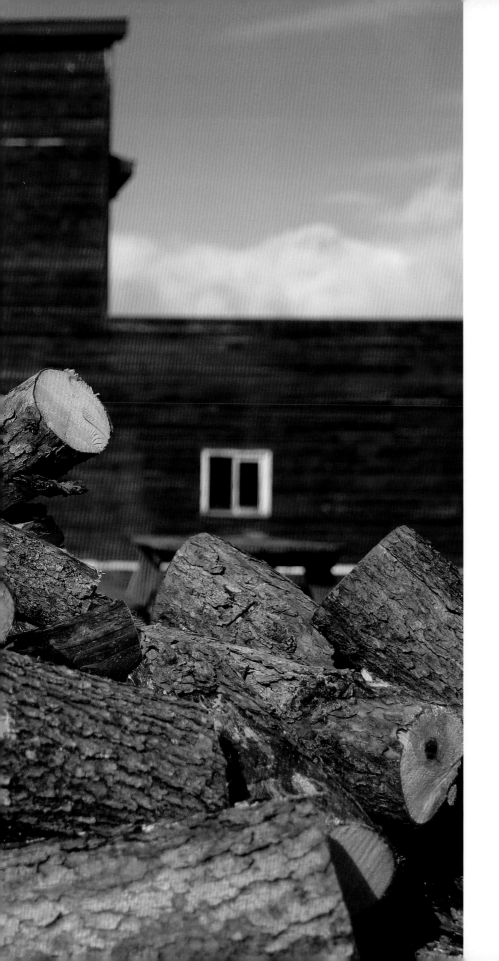

Logs are cut and tossed behind the Keno City Hotel, one of two bars in a town with a population of 20. Named after the casino game, it was once a boom town for gold and silver prospectors.
KENO CITY

A modern-day cowboy meandering past timber storefronts and saloons evokes the Wild West. Wistful visitors can pan for gold before taking in games of chance and a nightly revue.

DAWSON CITY

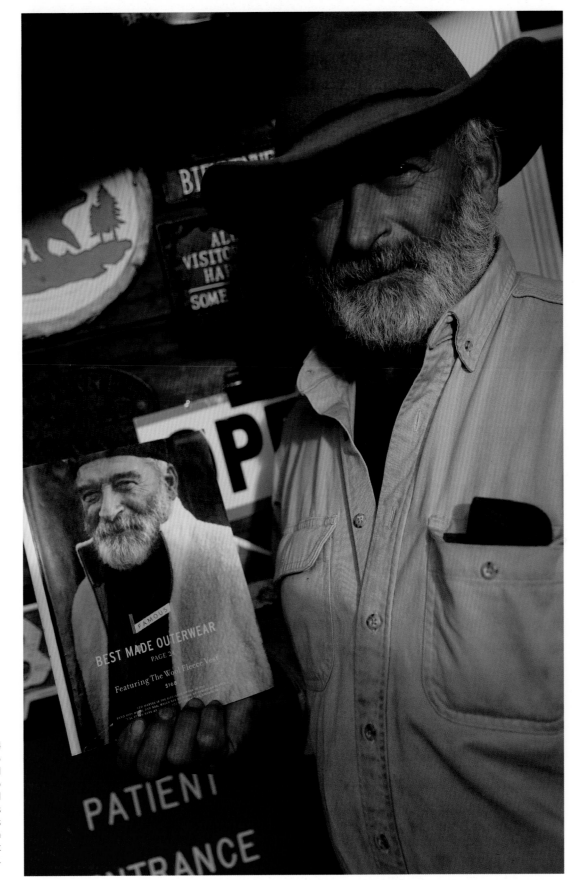

Passionate hotelier and self-made historian Leo Martel is rebuilding and preserving the 1920 Keno City Hotel. The Silver Trail that once brought miners now transports visitors eager to embark on adventure and learn about the intriguing history.
KENO CITY

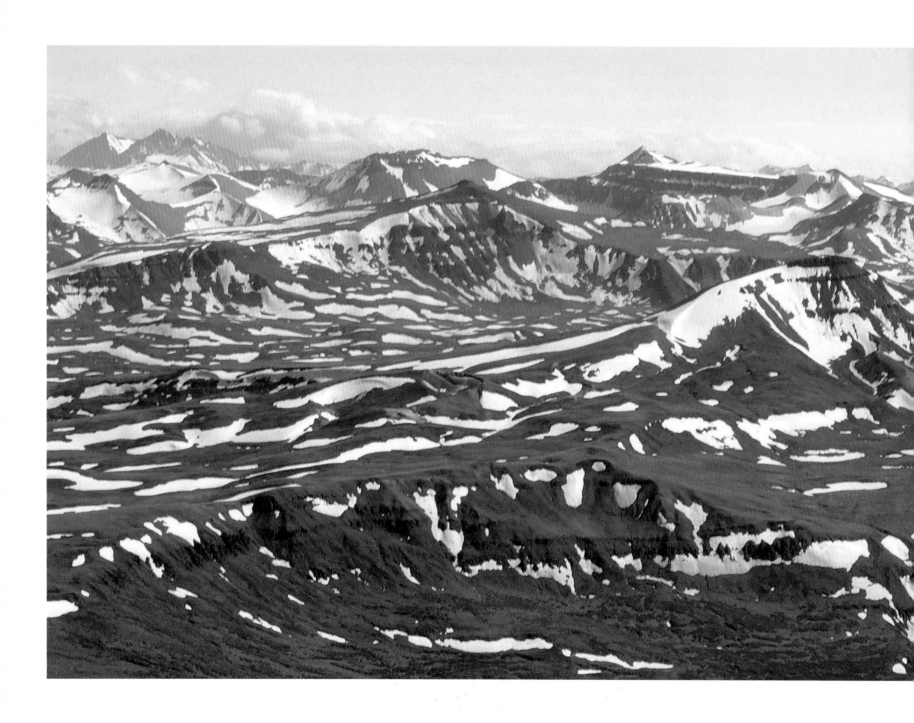

Patches of snow streak the St. Elias mountain range. Mount St. Elias is the second-highest peak in Canada at 5489 m. It was first summited in 1897 by an Italian party – the fourth attempt by various climbers.

KLUANE NATIONAL PARK AND RESERVE, SOUTHWEST YUKON

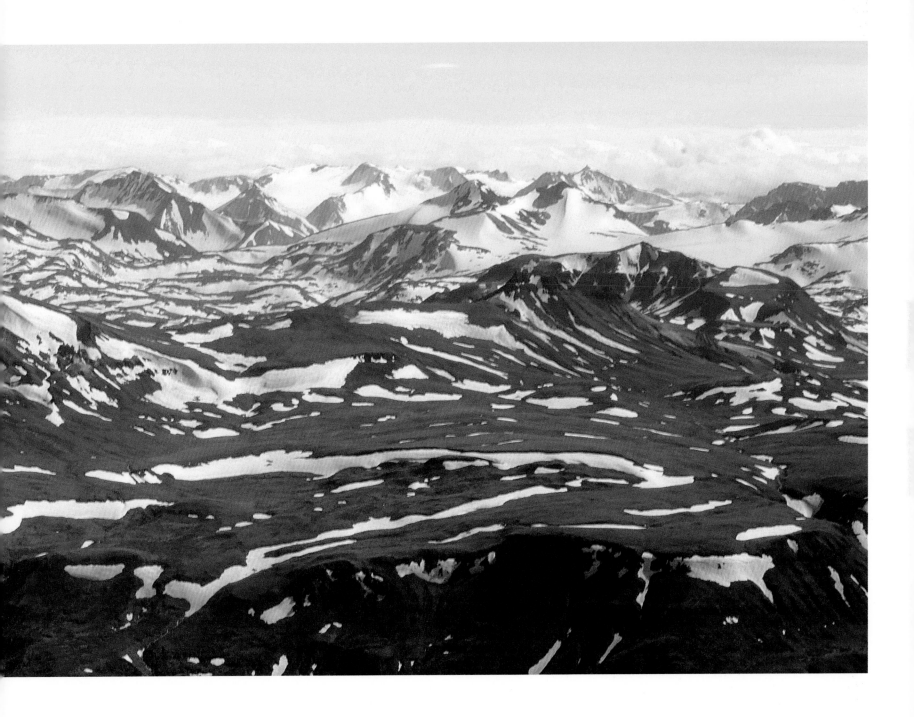

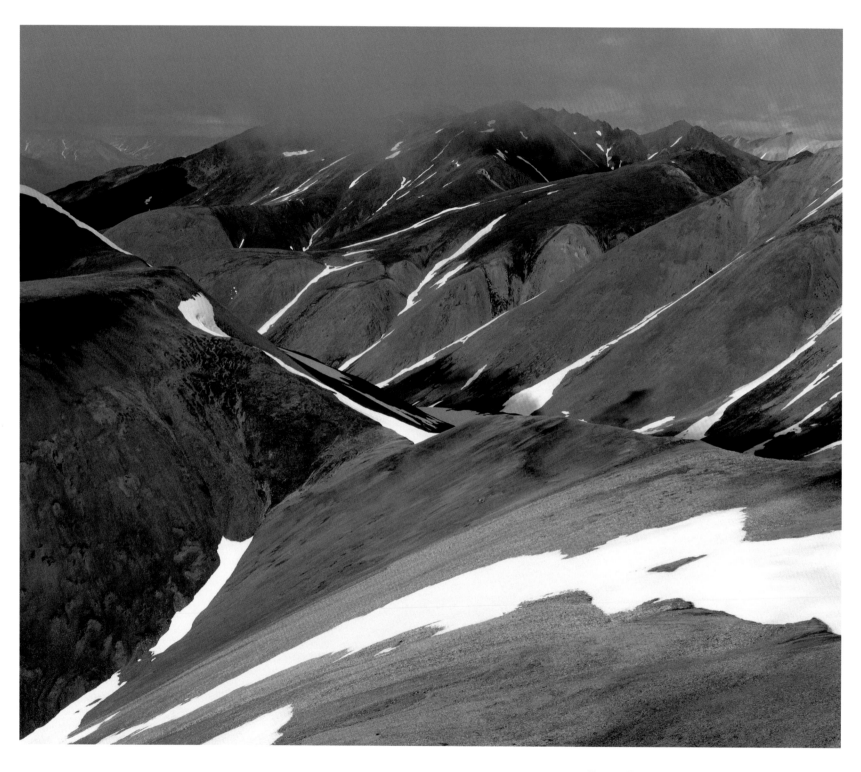

A vast wilderness with trails for the intrepid, the Kluane National Park and Reserve is also part of the traditional lands of the Kluane, Champagne and Aishihik First Nations.

KLUANE NATIONAL PARK AND RESERVE, SOUTHWEST YUKON

FOLLOWING ∘ Sheer cliffs impart a sense of grandeur. When in 1972 the Dempster Highway was being conceived, planners deemed the surrounding park an area to be protected.

TOMBSTONE TERRITORIAL PARK, CENTRAL YUKON

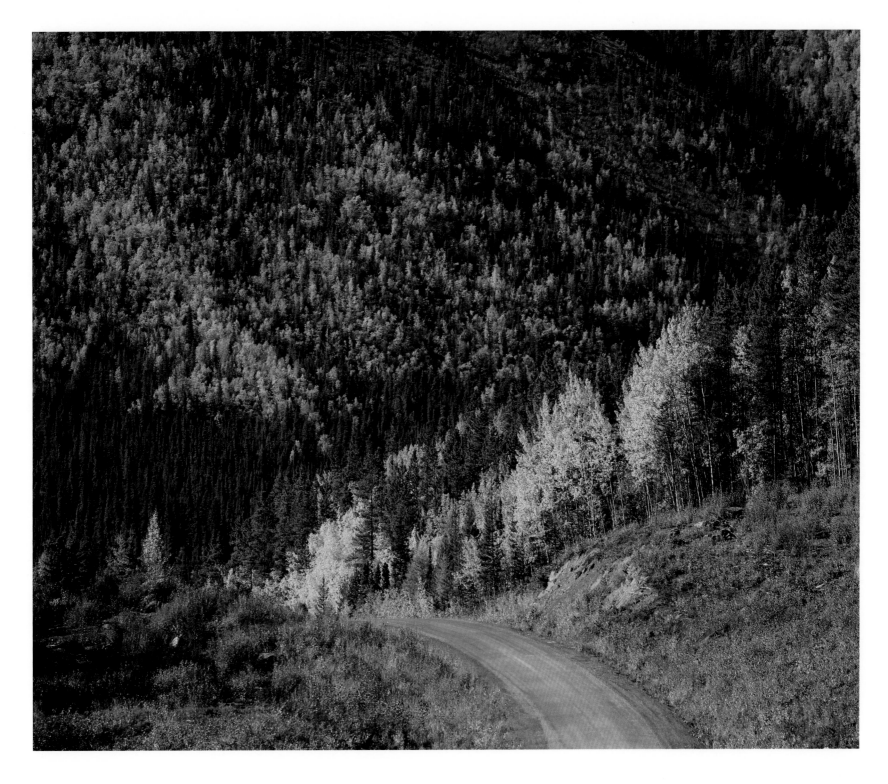

Colourful tones layer the scenery around every bend along
the Robert Campbell Highway.
NEAR FARO

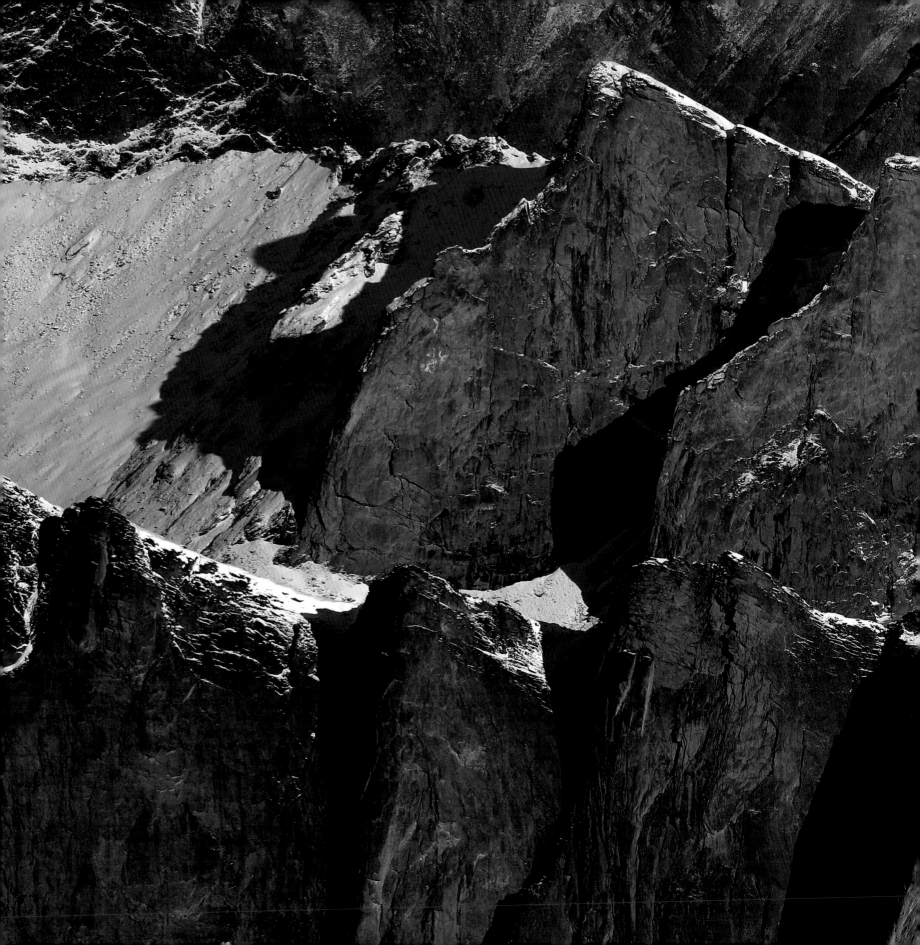

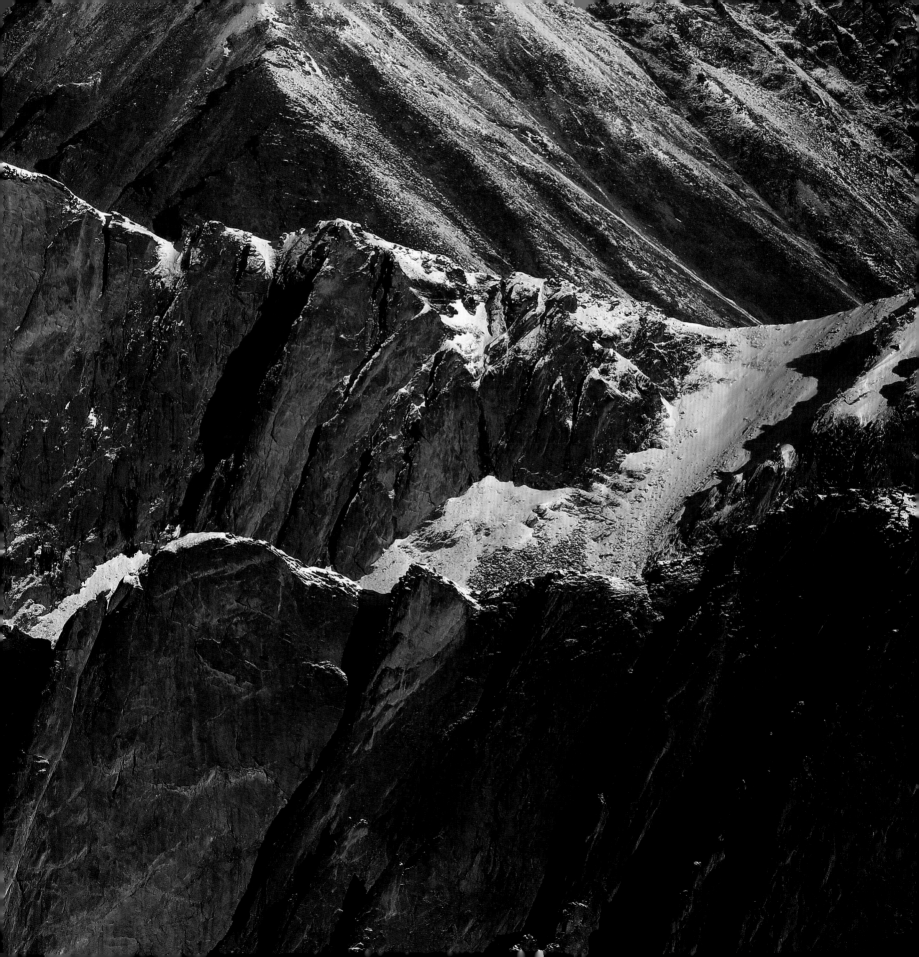

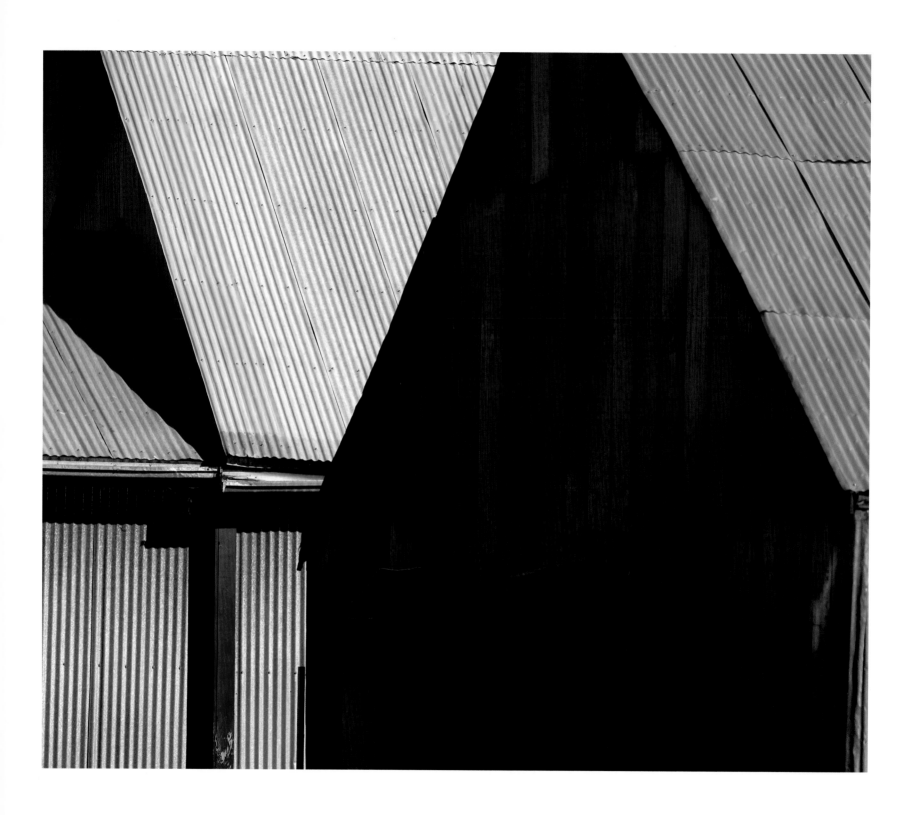

Pitched roofs of corrugated metal sport an interesting texture.
DAWSON CITY

This detail from a healing totem created by 20 carvers, including master carver Wayne Price, speaks to the healing process for former First Nations residential school children. It was erected in 2012 in the heart of the city.
WHITEHORSE

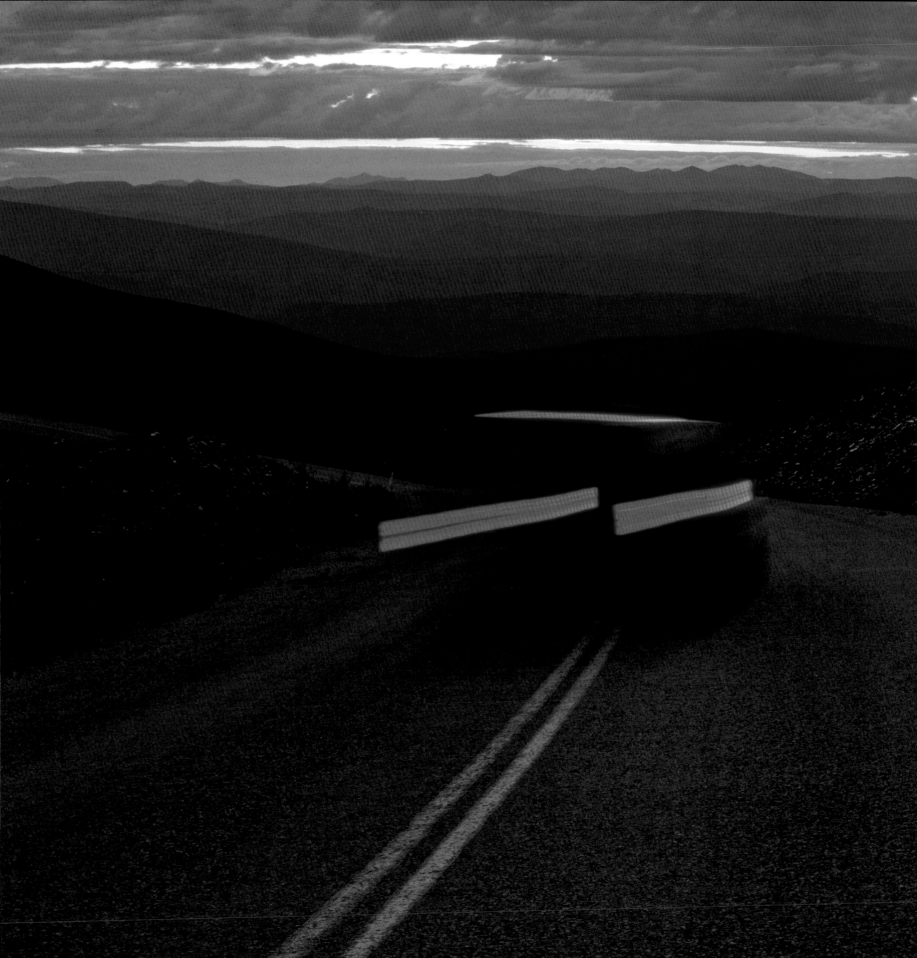

A nocturnal drive along the Top of the World
Highway looks over the Ogilvie Mountains, a part of
the North American Cordilleras.
**ALONG THE TOP OF THE WORLD
HIGHWAY, YUKON HIGHWAY 9**

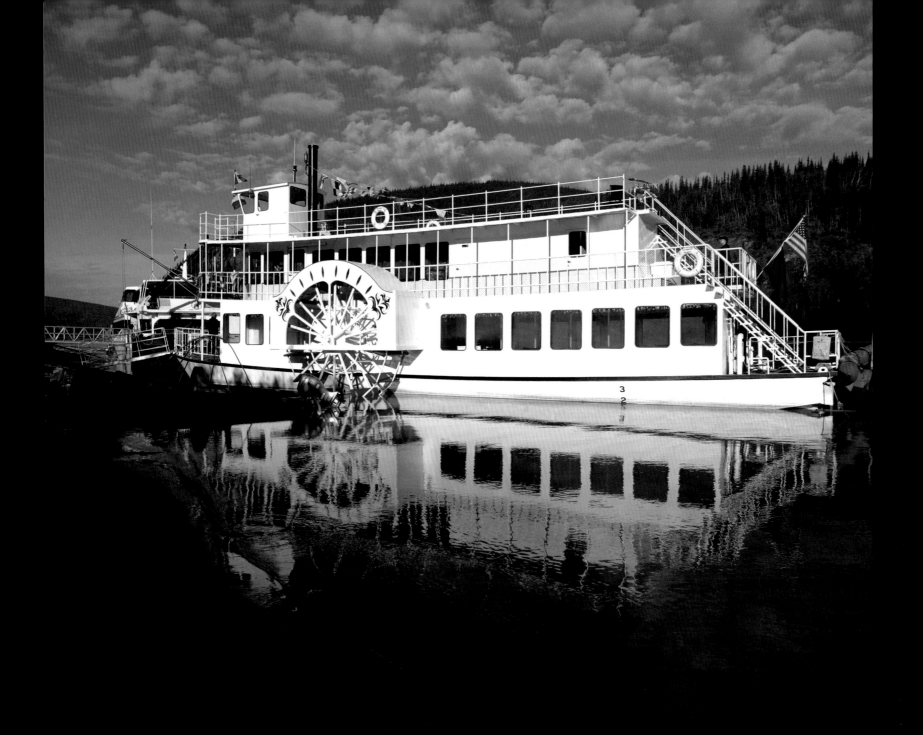

Christened in 2006, *Klondike Sprit* is a lovely reproduction of an historic paddlewheeler. Building the 27-metre vessel was a four-year labour of love for Nick Turner and Charlie House.
DAWSON CITY

Rivers know this: there is no hurry. We shall get there someday.

[A A Milne]

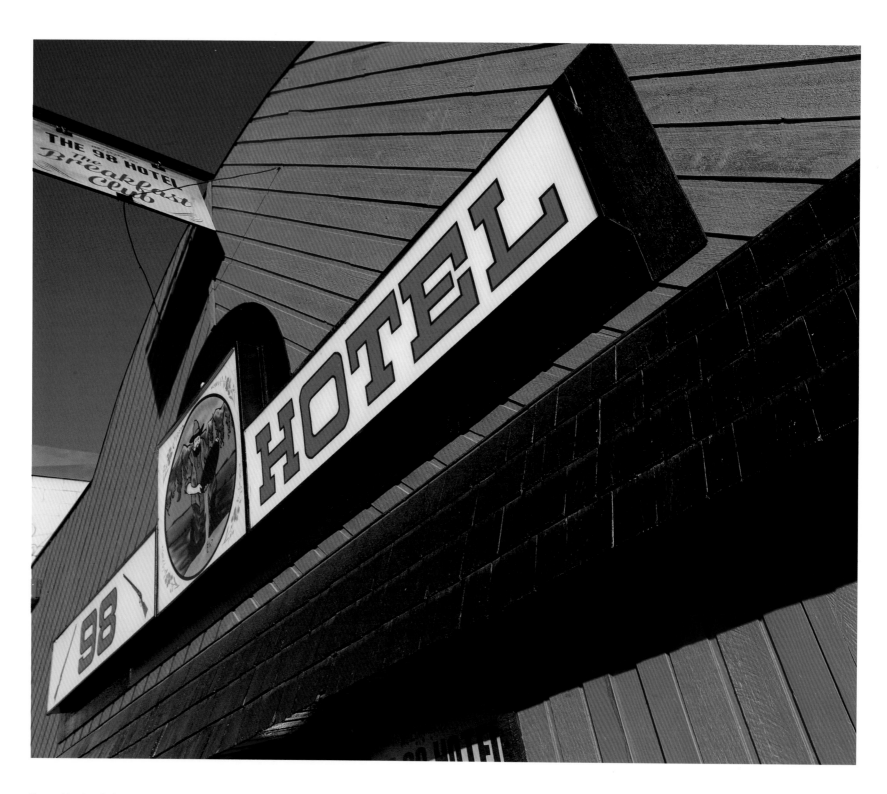

Erected in the 1940s, the 98 Hotel exudes the essence of a genuine old-time
establishment. The style of the wooden front recalls Klondike days.
WHITEHORSE

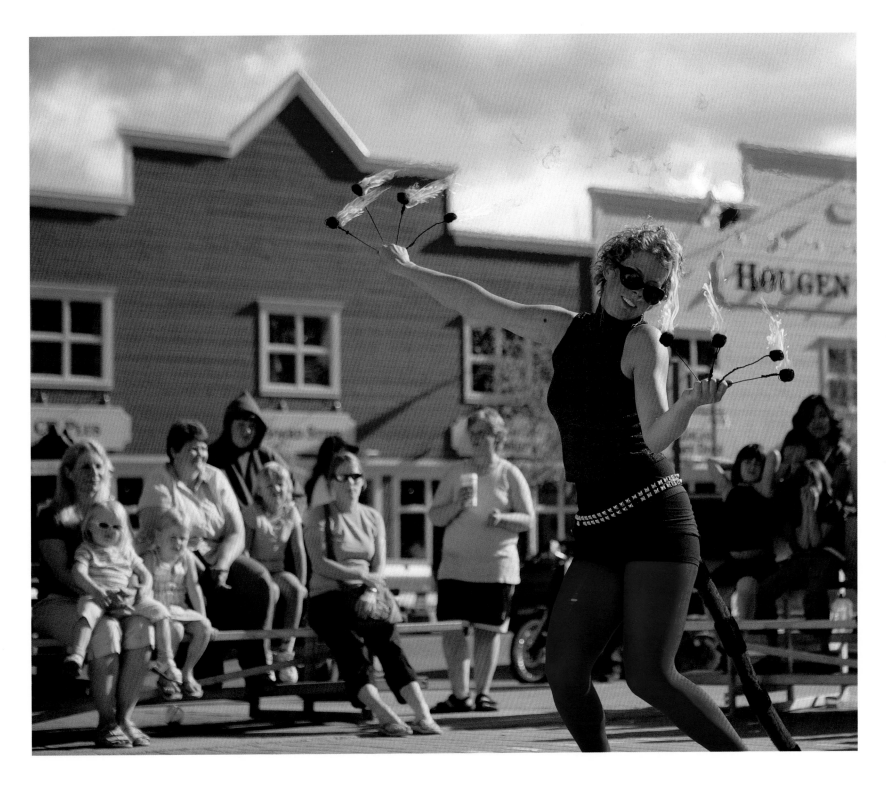

Summer solstice – the onset of summer and the longest day of the year – is celebrated joyfully on Main Street.
WHITEHORSE

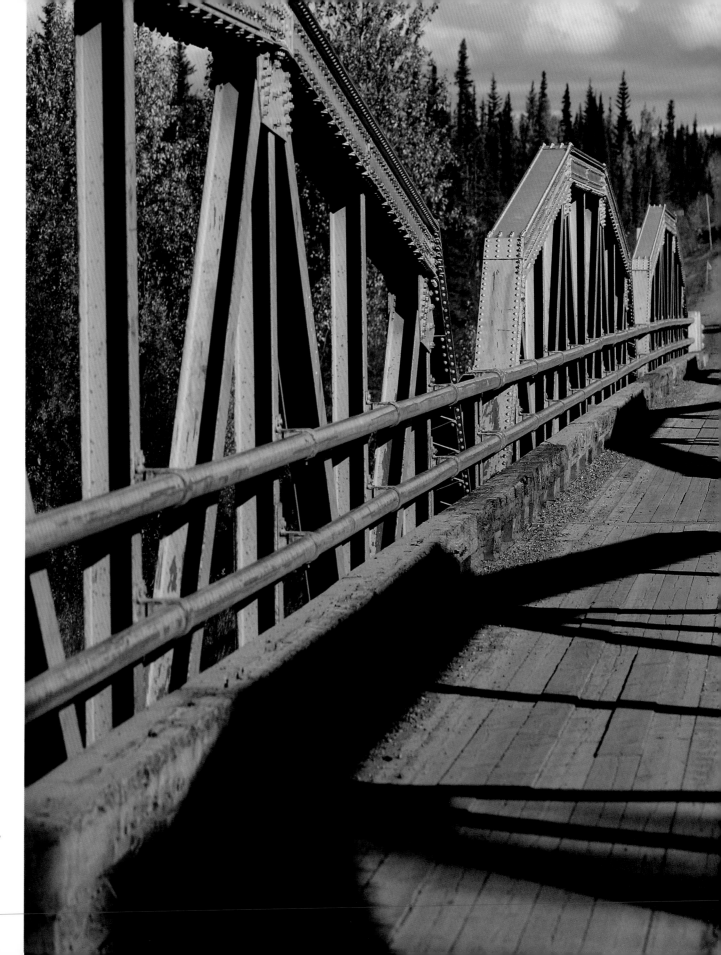

Travellers on the Dempster Highway, then Prime Minister Diefenbaker's "vision of the North," start by crossing the one-lane Klondike River bridge near Dawson City.

DEMPSTER HIGHWAY KM 0.3, YUKON HIGHWAY 5

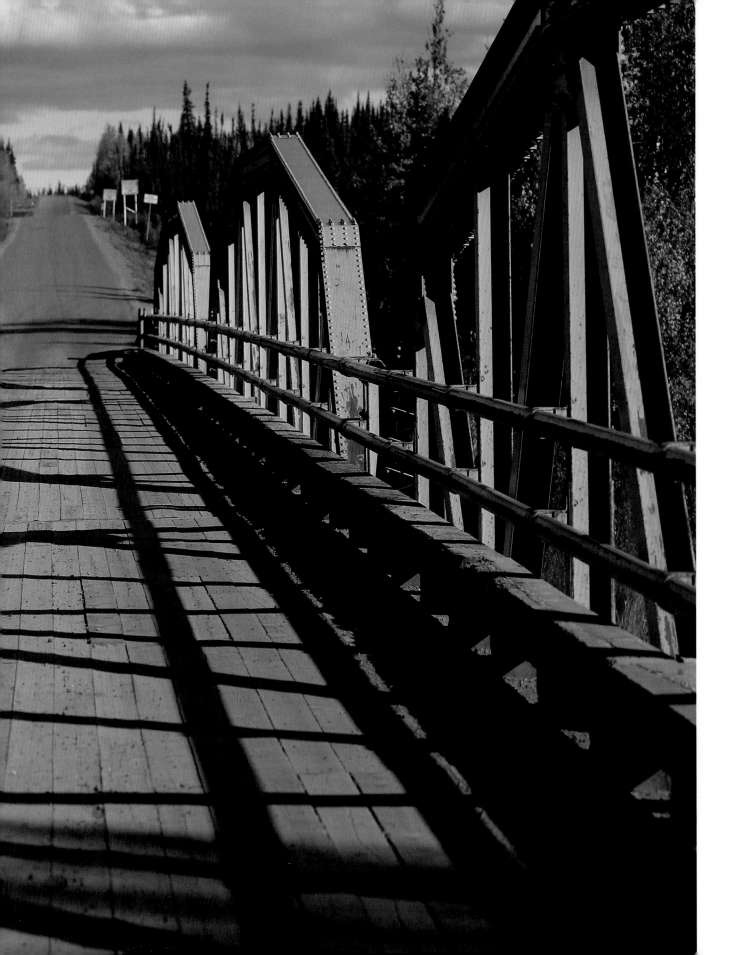

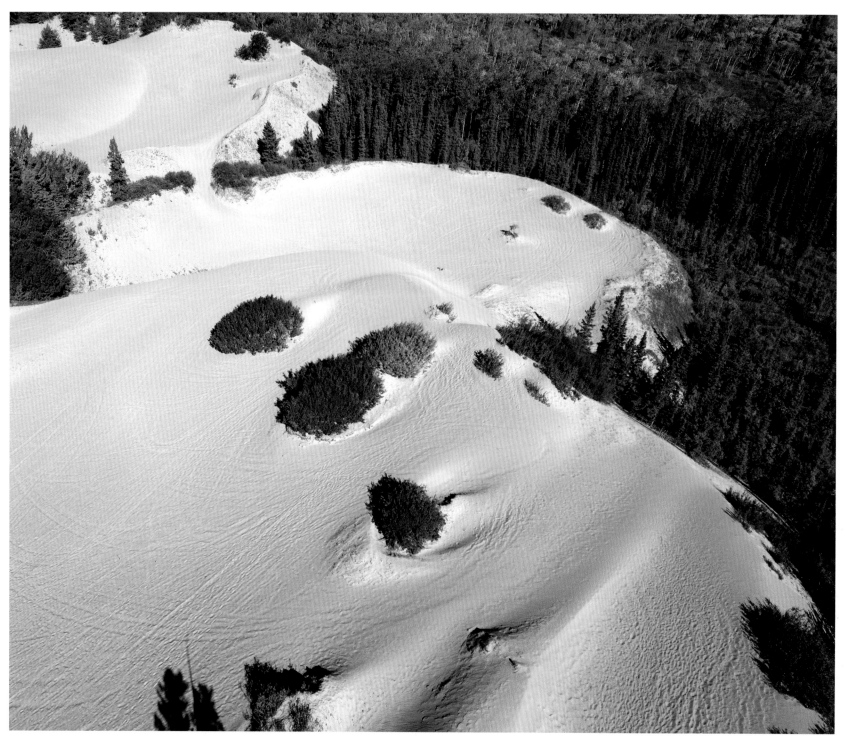

The dunes of Carcross Desert are surrounded by mountains that create a rain shadow that limits annual precipitation to less than 50 cm per year. Plant species not common to the area find the arid conditions ideal, although it is too humid to be technically considered a desert.

CARCROSS

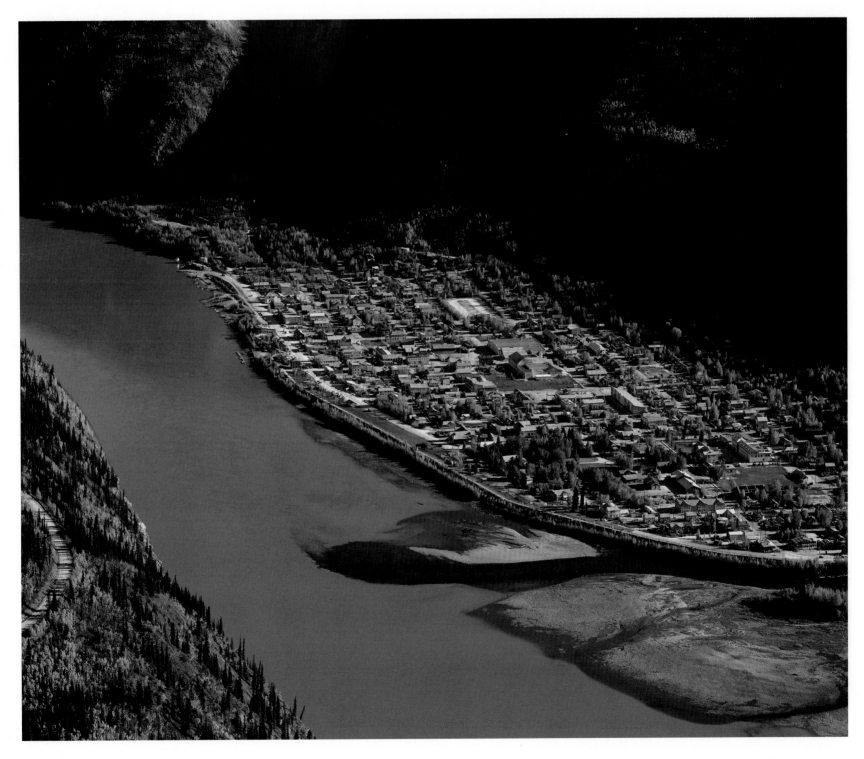

Sightseeing trails loop around the slopes surrounding Dawson City for a good birds-eye view. The area still has some operating mines and many placer claims (the right to mine loose material on public land).
DAWSON CITY

Descended from a herd in Alberta, Yukon elk follow receding snow on south-facing slopes to take advantage of vegetation as it pops up. As winter approaches, they move to more forested areas for shelter.
NEAR CHAMPAGNE LANDING

FOLLOWING ◦ Mostly undeveloped, the Ibex Valley is a pristine wilderness framed by Ibex Mountain and mounts Arkell, Ingram, Sumanik and Williams.
IBEX VALLEY

Dempster Highway dust alludes to good stories for those with wanderlust.
DAWSON CITY

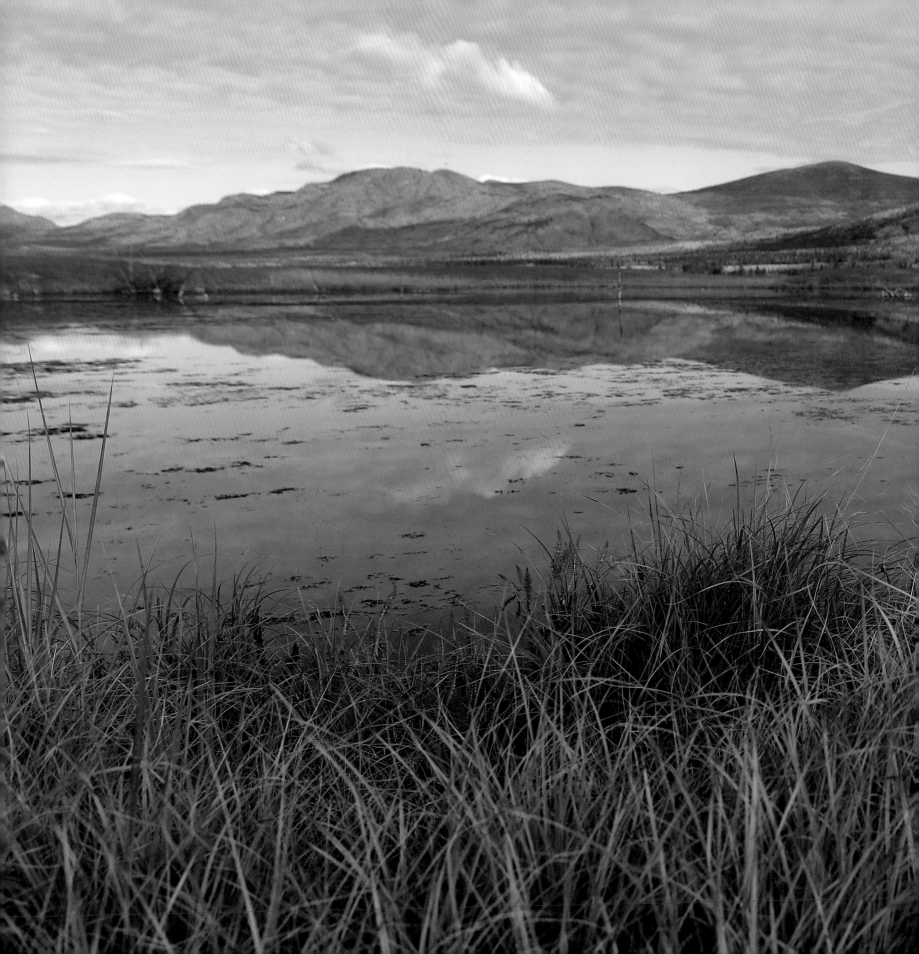

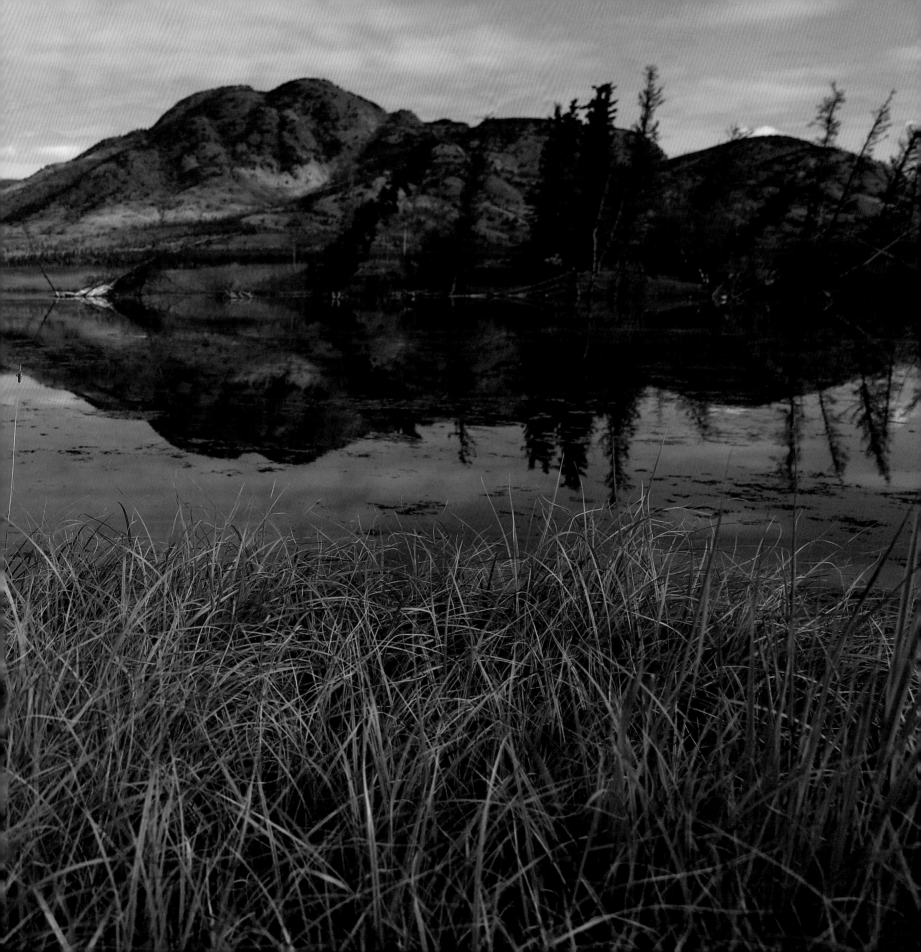

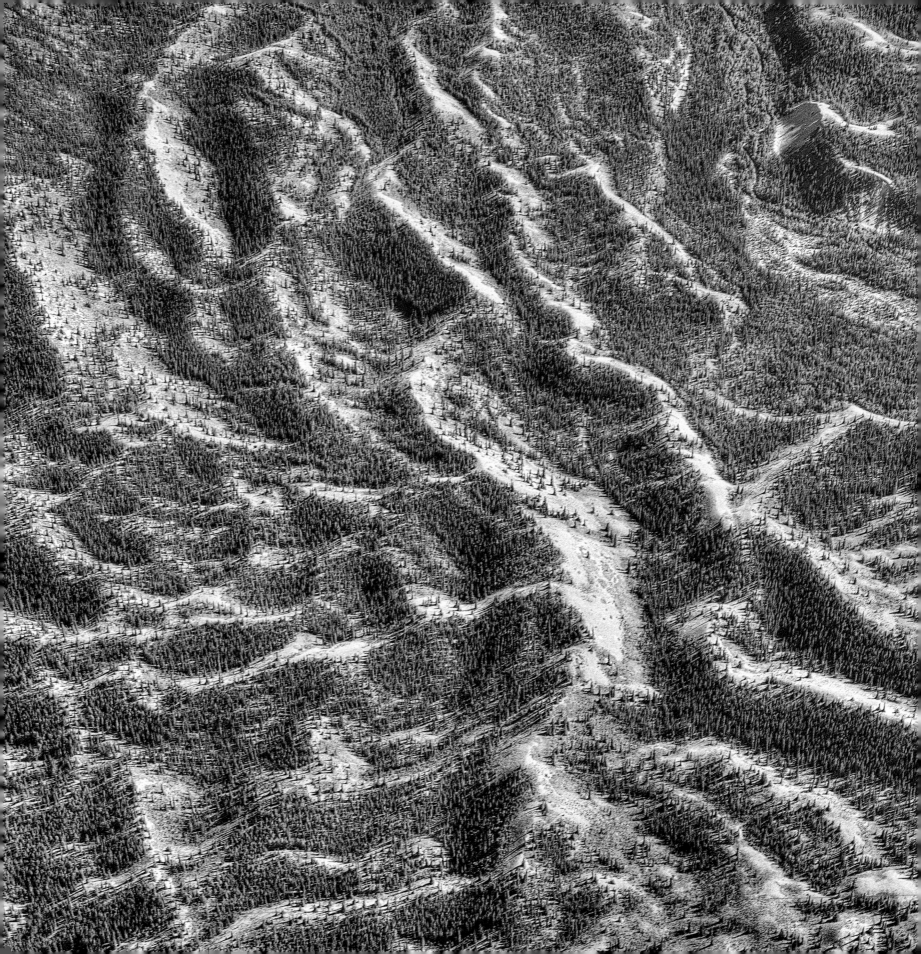

Great things are done when men and mountains meet; This is not done by jostling in the street.

[William Blake]

A charter flight over low-lying hills and spruce trees offers contrasting
perspectives. Of the territory's 482,443 km², roughly 281,000 km² is
covered in boreal forest.
KLUANE NATIONAL PARK AND RESERVE, SOUTHWEST YUKON

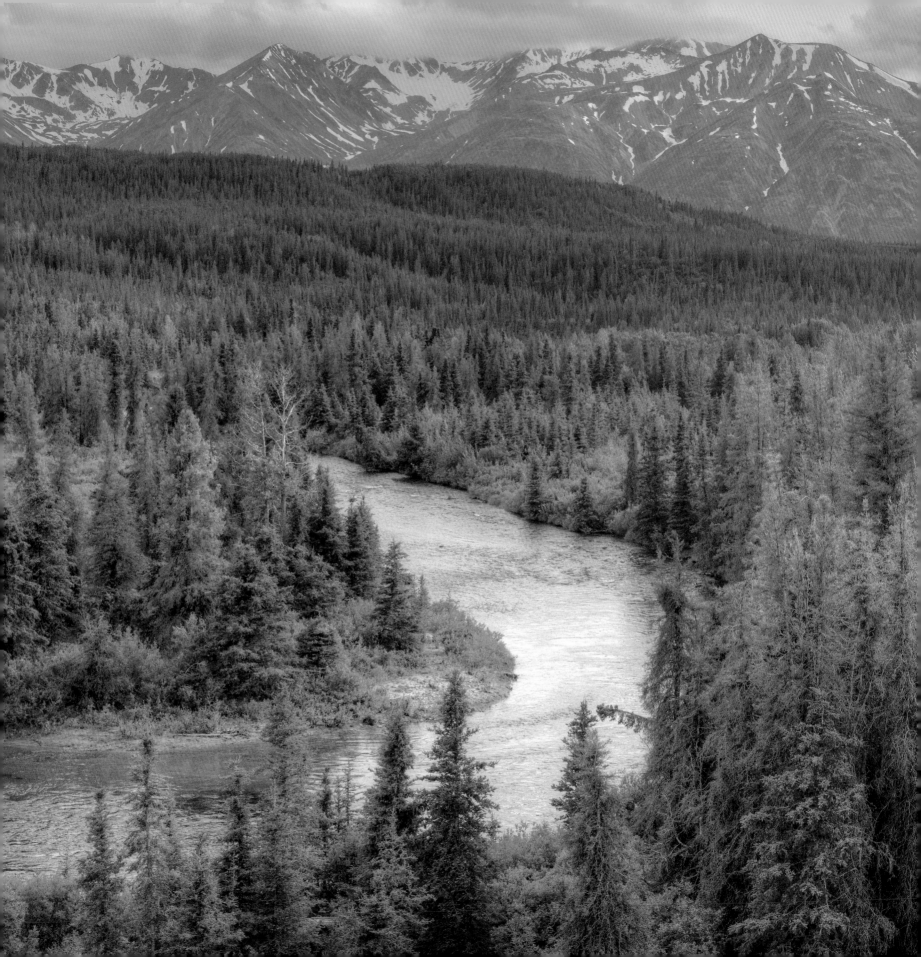

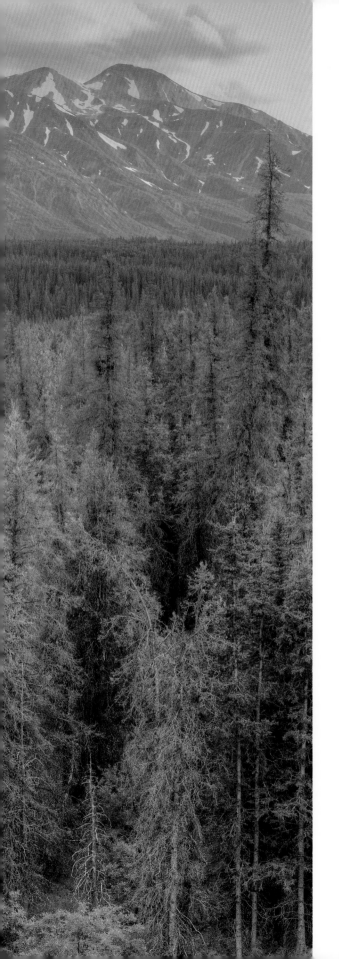

The St. Elias mountain range is a young chain that typically experiences about three earthquakes a day. These upheavals lead to annual rises of some 4 cm, although in an 1899 quake it jumped a record 10 m in two minutes.
KLUANE NATIONAL PARK AND RESERVE, SOUTHWEST YUKON

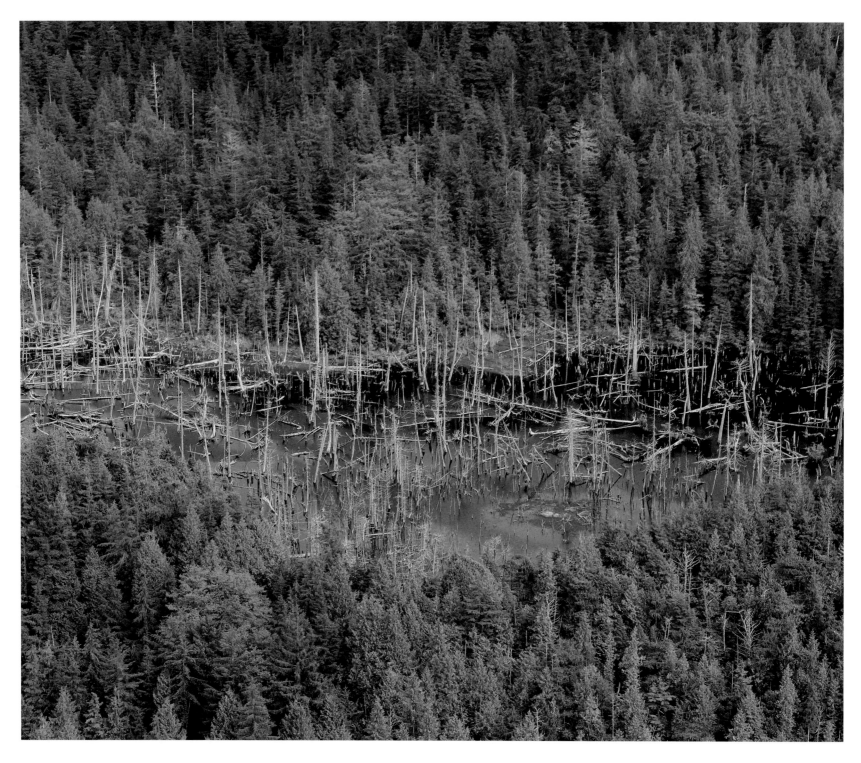

A wildlife habitat presents itself in many forms. Dead or hollow trees are sometimes called "wildlife trees" since their cavities open up spaces for food storage, roosting or denning.

ALONG ROBERT CAMPBELL HIGHWAY, YUKON HIGHWAY 4

FOLLOWING ◦ A more narrow and rustic route, the Robert Campbell Highway winds through thickets and arresting vistas for 583 km. From Watson Lake to Carmacks, the largely gravel track was built in the late 1960s and links to some remote villages.

ALONG ROBERT CAMPBELL HIGHWAY, YUKON HIGHWAY 4

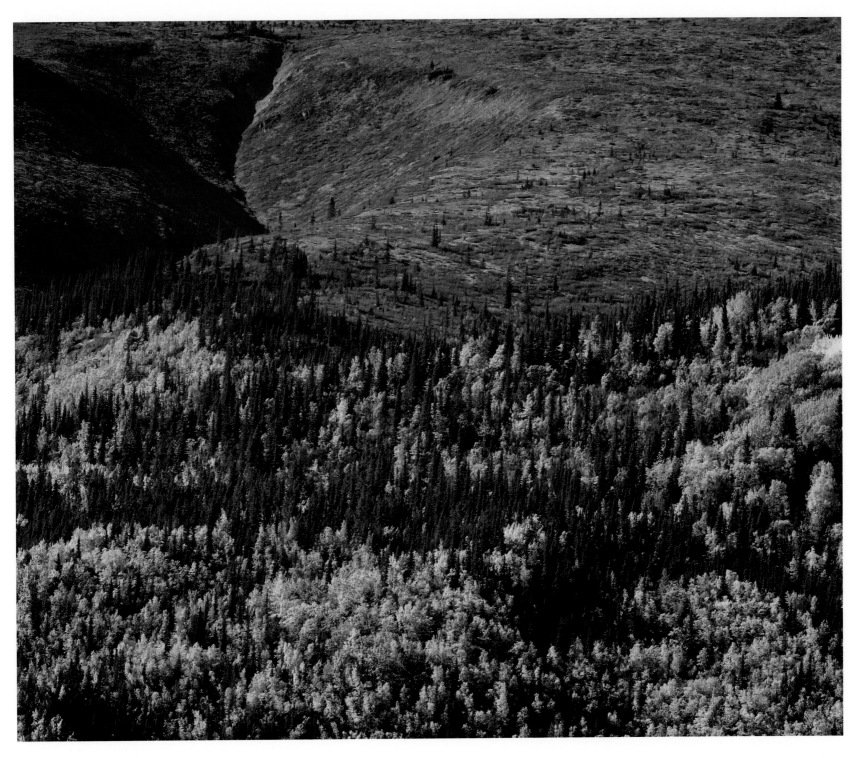

Nature's artistry surrounds travellers on rugged terrain. Classified as the Cordilleran Orogen Geological Region, the territories were born of the collision of large land masses, convergent plates and volcanic activity.
ALONG ROBERT CAMPBELL HIGHWAY, YUKON HIGHWAY 4

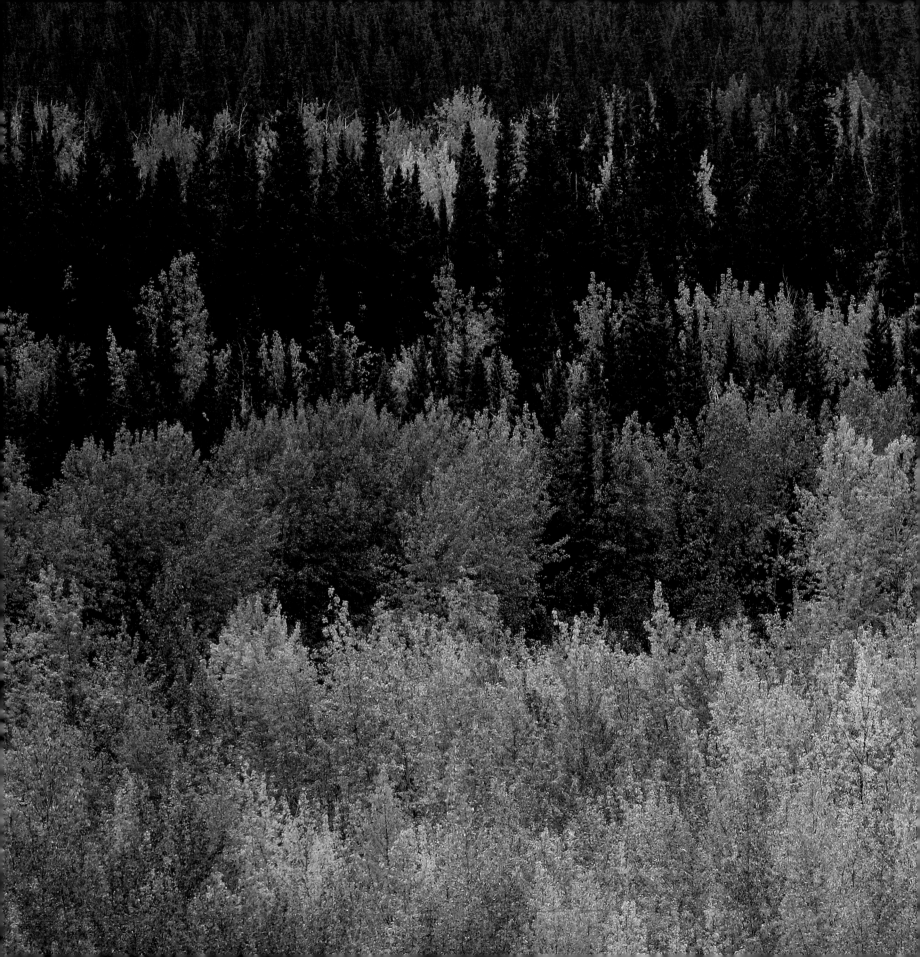

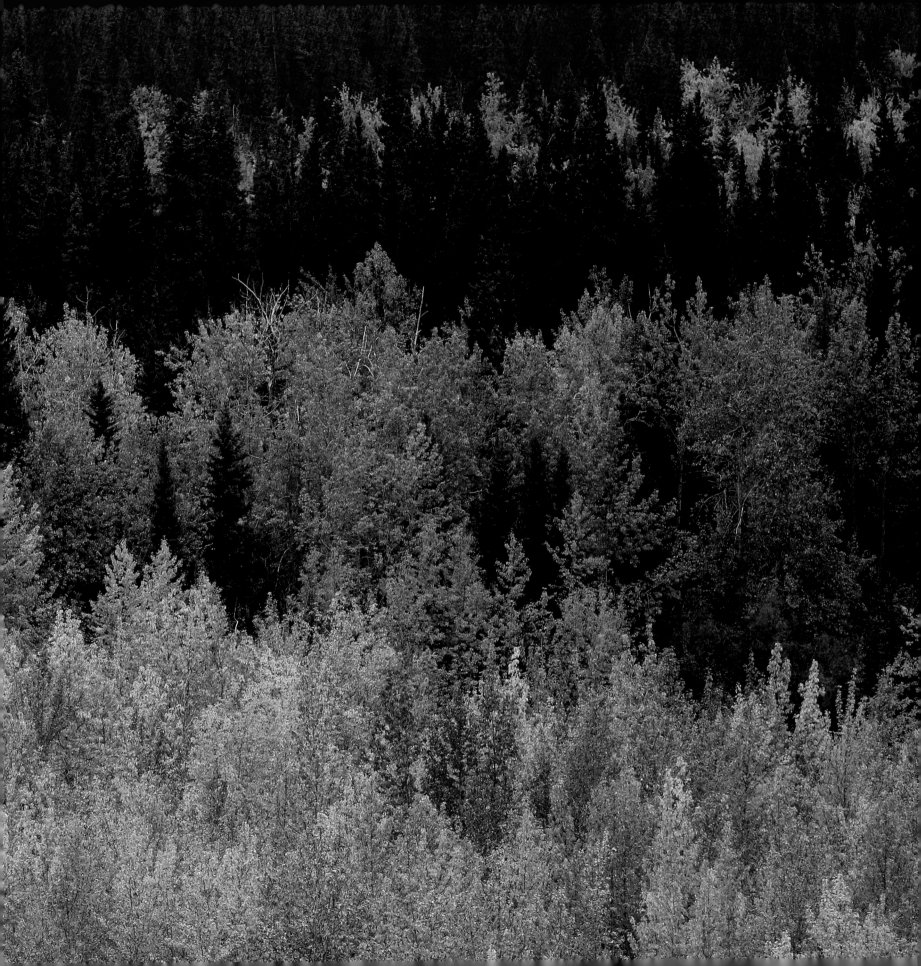

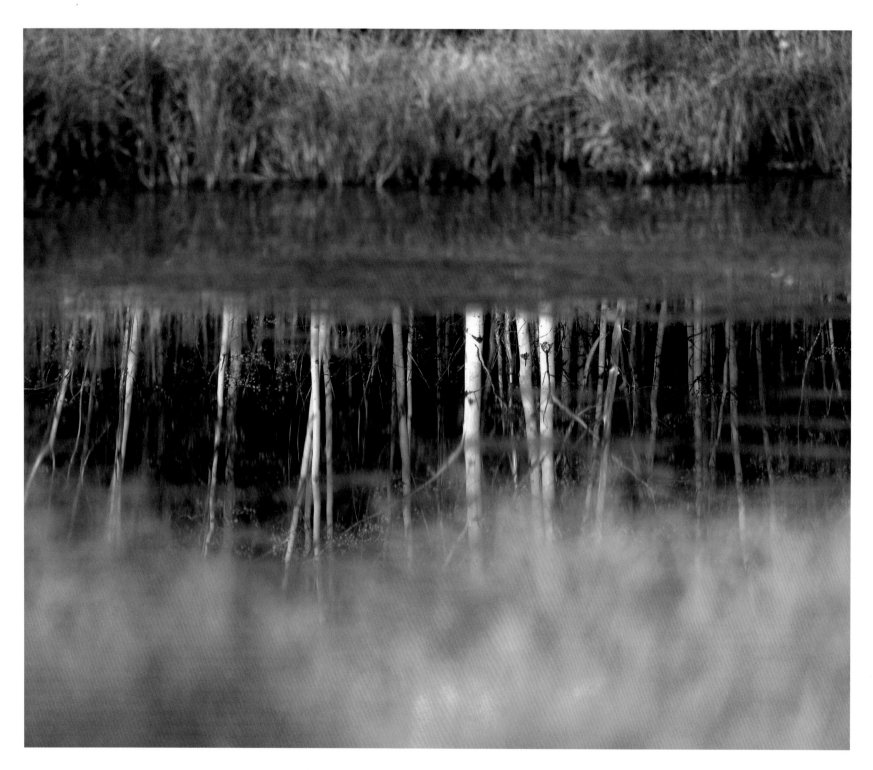

A notable wildlife habitat, marshes in the Ibex Valley are an important home base while the banks of the Takhini River are a migration corridor for a number of species.
ALONG THE ALASKA HIGHWAY, YUKON HIGHWAY 1

Straight cattail reeds have lost almost all of their cottony seeds as growing season ends. An aquatic plant, they are a sign of a healthy marsh, thriving in slightly brackish water while helping to filter pollution.
IBEX VALLEY

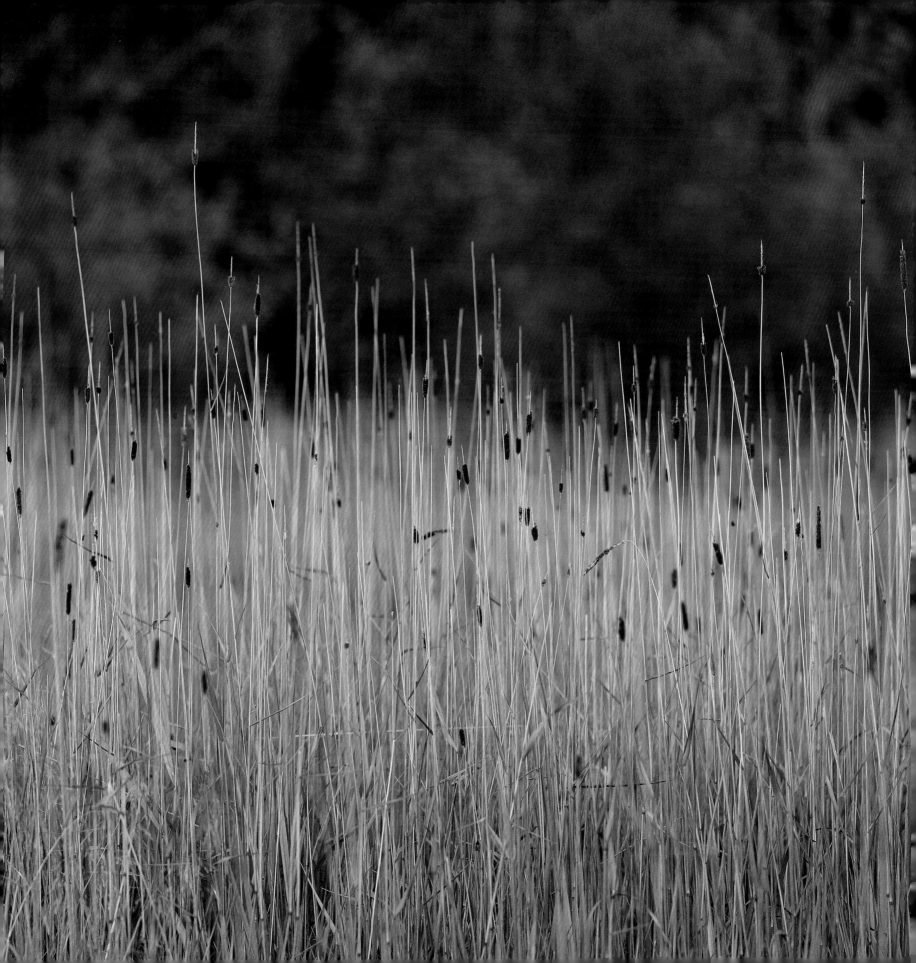

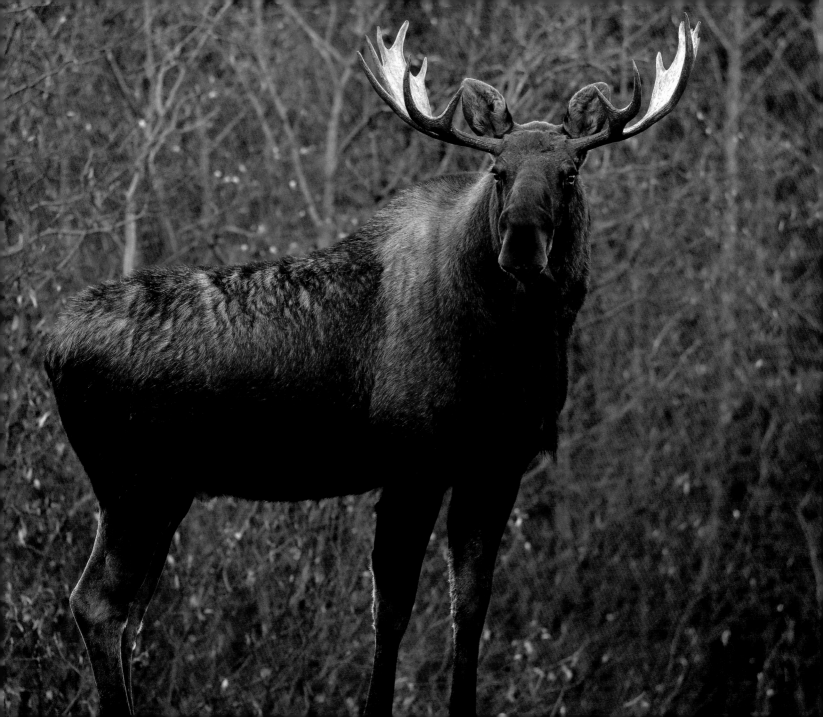

It was in the Klondike
that I found myself.
There, nobody talks.
Everybody thinks.
You get your perspective. I
got mine.

[Jack London]

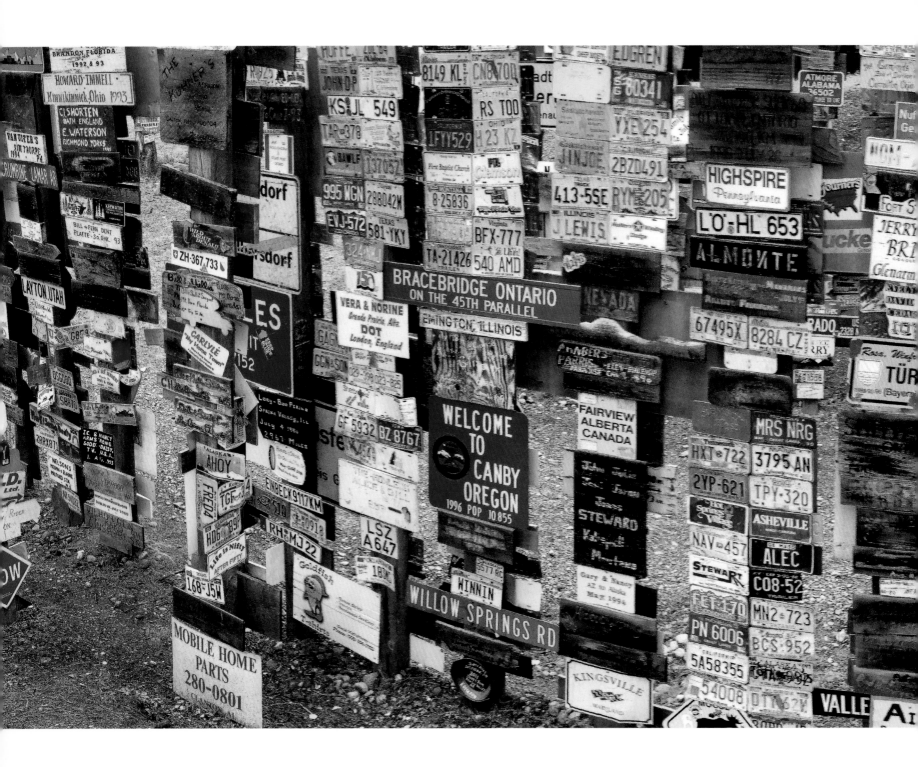

Sign Post Forest has been spreading since 1942 when American GI Carl K. Lindley erected a signpost while on light duty. Feeling homesick, he had added a personal directional marker to his hometown of Danville, Illinois. The landmark continues to grow as visitors contribute their own signs.

WATSON LAKE

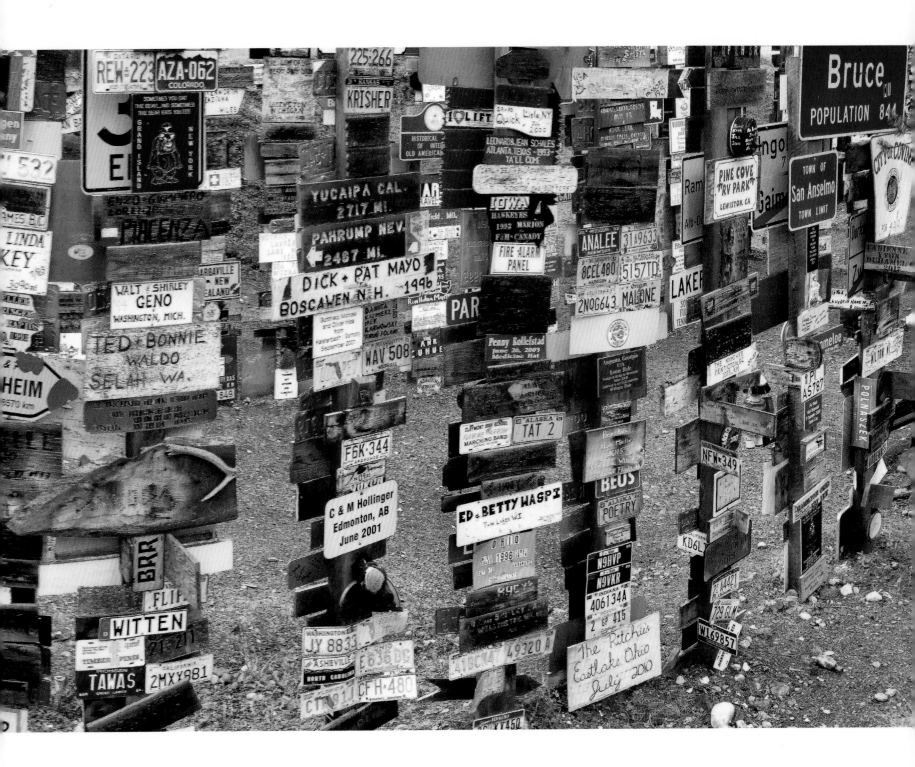

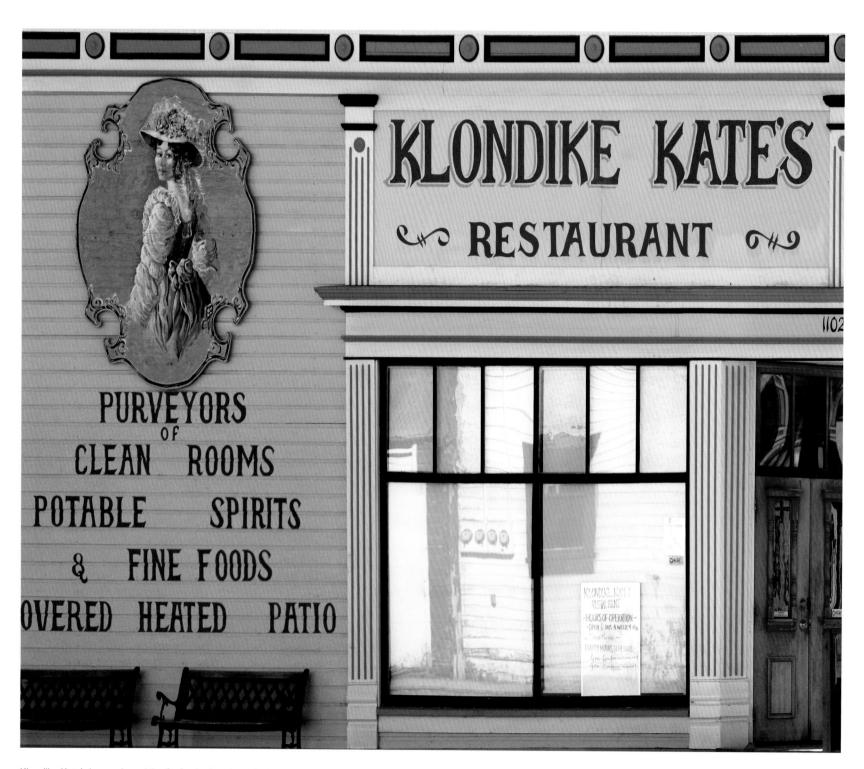

Klondike Kate's keeps the spirit of a fun-loving dance hall in a renovated establishment. The "Queen of the Klondike," Kathleen Eloisa Rockwell, was a dance-hall sweetheart from New York who became rich by collecting the gold thrown at her feet by prospectors after performances.
DAWSON CITY

FOLLOWING ○ Accessible from the highway, the Blackstone River is named for the rocks found along its banks. It flows into the Peel River past some astonishing scenery.
DEMPSTER HIGHWAY KM 117, YUKON HIGHWAY 5

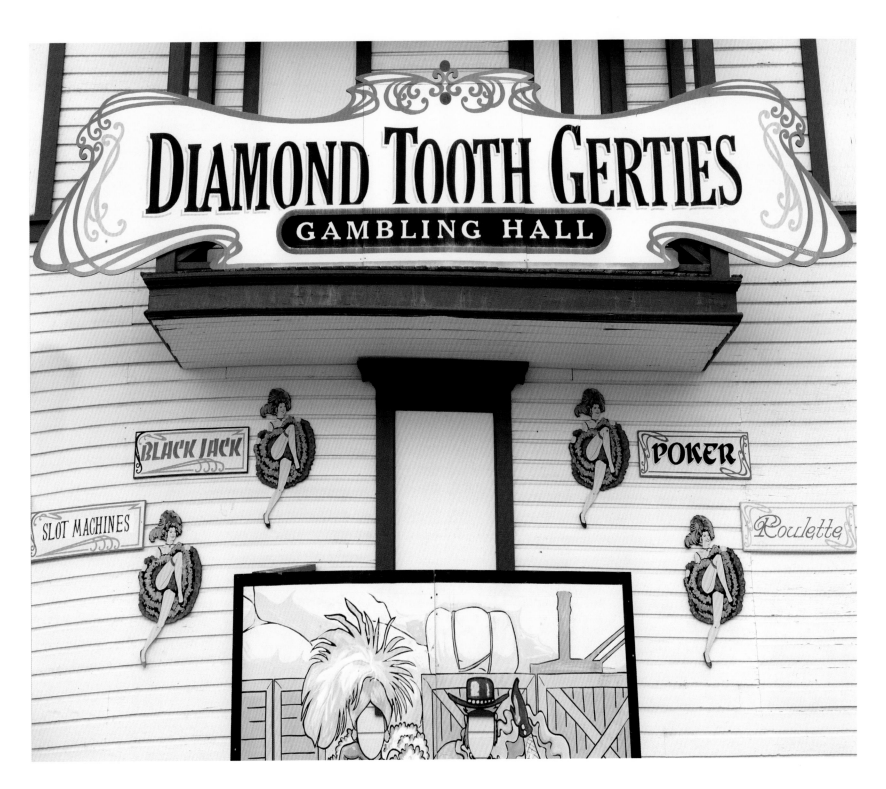

At Canada's oldest gambling establishment, patrons can enjoy the only casino in northern Canada. Named for one of the great dance-hall stars of the Gold Rush era, Diamond Tooth Gertie's also features daily vaudeville shows.
DAWSON CITY

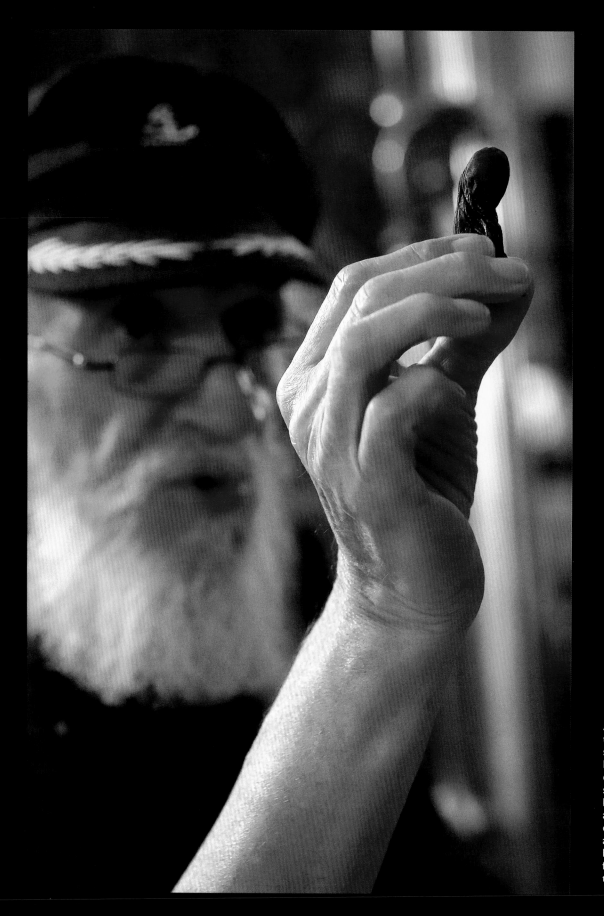

A true but grisly challenge, the Sourtoe Cocktail is served at the Downtown Hotel. The prohibition-era drink started with a severed frostbitten toe and has led to the formation of a strange club. Members choose a drink into which a mummified human toe has been slipped, and must follow the rule that the toe touch the sipper's lips.
DAWSON CITY

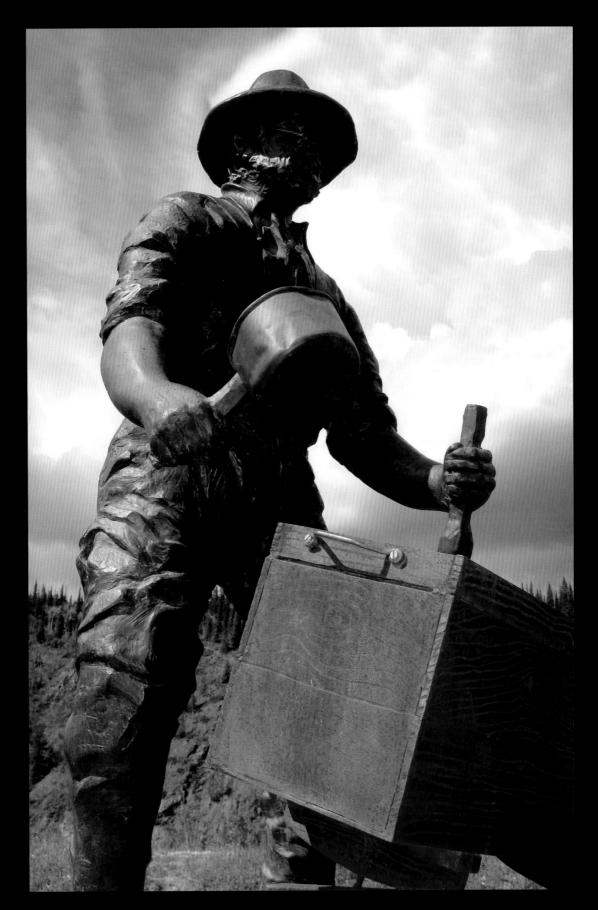

In Waterfront Park, artist Halin de Repentigny pays homage to the Klondike spirit with Tribute to the Miner, a bronze statue depicting a hardy miner with his rocker box.
DAWSON CITY

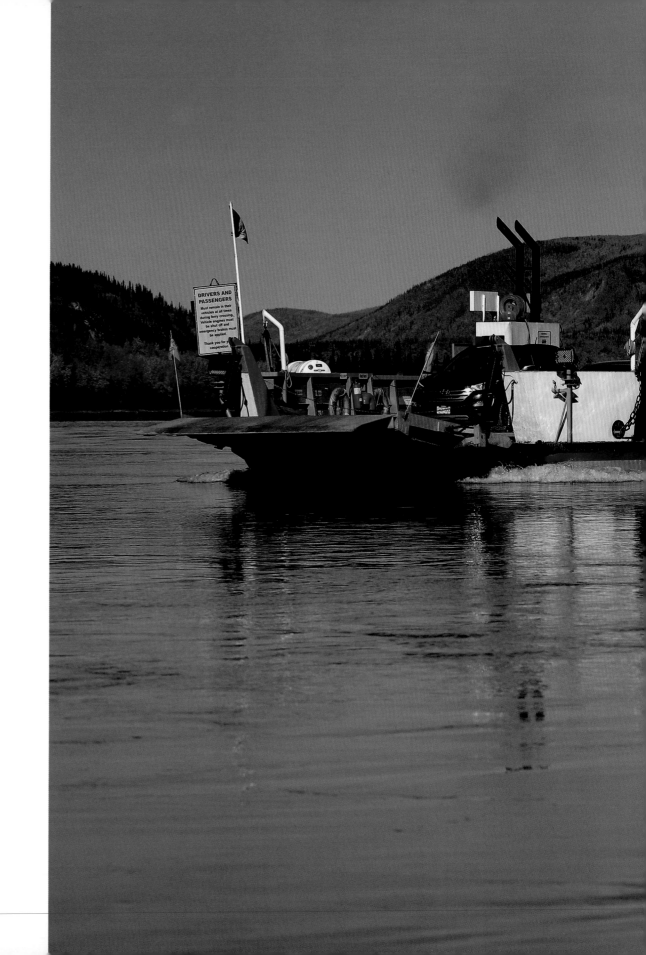

Connecting Dawson with West Dawson and
Sunnydale, the *George Black Ferry* operates
on the Yukon River from the start of the melt
until freeze-up. It runs virtually 24/7 at no
cost to travellers, since the river is part of the
Top of the World Highway.
DAWSON CITY

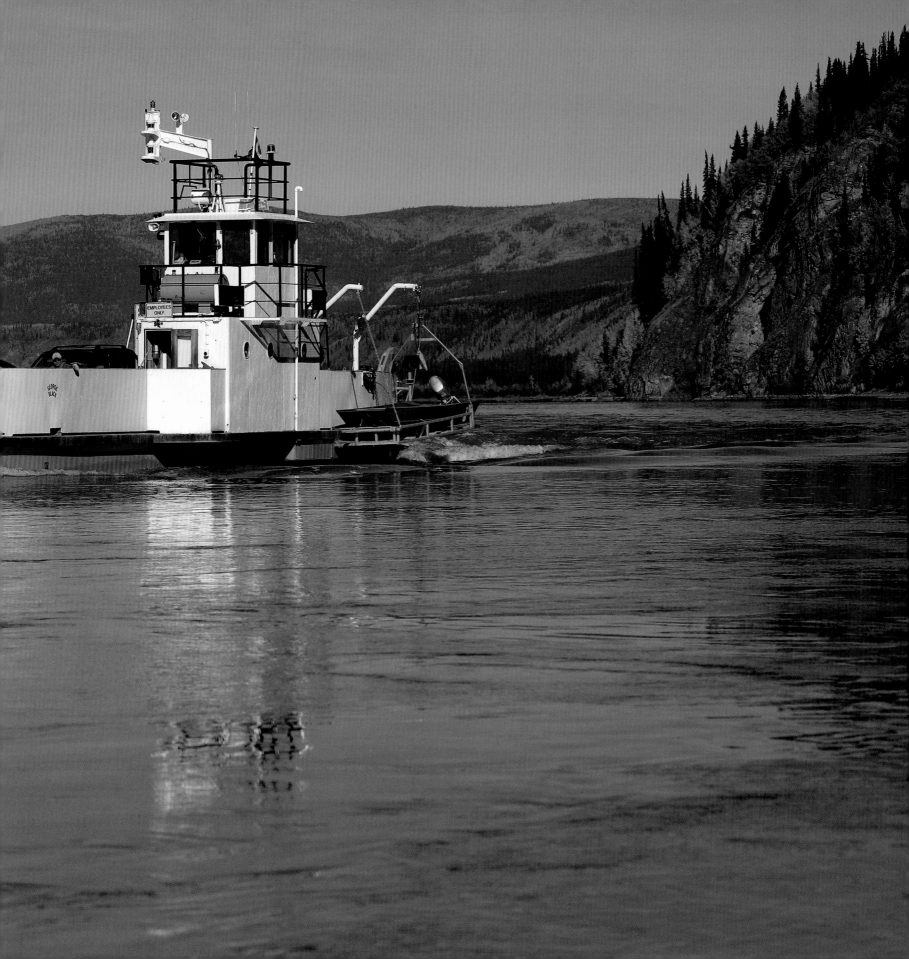

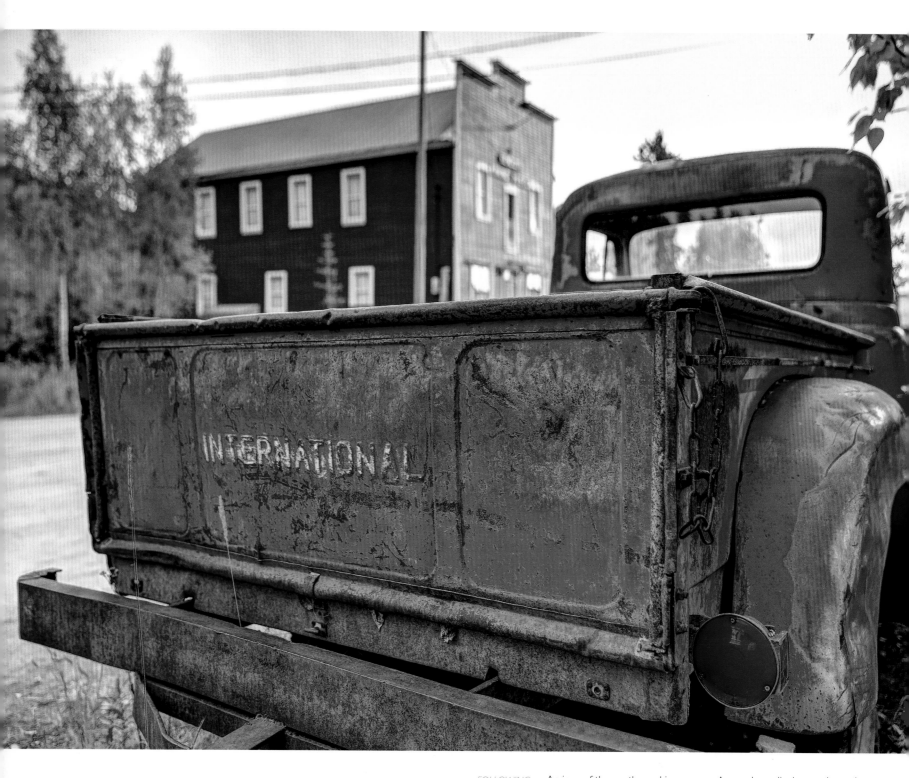

This vintage pickup truck is permanently parked in Keno City at the end of the Silver Trail (Highway 11). A boom town in 1919 when rich silver and lead deposits were found, it now relies largely on tourism for revenues.
KENO CITY

FOLLOWING · An icon of the northern skies, a green Aurora borealis dances above the *SS Keno*, a preserved paddlewheeler. The aurora's unique lights contain some electricity, a fact first discovered in 1859 when two American Telegraph Line operators in Boston, Massachusetts and Portland, Maine cut their battery power and continued chatting for about two hours during the light show (reported in the *Boston Traveler*).
DAWSON CITY

An abandoned cart is a relic from the O'Brien Brewing and Malting Company, which operated nearby from 1904 to 1919. Also known as the Klondike Brewery, it was forcibly closed during prohibition.
DAWSON CITY

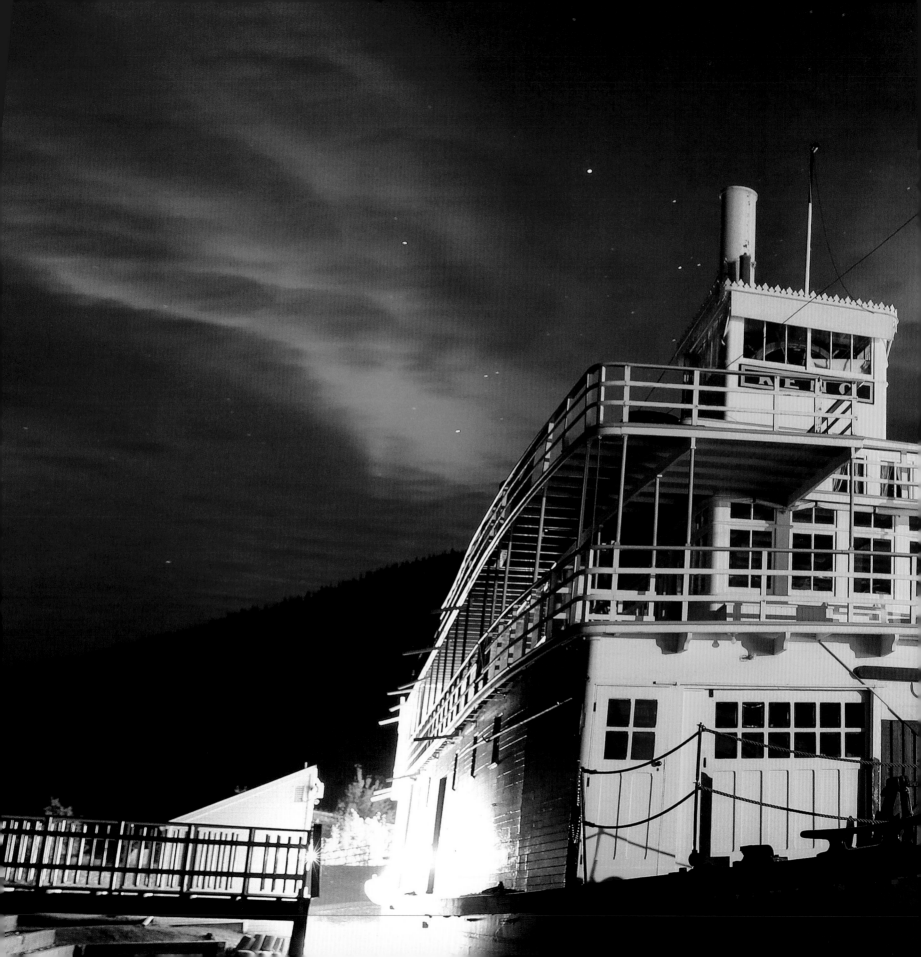

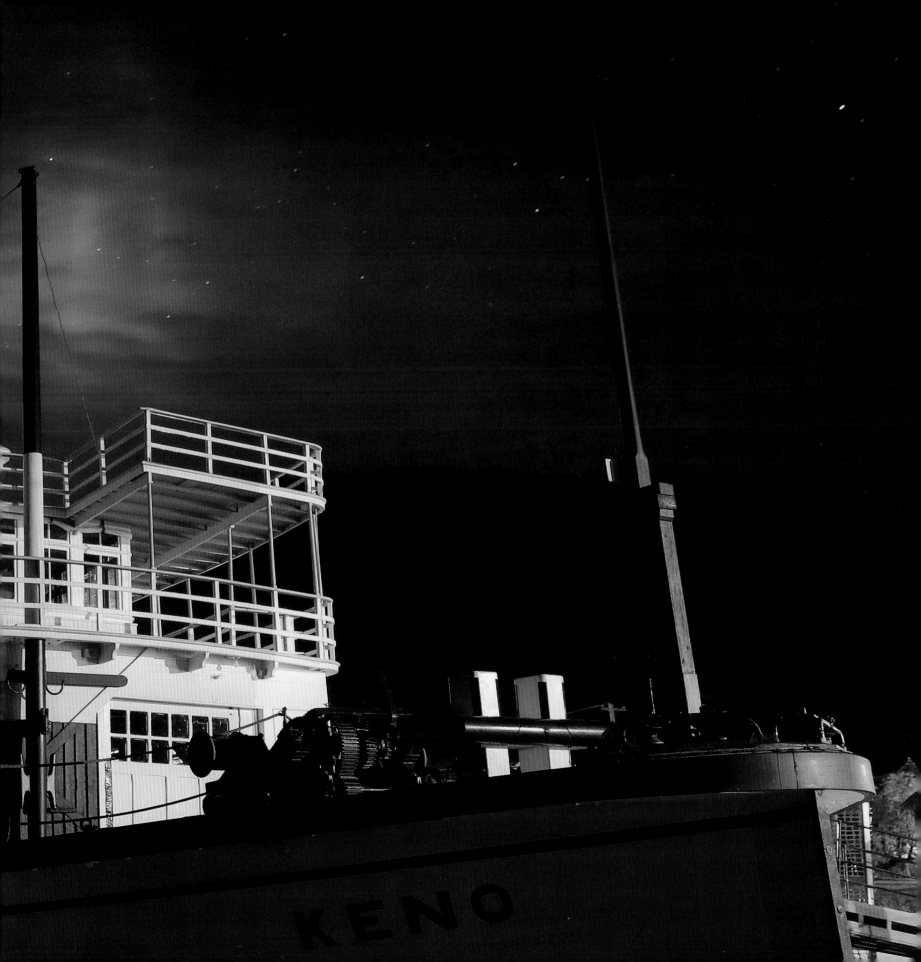

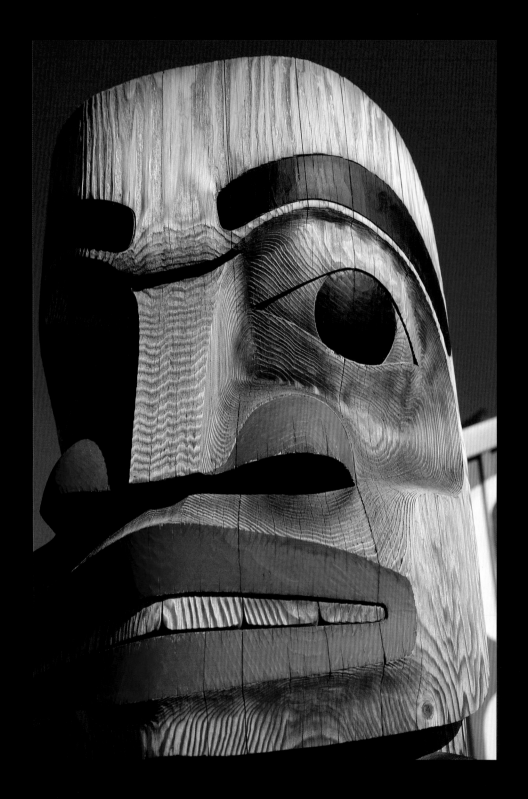

Gifted carver Keith Wolfe Smarch renders Northwest Coast art in pure traditional Tlingit form with a new vision around themes. His four totem poles can be seen at Carcross Commons.
CARCROSS

Behind the city's Visitor Information Centre, sun glints through a marble-and-steel sculpture created by artist Ken Anderson to represent the Wolf and Crow clans.
WHITEHORSE

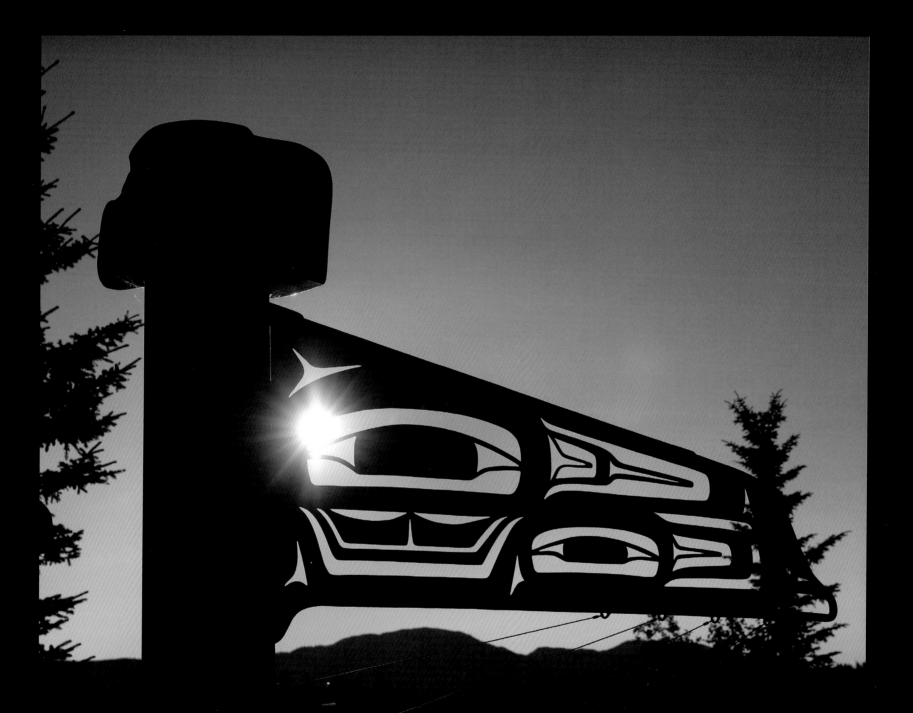

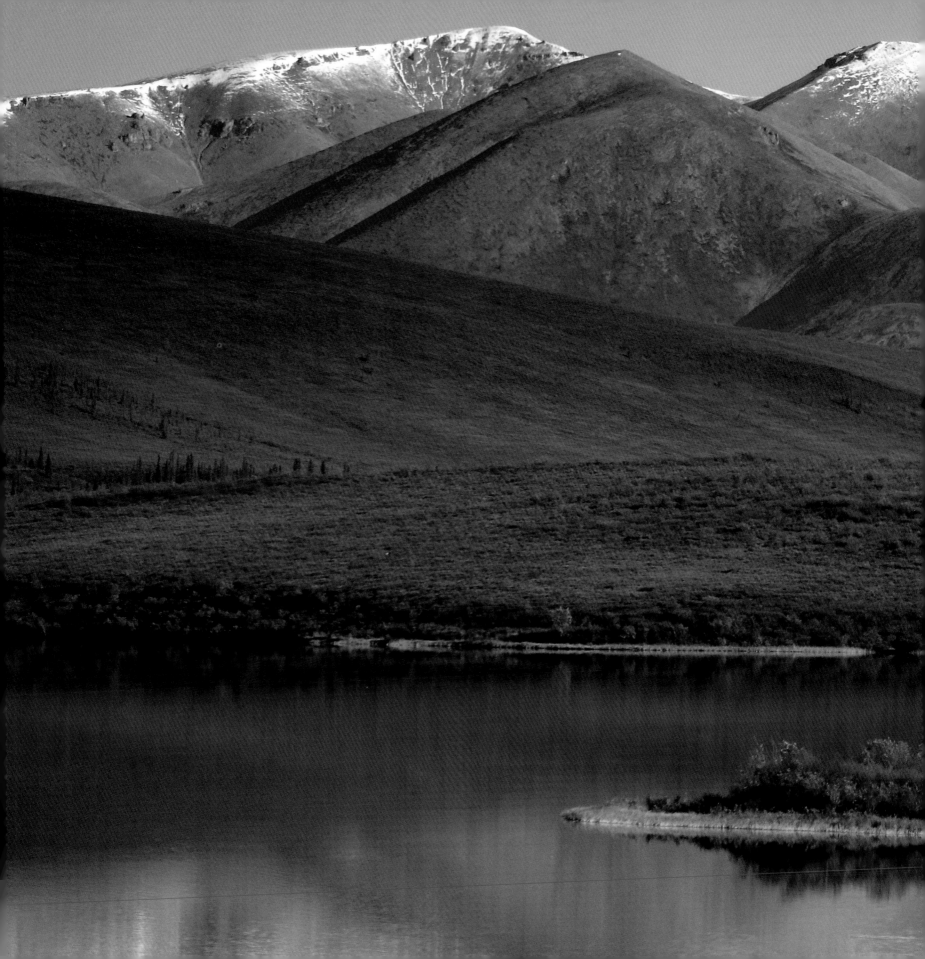

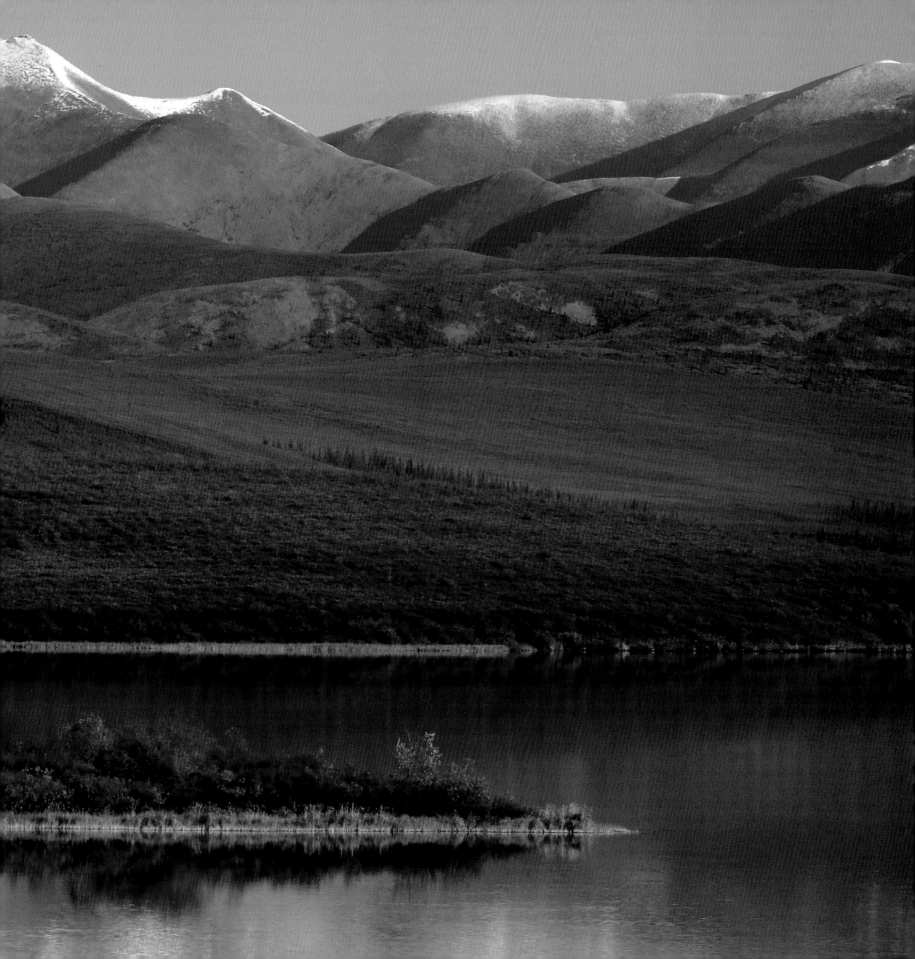

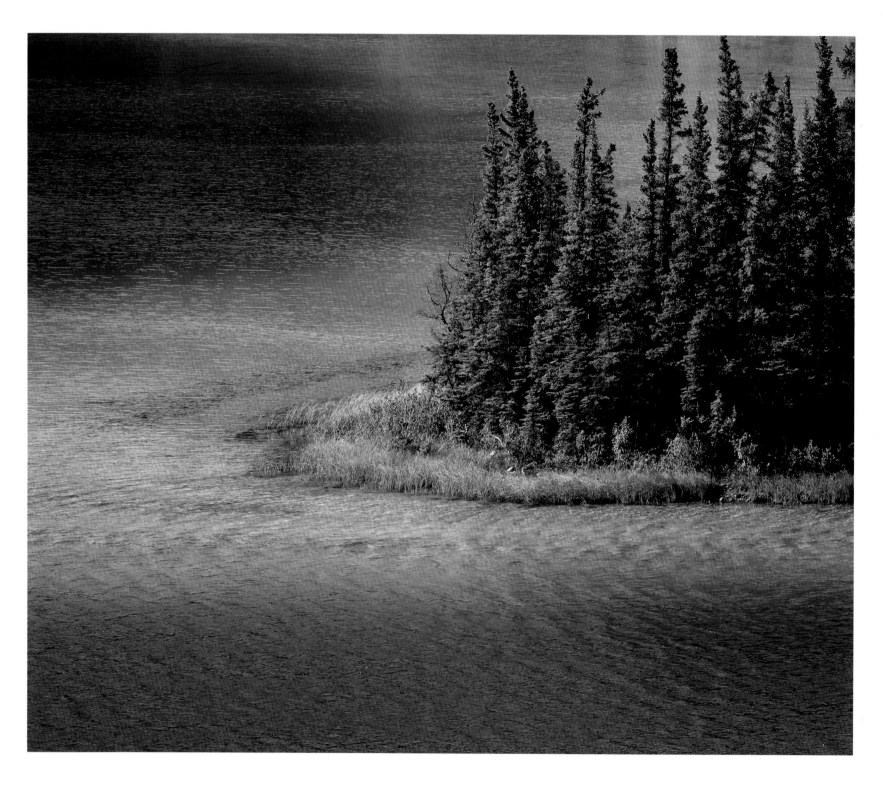

Extraordinary green hues sweep through shallow waters as light reflects off white clay and mineral deposits in Emerald Lake.
SOUTH KLONDIKE HIGHWAY KM 117, YUKON HIGHWAY 2

PREVIOUS · Fall colours soften the landscape below the Ogilvie Mountains at the top of Tombstone Territorial Park. William Ogilvie was a government surveyor who mapped the territory by canoe from 1887 to 1889. He reportedly identified the Alaska boundary line by carving A (for Alaska) and C (for Canada) into trees.
DEMPSTER HIGHWAY KM 116, YUKON HIGHWAY 5

"It is wonderful to feel the grandness of Canada in the raw.

[Emily Carr]

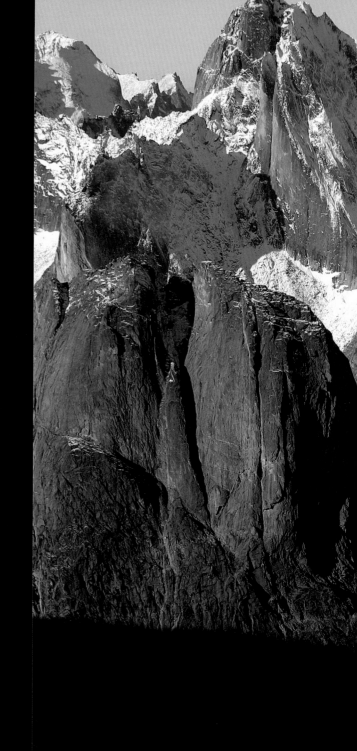

Angles of the Tombstone mountain range and Mount Monolith create
stark shadows around a reflection in one of the Twin Lakes.
TOMBSTONE TERRITORIAL PARK, CENTRAL YUKON

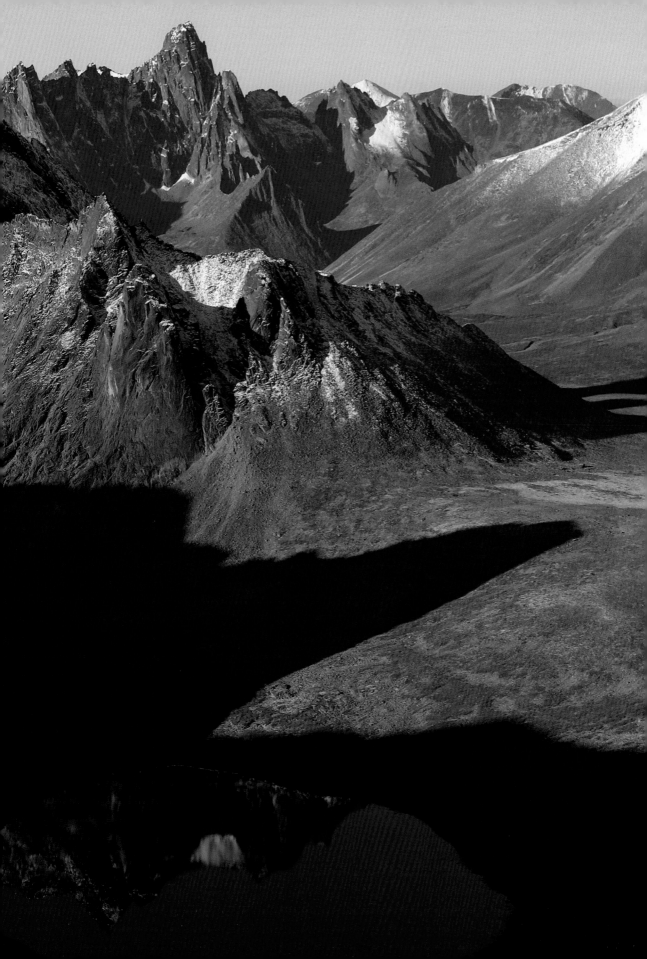

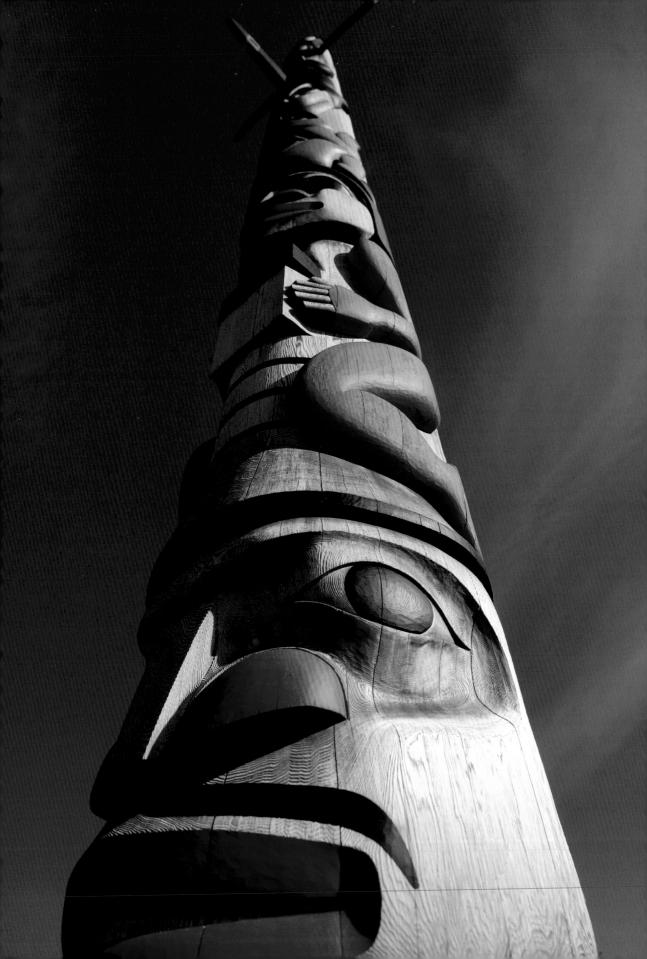

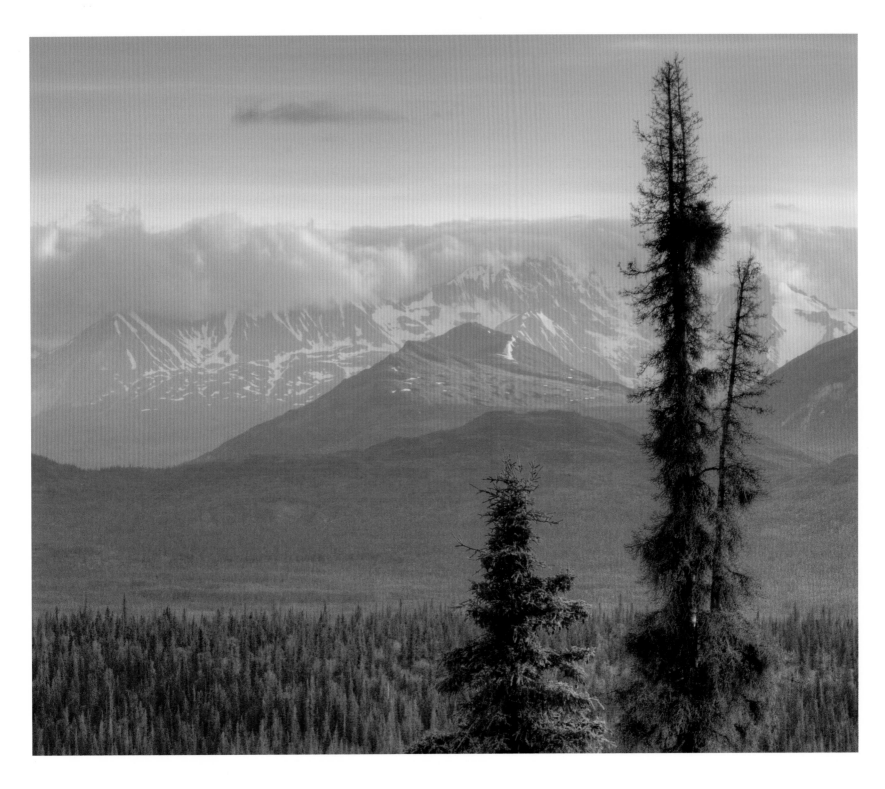

An 11-m totem pole is a symbol of healing for First Nations people who were forbidden from following their traditional culture for many years. Wood chips from the carving were burned and sealed inside the totem as a symbolic gesture to send the residential school children back to their mothers.

WHITEHORSE

Fir trees below and snow drifts above present a quintessential image of Canada. The St. Elias range blocks damp Pacific Ocean air as it comes eastward, resulting in considerable precipitation and snow.

KLUANE NATIONAL PARK AND RESERVE, SOUTHWEST YUKON

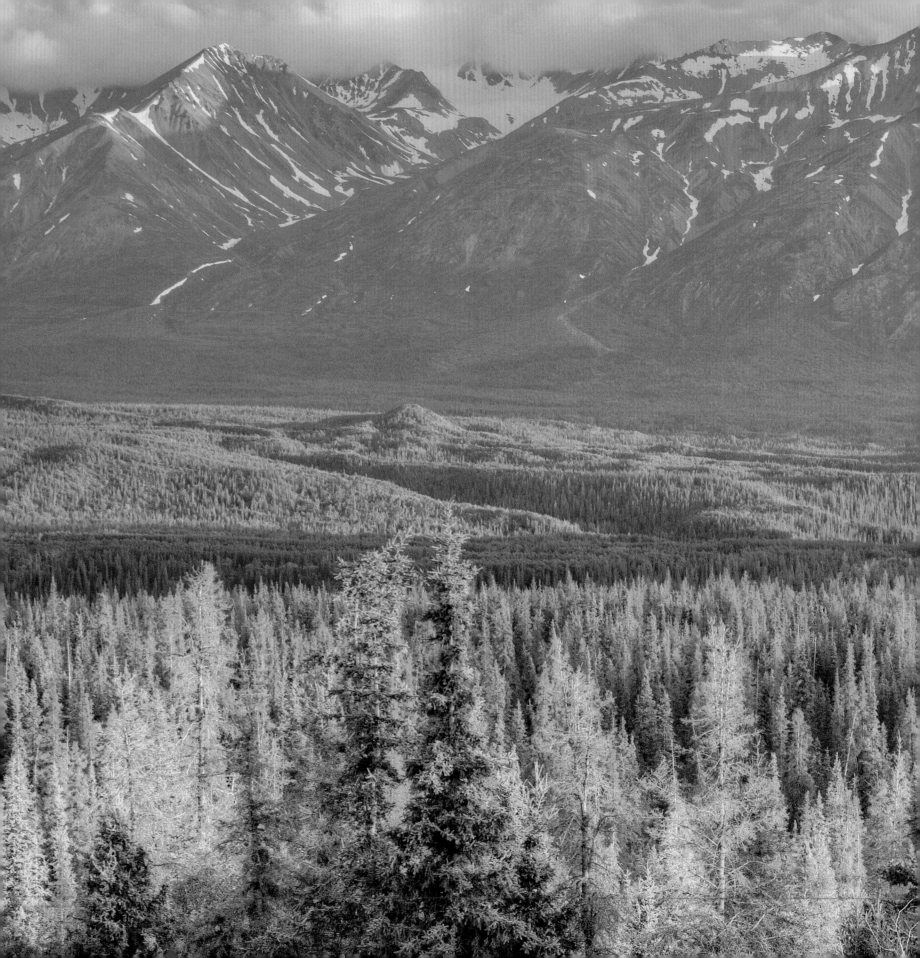

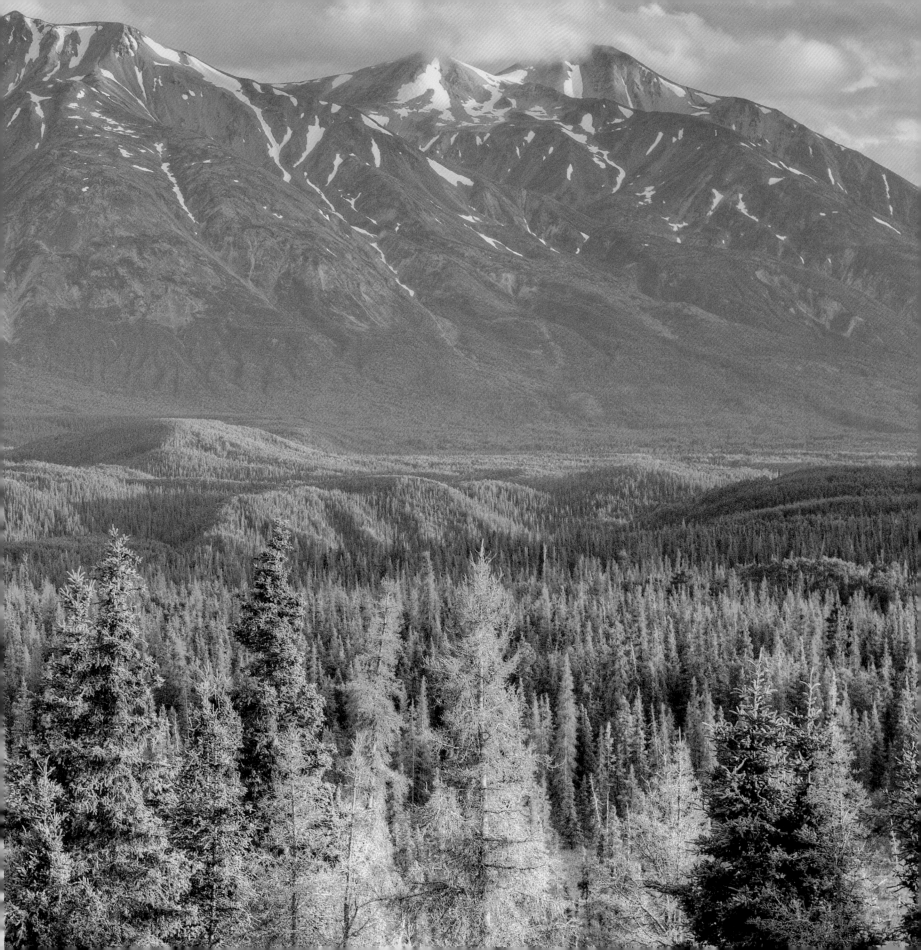

Hoarfrost coats vegetation at the top of Monument Hill, one of Keno Hill's five summits. Evidence of the mining era remains, some from the '60s and '70s, and some from the 1920s.
NORTHEAST OF KENO CITY

PREVIOUS ∘ The St. Elias foothills and peaks create a remarkable sight near Haines Junction. The town is close to Kluane National Park, one of three such parks in the Yukon and 42 in Canada.
KLUANE NATIONAL PARK AND RESERVE, SOUTHWEST YUKON

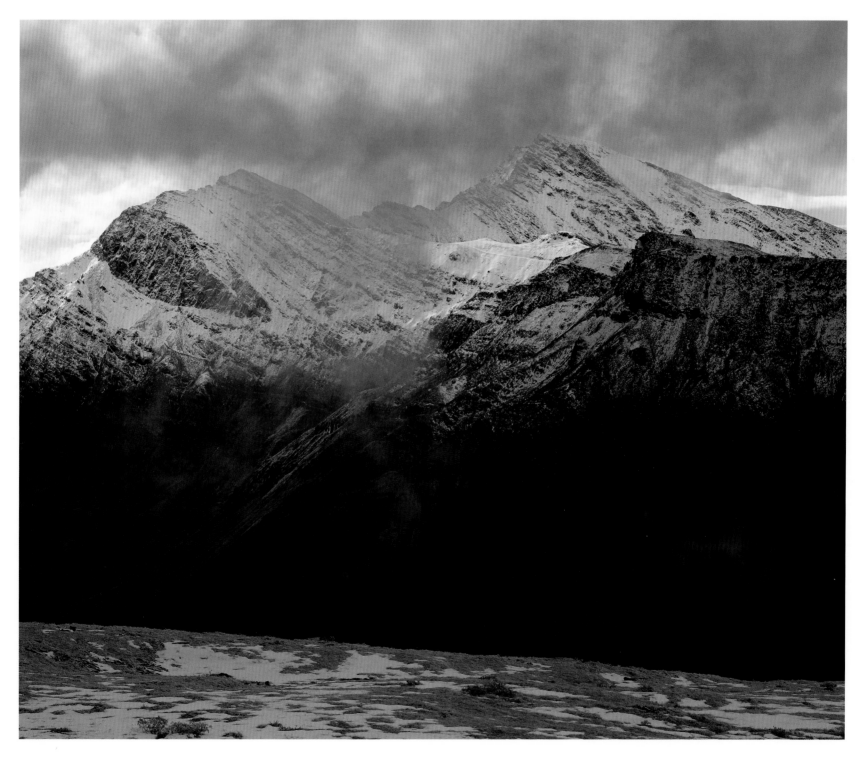

A dramatic view from Mount Hinton underlines the strength and longevity of this craggy scenery. Bunker Hill trail or Sourdough Hill trail lead to the top. ("Sourdough" is the nickname for Yukon residents.)
NORTHEAST OF KENO CITY

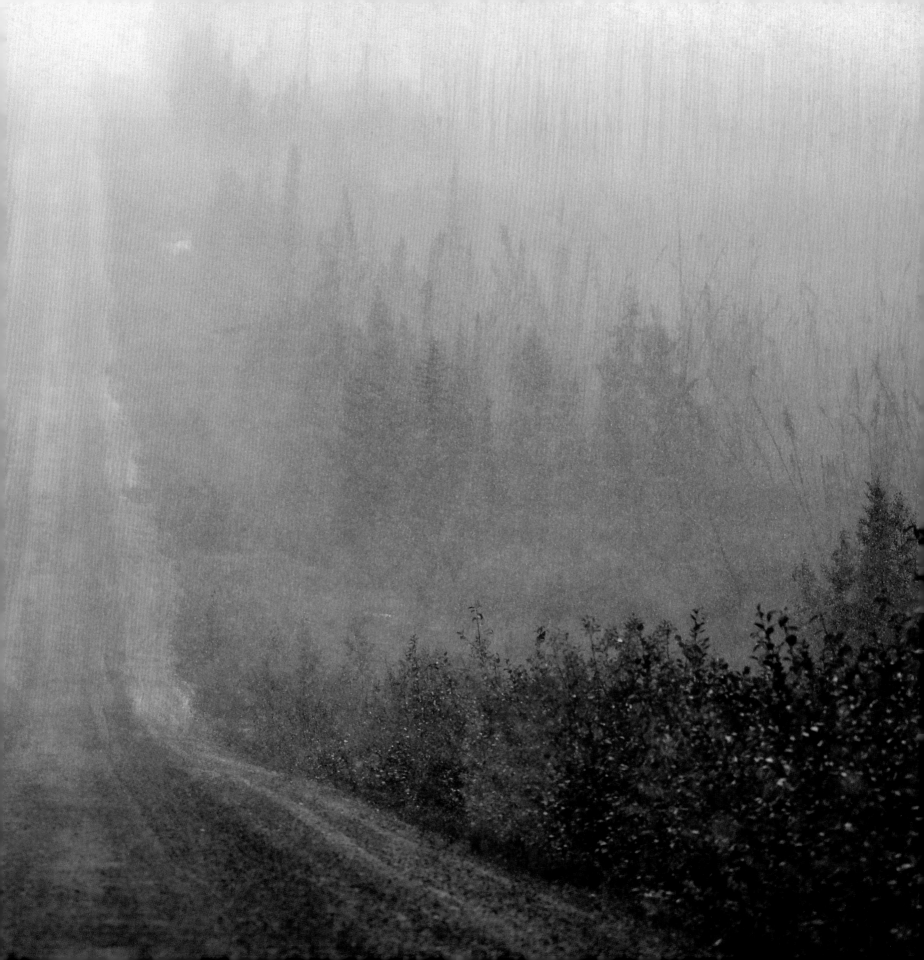

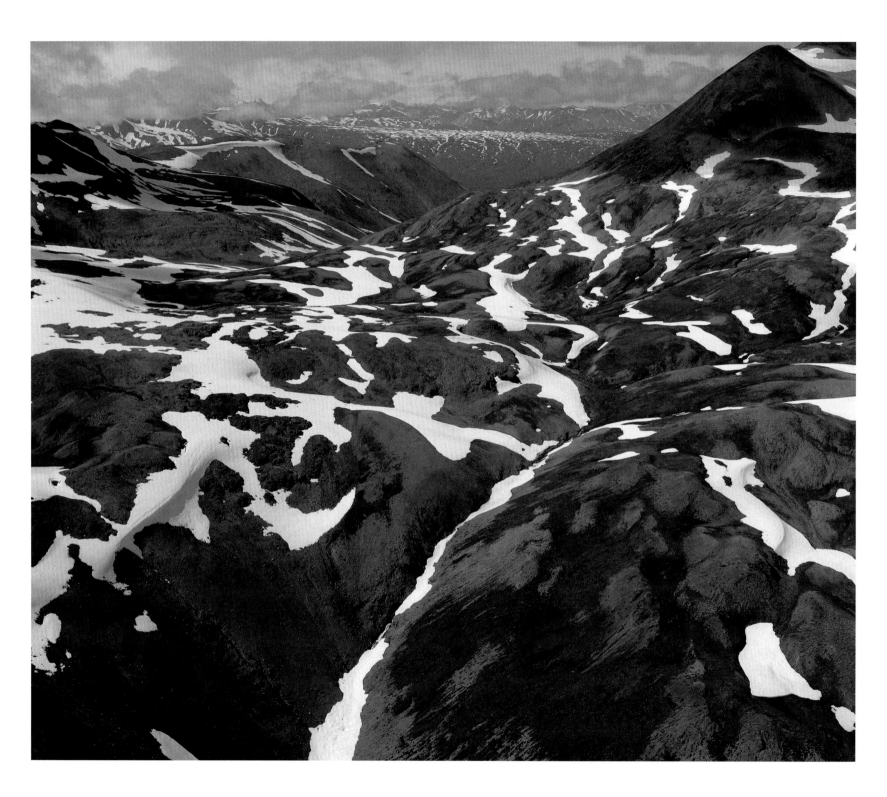

Snow pools in crevices before winter sets in. A boundary peak in Kluane
National Park is the westernmost point in Canada.

KLUANE NATIONAL PARK AND RESERVE, SOUTHWEST YUKON

PREVIOUS ◦ Fog blankets the highway near the Nahanni Range Road, a gravel route
into the Northwest Territories that is not well-maintained and not recommended.

ALONG ROBERT CAMPBELL HIGHWAY, YUKON HIGHWAY 4

It's not the mountain we conquer, but ourselves.

[Sir Edmund Hillary]

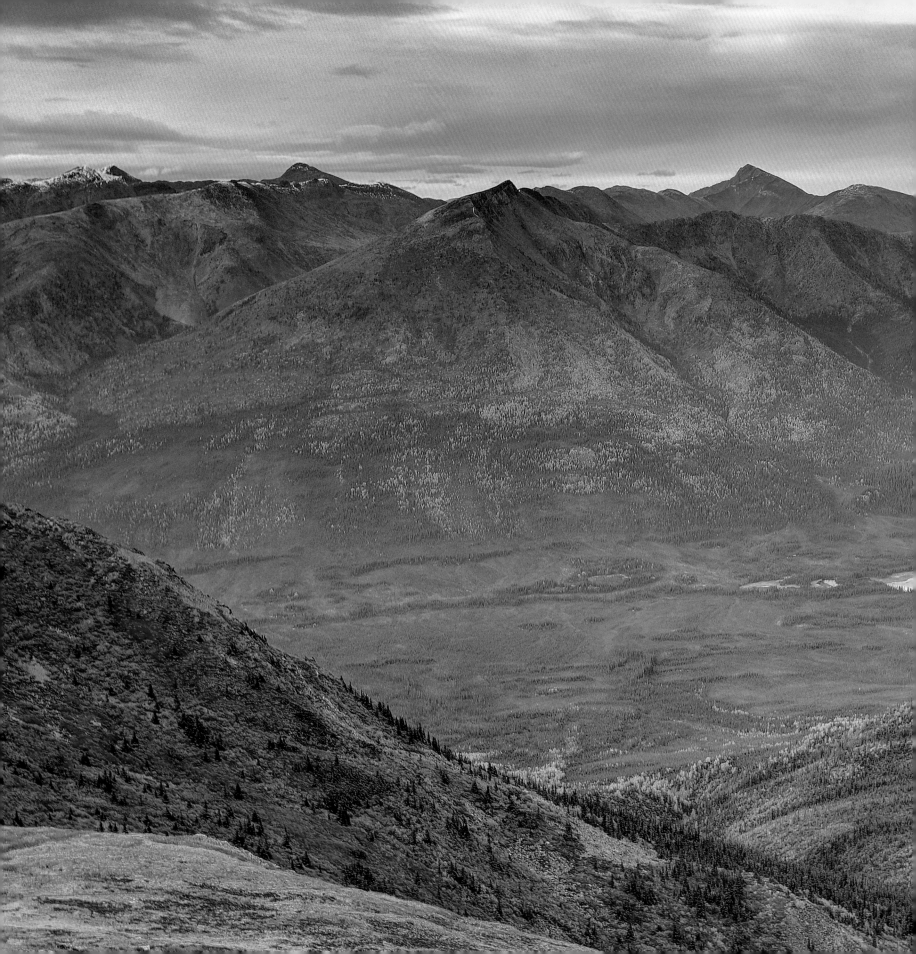

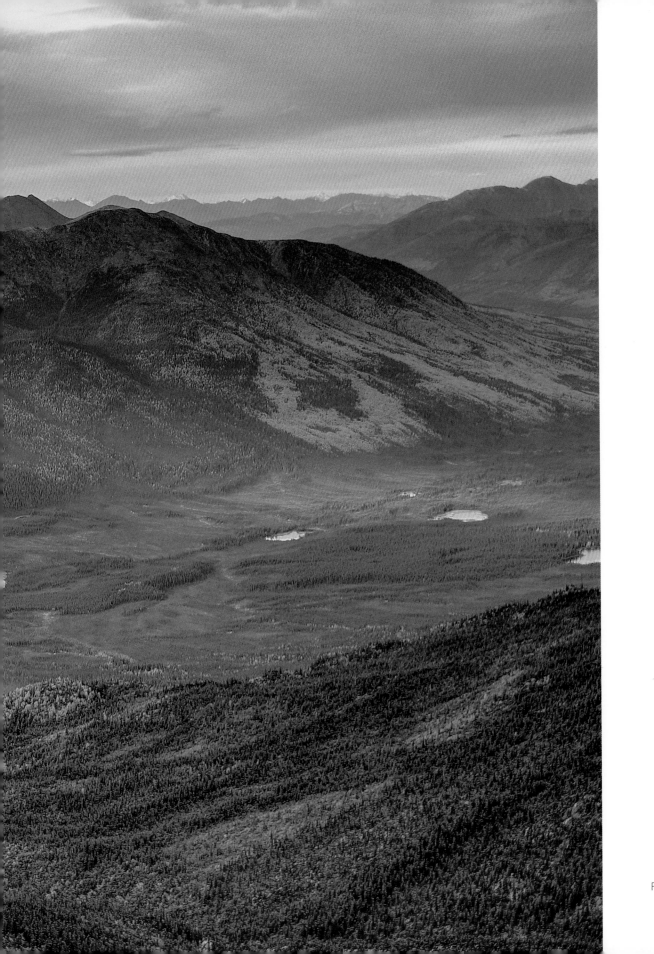

A commanding view from Keno Hill takes in the Potato Hills, Davidson Range and the McQuesten River with peaks stretching as far as the eye can see.
NORTHEAST OF KENO CITY

213

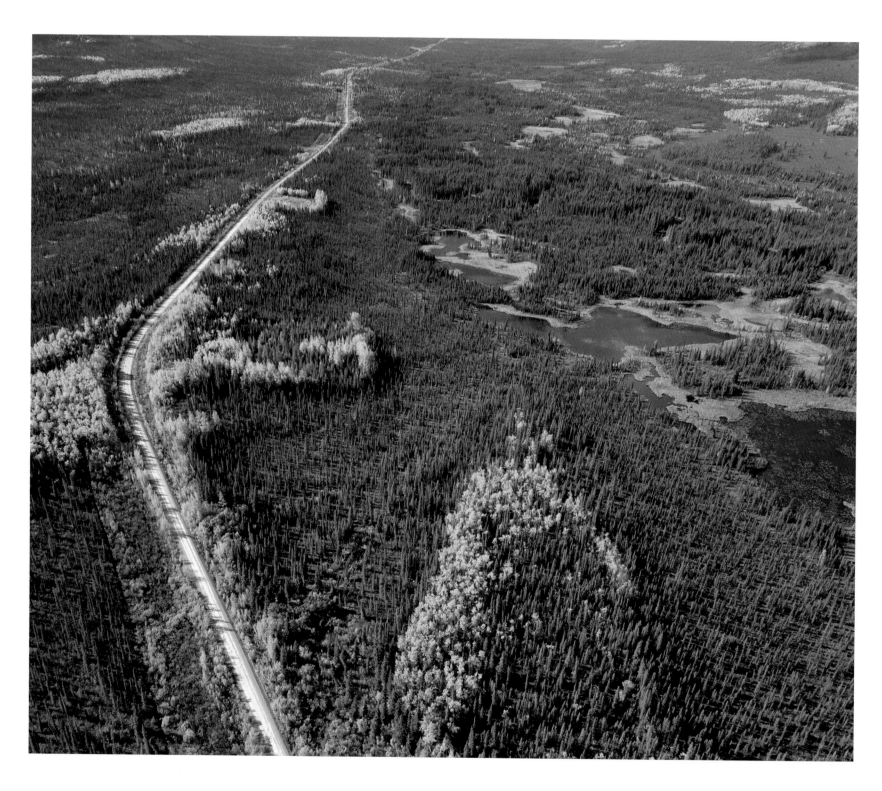

An overview of the highway heading to Ross River shows a mere slice of
the vast Yukon forest.
ALONG ROBERT CAMPBELL HIGHWAY, YUKON HIGHWAY 4

Around the softly sculpted foothills of Money Peak, the Robert Campbell
Highway veers westward toward its destination in the village of Carmacks.
ALONG ROBERT CAMPBELL HIGHWAY, YUKON HIGHWAY 4

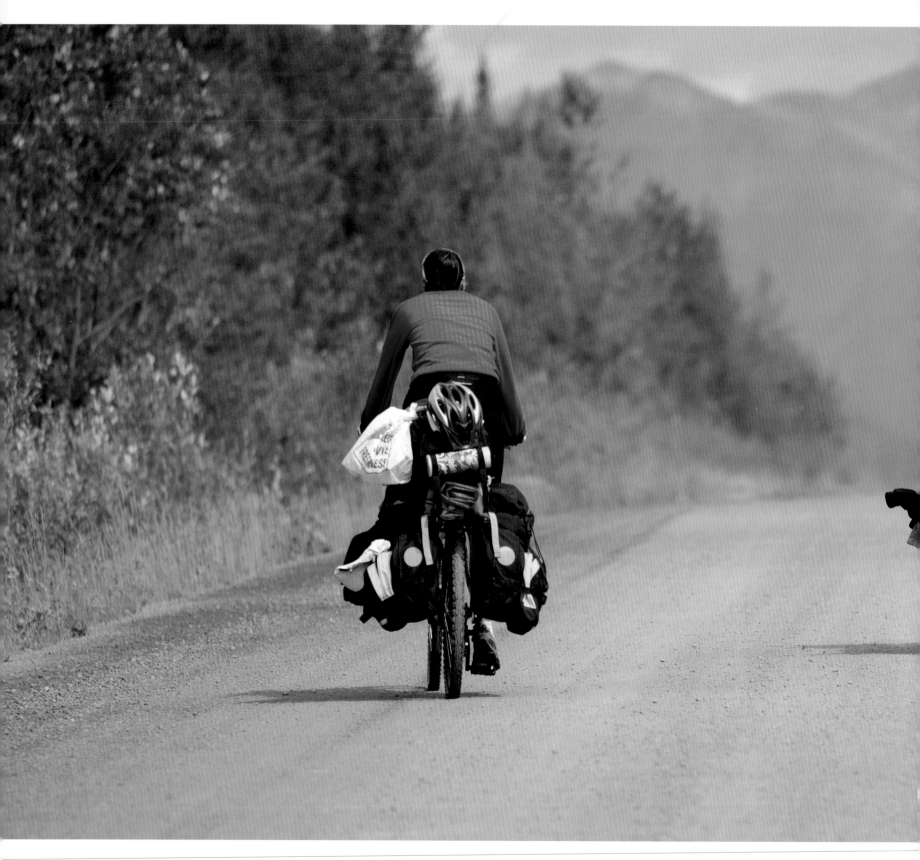

Cycling the Dempster is a great way to see the country from the ground up. Good planning and some unusual encounters along the way can generate wonderful stories.
ALONG THE DEMPSTER HIGHWAY, YUKON HIGHWAY 5

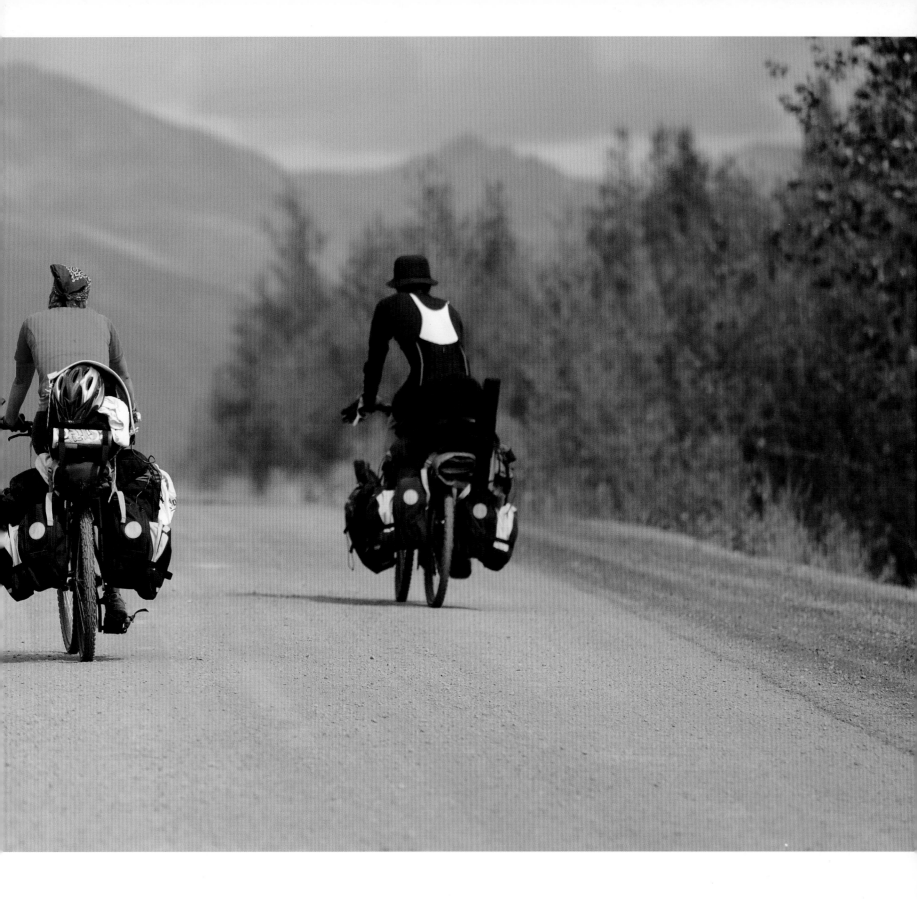

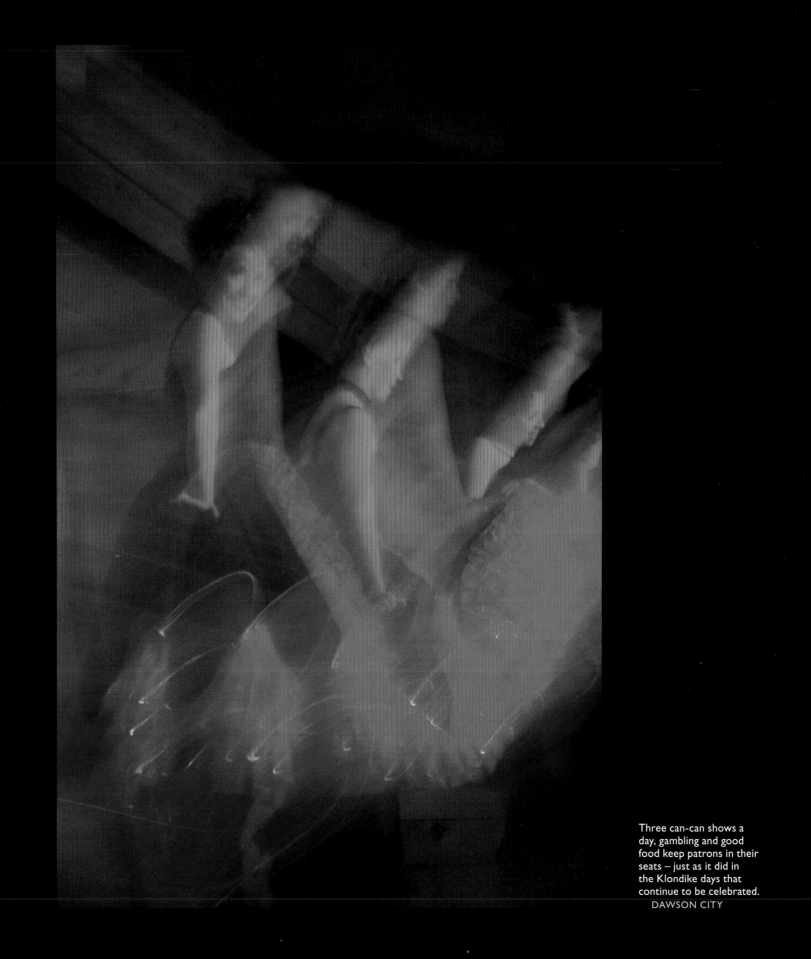

Three can-can shows a day, gambling and good food keep patrons in their seats – just as it did in the Klondike days that continue to be celebrated.
DAWSON CITY

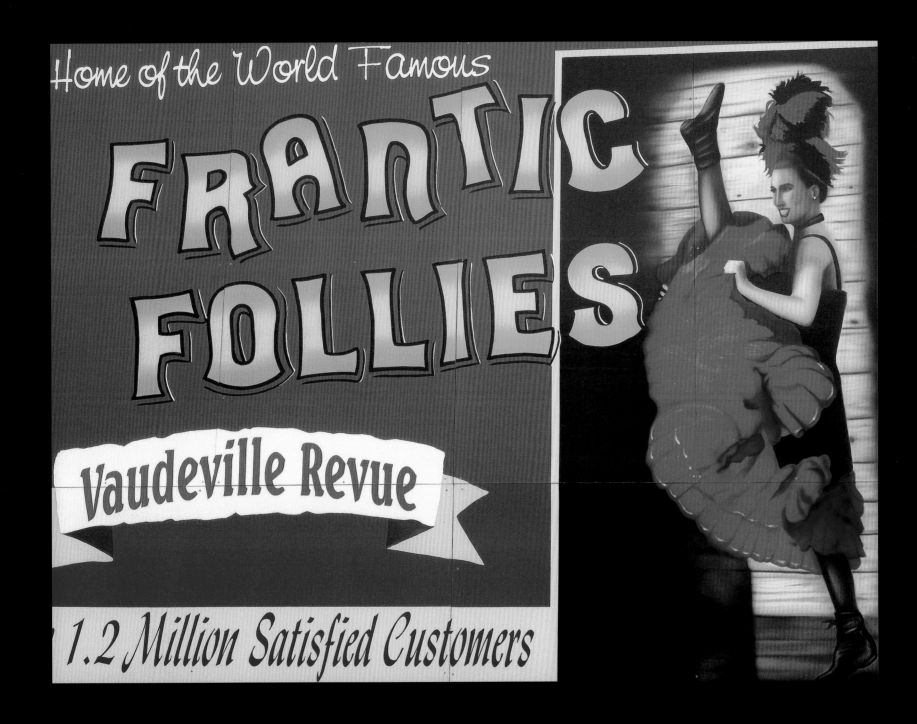

A street mural by Bill Oster attests to the long-running Frantic Follies that were closed in 2017. However, organizer Grant Simpson now has exciting new local talent and big headliners in the Klondike Follies Cabaret.
WHITEHORSE

Painted and accessorized to look like a Gold Rush-era street, the
Dawson City Hotel welcomes summer visitors and encourages
them to discover all that the "Paris of the North" has to offer.
DAWSON CITY

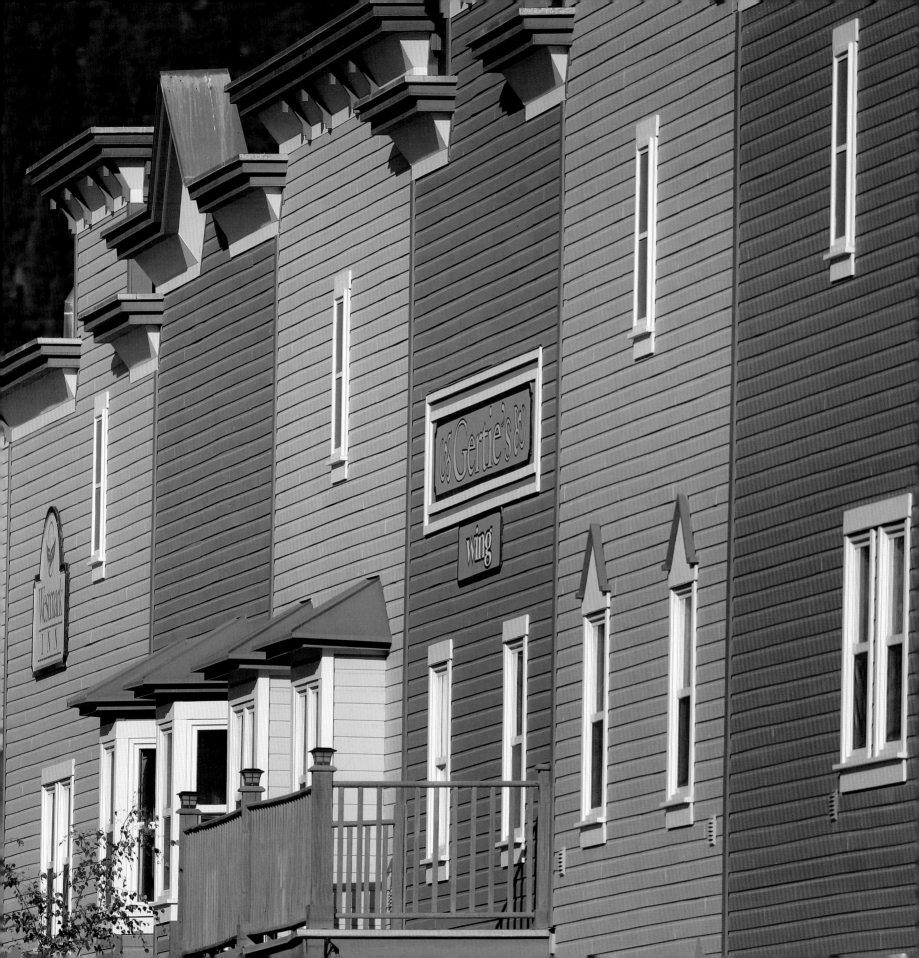

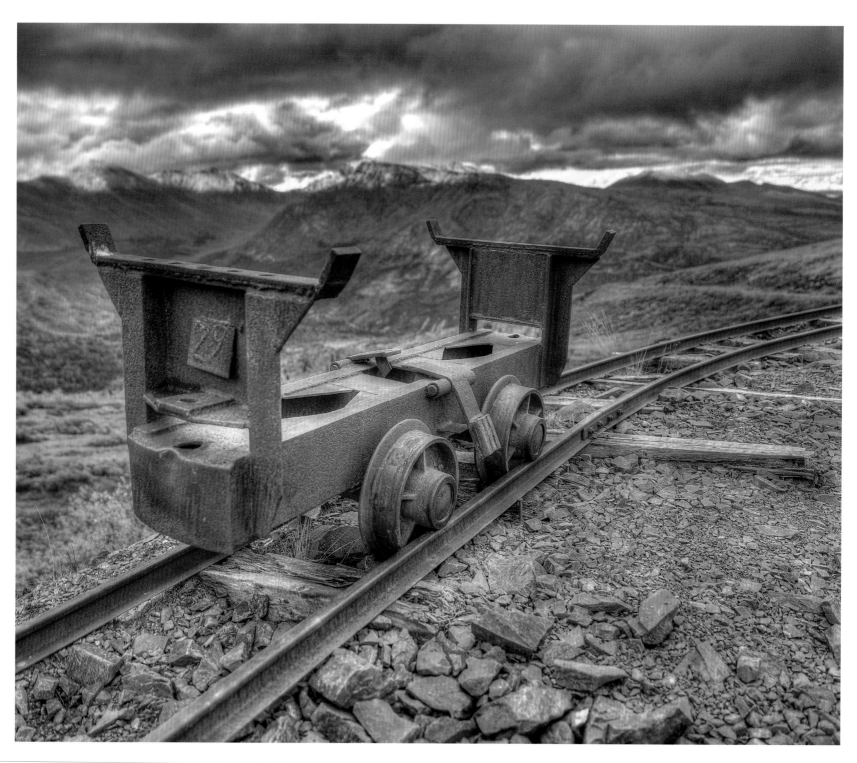

Abundant silver, lead and zinc deposits kept the Keno Hill Camp thriving from 1913 until 1989, producing more wealth than the Klondike Gold Rush finds. Ghostly souvenirs of the first several years of hand-mining dot the area.

NEAR KENO CITY

FOLLOWING ▶ After the few short years of the Klondike Gold Rush, gold operations continued until the 1960s and left snake-line "tailings" dropped by massive transport trucks. Modern mining technology has replaced the intrusive practice, but plans are underway to protect an area of the tailings as an important part of the region's history.

DAWSON CITY

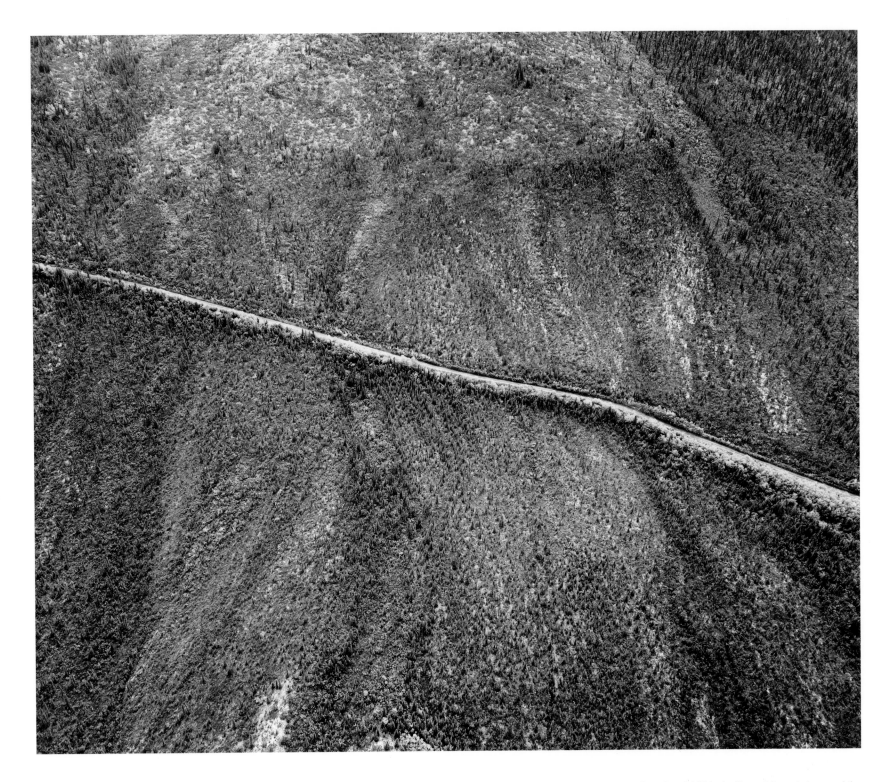

The road up Sourdough Hill looks like a ribbon tied around the mountain. The hill, which is 1187 m high, is next to the site of the Bellekeno mine and more than 35 historical deposits.
SOUTHEAST OF KENO HILL

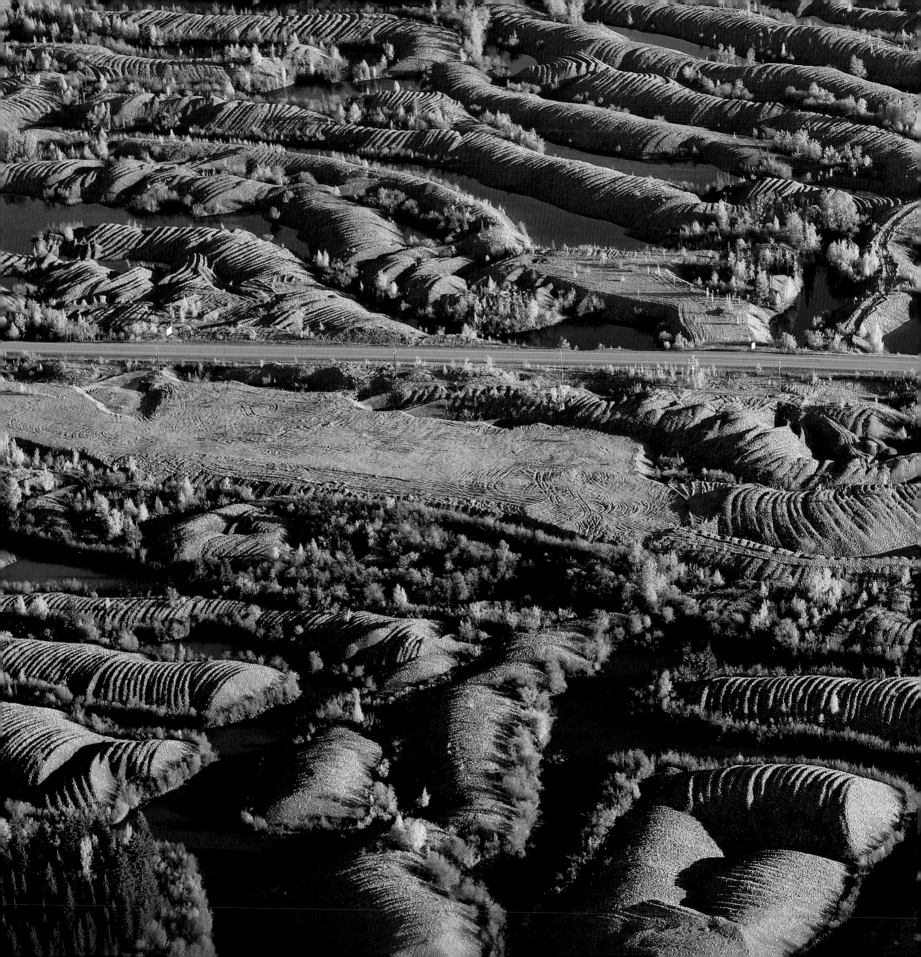

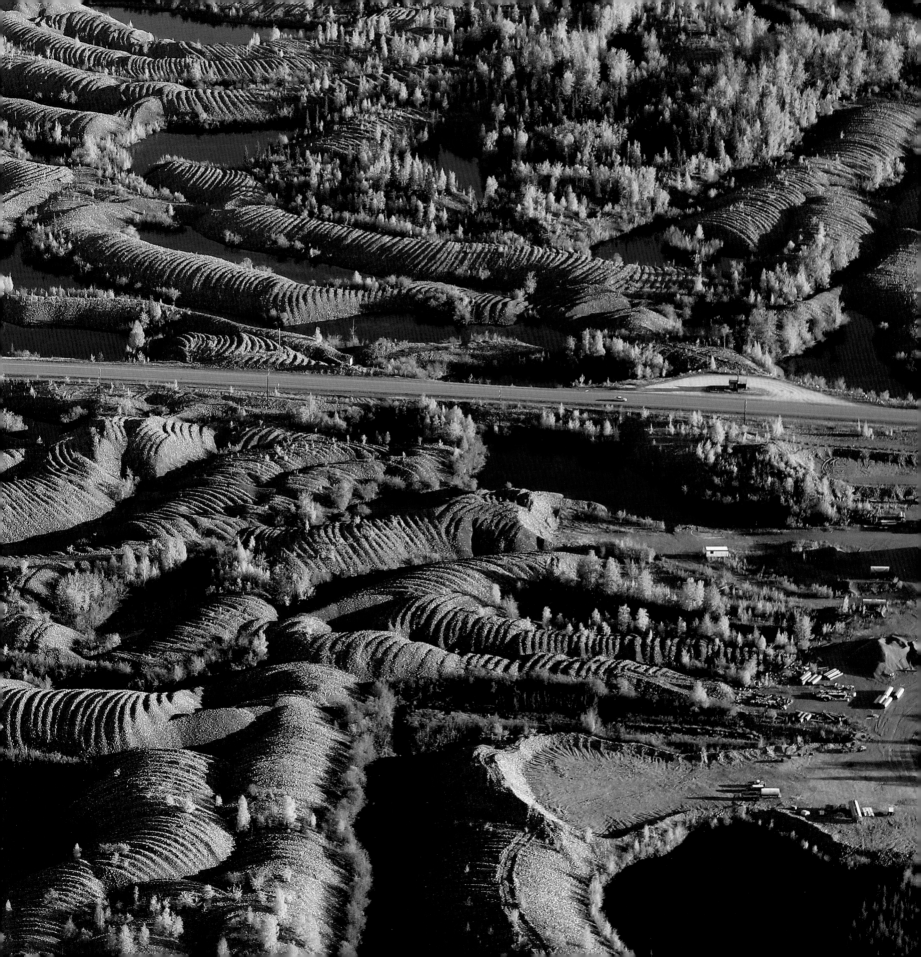

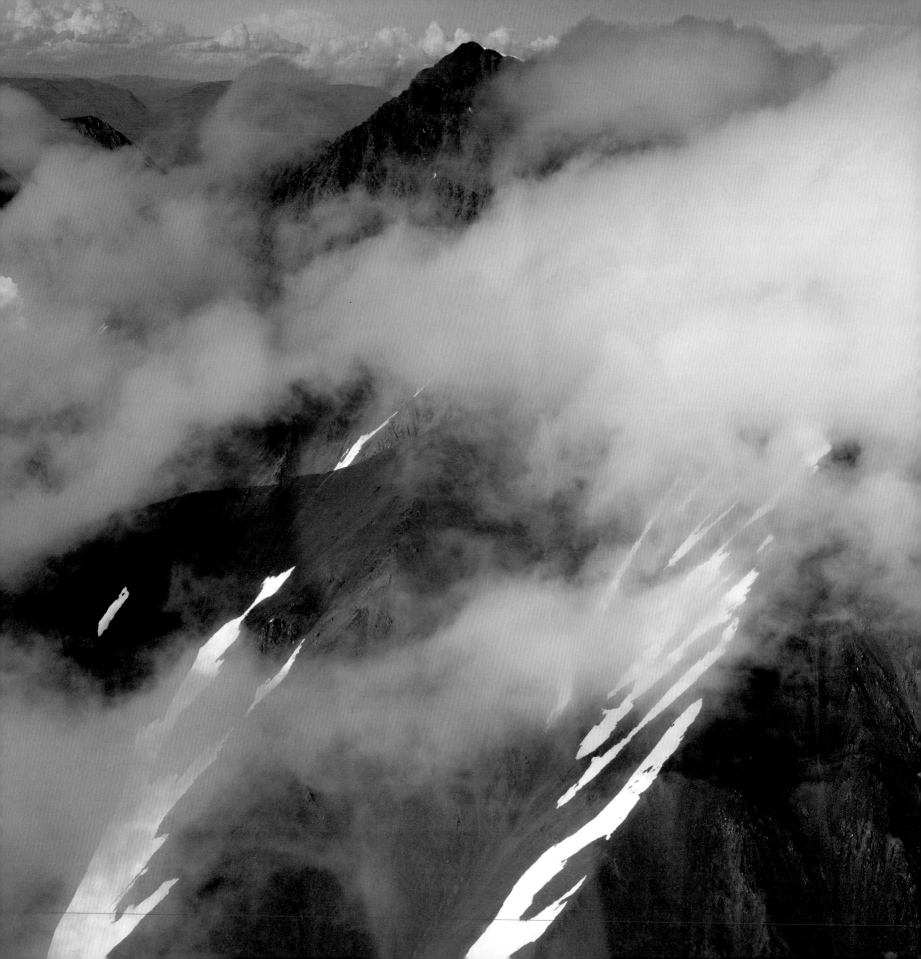

One forgets that there are environments which do not respond to the flick of a switch or the twist of a dial, and which have their own rhythms and orders of existence. Mountains correct this amnesia.

[Robert MacFarlane, *Mountains of the Mind: Adventures in Reaching the Summit*]

Clouds billow over shaggy slopes. The Kluane National Park expanse is roughly 83% mountains and glaciers.
KLUANE NATIONAL PARK AND RESERVE, SOUTHWEST YUKON

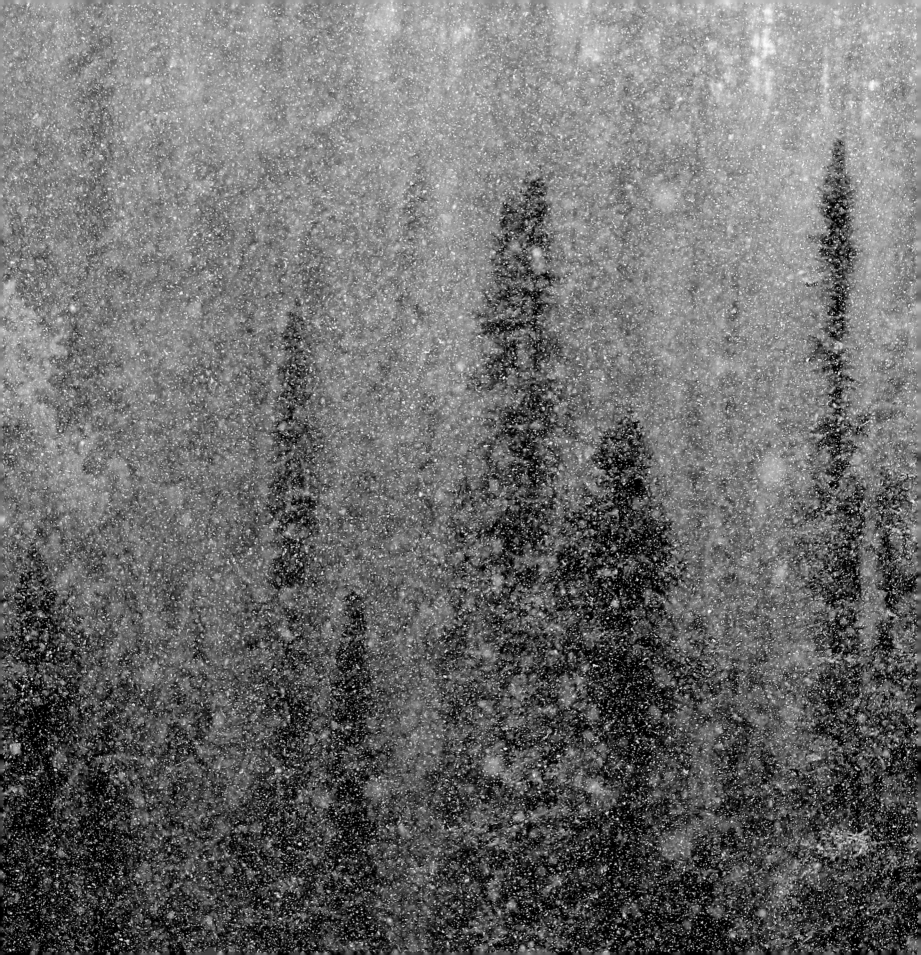

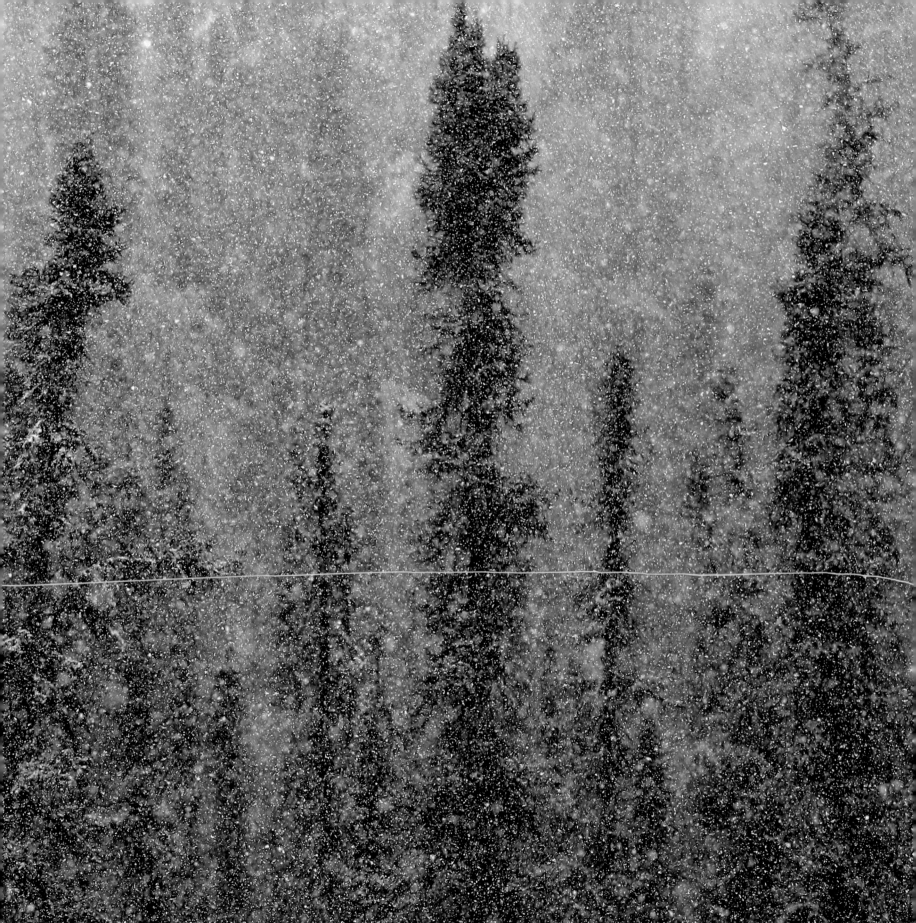

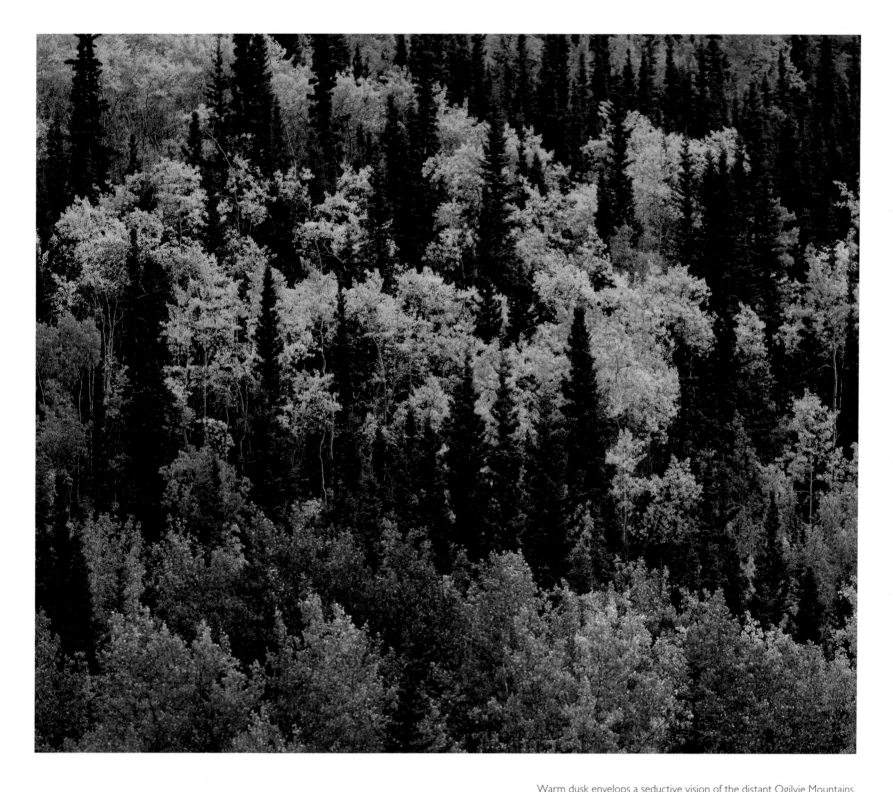

Warm dusk envelops a seductive vision of the distant Ogilvie Mountains. The rock formations of the north and south ranges are very distinct.
ALONG THE TOP OF THE WORLD HIGHWAY, YUKON HIGHWAY 9

A forest wall backs onto Teslin, once a summer gathering place for the Tlingit tribe. The Gold Rush and the building of the Alaska Highway/Yukon Highway 1 solidified a permanent settlement.
TESLIN

PREVIOUS ◦ A spruce and pine forest is almost obliterated during a surprise snowstorm near Frances Lake in the Tintina Trench rift valley.
ALONG ROBERT CAMPBELL HIGHWAY, YUKON HIGHWAY 4

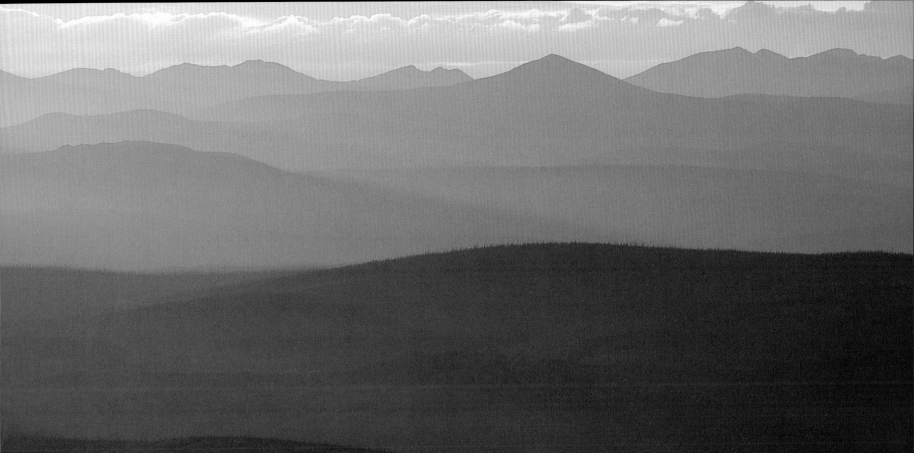

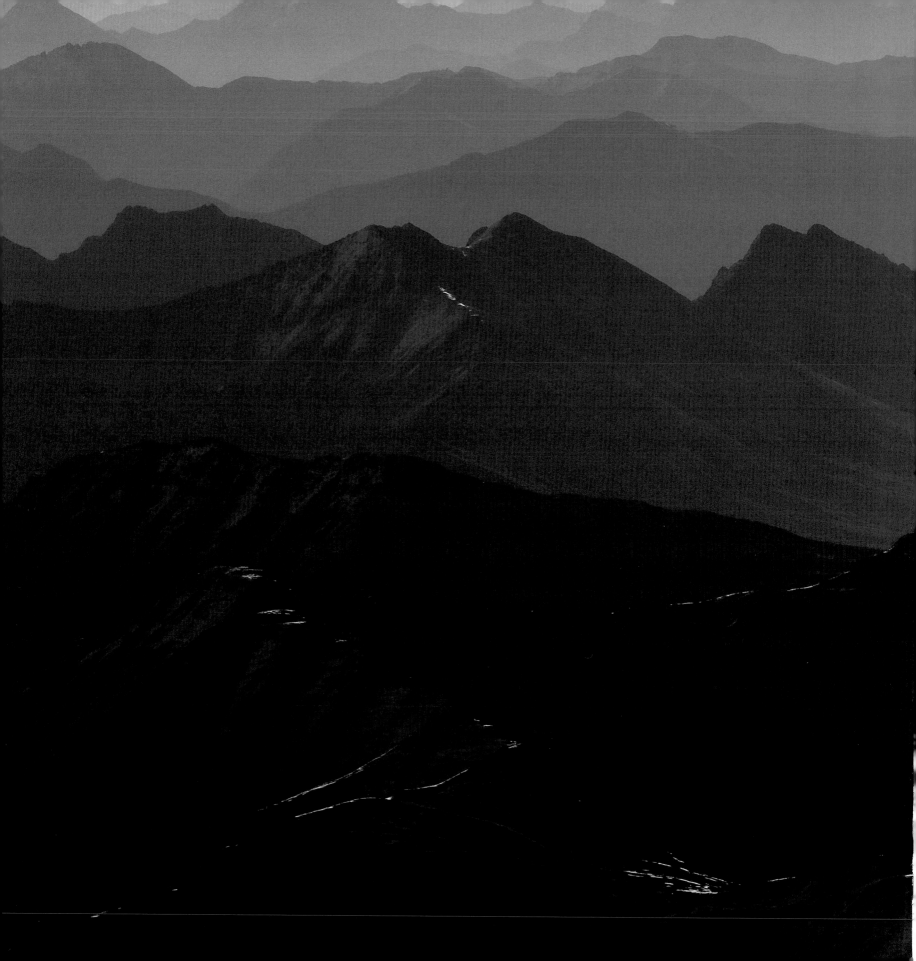

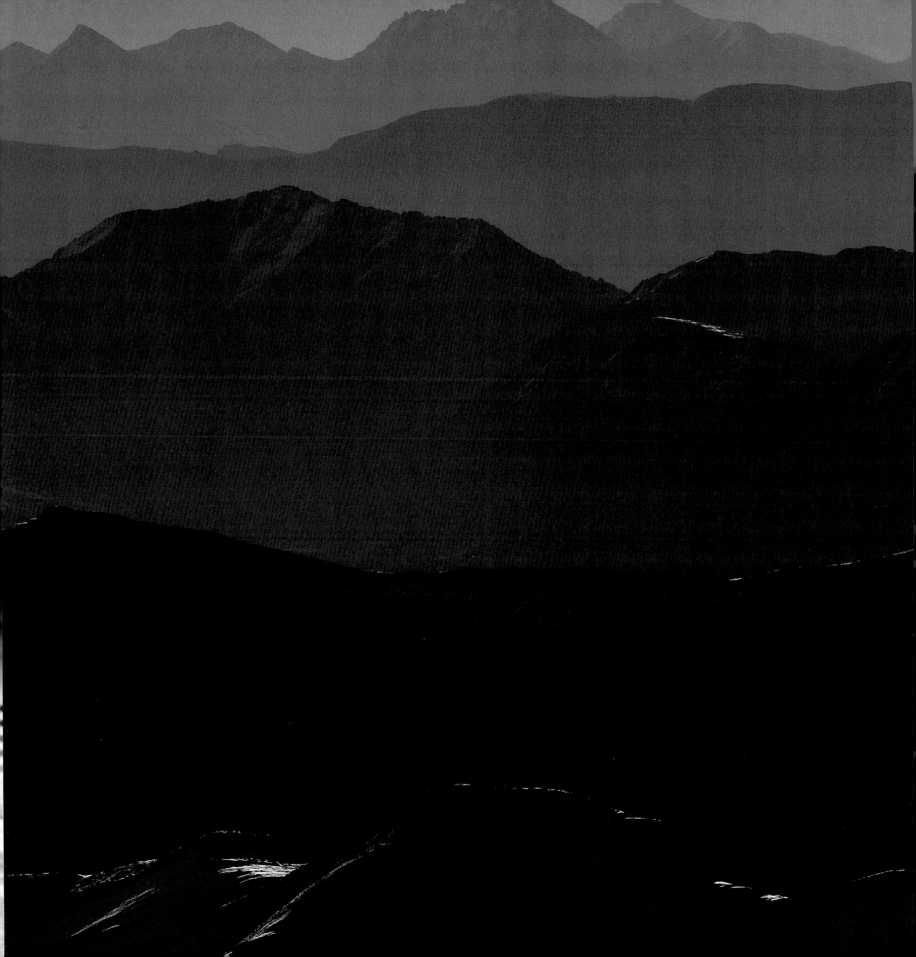

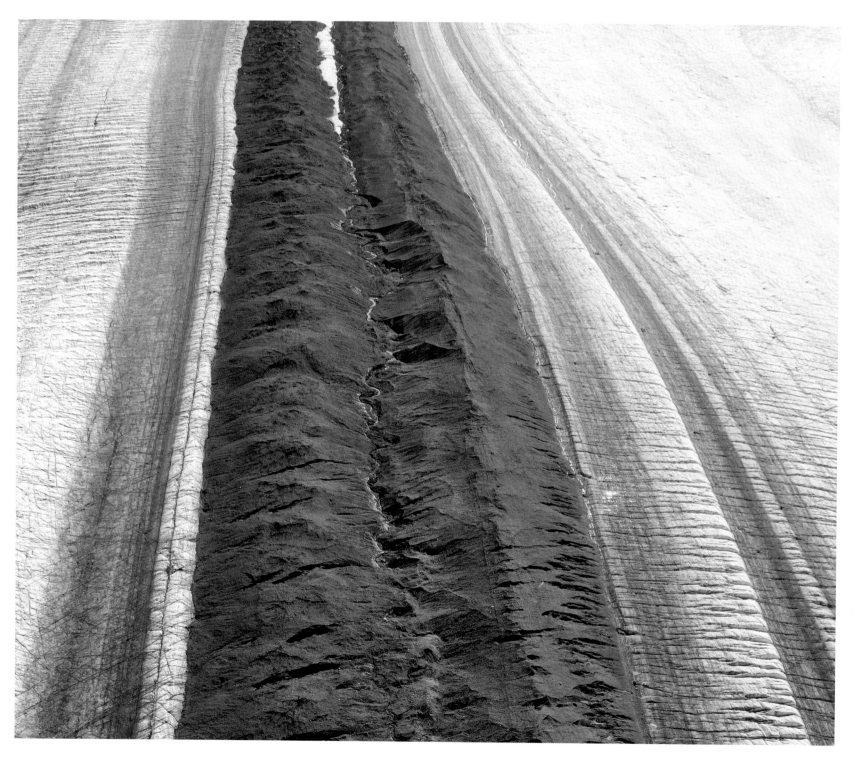

A unique collision of two glaciers, the Kaskawulsh Glacier is 4.8 to 6.4 km wide at its broadest point. Until recently, its meltwater channelled down to the Bering Sea. Since 2016 the receding flow has switched to the Kaskawulsh River and the Gulf of Alaska.
KLUANE NATIONAL PARK AND RESERVE, SOUTHWEST YUKON

PREVIOUS ∘ The southern pinnacles of the Ogilvie mountain range are darker than the northern part. They consist of more jagged igneous rock and slopes.
TOMBSTONE TERRITORIAL PARK, CENTRAL YUKON

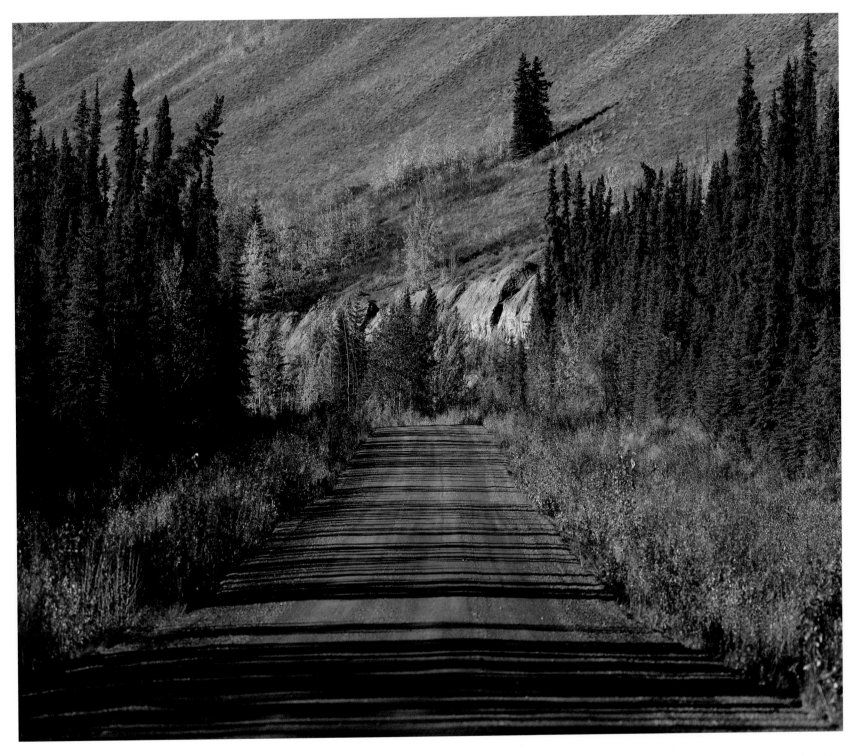

The Robert Campbell Highway heads into Ross River, a small community with a creative vibe and great fishing on the Ross and Pelly Rivers. It is the last stop for many adventurers continuing to the backcountry or along the next stretch of isolated road.

NEAR ROSS RIVER

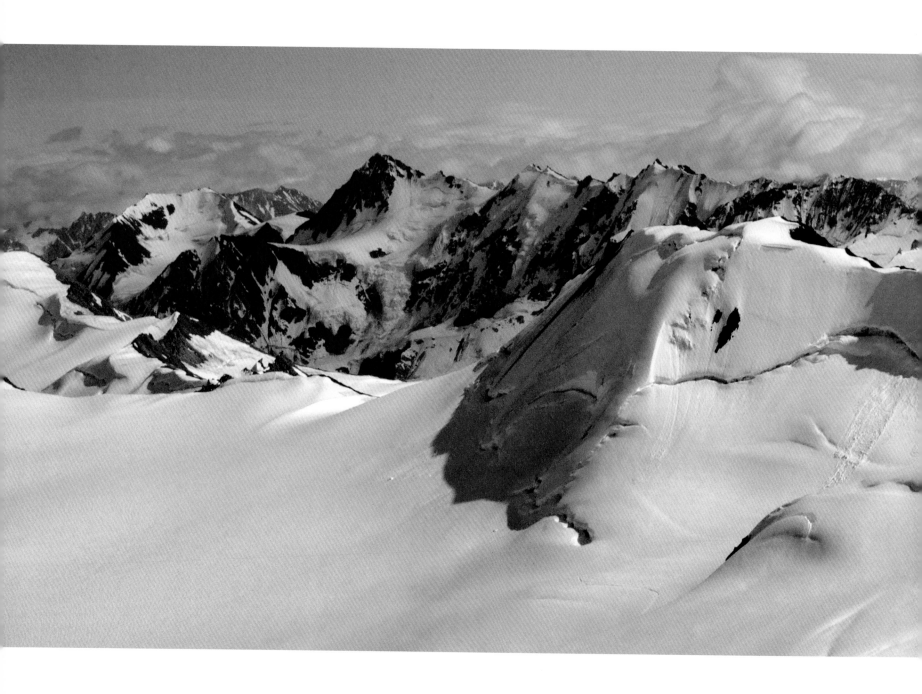

An incomparable view of the St. Elias Mountain Range shows an impressive expanse blanketed by snow. This was the first view of North America by the Russian Bering expedition team sent by Peter the Great in 1741.

Explorer Vitus Bering, a Danish cartographer in service to Russia, named it after nearby Cape St. Elias.

KLUANE NATIONAL PARK AND RESERVE, SOUTHWEST YUKON

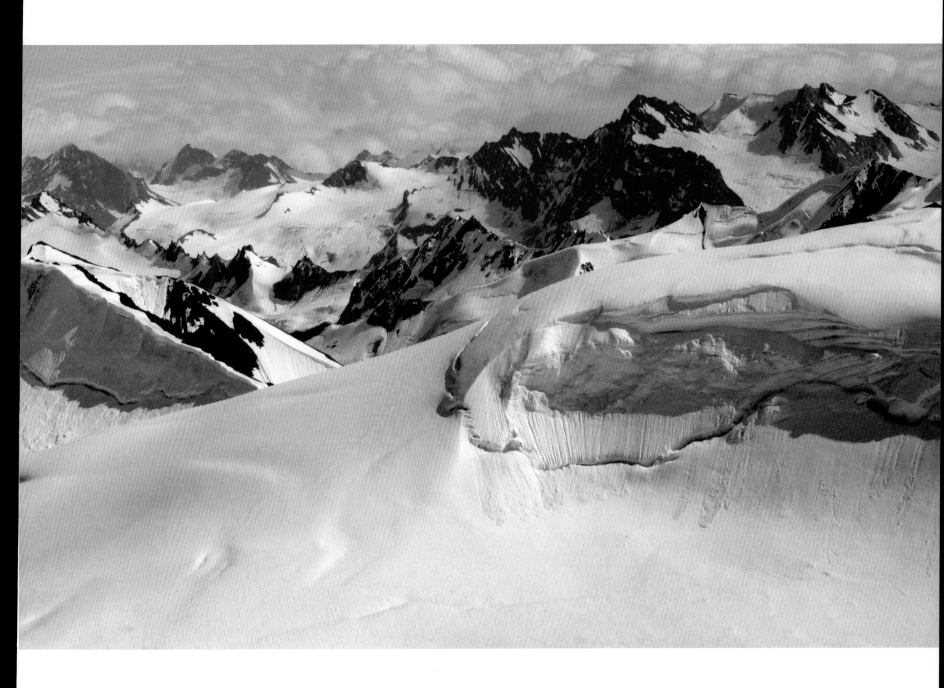

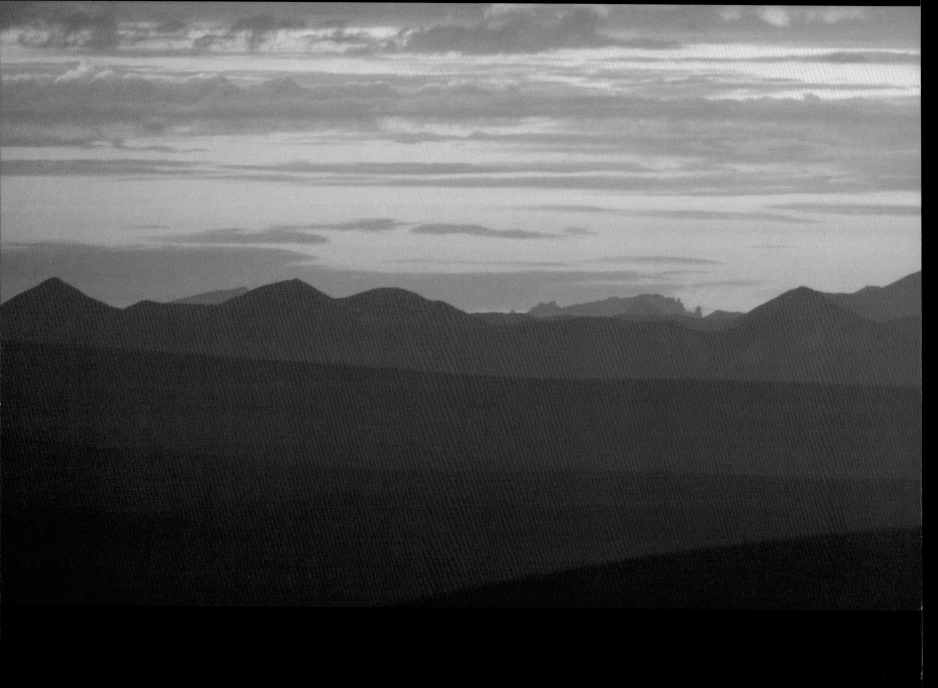

Sunset over the Ogilvie Mountains blurs the details of the range's layers. While few trails and many challenges exist, opportunities abound for encountering incredible thrills and natural wildlife.
ALONG THE TOP OF THE WORLD HIGHWAY, YUKON HIGHWAY 9

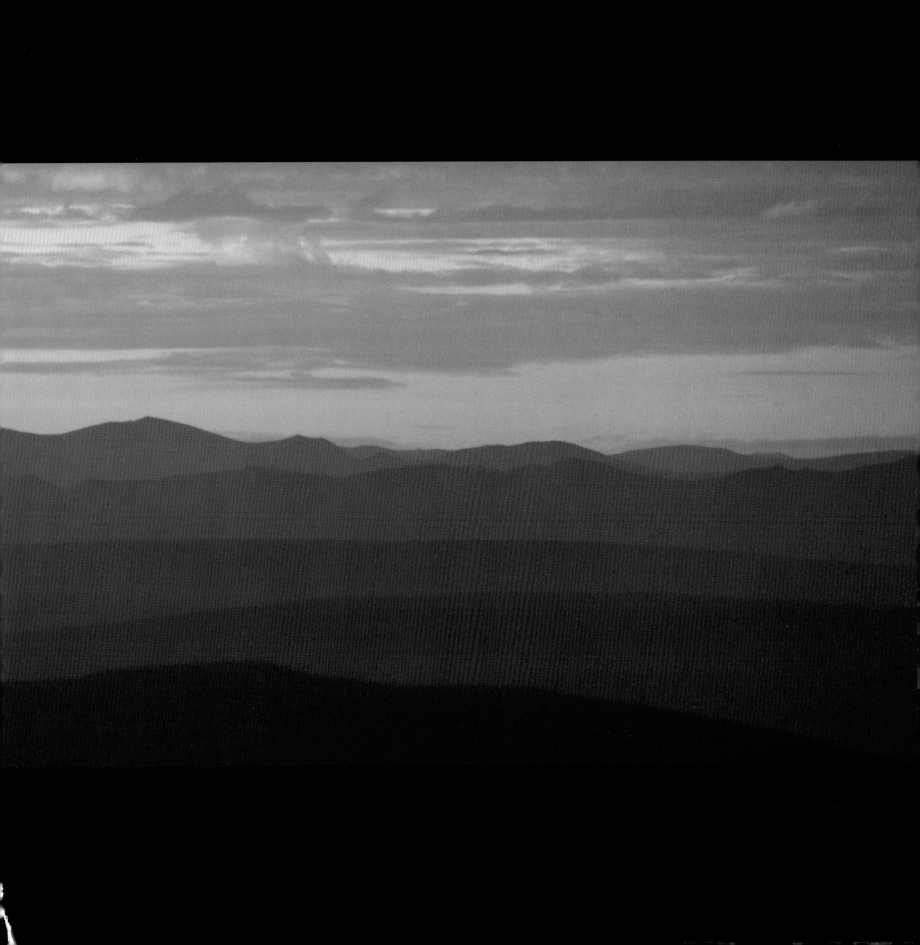

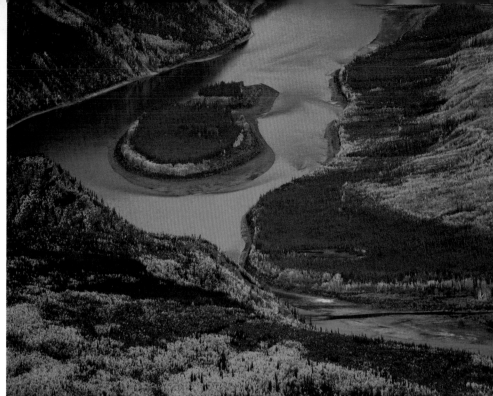

Yukon
LARGER THAN LIFE

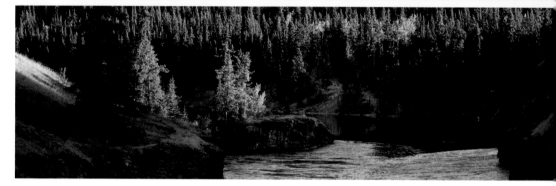

Home to some of the most pristine and stunning landscapes on Earth, resonant indigenous traditions, and a captivating Gold Rush and Ice Age past, Yukon stands alone in its unique balance between incredible natural beauty and rich cultural heritage. From the spontaneous self-guided daredevil to the arts and culture hound and solace-seeking nature-lover, our Larger than Life territory offers something for every kind of traveller.

Experience Yukon's fascinating Ice Age history with a trip to the world-class Beringia Interpretive Centre, where you'll learn the story of the 3200km² non-glaciated landmass stretching from Siberia to the MacKenzie River. Yukon is of special interest to archeologists and paleontologists worldwide for the crucial role it played in the migrations of many animals and humans between Asia and the Americas. They are also fascinated by the treasure trove of early human artifacts and fossilized specimens of mammoths and scimitar cats.

Experience the warm hospitality and rich cultures of the 14 First Nations in the Yukon. Explore the rich tapestry of music, dance, arts and storytelling. Step into Yukon's world-class cultural centres or join an interpretive hike to learn more about First Nations traditions. Wherever you travel in the territory, First Nations history and culture are part of what makes it the special place that it is.

Brush up on your Klondike Gold Rush history, which in just three years saw a migration of an estimated 100,000 often colourful characters migrate Yukonward to stake their claim to the elusory riches foretold by the Bonanza Creek discovery. Legends abound from the territory's portrayal in the famous works of Jack London, Robert Service and Pierre Berton, and you'll be able to walk in the footsteps of these pioneers as you hike the daunting Chilkoot Trail or stop to pan for gold along the storied Yukon River.

Tour one of Yukon's many national and territorial parks, including spectacular Kluane, which encompasses the world's largest subarctic ice fields and 17 of Canada's tallest mountains, including the country's tallest, Mt. Logan. Parks visitors have access to extraordinary hiking, camping, flightseeing, wildlife viewing and interpretive opportunities found nowhere else in the world.

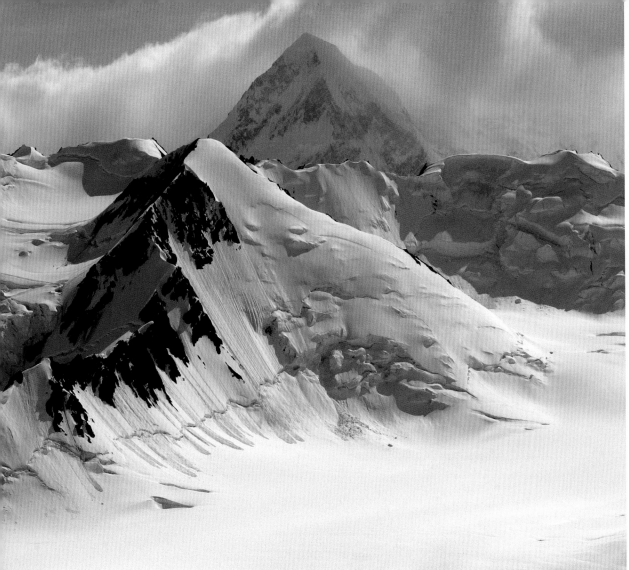

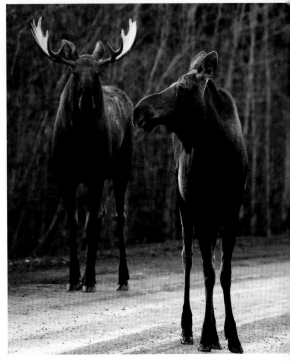

Summer or winter, fall or spring, Yukon's unique and authentic experiences are accessible year-round. Journey along our back roads and iconic highways for amazing scenic vistas and opportunities to view wildlife. Come hike or bike our incredible mountain trails, paddle our untamed rivers, drop a line into one of our countless lakes and soar over breathtaking glaciers and mountain ranges by floatplane. With Yukon's famous midnight sun, there will be plenty of time to see it all, and in winter let the dancing aurora provide a sweeping backdrop to your dogsledding, snowmobile, fat-biking or ice-fishing excursions.

Throughout the territory, enjoy a thriving arts scene, exceptional shops and restaurants, up-and-coming breweries and distilleries, excellent hotels and services, and seasonal craft markets and festivals – all flavoured by our outstanding and unparalleled brand of authentic

Explore the rich tapestry of music, dance, arts and storytelling.

homespun hospitality. From Dawson City's renowned music festival and eclectic array of Discovery Day events to Whitehorse's Adäka Cultural Festival and Sourdough Rendezvous winter carnival, there's never a dull moment. And with exciting events like the Yukon River Quest paddling marathon and 24 Hours of Light Mountain Bike Festival in summer, and the Klondike Trail of '98 International Road Relay and the Yukon Quest 1,000 Mile International Sled Dog Race in fall and winter, there's no bad time to visit.

With convenient flight connections and good road systems, it's easier to get here and around than ever before. One visit and we're sure you will see just how exciting and unforgettable a place Yukon is, and the many natural attractions and authentic cultural experiences that await you. Yukon is truly a land Larger Than Life.

The Explorers

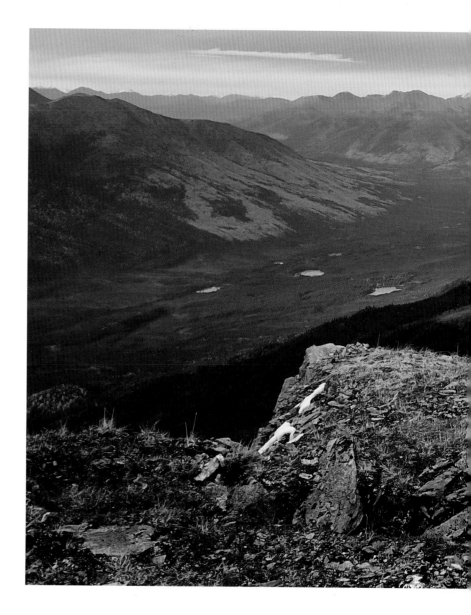

Jean Lepage

Born in Sablé-sur-Sarthe, France, Jean-Louis Lepage travelled extensively across Europe between the ages of 18 and 25. He came to Canada in 1966, settling first in Montréal for 18 months, then moving to Toronto. Jean-Louis has visited at least one different country every year for the past 30 years, and has seen more than 85 countries so far. Since 1991, he has worked as George Fischer's assistant on more than 50 photography books featuring various countries. He likes to travel to the mountainous regions of Mexico in the winter and Europe in the fall. His home base is Toronto, Canada.

Réginald Poirier

Réginald Poirier was born on Les Îles de la Madeleine in the province of Québec and studied agronomy at Montréal's McGill University. His Acadian roots surely account for his abiding love of the sea, the wind and island living. For over 20 years, this Madelinot has managed the Domaine du Vieux Couvent, a superb small hotel on Les Îles. When George and Réginald met 30 years ago, they became instant friends. It is Réginald's deep-seated penchant for adventure that has led him to accompany his photographer friend on a number of expeditions.

Acknowledgments

A heartfelt thank you to Jim Kemshead and Moriah MacMillan from Travel Yukon and their efforts to help me put plans together, good advice and help with details of the book. Your home is a wonderful region that everyone should seek opportunity to explore. For taking time to help with the last bit of research, I am obliged to Angel from the 98 Hotel and Lance Burton who were gracious with their information.

To my art director Catharine Barker, I am grateful once again for your creativity in showcasing my travels on paper through design and research for captions. I am also thankful to E. Lisa Moses for her inspirational wordsmithing and expertise in editing. I was fortunate to have both Jean Lepage and Réginald Poirier along for this wild ride – my travel experience is always enriched by your company. I appreciate your assistance and am blessed to also call you friends.

George Fischer

Landscape photographer George Fischer has produced more than 65 photographic books in addition to prints commissioned by various international companies, major publishers and private collectors around the globe.

Recognized by the tourism industry for his unique interpretations of destinations, features and spirit of place, he has provided photography for promotional literature published by tourist boards and international tour operators. Tourism boards include Jordan, France, Italy, Guatemala, Cuba, the Maldives, Malta, Iceland, the Faroe Islands, and regions in the United States and Canada.

In November 2017, George received the Ontario Tourism Award of Excellence in Photography. Among his major accomplishments is the book, *Canada: 150 Panoramas*, which made the best-seller list at Indigo and quickly sold out of its first printing. In 2007, *Unforgettable Canada, 100 Destinations* was on The *Globe and Mail*'s bestseller list and has sold over 75,000 copies. In subsequent issues it was expanded to 125 destinations and is now in its fourth printing.

An avid outdoor adventurer and cyclist, George has hiked Machu Picchu in Peru, cycled the legendary five iconic climbs of the Tour de France and in Bolivia cycled what is dubbed "the world's most dangerous road." He has summited Mount Kilimanjaro in Tanzania, Gokyo Ri in the Himalayas, Torres del Paine in Chile and Mount Fuji in Japan. In Iceland, he trekked across mountains and glaciers. Closer to home, he has photographed every region of Canada and most recently delved into the colourful history of The Thousand Islands Region and the Northwest Territories.

See more of George Fischer's work at GeorgeFischerPhotography.com

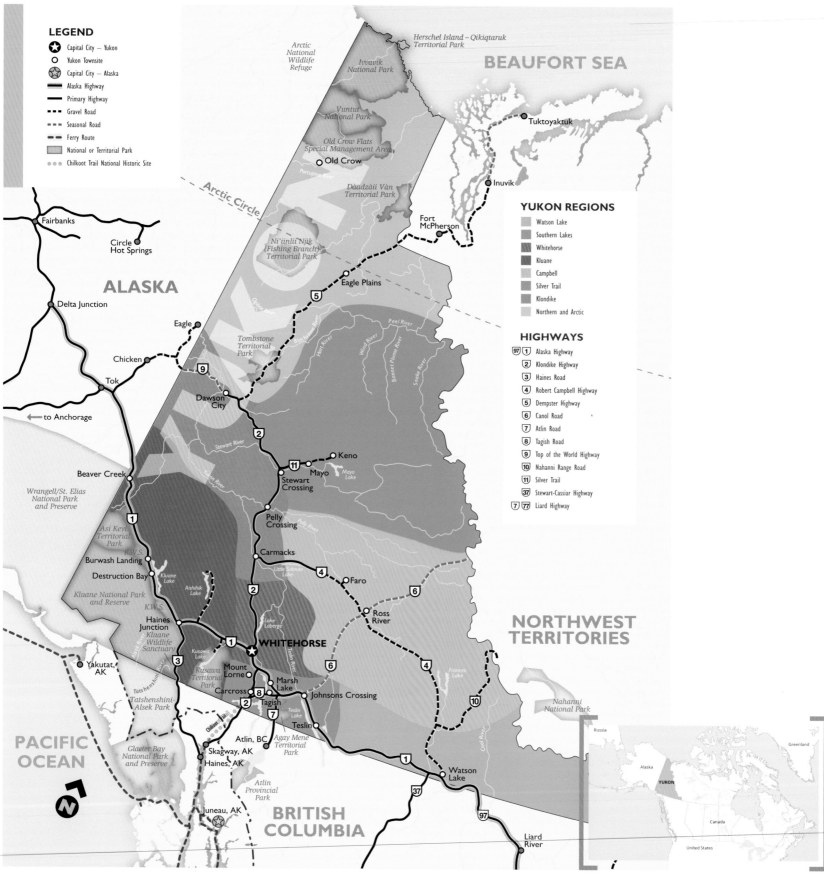

LEGEND

- ⬡★ Capital City – Yukon
- ○ Yukon Townsite
- ⬡★ Capital City – Alaska
- ▬▬ Alaska Highway
- ▬▬ Primary Highway
- ▬ ▬ Gravel Road
- – – – Seasonal Road
- – – – Ferry Route
- ▨ National or Territorial Park
- ⦙⦙⦙ Chilkoot Trail National Historic Site

YUKON REGIONS

- Watson Lake
- Southern Lakes
- Whitehorse
- Kluane
- Campbell
- Silver Trail
- Klondike
- Northern and Arctic

HIGHWAYS

- 97 1 Alaska Highway
- 2 Klondike Highway
- 3 Haines Road
- 4 Robert Campbell Highway
- 5 Dempster Highway
- 6 Canol Road
- 7 Atlin Road
- 8 Tagish Road
- 9 Top of the World Highway
- 10 Nahanni Range Road
- 11 Silver Trail
- 37 Stewart-Cassiar Highway
- 7 77 Liard Highway

BEAUFORT SEA

Herschel Island – Qikiqtaruk Territorial Park

Arctic National Wildlife Refuge

Ivvavik National Park

Vuntut National Park

Old Crow Flats Special Management Area

Tuktoyaktuk

Inuvik

Old Crow

Dàadzàii Vàn Territorial Park

Fort McPherson

Ni'iinlii Njik (Fishing Branch) Territorial Park

Arctic Circle

Eagle Plains

YUKON

Fairbanks

Circle Hot Springs

ALASKA

Delta Junction

Eagle

Tombstone Territorial Park

Dawson City

Chicken

Tok

to Anchorage

Beaver Creek

Wrangell/St. Elias National Park and Preserve

Asi Keyi Territorial Park

Stewart River

Keno

Mayo

Stewart Crossing

Pelly Crossing

Carmacks

Faro

Burwash Landing

Destruction Bay

Kluane National Park and Reserve

Kluane Lake

Aishihik Lake

Ross River

NORTHWEST TERRITORIES

Haines Junction

Kluane Wildlife Sanctuary

Lake Laberge

WHITEHORSE

Kusawa Lake

Yakutat, AK

Kusawa Territorial Park

Mount Lorne

Carcross

Marsh Lake

Johnsons Crossing

Tatshenshini River

Tatshenshini-Alsek Park

Tagish

Agay Mene Territorial Park

Nahanni National Park

Teslin Lake

PACIFIC OCEAN

Glacier Bay National Park and Preserve

Chilkoot Trail

Skagway, AK

Haines, AK

Atlin, BC

Teslin

Atlin Provincial Park

Watson Lake

BRITISH COLUMBIA

Juneau, AK

37

97

Liard River

Russia

Greenland

Alaska

YUKON

Canada

United States

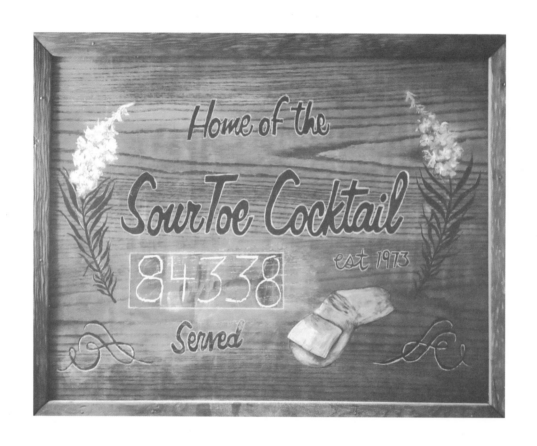